Daumier and His World

DAUMIER

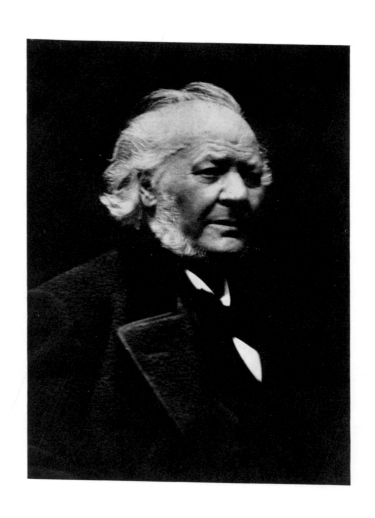

and His World

HOWARD P. VINCENT

Northwestern University Press
Evanston 1968

Howard P. Vincent is Professor of English at Kent State University, Kent, Ohio

Daumier's alphabet is reproduced with the permission of the Bibliothèque Nationale (D325; 1836).

The illustration on the cover, *Don Quixote and the Dead Mule*, was formerly in the Baron Gourgaud Collection and is now in the Louvre. Courtesy Photo Bulloz.

FRONTISPIECE Photograph of Daumier by Nadar
Bibliothèque Nationale

To the memory of Clarence A. and Lucy S. Vincent

CONTENTS

ILLUSTRATIONS

ACKNOWLEDGMENTS

If I do borrow anything . . . you shall find me to acknowledge it, and to thank not him only that hath digged out treasure for me, but that hath lighted me a candle to the place.

JOHN DONNE
"The Progress of the Soul"

LIBRARIANS, archivists, critics, scholars, and collectors have been indispensably helpful during the many years in which this book was being composed. M. Jean Adhémar of the Cabinet d'Estampes in the Bibliothèque Nationale has in his friendly way encouraged and assisted me in the early stages of my studies, as did also Mr. Carl Schniewind, then Curator of Prints at the Art Institute of Chicago. M. Geoffroy-Dechaume, grandson of Daumier's executor; M. Louis Sergent; and M. Seuillerot generously allowed me to examine and to use important Daumier documents in their collections. M. Jean Cherpin of Marseilles and M. Philippe-Jones of the Museé Royale of Brussels were both cordial and cooperative. Staff members of the libraries and museums of the Art Institute of Chicago, The Newberry Library, the University of Chicago, the Illinois Institute of Technology, Northwestern University, Harvard College, the Boston Public Library, the Library of Congress, the Frick Gallery, the New York Public Library, the Victoria and Albert Museum of London, the Courtauld Institute, the Tate Gallery, the British Museum, the Louvre, and the Bibliothèque Nationale have ever been ready to help.

Mary Wilson Vincent has with the traditional patience of the scholar's wife endured the study for and the writing of this book over many years. Dr. Bernard Lemann, Dr. Samuel K. Workman, Dr. Louis Gottschalk, Dr. Haydn Huntley, Dr. Richard Goldthwaite, and Dr. Walter Scott have all read the manuscript and made considerable improvements in it. Most profoundly, and however inadequately, I wish to thank Madame Liliane Kieffer for the archival research which gives any substance and originality to this study. Much of the research

for this book was made possible by a grant-in-aid from the American Philo-
sophical Society, Philadelphia, for a summer of research in 1954. Further re-
search assistance was most generously given me, in released time and in money,
by the Research Committee of Kent State University. To both institutions I
am deeply grateful.

Further acknowledgments, more scholarly than personal, will be found in
the notes at the back of the book.

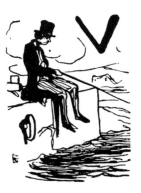

INTRODUCTION

PAUL VALÉRY wrote despairingly, after looking over the literature on the artist, that "Everything has already been said about Daumier." He was wrong, as he must have known, and as he demonstrated by saying something new, or at least something quotable.

It is questionable whether everything may ever be said, or even the ultimate facts discovered, about a genius. This is especially and distressingly so about the career of Honoré Daumier. We still coast along on the Daumier myths shaped long ago by the early biographers, and until the long study by Jean Adhémar and the more recent researches of Jean Cherpin, we have had little or no archival search, no real collecting of information. Cherpin has done something toward correcting one or two of the myths, but his work is little known outside France and we still await what will certainly be the definitive book on Daumier, when and if he completes it.[1] But to date, no one has, for instance, *used* the prison records and the other evidence to tell the story of Daumier's career under Philipon on *Caricature* and *Charivari*. Philipon has gone completely into limbo and yet he was a figure of major importance in the life of the young Daumier. Everyone knows that Daumier suffered imprisonment—and celebrity —for *Gargantua*, but what, exactly, *Gargantua* referred to, and what its consequences were, has never been clearly told, with the salient facts significantly related. The beautiful and famous story about Daumier's receiving the Valmondois house as a surprise gift from Corot has gone unexamined, the deed of sale resting untouched, until now, since the day of its deposit. There has been no successful search for new letters, although there certainly must be a number

lying undisturbed in family attics. Where, one asks, are the Philipon family papers, which, if found, would open up a new phase of Daumier study?

Curiously enough, not many critics have applied themselves to the close analysis of Daumier's complex art, although perhaps they may be awaiting the sound factual basis provided by good scholarship before proceeding further with criticism. The canon of Daumier's *œuvre* in painting is complete confusion both as to genuineness and as to dating, although now the studies of Jean Adhémar, K. E. Maison, and Oliver Larkin represent a good beginning of a task first proposed, even attempted, by Marceau and Rosen back in 1937. There is, then, no satisfactory catalogue of the paintings to replace and to correct the pioneer work of Fuchs. The lithographs and the woodcuts have splendid catalogues by Delteil and Bouvy, although even there additions and corrections may be made. The sculptures have been catalogued by Maurice Gobin, but even in that book serious questions arise to disturb the biographer. To sum it up, the literature on Daumier may be immense, but much still needs to be done.

This present study of Daumier makes no pretense to finality—no book on the subject ever can. It combines the findings of all the previous studies and adds to them further materials discovered in the French archives. It has no bibliography, because Adhémar's is quite adequate for most purposes; however, the notes at the back of the book include the main work that has been done to date.

Daumier and His World attempts to show the development of Daumier as a man and as an artist, through close attention to his work as well as to the vital statistics. It considers that work, especially the lithographs, as both biographical and aesthetic facts. It traces and isolates his central symbols, the metaphors of his art.

This is a study of Daumier and his world; the one cannot be understood without the other. Daumier's life is set against, blended with, the backdrop of nineteenth-century France. Politically it was a century in which the democratic principle became, through violent struggles, embodied in political institutions. Twice, Daumier saw France try and fail to establish democratic government; at the end of his life he welcomed her third, successful try. During all this time he was the discerning recorder and critic, composing a *comédie humaine* inexhaustible in its richness and range, and unsurpassed in its mastery.

A humble, retiring man, Daumier avoided the spotlight, preferring to assail hypocrisy and inauthenticity rather than to indulge in self-dramatizations like his friend and admirer, Gustave Courbet. There are two qualities which perhaps sum up the essential character and the career of Daumier. The first is integrity, an integrity of an order which kept him from drawing a false or a sentimental line. The second was applied to Daumier at the time of his funeral, when Forain remarked, "Daumier was different from the rest of us—he was *generous*." It was a judgment acknowledged by all of his friends, and it must be the verdict of his biographers.

 H. P. V.

NOTE

ALL D REFERENCES in parentheses within the text (e.g., D1387) are to the standard catalogue of Daumier's lithographic work: Loys Delteil, *Le Peintre-graveur illustré (XIXe et XXe siècles): Honoré Daumier*, 11 vols. (Paris, 1925–30).

Similarly, all B citations (e.g., B73) are to the standard, authoritative catalogue of Daumier's woodcuts: Eugène Bouvy, *Daumier, l'œuvre gravé du maître*, 2 vols. (Paris, 1933).

All illustrations not otherwise credited are from the author's collection.

In the text of this volume, those titles, or legends, of Daumier's works that are within quotation marks indicate that the works originally appeared in a periodical such as *Charivari*.

Daumier and His World

CHAPTER ONE

The Early Years

ONORÉ-VICTORIN DAUMIER, born in Marseilles at three o'clock on the afternoon of 26 February 1808, was the second child and first son born to Jean-Baptiste and Cécile-Catherine (Philip) Daumier.[1] The building in which he was born, near the Old Port, stood until 1927 when, despite widespread protest, it was razed in the modernization of the quarter.

Genius is as unpredictable in its origins as in its achievements; it lights where it lists. The humble genealogy of Daumier gives little, if any, forewarning of future greatness.[2] The maternal grandfather, Honoré Philip, who came to Marseilles from Entrevaux in 1794, was a tinsmith. The paternal grandfather, Jean-Claude Daumier, was born in Béziers, 16 December 1738, but migrated to Marseilles in 1767, set up as a glazier, and married Louise Silvy on 11 March 1770, subsequently siring eight sons. Jean-Baptiste, the artist's father, was born 26 February 1777.

Daumier's father was the first of the line who in any way distinguished himself. Apprenticed at the age of twelve to the glazier's trade, Jean-Baptiste showed interests unusual for his class and craft; he wanted to read and write—to write poetry. Aided by a friend of his father's, a bookseller, he borrowed and bought books, reading Delille's translation of Virgil, the writings of Jean-Jacques Rousseau, and the drama of Racine—all useful to him in forming his poetic style.

Upon his marriage to Cécile-Catherine Philip on 27 December 1801,[3] Jean-Baptiste moved to a country cottage near Marseilles where he might

3

meditate and write. "Poetry," he wrote, "was then for me a natural instinct . . . it lightened the obscurity of my life, and gave me the strength to endure un-pleasant labors but little compatible with literary work." [4] By 1807 he had com-posed sufficient verse to be accepted into the literary club of the city, a body under the aegis of the Marseilles Academy although not a member of it. His verse tragedy, *Philippe II*, adapted from Abbé de Saint-Réal's prose play *Don Carlos*, and his poem *A Spring Morning* were both praised by the Academy as "pieces of poetry revealing talent perfected by sound study."

Dazzled by this praise, Jean-Baptiste was persuaded that his modest talents were genius, that provincial success could be transformed into a Parisian con-quest. Leaving his family behind, Jean-Baptiste departed from Marseilles in 1815, manuscript in hand, to conquer the literary capital of France. He could not have chosen a more unsuitable moment. France, and Paris especially, was in a turmoil; Napoleon had escaped from Elba for the disastrous One Hundred Days. The ensuing events had left confusion in Paris, and Jean-Baptiste found, he later wrote, that "politics had overshadowed the muses."

Nevertheless, Jean-Baptiste's letters of introduction must have been effective. He was received courteously by men of eminence who asked him to read his verses. Among those who listened and applauded were Commodore Sydney Smith, Alexandre Lenoir, and Anisson-Dupéron, director of the Royal Press. One of these men actively promoted his interests. Lenoir, well known as an art collector and as director of the Royal Museum of French Monuments, wrote him in August 1815 asking him to bring his verse tragedy to a dinner party to read to the guests. [5] On 2 September Lenoir again wrote Jean-Baptiste, urging prompt-ness at an engagement to attend the Duc D'Avray, First Gentleman of the King's Chamber, through whom they might possibly reach the ear of King Louis XVIII. A month later Lenoir wrote again; the letter indicates that Jean-Baptiste actually had an audience with His Majesty, to whom he had written a poem. Shortly after, in November 1815, *A Spring Morning* was published by the Royal Press in a small octavo pamphlet of twenty-seven pages. Jean-Baptiste sent copies to Madame Daumier in Marseilles so that she could distribute them to friends and arrange for their sale. She wrote her husband (or dictated to a public stenographer), on 22 January 1816, that the wide distribution of presentation copies had seriously cut into the sale of the book. The literary club of Marseilles renewed its praise of the verses, and the book was reviewed in the local *Moniteur*. But *A Spring Morning* brought in little money to the now hard-pressed Daumier family.

When Jean-Baptiste wrote Cécile about his financial difficulties in Paris, she countered, 30 March 1816, with her tale of woe. [6] Out of funds, she had applied to her parents for bread, only, to her shocked surprise, to be refused. In this crisis she turned to a friend, M. Bonnet, who advanced her one hundred francs; this had been the family's sole support for the past twenty days. On the day she

wrote, her husband moved from 24 Rue de l'Hirondelle to the Hôtel de Limoges, 4 Rue de l'Ecole de Médecine. Presumably it was to this latter address that Cécile and her three children came when they joined Jean-Baptiste in Paris during September 1816. Young Honoré Daumier never, so far as is known, saw Marseilles again.

Much has been made, from regional pride, about the profound influence of Marseilles on the artist Daumier. It has been stated that "the warmth of heart, the quickness to pursue an idea, the swift insight which made him seize in a single stroke a scene or a situation, and to enter into them without touring around them" were special qualities which he owed to his natal region. This is mere rhetoric. It is true that region plays a role in the shaping of the young child, but all the characteristics which critics enumerate as Marseilles' gift to Daumier are qualities amply found in other regions and in artists in every part of the world. One no more explains Daumier simply by his birthplace than by his heredity.

II

IF ANY PARTICULAR PLACE had pre-eminence in shaping the genius of Honoré Daumier, it was Paris. Arriving at the age of eight, he lived there most of the rest of his life. The streets of Paris were his school and college, his occupation and pastime. They were his career. They formed him, made him aware, and out of this awareness he himself shaped Paris and her people into the thousand forms of his prints and paintings, all a devoted record of his city.

Obscurity covers the early years of the Daumiers in Paris. The father, Jean-Baptiste, had minor literary successes[7] sufficient to gain him citation in a biographical dictionary as a "glazier of Marseilles who without any kind of training and solely through the inspiration of nature, has composed a fairly good poem," but had his son not developed into a great artist, Jean-Baptiste would be forgotten today. His being a father, not his poetry, is his claim to fame; his best piece of poetry was young Honoré. As Mayor has wittily said, Honoré would draw what his father had failed to write.[8]

There has been a tendency on the part of biographers to scoff at Jean-Baptiste Daumier and his literary aspirations, but it is possible that had he remained merely a successful glazier in Marseilles, uninterested in literature and the arts, his young son would never have become an artist; the glazier's son would perhaps have contented himself with the family craft. It was the shock, the associations, the inspiration of Paris, together with the intellectual stimulation from his father's cultured friends, which opened the world of art to Honoré. In following the will-of-the-wisp of the arts, his father had set a precedent which young Honoré would willingly, and more successfully, follow.

Little more is known of Jean-Baptiste. Another volume of poetry, *Les Veilles poétiques*, was published in Marseilles in 1823. In this he referred to his "foolish love of futile fame, / To the magic favors of that vain idol" which had made him leave Marseilles and its beautiful skies. By 1832 he was financially dependent on Honoré. It is possible that he again took up his glazier's trade; his son's later marriage with a glazier's daughter suggests this. He died insane many years later, in 1851, in the asylum at Charenton.⁹

Honoré had little formal education and was put to work early.¹⁰ For a time he was a *saute-ruisseau* (gutter-jumper), the slang term for a notary's errand boy. His later print of "The Saute-Ruisseau" need not, despite the feeling which Daumier put into it, be taken as a self-portrait, as some scholars have thought. Nor must too much be made of the suggestion that during this time Daumier developed his animosity toward lawyers. For all we really know, he may have enjoyed the work.

About 1822 he served a brief time in Delaunay's bookstore in the Palais-Royal, then the commercial center of Paris. By this time, however, he had developed an interest in art and confronted his parents with his intention to become a painter. Appalled, they put the matter to their friend and patron, Alexandre Lenoir, to get his trained judgment. It is to Lenoir's everlasting credit that he approved Honoré's desire. So with a minimum of difficulty Daumier entered upon his life's work.

Daumier was fortunate that his first teacher was Lenoir himself.¹¹ As a painter, Lenoir held a distinguished place in Paris art circles. As an archaeologist, he had become an authority on medieval monuments and it was his watchfulness which had preserved many works of art during the French Revolution. He was also a collector of paintings. Under his tutelage Daumier had excellent examples to follow, copies of paintings by Rubens, Tintoretto, and Rembrandt, to augment the rich resources of the Louvre, where Lenoir sent his student to copy the classic and neoclassic models. This method may have been conservative but it proved sound. Above all, Lenoir admired the art of Michelangelo, of which he wrote in superlatives. Rubens, Rembrandt, and Michelangelo—these three artists whose influence we see in Daumier's painting—entered his life while he was a student under Lenoir.¹²

In time Daumier was to rebel against the academic routine imposed by Lenoir, "copying the classic noses," but it seems certain that this discipline was responsible for the foundation in formal rules which gives firmness and fullness —and certainty—to his art. The sentimental tendency to view Daumier as Natural Genius as opposed to Academic Formalism should not obscure Lenoir's place in his technical education as an artist.

There were, of course, other teachers, other studios. Daumier studied briefly in the ateliers of Suisse and Boudin, which means little more than that he had the opportunity to paint from live models at a minimal cost and to enjoy the

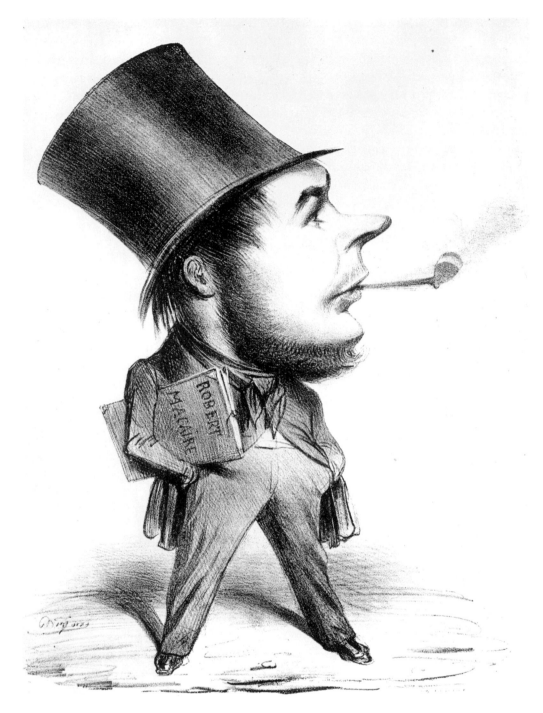

PLATE I Lithograph of Daumier by Benjamin
By permission of the Harvard College Library

companionship of, and to learn from, other students. Here he became the close friend of Jeanron (later Director of the Louvre), and the two of them collaborated on a painting, a sign for a midwife, for which they received fifty francs. Another close friendship was begun with Préault, a sculptor (undeservedly forgotten today) and a mordant wit. Here, too, Daumier may have met Charles Philipon, then an energetic, enthusiastic art student in flight from the family paper business in Lyons. Daumier would later come under his spell and would learn from him more than academies and Louvre copying could ever teach. And, finally, during these student days Daumier learned the art of lithography.

III

LITHOGRAPHY WAS LITTLE OLDER than Daumier himself.[13] Indeed, by one of those felicitous coincidences of fate, Daumier and lithography had come to Paris within a few months of each other. Although both had been born elsewhere, both found in Paris that remarkable rebirth leading to a secure place in the history of art. As the name indicates, lithography is simply the art of printing from stone, or, in Pennell's definition, "surface printing—not necessarily from stone—by means of chemical affinity—a method based upon the simple fact that the calcerous stone imbibes water and grease with equal readiness, having an affinity for both" and that water and grease are irreconcilable. The technique had been discovered in 1798 by a German, Aloys Senefelder, a struggling actor-playwright seeking an inexpensive method for printing his plays. He found that the smooth Kelheim stone used for flooring in Bavaria had the fine porous texture best able to take the drawing from the grease crayon and to print that drawing in almost limitless quantities. The new process was simple and direct, unlike etching and engraving with their several awkward steps and their more expensive and extensive equipment. A rapid, convenient, and inexpensive pictorial technique, lithography was a godsend for the future development of illustration in a democratic, cheap press, for almost half a century was to pass before an easy means of reproducing photographs through the halftone process came on the scene.

Comte Charles Philibert de Lasteyrie du Saillant was the first man to open a lithographic shop in Paris, on the Rue du Bac, in 1815. The subsequent installation of presses by both Godefroy Engelmann and Delpech shortly afterward assisted in making lithography the reigning fad of the city. Dilettantes of all ranks, from dandies to duchesses, even the King himself, toyed with the process. "Everyone," according to a contemporary (1819) song, "gets his picture displayed though he may not have posed for it. Everybody's doing it!"

By 1828 there were twenty-three lithographic establishments in the Department of the Seine alone, with 180 presses operated by 500 workmen producing

three million francs' worth of prints each year. This was more than a fad, it was an industry.

First a toy, then immediately a commercial convenience, lithography quickly became an art when the distinguished artists of France explored its possibilities. Gros, Guérin, Boilly, Bonington, Horace and Carle Vernet, Isabey, Huet, Ingres, Delacroix, and Géricault all created important prints. An exile from Spain, Goya in 1824 learned lithography in Bordeaux and Paris, and composed his bullfight prints "which seem," said Focillon, "to announce the forms of Daumier."[14] With such artists seriously employing the medium, lithography had arrived.

Daumier at first disliked lithography.[15] Apprenticed to the artist and shop-owner Zéphirin Belliard (also a Marseillais), Daumier grew disgusted with copying sentimental pictures of a royalist nature. He turned to other hack work, drawing lithographic alphabet sheets for children, making illustrations for books. None of this work has been identified.[16] For a time he found employment on a periodical founded by William Duckett (despite his name, a Frenchman). By 1829 Daumier was working for Ricourt (who was later to become the founder of *L'Artiste*), a print publisher in the Rue du Coq. It is said that Ricourt told Daumier, "You have the touch." With that remark Daumier criticism begins.

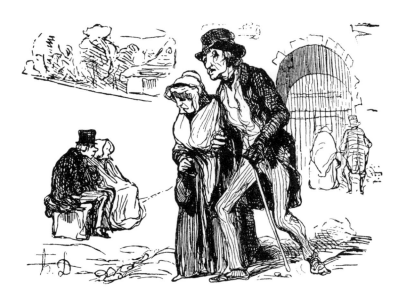

CHAPTER TWO

Caricature and the

1830 Revolution

AUMIER WAS A QUIET, PEACEABLE MAN, yet the entire background of his life was violence and revolution. As a child he had seen the final overthrow of Napoleon and the subsequent Restoration. Later, he would see and record the turbulent events of the revolution of 1848, the coup d'état of Louis-Napoleon, the Crimean War, the Franco-Prussian War, and the terrible and terrifying holocaust of the Commune. Now, at the beginning of his artistic career, he had the privilege of observing close at hand and of criticizing with eyewitness authority the Glorious Revolution of July 1830 which, whether it be to us chiefly a vigorous painting by Delacroix or a tedious textbook incident, was for Daumier and his friends a radiant, if unexpected, opening of political and social possibilities. It is against these violent events in the history of France that the life and art of Daumier must be posed.

The revolution of 1830 grew out of political and social events too complicated for recapitulation here.[1] It was accompanied by emotional and intellectual attitudes generally called "Romanticism"—a term, like Republicanism, resistant to satisfactory definition. In 1828 Victor Hugo defined it as "liberty in art, liberty in society," words representing dreams which strove for realization two years later when rioting broke out in the streets of Paris.

On 26 July 1830, King Charles X, a feeble old man infatuated with the trappings rather than with the true responsibilities of kingship, allowed Polignac, his chief minister, to publish the long-threatened "ordinances," repressive laws decreeing a strict censorship of the press, altering the electoral laws, and

ordering new elections. It was the first of these ordinances—against the press— which provoked the fierce, successful retaliations undreamed of by the King or Polignac. The protesting journalists closed ranks. First they issued a defiant manifesto; then up went posters urging all to reject the new tyranny. The propaganda was so successful that the rebellious leaders moved into revolutionary action. In quick succession, Thiers, of the liberal *Globe*, declared that the government no longer existed and that force alone ruled; August Fabre, editor of *La Tribune*, ordered the building of barricades in the narrow, crooked streets; and the dreaded drum-roll calling the citizens to riot was heard. First to respond (even as eighteen years later) were the students of Paris. Sporadic fighting broke out, and by the evening of 28 July the revolutionary forces controlled the eastern sections of Paris.

Taken by surprise, the King and his ministers attempted little real resistance. Refusing until too late to compromise by dismissing Polignac and withdrawing the odious ordinances, King Charles was forced to flee, first to Saint-Cloud and finally to England, noticed mainly by cartoons from the pens of Charles Philipon, Gavarni, and Honoré Daumier. He was not to be the last fugitive monarch that Daumier would so satirize.

In the meantime, while the rebellious but leaderless Republicans were dying on the barricades, the bourgeoisie, led by Thiers, Talleyrand, and Lafitte, manipulated events to their own interest. Thiers secretly visited Louis-Philippe, who, world traveler that he was, soon made the shortest but most fateful trip of his life, from suburban Neuilly to the town hall of Paris, to receive the throne of France. Riding unmolested through a crowd which respected his courage even while detesting his royal connections, he reached the balcony of the Hôtel de Ville to receive the embrace of Republican approval from the venerable Lafayette. Lafayette's grudging approval overcame the rioters' distaste for royalty. "*You* are the best of republics," Lafayette is reported to have said, a fatuous remark which later he denied having made. In any case, with Louis-Philippe's accession, the revolution was over.

Lafayette and the revolutionaries accepted Louis-Philippe through sheer necessity. France was radically split into three main political groups: the old-line Monarchists, or Carlists; the disorganized but explosive Republicans; and the powerful bourgeoisie, the propertied middle class. Louis-Philippe seemed to be the one man most tolerable to such diverse factions. He was of royal blood, and the Monarchists could at least accept one of their class even though longing for the return of Charles X; he had served bravely at the battles of Jamappe and Valmy for revolutionary France, and he had also long professed liberal principles, both factors effective in appealing to the Republicans; he was witty and well informed, an excellent family man, a good handshaker, and sympathetic to business and industry, so the bourgeoisie saw him as the hail-fellow-well-met sort sympathetic to property rights. Since the aged Lafayette would not accept

a presidency, the next best thing was to set up a constitutional monarchy, carefully changing the royal title from "King of France" to "King of the French People."

II

HEINE ASKED PERTINENTLY, "Who won the great fight in July 1830? Who lost it?" The answer to both questions is: the Republicans.[2] They won the battle of the barricades. Stendhal said in admiration, "The lowest rabble was heroic, and after the battle was full of the noblest generosity." But they lost the revolution by failing, in the end, to gain the liberties for which they had hoped and fought. They were politically innocent. Carrel told a friend, "The men that I appear to direct are not ready for the Republic; no political intelligence, no discipline."[3] They found that revolutions are often unprepared-for outbursts quickly exploited by bankers and politicians who coolly seize the sources of power: the press, the banks, the police and army, and the government. They expected universal male suffrage, lower taxes, and a government actively interested in social reform. They did not expect the grab and greed which the new honors list, naming sinecures and promotions, showed. Barbier, who was later to be a fellow worker of Daumier's on *Le Charivari*, spoke bitterly of "those who drew profit from the revolution: those bourgeois in kid gloves who watch the bloody street fights from the windows." A closer friend of Daumier's, the artist-actor Henri Monnier, aptly wrote, "The anger of the Republicans is the justified anger of Hotspur on the battlefield approached by the elegant swish with his pouncet box." Daumier himself, as early as September 1830, drew two men staring at the prints in Aubert's shop window (D8). One says, "He's [the cartoonist] right, the bloke, we made it [the cake of revolution] but they [the top-hatted bourgeoisie] feast on it." Three months later Daumier cartooned (D18) the Republican sheep being shorn by their shepherd, Louis-Philippe, who consoles them: "Poor sheep, you have done well, I will always care for you." These comments and cartoons are but a mild foretaste of the anger and of the feral attack unleashed six months after the Glorious Revolution when, at last certain of their loss, the Republican press discarded restraint and moved from uneasy truce to bitter battle.

Louis-Philippe had begun well, with these words: "Henceforth the Charter will be a fact." The Charter granted generous civil rights, including the freedom of the press, the spread of suffrage, and a considerable broadening of the base of representation in the Assembly. From the Charter, its integrity thus assured, the people expected a genuine constitutional monarchy, conceived of their new King as a symbolic figurehead rather than as a practicing tyrant, and felt that power would now rest in an areopagus made up of high-minded men representative of all France and chosen by most of the people.

These dreams faded quickly. Whatever his promises and proposals, Louis-Philippe went his own way. He had no intention of being the puppet of the grocers and the bankers who had juggled him onto the throne. He would encourage and use them, but they might not dictate to him. "They may do as they wish," he said, "but they shall not prevent me from driving my own carriage."

As power and wealth accumulated, the liberal professions of July and August 1830 slid easily away. France had not really changed its course; it ran in the same channels as before. Louis-Philippe quickly adopted a policy of stasis as opposed to movement. At home there was to be no change in the suffrage; the Assembly would still be appointed by the 240,000 Frenchmen with large property holdings, and the rest of the 28,000,000 citizens would still be denied the vote. In foreign policy there was to be equal inaction. Intoxicated with the air of freedom, the ardent spirits in France implored their King to send military aid to the struggling peoples of Poland, of Italy, and of Belgium. When he coldly refused —peace at any price—they cried out that France had sacrificed her sacred honor; Stendhal said bitterly, "I blush to be a Frenchman." The King and his ministers formed, in Marx's description, "a stock company for the exploitation of France's wealth, whose dividends were divided among ministers, Chambers, 240,000 electors (from a population of 28 million), and their followers, and Louis-Philippe was their director."

In 1831, in a speech which the King made to a delegation from the provinces, he proclaimed: "We must not alone cherish peace, we must avoid every thing that might provoke war. As regards domestic policy, we will endeavor to maintain a *juste milieu*."[4] This Juste-Milieu (happy medium) came to characterize the reign of Louis-Philippe.

III

THE REVOLUTION had been in good part the press's fight against censorship. "The French may publish and have printed their opinions in conformity with the laws. The Censorship will never be established," promised the new government in the Charter.

With this new freedom, the press of France flourished.[5] Anyone and everyone with two spare francs to rub together and with half an idea in his head, although this was not always necessary, rushed to found a periodical as a sounding board for his opinions. Politically the papers fell into three main groups along party lines: the Legitimists (Monarchists), the Republicans, and the government. These groups fought one another, but often the Legitimists and Republicans found common cause in their opposition to the government. Chief spokesmen for the Republican opposition were *Le National*, edited by Armand Carrel, and *La Tribune*, edited by Marrast. Into this journalistic orgy, Charles Philipon plunged promptly and wholeheartedly.

Charles Philipon deserves a place of the highest honor in any biography of Daumier.[6] A master journalist, a courageous enemy of political tyranny, the resourceful and inventive founder of two of the leading satirical magazines of the nineteenth century, creator of the Pear, and collaborator with Daumier in the *Robert Macaire* satires, Charles Philipon was a person close to greatness. It is surprising, even shocking, that historians have honored him with but a phrase, or at best a paragraph, and not with a biographical study.

Philipon was born in Lyons, son of Etienne Philipon, paper merchant, by his second wife, Fleurie Lisfranc of Saint-Martin. She was a royalist, yet her son achieved his place in history through his anti-royalist activities. Philipon's ancestry was creditably distinguished. On his father's side he was connected with the famous Girondist, Mme Roland; with General Philipon, who had under the Empire distinguished himself in the war against Poland; and with Philipon de la Madeleine, author of the *Dictionnaire des rimes*. On his mother's side he was cousin to Lisfranc, the celebrated surgeon.

Philipon received his early education at the Ecole de Saint-Pierre in Lyons, which he characterized as "a stupid municipal school, at least at the time I was its ornament." Later he attended the Collège de Villefranche (Rhône). Both of these schools provided Philipon "the worst studies one might be allowed to pursue." Following a year (1818) of work and reflection in the library of a friend, Philipon went to Paris to study in the atelier of Gros, the celebrated artist. (A fellow art student in Gros's atelier was Henri Monnier, later to serve as a member of Philipon's staff.) Although he was a favorite of Gros, Philipon frittered away his time because he saw little future for art in a world of paper manufacture at Lyons. He wrote:

> My father had destined me for business and I wished to obey my father. Consequently, one day I said farewell to the arts and the artists, to Paris and its lively, brilliant, intelligent world, and I returned to my native city resolved to take up my business study.

The attraction of Paris persisted. Lyons now seemed tame; the Lyonnais impressed Philipon as concerned exclusively with money and its pursuit. He felt himself sacrificed to a horrible way of life. Without knowing how he might live or what he could do, Charles Philipon returned to Paris, the young provincial eager to conquer the capital.

Philipon found meager work sketching rebuses (a decade later they were made a regular feature of *Charivari*), etiquette books, and catchpenny pamphlets for children, with titles like *The Story of the Phenomenal Child Polichinelle* or *The Story of the Bad Boy and Touche-à-Tout*. These hack works, sold for two sous, were moral little pieces, "each more interesting and each worse designed than the other." Philipon's ingenuity led him to perfect the *macédoine*, the story told on a single page in a series of vignettes, one of the ancestors (may God forgive him)

of the modern comic book. For each sheet Philipon received ten francs, and for a while he turned out three a day. He lost his lucrative job when cheaper labor moved in and took over his desk.

More significantly for the future of journalism, Philipon also drew a number of lithographic caricatures. Even though most of these were hack work at best, they made him aware of the possibilities of lithography as a satiric and caricatural weapon, and enabled him later on to appreciate the problems faced by his great stable of cartoonists. As for these prints of the 1820's, he later wrote with proper modesty, "If by chance some of these sketches should happen to catch your eye, give them a tear, no, give a smile to these children of need. They nourished their father, it is their only merit; they greatly need this merit to be worth something." Leafing through the collection of Philipon lithographs now preserved in the Cabinet des Estampes in the Bibliothèque Nationale, the observer need shed no tear; rather, he will indulge in a frequent smile, and even while he may not greatly cherish the cartoons, chiefly because of their frequent sentimentality and their technical deficiencies, neither will he be completely contemptuous of them, for they often have the merit of wit. At any rate, it is possible to appreciate them as part of the education of a superb editor.

Philipon's free-lance career was suddenly altered by the ill fortune of his brother-in-law, M. Aubert, who had married Philipon's half-sister. While living at Chalons-sur-Saône, Aubert had been ruined by speculation, and he had returned to Lyons to lick his wounds. From there he wrote asking Philipon to find a job for him in Paris. Without any special position of his own, Philipon proposed to Aubert that he come to Paris and open up a print shop. He offered to assist this venture by securing artists and even by supplying some of the funds. Aubert took him up on the suggestion; within a fortnight he and his wife were in Paris, and Philipon was in danger of being hoist with his own petard. From a friend, Philipon borrowed 600 francs, which were paid as the first six months' rent on a little shop in Number 15 Galerie Véro-Dodat. A few prints deposited by Gehaut Brothers and by two or three other publishers served as the first stock, the only capital of Aubert and Philipon, everything else having gone into the rent.

The success of Aubert and Philipon (the latter a silent partner) was phenomenal, worthy of the Juste-Milieu commercialism which Philipon was shortly to satirize. Two years after founding the concern, they had changed the location of their shop and were paying a rent of 3,000 francs a year, had a salary scale of 2,500 francs a year, and were publishing two periodicals—*La Caricature*, with annual expenses of 40,000 francs, and *Le Charivari*, at 120,000 francs annually. Add to this investment and resource more than 50,000 francs' worth of lithographs, and Aubert-Philipon had a capital investment of over 200,000 francs per year. From the status of a fly-by-night artist, Philipon had rocketed to the stature of a capitalist. It is little wonder that, gifted with a fine ironic sense, he

was able to write such understanding and witty captions for Robert Macaire the Promoter. For, principles aside, there was a touch of Macaire in Philipon himself.

To Philipon must go the chief credit for recognizing the full possibilities of lithography for popular magazine and book illustration. He studied the technique carefully, even to the extent of writing a book on the subject. The power of a picture far exceeds that of words—on this principle Philipon based his journalistic career. His first periodical, *La Silhouette* (1829–30), was a variety magazine featuring a lithograph in each issue, either as art or as illustration of the satiric text.[7] Not a particularly strong magazine—although it had contributors like Balzac and Charlet—it was a practice exercise for the creation of the great pair, *Caricature* and *Charivari*. Philipon was the founder of modern journalistic caricature.[8] Daumier, his pupil in political warfare, became the creator of the modern political cartoon.

Silhouette had given Philipon sufficient experience so that when the revolution came he was ready to launch a periodical which would utilize his proven editorial skill and his friendship with a wide circle of vigorous young artists, all, like him, Republicans in disposition and having, in an Emersonian phrase, "knives in their brains." His skill was joined with an intense energy and great courage. Philipon dropped *Silhouette* and created *Caricature* in 1830.[9] Two years later he paired *Charivari* with the successful *Caricature*. Both were Philipon's creations, and if they are remembered today because of Daumier's part in them it is perhaps an unfairness to Philipon even if it is the way of the world.

Caricature first appeared on 4 November 1830 in the format which it kept for the four years of its existence. Published each Thursday, it carried one page of text and two full-page lithographs, one of them in color (occasionally, one two-page print was substituted). The prints were the chief attraction, but the text, especially when written by Philipon himself, was sprightly and witty, often being a running commentary on the prints of the day. The subscription rate was thirteen francs for three months, forty-six francs for a year. Grandville made a poster to advertise the magazine and designed the masthead. For the first two years he was also the leading cartoonist, later yielding primacy to the powerful caricatural gift of the developing Daumier.[10]

New in conception, *Caricature* for its first few months was not a great advance over *Silhouette*, save that it was more attractively and more expensively printed. Some of the early contributions—two lithographs by Decamps, pseudonymous articles by Balzac—are still of interest, but had *Caricature* ceased publication at any time during the first three months its passing would have attracted but little notice. *Caricature* became significant, found a focus, when political events had so decidedly worsened for French liberals that protest seemed imperative if the promised freedoms were to be realized. *Caricature* then became politically caricatural, acutely conscious of its novel role in journalism.

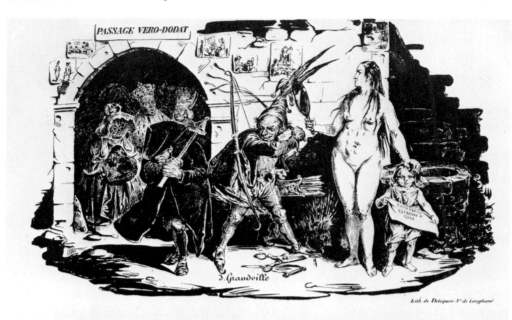

PLATE 2 A page of *Caricature*
Courtesy of the Art Institute of Chicago

As Philipon wrote in the twenty-sixth issue of the magazine, 28 April 1831,
"The power of this kind [i.e., caricatural] of opposition was unknown before the
July revolution because the censorship, abolished for the press, still remained
for prints and lithographs." Philipon then added a clear statement of his
deepened and decisive purpose for the future:

> *Caricature* will not cease to be the faithful mirror of our scoffing age, of political
> treacheries, of monkey business and of pious [i.e., hypocritical] parades, monarchic
> or patriotic, of these times when the grocer attends the court ball, when the car-
> bonari make the martial laws, when the sovereign people die of hunger.

Aroused to wrath, Philipon rose to a kind of greatness.

The cartoons and the columns of *Caricature* now attacked the King, the
Prime Minister, and the ministry in general, demanding that the government
fulfill promises more than six months neglected, and protesting against bills
made to burden rather than to ease the "sovereign people." The entire Republi-
can press joined in the outcry, angering the government into retaliation by
means of police invasion (illegal entry) and repression. Directed by Guisquet,
Chief of the Paris police, squads of officers known as *guisquetaires* swooped down
on print shops and newspaper offices to seize issues of newspapers held to be in-
flammatory in tone and intent, while simultaneously the government brought
suit against the offenders, litigation which cost money to defend, and which, if
lost, meant more money in fines and imprisonment.

The four chief targets of these illegal raids were the two great Republican
papers, *Le National* and *La Tribune*, whose authority and weight gave them the
serious leadership in Republican ranks, and Philipon's *Caricature* and *Charivari*.
The first two were the cannon booming the phrases; Philipon's were the deadly
snipers' rifles. Words wound, but Philipon knew—and it was his specialty—
that one picture was worth ten thousand words. Words reach a sophisticated
mind; the picture speaks to one and all. Philipon's gift was to combine his words
and his artists' prints with deadly effect. By 5 May 1831, the *Caricature* attack
being unambiguously oppositional, Philipon himself drew a cartoon, "Soap
Bubbles," in which the bursting bubbles were the government promises vanish-
ing in air. Guisquet's men raided the Aubert shop, where the lithograph was
printed, and seized the provocative cartoon. A week later Philipon aggressively
printed a defiant letter from "The publisher of 'La Caricature' to M. Persil."
Persil promptly ordered the seizure of this issue. Philipon was brought to court.
Fined but freed, Philipon boldly published (26 May 1831) an account of his own
trial, and he also prepared the feature lithograph, a coat of arms appropriate to
the Juste-Milieu, drawn by "Ch. Philipon, first blazoner of the best of repub-
lics." The pun was plain to the readers: "blazoner" carried the meaning not
only of heraldic artist but also of "besmircher." Besmirching became Philipon's
business in this "best of republics."

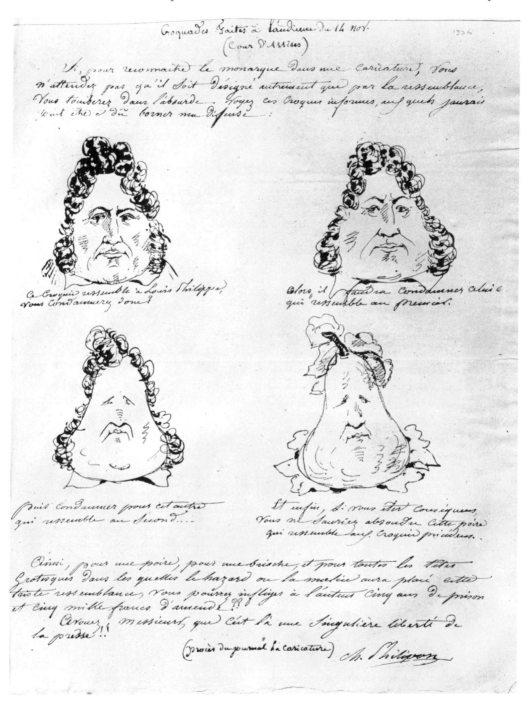

PLATE 3 *Metamorphosis of the Pear* by Philipon
Courtesy of the Art Institute of Chicago

Trivial lithographs, the satires of fashions and manners which had taken so much space in the early issues of *Caricature*, were now replaced by political cartoons only, cartoons which stung. The police visited the Aubert shop frequently. No one has made a tally of the seizures, but *Caricature* mentions dozens of them. (Not every seizure provoked a prosecution, of course.) The following imbroglio, while not affecting Daumier directly, shows the atmosphere in which he worked and the character of the man who taught him the art of satire. On 30 June 1831, again threatened with prison, Philipon printed a plate showing Louis-Philippe as a mason refacing the July 1830 signs (i.e., forgetting old promises). Persil ordered the issue seized. Philipon was brought to trial for crimes against the person of the King. Again the court judged him guilty, fined him 2,000 francs, and sentenced him to six months in prison (a term which did not begin until 13 January 1832).

Prosecution could not stop Philipon. On 14 July, *Caricature* carried his article, "Two Words about My Condemnation," as well as his apt cartoon depicting a lithographic press weighed down by huge stones which were variously labeled seizures, trials, fines, and imprisonments. In the same issue he printed a list of subscribers to a fund being raised to help him pay his fine and carry on his fight. Raffet's name appeared and, surprisingly for an impecunious royalist, Honoré de Balzac donated fifty francs to the cause.

Research has not yet traced the intricacies of litigation and persecution against Philipon, but they were long-drawn-out, fatiguing, and expensive. He nevertheless made excellent journalistic use of his tribulations, and in publicizing them continued his attack on Louis-Philippe. Philipon above all created the Pear, his master satiric stroke, so simple that it was genius.[11] His caricatural eye had noted that the King's head was thick at the base and somewhat pointed at the top, like a pear! Since pear also had a slang meaning of "simpleton" and "fool," he would publicize the pear as a symbol of the King.

When arraigned in court for this satire, Philipon denied that the Pear was an insult. After all, a pear is only a pear! He then demonstrated to the amused jurors that he had but drawn what he had seen. Before their eyes he sketched on a sheet of paper four pears, a "metamorphosis" in the manner of his artist friend Grandville, in which by stages the head of Louis-Philippe, without losing its shape, became the pear. Philipon told the court:

> They are connected with each other by imperceptible links. Each looks like the other. The first resembles Louis-Philippe, the last resembles the first, nevertheless the last—it's a pear! Where would you stop, if you would follow the principle which they allow you? You would condemn a man to two years of prison because he had made a pear which looked like the King. Then you would have to condemn all the caricatures in which could be discovered a head narrow at the top and large at the bottom! Then you would have your troubles, I tell you, because the cunning of the artists would show you all those connections in countless things more unusual.

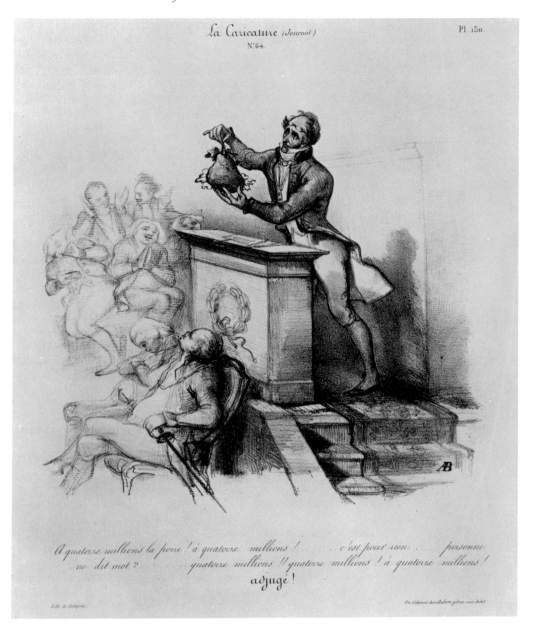

PLATE 4 *Philipon and the Pear* by AB
Courtesy of the Art Institute of Chicago

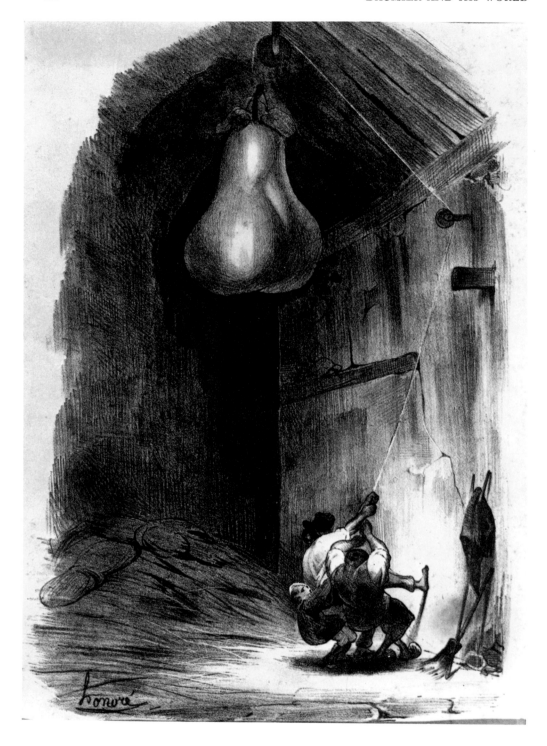

PLATE 5 *The Pear Hanged in Effigy*

See how you would have restored the royal dignity! See what reasonable limits you would place on the freedom of the crayon, a liberty as sacred as all the others, for it gives life to thousands of artists and printers, a liberty which is my right, and which you should not deprive me of . . .![12]

Brave words; the Frenchmen enjoyed the wit and Philipon's fine performance, but nevertheless the law was not amused and Philipon's newspaper suffered a further fine.

Tauntingly he printed his "metamorphosis" (Plate 3) to help raise funds for the fine,[13] and the Pear continued in *Caricature* and *Charivari*, becoming the chief symbol of the Citizen King, even more typical than his top hat and cotton umbrella. It was easy to draw, expressive in meaning, and could be found all over Paris. The King himself could not miss seeing it everywhere. On one occasion he encountered a small boy scrawling it on a wall. With a smile, he took the crayon from the child and finished the design. Then handing the lad a coin with his likeness he told him to have the true image of the King instead of the caricatural one. But a man may smile and smile and be a villain, and the state's prosecution of Philipon and his associates increased in severity.

In general, the Pear was the favorite caricatural device of the cartoonists Grandville and Traviès. Daumier himself used the symbol very little, although effectively. His most forceful cartoon of the Pear (D47), in *Caricature*, 19 July 1832, shows several men tugging, by means of a rope over a pulley, an enormous pear to the top of a barn (Plate 5). Daumier is impolitely hanging Louis-Philippe in effigy; certainly the obscene suggestion of the print was obvious to the masculine mind, and painfully comic.

In the middle of January 1832, Charles Philipon was taken to Sainte-Pélagie prison, to serve the sentence imposed some months earlier. There he was to share some of the benefits of the "best of republics" with other political prisoners, such as Carrel, Marrast, and Raspail, the great names of Republican leadership. With imprisonment, Philipon became one of the Republican martyrs, a figure almost as important symbolically as those leaders.

Even as he went, Philipon breathed defiance, for *Caricature* on 12 January 1832 had printed another of "the great blazoner" coats of arms, this time the "Arms of the Great Chicken." The cartoon did nothing to endear him to his prosecutors; nor, indeed, did Philipon's gay pretensions to fondness for the Juste-Milieu in words written from a Sainte-Pélagie cell:

There are those who don't like the Juste-Milieu. Me, I like the Juste-Milieu. I like it as I like Odry, as I like Arnal [two well-known clowns], as I like everything which amuses me. I like it as a monstrosity; I like it as a two-headed child, as a five-footed sheep, as a female Cyclops, a flame-colored rat, an acrobatic monkey, a learned canary, the fossil whale, the Siamese elephant, and the giant flea.

Although free in spirit, Philipon was nevertheless in prison, and Daumier, his pupil in politics, would soon join him.

CHAPTER THREE

"Gargantua" and

Sainte-Pélagie

T IS CERTAIN, although the exact business arrangements are unknown, that from the July revolution until his contretemps with the censor, in December 1831, Daumier worked for Aubert and Philipon, composing prints for independent sale and hoping meanwhile to break into the *Carica-ture* circle. At the time, for a magazine appearing only once a week, Philipon had more artists than he needed: Grandville[1] at the head, Gavarni,[2] Traviès,[3] Decamps, Beaumont, Berthaud, Monnier, and even Philipon himself were on call for the weekly illustrations. Daumier was close to this group and constantly under the eye and the tutelage of Philipon. His moment would come.[4]

Daumier's development during these eighteen months is shown in several prints where one also sees Philipon's directing hand in the choice of political subjects. Two plates (D24, D28) hit at the severity used by Marshal Soult in dispersing the Paris crowds. Though the tones are soft and weak, the composition is firm, employing the design—the triangle receding from a strong central figure—used earlier (D1, D2), which was always a favorite with Daumier. Progress can be identified more precisely in comparing two versions Daumier drew of the same subject, "The Nightmare." The first (D25) shows Lafayette asleep on a divan, a large syringe (a symbol for Marshal Soult) weighting his belly and causing him bad dreams—Daumier's reminder that Lafayette's approval of Louis-Philippe had led to Republican riots and repression. A few months later, with surer technique, Daumier repeated the subject (D41), this time more pertinently replacing the syringe with a Pear. This second version is technically,

24

as well as satirically, better; the tones are more cleanly contrasted, the design is more orderly; the Pear delicately but surely balanced on Lafayette's belly moves upward to the wall portrait of Louis-Philippe—Daumier's point rendered unambiguous.

A cartoonist who continually satirized the King and his ministers was certain to run into trouble. Daumier's turn came as his skill increased and his political jabs became more severe. Late in 1831 riots broke out in Lyons between the economically depressed silk-workers and the government. The King sent his son, the Duke of Orléans, with dubious proffers of peace to the rioters.[5] Daumier showed the "Departure for Lyons" in three pictures. The first (D30) was allowed only after Daumier removed a scatological reference; the second (D32) was flatly forbidden. The third, "Arrival at Lyons" (D33), was also forbidden, but had the censor interested himself in aesthetic matters he might have noticed Daumier's considerable advance in print-making. The tall, slender Duke extends the scroll of royal clemency toward the city, a cluster of buildings in the far rear. An arc of light sweeps from front to back to suggest the course of this royal star from Paris to Lyons; it suggests also the rainbow of false hope and false royal promise. In this print Daumier came close to his potential artistic power.

He was even closer to the royal wrath. His next print inspired a raid on Aubert & Company by the *guisquetaires*, who seized the stone and summoned Aubert, Delaporte (the lithographer), and Daumier to trial. This plate was "Gargantua." As a mark of Daumier's accession to fame and his arrival at satiric power, it merits a detailed description and analysis which critics curiously have avoided making. They have seen the picture in its general antiroyalistic stance but not in its specific satiric intent; that is, not in the way the print was understood by Frenchmen in December 1831.

To us "Gargantua" is merely an introduction to a rising young cartoonist; to the French in 1831 it was an appropriate, savage attack upon the new civil list being approved by the National Assembly for King Louis-Philippe. This list, says Louis Blanc,

menaced the kingdom with a burden of 18,533,500 francs. . . . This was assigning to Louis Philippe an allowance thirty-seven times greater than was paid by France to Bonaparte, first consul, and a hundred and forty-eight times greater than that which in America is deemed sufficient for the president of the flourishing republic of the United States. . . . They must, besides, have assured to the king, as real appendages of his crown, the Louvre, the Tuileries, the Elysée-Bourbon; the castles, houses, buildings, manufactories, lands, pastures, farms, woods, and forests, comprising the domains of Versailles, Marly, Meudon, St. Cloud, St. Germain, Fontainebleau, Compiègne, and Pau; the manufactory at Sèvres, and those of Gobelins and Beauvais; the Bois de Boulogne, the Bois de Vincennes, the Forêt de Sénart, to say nothing of a splendid personal endowment, comprising diamonds, pearls, precious stones, statues, pictures, cameos and other worked stones, museums, libraries, and other collections of art and science.[6]

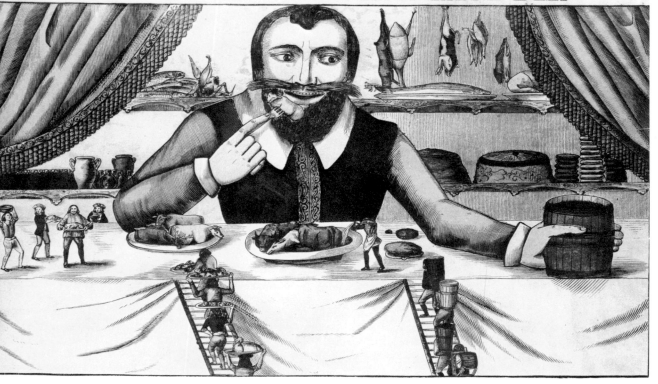

LE CÉLÈBRE GARGANTUA.

PLATE 6 Epinal print of *Gargantua*

These lavish gifts were proposed at a time when in the twelfth arrondissement alone there were over 24,000 people in desperate need. To a nation in which the majority lived in appalling poverty such a budget was an outrage. Swift's stabbing metaphor in *A Modest Proposal*, a people being eaten by the crown, is rendered in a truly French version, the myth of Gargantua, the great glutton.

II

LIKE ANY LITERATE FRENCHMAN, Daumier was familiar with Gargantua, once a folk hero in the Lyons area, who was given immortality by Rabelais. About 1830, L'Imagerie Pellerin at Epinal, publishers of vigorous, luridly colored woodcuts popular among the lower classes, had issued a large plate of *Le Célèbre Gargantua* (Plate 6), in rich reds and bold blues, showing Rabelais' gluttonous hero at dinner, eating whole sheep, beeves, and pigs, while tiny retainers scurried up ladders onto the table to place more food before their hungry

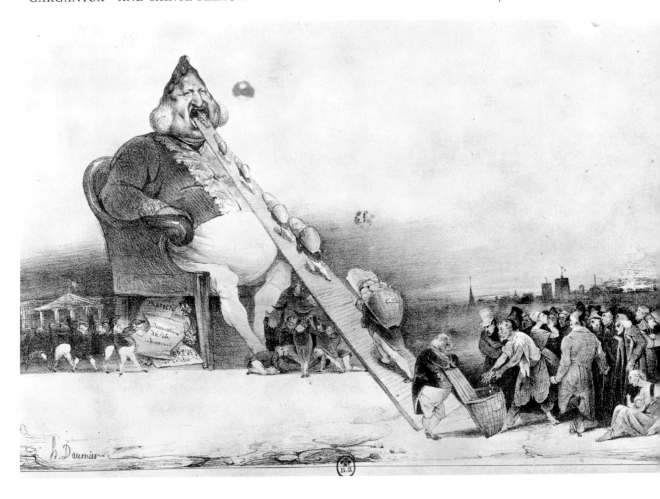

PLATE 7 *Gargantua*
Bibliothèque Nationale

master. Daumier probably knew the Epinal picture,[7] but unquestionably it was Philipon's idea to make political capital of a popular print and a popular hero. The Rabelaisian style of wit was more congenial and habitual to Philipon than to Daumier, all of whose independent satire—that is, work *not* in association with Philipon—had compassion and, in general, was unliterary and unallusive to fiction. (It is also significant that Daumier never used Rabelais again. His satiric forebear and favorite was Molière.) But even though "Gargantua" had been Philipon's suggestion, it was Daumier who drew the print and who unrepentantly suffered imprisonment for his deed.

In Daumier's picture (Plate 7), the thin-shanked, huge-bellied figure of the King sits like a massive idol on an enormous throne towering far above the plain outside Paris. A long ramp extends from the earth to his wide-opened mouth,

and up this ramp little men carry baskets of gold to dump into his great maw, filling the bloated belly. At the base of the throne other tiny figures resembling the ministers of state scramble for the spoils from Gargantua-Philippe. Caesar has here grown great and the petty men beneath crawl about his legs like pygmies. To the left behind the throne is the Exchange, representing the 18,533,500 francs of the budget; in the distance to the right is Versailles, representing the many appendages so liberally bestowed by the Assembly. And the throne itself, what Marx called "the golden pedestal of the July Monarch," is drawn as a *chaise percée* (toilet seat).

Critics who have wondered why this print provoked such a violent reaction from the crown fail to see the scatological implications—it is a savage statement which neither monarch nor ministers could ignore. Critics have also disapproved of the drawing, calling it thin and timid. Compared with the later Daumier this is true; compared with the work of most of Daumier's colleagues, Gavarni excepted, this is not true. Even in later years Daumier was to do worse. Grossness contrasted with pettiness, greed and subservience to that greed—these are effectively embodied in the figures, the tones, the masses, and the composition of Daumier's print. The concepts of "littleness" and "greatness" have some of the devastating implications of *Gulliver's Travels*, including Swift's fecal humor. If the plate does not entirely please modern aestheticians, it at least achieved its satiric intent and stung the forces of the crown to retaliation.

Although "Gargantua" could not be printed in *Caricature*, it received emphatic attention in that journal on 29 December 1831, in an article "16th, 17th, and 18th raids on Aubert's," in words as placatory as a kick in the teeth. Where, wondered Philipon ironically, is any offense?

> We have turned over "Gargantua" again and again in every way, and we are forced to say that, of the judge who ordered the seizure, or of ourselves who do not understand the motive, one of us is a . . . (The cruel alternative in which I find myself between the truth and a new trial will excuse my lacuna.) M. Gargantua is an enormous fellow who swallows and digests very well a natural budget, which he converts immediately into secretions of very good odor at court, in crosses, ribbons, brevets, etc. etc. . . .
>
> I have then good reason to cry to the jurors: *They will finish by making you see that resemblance there where it will not be!* For Gargantua does not resemble Louis-Philippe: he has the head narrow at the top and large at the bottom, he has the Bourbon nose, he has large features; but far from presenting that air of frankness, of liberality, and of nobility which so eminently distinguishes Louis-Philippe from all other living kings, who, just between ourselves, do not shine by those qualities, M. Gargantua has a repulsive face and a voracious air which make the gold pieces tremble in his pocket.

This, certainly, is the defense contemptuous, demonstrating Philipon's share in the creation of Daumier's print.

Daumier, Aubert, and Delaporte came up for trial on 23 February 1832, charged with fomenting disrespect and hatred against His Majesty's government and of offense to the King. Legorre represented the crown, M. Blanc the defense. All three defendants pleaded guilty; the court sentenced each to six months in prison, plus a fine of 500 francs and costs. The sentence was not to begin until 27 August, roughly six months from the date of the judgment.

Even before the trial for "Gargantua" took place, however, Daumier's first print, in *Caricature* (9 February 1832), "Most Humble, Most Submissive, Most Obedient" (D40), appeared. It was in effect a rerun of the earlier scandalous print, but with the person of the King, or Gargantua, removed and the unoccupied throne not in the form of a *chaise percée*, so that the plate was technically "innocent." Crowded together at the base of the throne, in a dark triangle stretching diagonally across the page, cluster the members of the National Assembly, Louis-Philippe's gang of politicians, all on their hands and knees or lying prostrate, clutching at whatever favors the throne has let fall before them. It is a diminished and distorted, but only lightly disguised, version of the now notorious "Gargantua," seized and coming up for trial.

The scandalous success of Daumier's satire is evidenced in a later print (author unknown, but probably Grandville) in *Caricature* showing the triumphal procession in honor of *Le Constitutionnel*, symbolized in the fat figure of the newspaper's owner and editor, Dr. Véron. One of the figures in the procession is Daumier, seen at the right of the print, carrying on his shoulders the *chaise percée* which he had recently made famous and for which he would endure prison (Plate 8).

With the first appearance of his work in *Caricature*, Daumier's career on the magazine had truly begun. During the six months before entering on his prison term, he drew several fine cartoons for the publication. Three of them (D43, D45, D46) are portraits of Charles de Lameth, Dupin the Elder, and Marshal Soult, all in bust, and are the beginning of the Philipon gallery of politicians to be discussed in detail in a later chapter. And just before leaving for prison, Daumier produced a plate (*Caricature*, 23 August 1832) that was again an echo of "Gargantua"; once more the throne, now occupied, but with only the lower part of one leg of its occupant showing, is approached in servility and obeisance by the statesmen seeking favors at (the title) "The Court of King Pétaud" (D49). Pétaud is the Lord of Misrule. With such impertinence, it is no wonder that the subsequent issue of *Caricature*, 30 August 1832, carried this news:

> At the moment we write these lines, they have arrested before the eyes of his father and mother, of whom he is the sole support, M. Daumier, condemned to six months in prison for the Caricature of Gargantua. *Plats valets, dites donc*: "*l'allègresse est universelle.*"

The concluding phrase is difficult to translate since it puns heavily on both the adjective *plat* (flat, servile, deflated, hungover, failed) and the noun *valets* (base

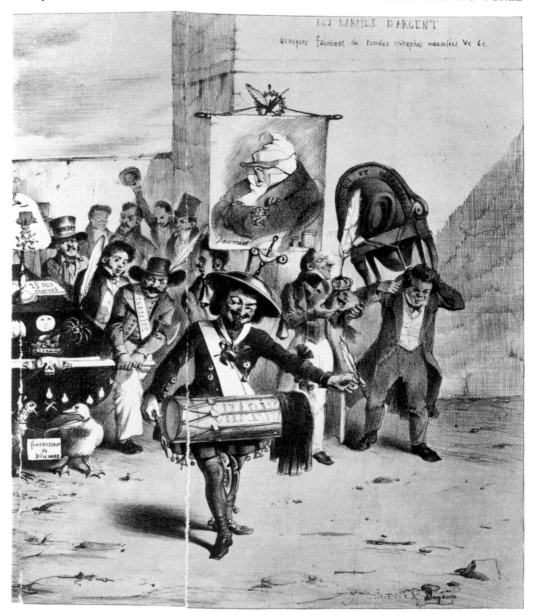

PLATE 8 *The Procession for Le Constitutionnel* by unknown artist
Courtesy of the Art Institute of Chicago

servant, sycophant). For such men, in Philipon's opinion, Daumier's imprison-
ment would be cause for "universal joy."

Daumier's prison sentence was put into effect. On 27 August 1832, Bouroux,
one of Guisquet's men, took Daumier from his home at 12 Quai de la Grève for
detention at the Prefecture.[8] From there he wrote a hasty unpunctuated note to

Madame Philipon: "Madame. I have just been arrested I beg of you please to let Mr. Philippon [*sic*] know that I recommend myself urgently to his kindness For I am in the most painful position I am at the depot of the préfecture."[9] Philipon replied immediately, saying that he would ask for Daumier's transfer from prison to the sanatorium where he himself had formerly been detained. Philipon would return for another term of imprisonment on 6 September 1832.

Four days later a bailiff named Poupeloz led Daumier along the ironically named Rue Gracieuse to the doorway of Sainte-Pélagie prison on the Rue de la Clef.[10] There he was given his gray prison costume and placed in the East Wing, which was reserved for political prisoners of Paris. Sainte-Pélagie adjoined the zoo, and the caged Daumier could look out from his cell at the caged animals. *Caricature* (30 August) announced Daumier's detention. Gargantua had swallowed Daumier.

III

DAUMIER WAS PLACED IN CELL 102. The record of entry described him as aged 24, with a retroussé nose, average-sized mouth, black hair with a cowlick high on his forehead, prominent oval chin, average eyebrows, normal coloring, and gray eyes. His height was given as 1.71 meters (5' 7").

Sainte-Pélagie was fairly liberal in its treatment of political prisoners; after all, one could not be sure whether some day soon the prisoners might not be rulers. The director of the prison was one Prat, a peaceable man with a cheerful disposition out of keeping with his office. He was short, wide as he was high, with an enormous belly which gave him the appearance of a huge calabash. He did his best in a miserable situation, trying to avoid trouble wherever possible. In general, he preferred to allow a subaltern to run things for him, but the assistant was a man of great stupidity, a grotesque individual. What was worst about Sainte-Pélagie was the dampness, which caused a number of illnesses and deaths. Philipon was so weak after but a short stay there that it was necessary to move him to a sanatorium to save his life. Daumier sketched a prisoner walking in one door of Sainte-Pélagie while another was being removed in a coffin through another door (Plate 9).

Sainte-Pélagie, however, was not pure gloom and desolation for political prisoners; they were given considerable freedom within the walls and some were even allowed outside if pressing personal business arose. There was a common room where the men might gather, and there were important men to meet. Philipon had been in Sainte-Pélagie shortly before Daumier arrived. Two distinguished men were still there. One was the chemist Raspail, who was carrying out scientific experiments even in prison, along with revolutionary planning. Another was Blanqui, soon to be, for the bourgeoisie then and for posterity in general, a symbol of anarchic revolution. Marrast, editor of *Le*

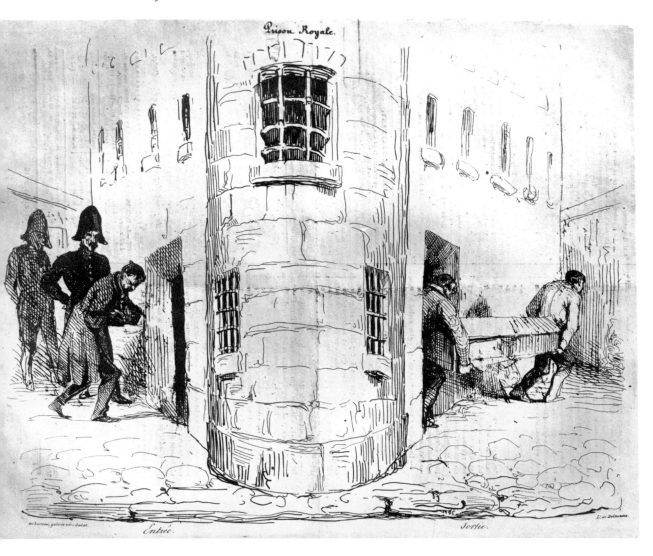

PLATE 9 *Entrance and Exit to Sainte-Pélagie*
By permission of the Harvard College Library

National, was also a prisoner. Prison, it would seem, was a Republican pantheon.

Furthermore, the atmosphere was electric with plans and hopes. The men kept their ears cocked for the expected drum-beat summoning a new revolution into the streets, and they were ready to act within the prison when the tocsin sounded. Political talk prevailed; Republicans and Monarchists (Carlists) argued with each other and among themselves, but they differed amicably, for at least they were united in opposition to the House of Orléans. "If they had not the same paradise," said Heine, "they had at least the same hell."

In all of this Daumier saw much to amuse him. The finest of all Daumier

letters (few survive) was written shortly after the artist's arrival at Sainte-Pélagie. He wrote to Jeanron on 8 October 1832:

My dear Genron [*sic*], I am forced to write you, not being able to come see you, for I am held at Sainte-Pelagie [*sic*] by a slight indisposition. I hear a big noise; I will suspend my letter a moment, you can take a walk while waiting.

Here I am back again, it was nothing, it was merely the Carlists fighting among themselves, for those creatures have been fighting like this for some time, not for honor, but because of family squabbles, for money.

Here I am then at Pélagie, a charming resort where not everyone enjoys himself. As for me, I enjoy myself here if only to be contrary. I assure you that I would get along well enough at the Pension Gisquet [*sic*] if, on occasion, thoughts of my home, I mean my family, did not disturb the charm of this sweet solitude!!! Apart from that, the prison will leave no painful memory; on the contrary—if at this moment I had a little more ink, for my inkwell is empty which much cramps my style, and forces me to dip my pen every second and annoys me; except for that, I say, I believe I lack for nothing. I work four times harder in pension than I would if I were home at father's. I am overwhelmed by a crowd of citizens who want me to draw their portrait.

I am mortified, desolated, troubled, even vexed that you have reasons which prevent you from coming to see your friend the Gouape [hooligan, or blackguard], called Gargantua. It must be that I was born for nicknames, since my arrival here they remember me more by my caricature than by my name, that of Gargantua has stuck to me; but besides, you would not believe that I have been in the process of writing for the past twenty-four hours, that is to say that, at this moment, I resume my letter which I had today left interrupted by the visits and then by the dinner which I had at Geoffroy's, a dinner of which the results will be memorable in the annals of la Gouape. M. Philipon has asked me whether I know a patriot landscapist, I spoke to him about Cabat and Huet; should Cabat not have returned, I beg you to tell me immediately because he has something very pressing to have done (Philipon I mean). You will not forget to give the address of both of them so that one may write them.

I am waiting for Landon's visit, who should come to see me; he has just received his diploma and at last the papers which prove his identity for freely entering Pélagie. This will give me a great pleasure; try to see him and make him come.

I await your reply impatiently. Answer me immediately on the Cabat and Huet matter.

My respects to your family.

Goodby from La Gouape.

H. D.

Everything is lovely. Don't speak of politics because the letters are opened.[11]

In a way, this letter tells us, prison was an interesting adventure for the young artist. There was the obvious delight he took in his notoriety, extending to his pride in his nickname. In keeping with this, Daumier himself drew Gargantua on the wall of his cell. Other prisoners before him had made Sainte-Pélagie a picture gallery with scrawled designs and captions both coarse and

expressive.[12] Cell 123 was a mural of grotesque unequivocal figures; cell 136 had a landscape of the view from the prison wall looking toward the Jardin des Plantes (the zoo). A cell on the fourth floor portrayed a bearded lady, "The Free Saint-Simonian Woman," a sarcastic summary of popular opinion concerning Saint-Simonian championship of freedom for women. Other cells had pictures of judges and juries bitterly remembered and unflatteringly drawn. One had a picture of Voltaire, another the trial of Solomon—sardonic footnotes on the state of justice in the Juste-Milieu. But above all Daumier saw the Pear, scrawled everywhere to remind him of Philipon's wit and the power of caricature.

Daumier also found amusement in teasing the other prisoners. Since he refused to talk about his "crime," some of the men assumed he must have committed no ordinary offense, asking him, "Say, why don't you want to tell me what you have committed?" To which Daumier, assuming a profound, mysterious manner, replied, "You will never know. It is a secret."

Another spectacle of special interest to Daumier was the rivalry between the Republicans and the Carlists. At Sainte-Pélagie the political prisoners made a special point of ritual celebrations honoring the causes for which they had been imprisoned. Each night in the small dark courtyard, the Carlists swore their allegiance before a bust of Count Chambord. When these rites were finished, the Republicans performed theirs, first kneeling before the red flag, then extending their arms skyward and invoking the name of liberty, crying with fervor, "Aux armes!" Finally, both Carlists and Republicans filed to their cells to be locked in for the night.

After two months the court approved Daumier's transfer to a sanatorium, the one to which Charles Philipon had formerly been transferred. Daumier's transfer took place 11 November 1832. The story of Daumier's residence in the home of Dr. Casimir Pinel, from 11 November 1832 to 22 February 1833, has never been dealt with by biographers.[13]

IV

DR. CASIMIR PINEL was the nephew of the famous Philippe Pinel, often referred to as the father of French psychiatry. Like his distinguished uncle, Casimir Pinel was opposed to the traditional harsh treatment of mental patients, who were at that time chained in dark cells, and often beaten. He felt that they should have plenty of light, clean air, and pleasant surroundings. To put his beliefs into action, Pinel had rented, 13 December 1827, a large house and grounds at 76 Rue de Chaillot, then almost in open country, for the care of the insane. Later when the health of the political prisoners in Sainte-Pélagie became a critical problem, Pinel offered his sanatorium to serve as a health-prison.

The Pinel sanatorium was described in *Caricature*, 8 August 1833:

This house, located near the Etoile toll gate, is situated in the most beautiful spot in Paris; the air there is pure; it offers to its patients the opportunity and the pleasure

of charming walks; its garden is large, well arranged, and completely equipped; the apartments are spacious. Proof both of the healthy character of the estate and of the fine care provided by Dr. Pinel for his patients rests in the fact that when the cholera ravaged Paris in general it touched not one single person in that establishment. Dr. Pinel is to be commended for the concern he has often shown in accepting under his care the prisoners transferred to him from Sainte-Pélagie prison. We could mention men of all shades of belief who have found in his house the solicitude of a friend and a father. We are happy to name some of our own friends, Bascans, Destigny, Marrast, and Philipon.

Since Philipon probably wrote this blurb, the closing sentence is a light sample of his irony.

Both in Sainte-Pélagie and at Dr. Pinel's, Daumier was without lithographic equipment. Nevertheless, during this time he drew fifteen sketches which he sent out to his friend Ramelet for transferral to the stones. *Chimeras of the Imagination* (Appendix, D29–43) must be judged on content rather than technique, since Ramelet's transference weakened the pictures. The series is one of Daumier's few ventures into psychology. Imprisoned in a mental home, Daumier observed closely the suffering creatures about him and recorded them for us: the fantasy life of mankind, normal and abnormal. Each portrays a special mental bias. "The Old Wolf," for example, shows an elderly man who sees beautiful women, drawn in tiny figures, everywhere about the landscape (probably Dr. Pinel's grounds), a picture which might serve as a frontispiece for Balzac's *Cousin Bette*. "The Preacher" dreams of clerical power, even of influencing the royal family, while figurines move about his chair. "The Miser" sits on the floor of his tiny cell, defensively clutching his fantasy moneybags from fear of imagined robbers. Can it be that these, and the other figures, are portraits of actual patients or people in the asylum? One portrait is certainly so. "The Doctor" (Plate 10) shows Pinel seated at his desk while about his chair the creatures of imagination enact scenes of disease, death, burial, and police brutality, the constant experience of Pinel as he worked with the political prisoners remanded to his care from Sainte-Pélagie. As he thinks of the suffering people, Pinel murmurs compassionately, "Why, the devil!" (*Pourquoi diable!*)

It is interesting to reflect that Daumier made but little capital of his prison experience in later prints, although he must have seen and remembered many sights which would have been excellent cartoon copy. A few remembrances survive, however. In one print (D93) a French worker-Galileo sits chained in prison before his judge; through the window the sun of France rises, while the prisoner murmurs under his breath, "But still it moves." Another mordant plate (D85) shows Doctor Louis-Philippe at the prison cot of a dead Republican, feeling the pulse and remarking to the attendant, "You may free this one, he will have no more trouble." (Pinel had saved Daumier from a like fate.) A third (Plate 11) in two versions (D192, D193) shows two prisoners listening to a third read from *La Tribune*; the young man standing may be Daumier himself.

PLATE 10 *The Doctor*
By permission of the Harvard College Library

PLATE II *Souvenir of Sainte-Pélagie*
Collection Benjamin A. and Julia M. Trustman, Brandeis University

Undoubtedly the reason that so few of Daumier's pictures employed the prison experience was his preference for referring to present rather than to past events, and to immediate political issues rather than to private or personal topics. Cartooning is not the remembrance of things past, except as they impinge on the present, but is rather the attack on Today. In the two years following Sainte-Pélagie and Pinel's sanatorium, Daumier was closely tied to the topical, aggressively fighting under Philipon's direction the men who had imprisoned him. Daumier could not afford and probably did not care to cast a look back.

But by far the most significant event for Daumier during his six months of imprisonment was Philipon's founding of *Charivari*, December 1832, a daily paper featuring one lithographic print in each issue with three pages of general satiric commentary. The project was planned by Philipon to augment the *Caricature* barrage. *Charivari* became Daumier's career.

A clever verbalist, Philipon selected an apt title. *Charivari* means "rough music, hubbub, uproar," or, according to the *Nouveau Petit Larousse*, a "tumultuous noise of pots and pans, accompanied by cries and whoops, which one makes before the house of those who have aroused displeasure." Americans know it as the *shivaree*, the rustic ceremony where friends gather outside the house of the bride and groom to render the night air hideous with discordant music. By his title Philipon indicated his intention to disturb the political nuptials of Louis-Philippe and his Assembly, that they might not sleep on the promise made to respect the Charter. One of Daumier's earliest woodcuts (B6) was a headstrip for *Charivari* (24 November 1833) showing the *Charivari* band,

PLATE 12 Headstrip from *Charivari*
By permission of the Harvard College Library

each member playing an instrument which was supposedly a metaphor of his talent (Plate 12). Forest plays the violin, Julien the cymbals, Bouquet the lyre, Aubert holds a music book, Philipon plays the big drum, Daumier the tambourine, Desperret the guitar, Traviès the bassoon, Grandville the flute.

Charivari was no idle figure of speech. For three years it gave the King and his parliamentarians no peace; only by tyrannical law, the censorship of the press, would they be able to quiet the cacophony from Philipon's raucous band.

CHAPTER FOUR

The Legislative Belly

ENIUS CHASTISED GROWS IN AUTHORITY, Tacitus said. Dante in exile, Cervantes in prison, Milton blind—all are examples of strength gained from trial. Daumier sentenced to prison for "Gargantua" is another, if more humble, illustration. From the *Silhouette* ·plates of midsummer 1830 to December 1831, prints by Daumier are competent but no more; they are timid and derivative, undistinguished. After "Gargantua" and his trial, Daumier's work is his own, talent achieved, authority established. No longer pseudo-Charlet, -Raffet, -Grandville, -Traviès, each print is Daumier's unmistakable autograph.

Himself an artist, Philipon discerned this; journalist and shrewd tactician as well, he capitalized on it. Making a place for Daumier on *Caricature*, he invented a new line of attack on the Juste-Milieu for him to carry out: the government had imprisoned Daumier; therefore let Daumier caricature the men responsible for his sentence, the men who by action and inaction were destroying the political liberties of France. Daumier must cartoon the very makers of history. With this decision began the cunning campaign of pillory and philippic (this pun is repeated endlessly in *Caricature*), through portraiture, of Louis-Philippe's hired politicians, a campaign lasting almost two years and having a tidy Aristotelian unity with precise beginning, middle, and end.[1]

Daumier's print, "Masks of 1831," his lithographic portraits in both *Carica-ture* and *Charivari*, and his climactic print, *The Legislative Belly*, must be seen in this coherent way, rather than simply as disparate creations. Planned by Philipon, Daumier's work of this time has a unity which gives each single print, and each maquette, new force and meaning. This series stemmed from a witticism of Philipon's: since Louis-Philippe was having his portrait gallery at Versailles, Philipon would have his at the Galerie Véro-Dodat; since Louis-Philippe had his court painter, Alaud, then Philipon would have his, Daumier; Philipon's portrait gallery would be an ironic caricatural counterpart to the Pear's.

The subject was the National Assembly, and the subjects were the members of the Assembly. The slogan for the Philipon-Daumier attack was soon supplied by Armand Marrast in *La Tribune*. Discussing the readiness of the Assembly to ring Paris with fortifications (to be turned against the people at need), Marrast wrote, "Oh, how we are cheated and laughed at by this prostituted Chamber!" Outraged, the Chamber demanded prosecution of *La Tribune* for its insult to the honorable legislative body. Fifteen days later the trial took place. Chief speaker for the defense was Marrast, editor of *La Tribune*, who in a speech of documen-ted detail on corruption and venality in the Chamber repeated the opprobrious term to the faces of the very men to whom it applied:

> The chamber which consented to extra legal courts and to prévotal courts; the chamber which tolerated the getting up of conspiracies by the police; the chamber which suffered the charter to be violated with impunity; the chamber which wasted the coffers of the state on interests by which it was the first to profit; the chamber which abandoned the personal safety of the citizen to the will of ministers; the chamber which prosecuted to the death liberty of opinion—what were these chambers? What name should be given them? The chamber which was constantly increasing the salary of office-holders, and then delivered them, bound hand and foot, up to ministers; the chamber which heaped loan upon loan, which lavished secret service money, which supported all privileges, which reared altars to base cupidity, which encouraged jobbing by the sinking fund, which caused every thing to gravitate towards the impure centre of the stock-exchange, which cast honour, national dignity, and the public treasure into the maw of kite-fliers—all these cham-bers, gentlemen, what were they but prostituted, prostituted, I say![2]

Though *La Tribune* lost in the courts, Marrast's memorable words echoed throughout France; they were made more pertinent by the decision in favor of that prostituted government and by the assessment of a 10,000-franc fine, with three years' imprisonment, against M. Lionne, security for the paper. Marrast's phrase was immediately picked up and emblazoned in Philipon's papers, to be given lasting fame in Daumier's subsequent lithograph of the Assembly.

II

> The pears . . .
> . . . are not flat surfaces
> Having curved outlines.
> They are round
> Tapering toward the top.
>
>
>
> The pears are not seen
> As the observer wills.
> WALLACE STEVENS
> "Study of Two Pears"*

THE OPENING SHOT in Daumier's and Philipon's two-year attack on the Juste-Milieu was a collective plate entitled "Masks of 1831" (D42, 8 March 1832). Portrait masks (life or death? death-in-life?) of Guizot, Etienne, Madier, Montjau, Thiers, Athalin, Lameth, Dupin, d'Argout, Keratry, D——, Barthe, Loboau, Soult, and Schönen are ranged in three rows. In the center of the middle row is a Pear, with a face indistinctly but surely suggested on its surface (Plate 13).

Critics of this lithograph have entirely missed Daumier's point, and hence his satiric mastery, when objecting that these faces are not as strongly modeled as those in the series of individual portraits. Exactly. These men are not to be seen as individuals; they are but masks which the Pear himself puts on, through which he ventriloquially speaks. A mask, Daumier knew and drew, is a false face, a dead image, not a living face; it is a mode of concealment and deception. That they were the masks of eminent men, considered to be statesmen but used by the King as his instruments, makes Daumier's point more savage. (Later, on several occasions, Daumier was to portray the assemblymen as puppets manipulated by the Pear.)

The long series of portraits which followed from this collective introduction was no hasty improvisation. To be sure of the "reality" of his portraits, Daumier first made thirty-eight (not thirty-six, as everywhere stated) busts in colored clay, each about six inches high, to serve as models for the lithographic portraits.[3] Philipon explained this to readers of *Caricature* (26 April 1832):

> *Caricature* formerly promised to give its subscribers a portrait series of the celebrities of the Juste-Milieu—portraits which, realistically studied, should possess a satiric character, a burlesque element, known under the name of *charge*. In its customary manner of doing all it can to achieve complete success, *Caricature*

[* From *Collected Poems of Wallace Stevens* (New York: Alfred A. Knopf, 1955). Reprinted by permission of the publisher.]

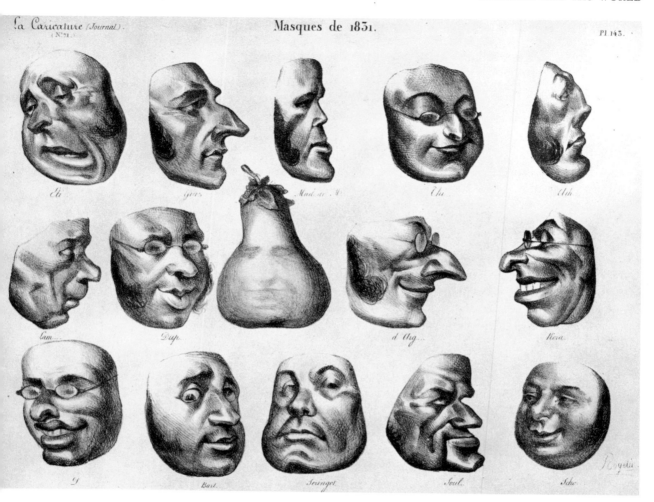

PLATE 13 *Masks of 1831*
Courtesy of the Art Institute of Chicago

delayed the portrait series because it had each person first modeled *en maquette*. The gallery of famous men now achieves a new excellence, catching the men at the moment when they have just been awakened from political inertia by the charivaresque noises [of our satirical attacks].

Possibly Daumier's maquettes were suggested by the plaster portrait busts of Jean-Pierre Dantan the Younger.[4] Dantan's plaster heads of celebrated people in France (to have been excluded must have been social disgrace) were the rage of Paris in the early 1830's. Dantan took a special feature of his sitter and exaggerated it greatly (*caricare*, to exaggerate), bringing off a comic effect. Gautier said that Dantan was the man "who knew best how to make plaster smile and sculpture, the most serious of the arts, laugh." Certainly Daumier had these

charges (there is no English-word equivalent for this form of caricature) in mind when he shaped his portrait heads, but there is no question of imitation, for he played down the caricatural element and achieved sculptural portraits which were at once funny and true.[5] Furthermore, he had no intention of rivaling Dantan; these *charges* were made to serve as models for Daumier and all the *Caricature-Charivari* artists; they were not for sale. Everybody in France knew about Dantan's *charges*; it was Philipon who suggested to Daumier that he do *his* maquettes so as to have permanent, private models for the future lithographs. Philipon described in *Caricature*, 26 January 1832, the very method Daumier shortly thereafter employed, and he further suggested the political direction:

> Take a piece of clay. Take the bit of clay and dampen and knead it. Then place it on a flat surface and, putting it under the palm of your hand, roll, roll, roll, as do the pastry-makers to make long cakes. But you do not wait until the cake is long. When your lump is nearly oval, you stop, take it delicately in the left hand, seize a knife with the right, and make a small incision in the lower part of the lump. This incision is the legs. That done, the lump already takes on a very pleasant turn for the better. You see then that you are creating a work of great importance. But that is not all. You pinch the lump on two sides, three-quarters, or nearly, up its height, and the arms are made, the powerful arms which hold with such pleasure our 16-million-franc budget, and the popular umbrella. Oh, there can be no doubt of it, this will be the living piece which you have kneaded. . . .

It was fortunate for Philipon that he had an artist who could carry out his ideas with such skill, just as it was providential for Daumier that he had a director with such fertile ideas and such infectious enthusiasm. Daumier later paid his tribute to this fiery energy, saying, "If it had not been for Philipon, who goaded me like a driver his oxen, I would have done nothing." Further suggestion of Philipon's influence in the making of the maquettes is his own lithograph (Plate 14) which shows a *charge*-seller offering for sale at a mere two sous each a tray of heads of Sébastiani, Périer, the King, and others.[6] The government censors seized this offensive print before it could be published in *Caricature*.

Two plates by Traviès (*Caricature*, 26 April 1832, and 13 November 1834) and one by Grandville-Forest (*Caricature*, 3 May 1832) show Daumier's sculptural heads as part of the artistic gear in the magazine office, clay models for any or all to use, constant reminders of their satiric objectives.

Two theories have been presented on Daumier's method of modeling his clay heads. The first maintains that he visited the Assembly, clay in hand, and modeled as he watched the representatives at debate.[7] The second and more probable version says that he attended the Assembly, observed it closely, and then returned to his studio to model from memory what he had just seen.

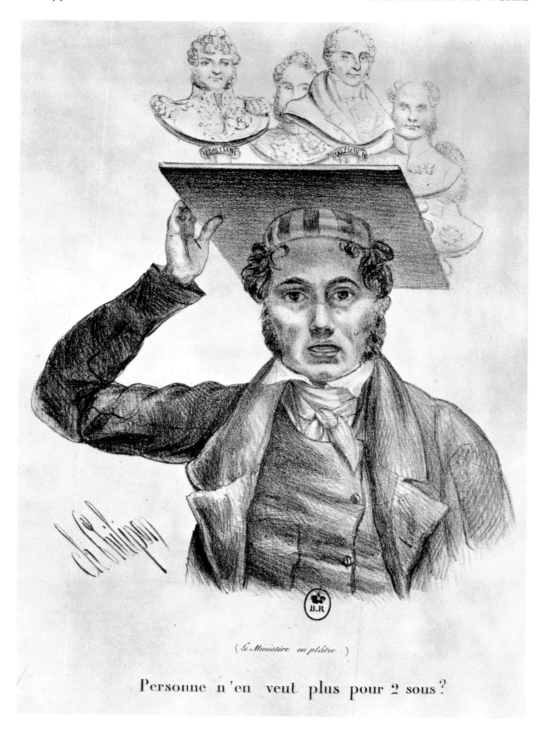

(le Ministère en plâtre)

Personne n'en veut plus pour 2 sous ?

PLATE 14 *The Maquette-Seller* by Philipon
Bibliothèque Nationale

Charles Philipon had suggested the busts, which were kept in the Galerie Véro-Dodat offices for his artists to use. Philipon bought them from Daumier for fifteen francs apiece and so preserved them for posterity to enjoy. Geoffroy wrote in 1905, "Philipon told me that there were originally thirty-eight, but that he had given one to Champfleury and the other to Nadar." Because Geoffroy's remark has gone unnoticed, the busts owned by Champfleury and Nadar, the celebrated photographer, have not been included in the record; thus most students have assumed that the thirty-six busts sold to the Parisian art dealer, Le Garrec, by Philipon's grandson in 1925 constituted the entire series.[8] The two forgotten busts disappeared from public view as well as from memory, for in his catalogue (1952) of Daumier's sculpture, Maurice Gobin mentions only thirty-six heads. Recently, however, in September 1957, number thirty-seven turned up for sale at an art auction in Chicago, where the present writer acquired it. So far as is known, it is the only terra-cotta bust by Daumier in America.[9]

The thirty-six busts owned by Le Garrec were treated by the sculptor Fix-Masseau in an attempt to stay the crumbling and flaking which were slowly destroying them. Furthermore, M. Le Garrec had each head cast in bronze in an edition of twenty-five numbered copies (except for seven of the heads, of which thirty copies were made), plus various unnumbered copies. Complete sets of these bronzes are at Marseilles, Lyons, and the Lessing Rosenwald collection in Jenkintown, Pennsylvania. Individual copies may be found in various places throughout the world. In recent years the originals have never all been shown at any single time, and most of them are not shown at all because of their fragile condition. Daumier apparently did not take these heads seriously, for he did not have them fired properly. It has been suggested that he may well have entrusted this job to the neighborhood baker and his oven. The subsequent history of the heads suggests how indifferently they were esteemed. When Philipon lent ten of them to the 1878 Daumier exhibition in Paris they were apparently brought to the gallery in a carriage which bumped over the paving while bust rubbed and bumped against bust. Conversely, the thirty-seventh bust, newly discovered, is in good condition, probably because it was in the hands of a Daumier enthusiast, an admirer like Nadar (or Champfleury), who guarded it with loving care. Such a theory at least explains the rather good state of preservation.

All who study the busts, either the originals or the excellent bronze castings, concede Daumier's sculptural gift, a talent recognized even by Rodin when he first saw the figure of *Ratapoil*. Studying, probably even copying, the drawings and paintings of Michelangelo, learning the art of modeling alongside his close friend and fellow student, the sculptor Auguste Préault, Daumier sharpened his instinctive feeling for the human figure and for the three-dimensional character of objects, a way of seeing which helps to explain the monumental grandeur of his simplest, smallest designs. Maurice Gobin asserts that before Daumier

created these busts he was just another cartoonist; in creating them he became an artist. "From this day on he is Daumier."[10]

People who view these busts as mere caricatures are not seeing them correctly—these portraits are of such an unsparing honesty that to most eyes, accustomed to the prettifications that people instinctively seek in a portrait, they seem exaggerated. They are not exaggerated, as can be seen if any single bust is compared with a contemporary portrait of the sitter and the portraitist's professional falsification is allowed for. The exaggeration for caricature is found in the lithographic portraits which Daumier made from his sculptural models. This point must be established emphatically. Compare the lithograph (D45) which Daumier made, working from the terra-cotta model, of Dupin the Elder (Plates 15, 16). The resemblance is almost identical, allowing for the different media, but not quite. Daumier has enlarged the lips and touched up one or two features to accentuate the apelike appearance of Dupin. But even the lithograph is a portrait, as Baudelaire insisted:

> In these works the artist displayed a wonderful understanding of portraiture; whilst exaggerating and burlesquing the original features, he remained so soundly rooted in nature that these specimens might serve as models for all portraitists. Every little meanness of spirit, every absurdity, every quirk of intellect, every vice of the heart can be clearly seen and read in these animalized faces; and at the same time everything is broadly and emphatically drawn. Daumier combined the freedom of an artist with the accuracy of a Lavater.[11]

Although Baudelaire's words describe all the lithographs in the series, they are forcefully appropriate to the Dupin portrait.

André-Marie-Jean-Jacques Dupin (1783–1865) was of Norman birth. By 1832 he had risen to the presidency of the Chamber of Deputies, and he became a distinguished chief justice during the reign of Louis-Philippe. A man of coarse wit, unabashed in frank jesting at other people's expense, he maintained the pose of his country upbringing by wearing hobnailed boots in the Assembly and in his court. This rough, tough, shrewd operator was a key figure in the Republican antihagiography. Louis Blanc described him:

> Of these the most influential was Dupin aîné. The majority of the chamber, composed of bourgeois of little refinement of mind or manners, liked M. Dupin aîné for his impatient gestures, his abrupt movements, his bitter and spiteful rusticity, his expressive and harsh features, an eloquence, the acrimony of which was never tempted [tempered?] by any consideration, a certain manner of presenting a subject, as narrow as it was picturesque, a happy common sense, and a knack of gracing commonplace ideas and vulgar sentiments by a decisive sally or a quick and subtle turn. He had the endowments and the defects that obtain success in an assembly of lawyers and shopkeepers: ... He was the orator best suited to the policy of the

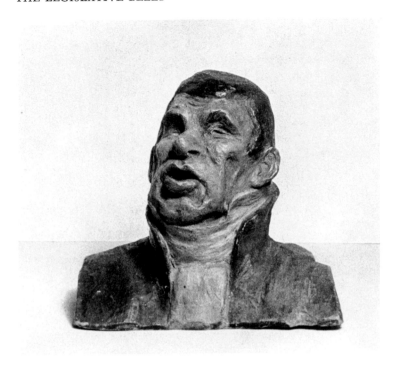

PLATE 15 *Dupin the Elder* (terra-cotta bust)

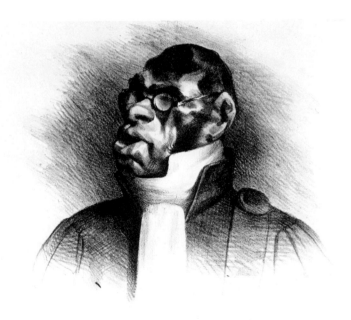

PLATE 16 *Dupin the Elder* (lithograph)

palace, because he admirably followed its changing phases. . . . An assembly personi-
fied in such a man was the true impress of the bulk of the bourgeoisie; and it may
be conceived how odious it must have been to all those whose hearts had been
exalted and whose desires had been enlarged by the revolution of July.[12]

Such was the man as described by Louis Blanc. Daumier's bust of Dupin has
special historical pertinence, since Dupin was a key man in the palace group.
But the other portraits have this same accuracy along with the same symbolic
radiance. Noblemen like Tocqueville are not shown in this rogues' gallery, and
when Guizot is included, as he had to be for representative purposes, he is shown
with his virtues as well as his faults, as a fanatic rather than as a fool.[13] But the
members of the group as a whole, an ignoble lot, are like Dupin. Champfleury
wrote of Daumier's bourgeois band:

> All the friends and intimates of the Palace pass there; the ministers, deputies, presi-
> dents of the Chamber, those who were voting the monies, the secret funds, those who
> wished to stop the street insurrections, those who feared for the King's life in the
> many attempts made on it, those who puffed at the flame of the journalists, attempt-
> ing to blow it out. All had been characterized by violent epithets: *reactionaries,
> fat cats*, members of the *prostituted Assembly*. They are all in this open gallery
> with the faces swimming in fat, with their huge bellies, with their swollen, stiff
> joints.

Blanc's discussion of Dupin the Elder, Baudelaire's critical approval, and
Champfleury's summation must suffice for a discussion of the dozens of por-
traits; individual citation would be repetitious and more a review of Louis-
Philippe's parliament than a study of Daumier's art.

III

A GROUP PRINT, "Masks of 1831," had initiated Daumier's attack on the
National Assembly. A nice sense of symmetry, of tidy completeness, led him to
conclude with another collective picture, assembling in the very arena of their
follies the Great Men whose faces and figures he had made familiar to France.[14]
The Legislative Belly (D131) was the satiric climax of Daumier's and Philipon's
campaign; by happy chance it was also an artistic triumph (Plate 17). Printed, in
January 1834, with special care for separate sale and not for publication in the
magazine, the lithograph is especially pleasing.
 Obviously the title, "The Legislative Belly," was Charles Philipon's, as his
accompanying sarcastic text proves:

> The *belly* is the most striking part of the legislative body, where at dinnertime are
> heard the grumblings and rumblings and those cries of cloture which would cut
> short the most interesting discussions and the business most important to the public

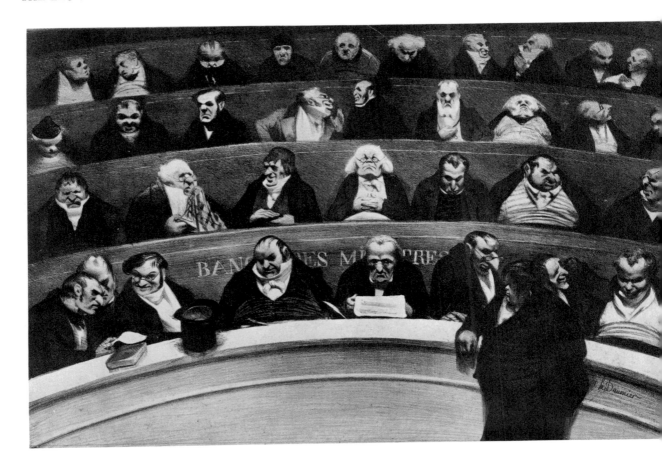

PLATE 17 *The Legislative Belly*
Courtesy of the Art Institute of Chicago

interest. The *belly* is the container of all the intestines into which the digested
[predigested, because the budget was already dictated by Louis-Philippe, or
Gargantua] budget precipitates. There [in that *belly*] sit all those deputies who after
election become tax collectors; all those newly decorated by prefects and by attorney-
generals [i.e., bribed]; all the counselors of the royal court, the presidents, the direc-
tor generals, and the army suppliers [and so, recipients of graft]. . . . The *belly* is a
synonym for *rump*. It is from the *belly* and from the *rump* that the chamber speaks.
The *belly* is the minister's god, it is the soul of the legislative body, it is its heart, its
head—it is everything for the 1834 chamber. It is this *belly*, it is this *rump*, which for
the past four years has toiled for the happiness of France. To them we owe the
respect for the 1815 treaties, the dastardly abandonment of Poland, the abandonment
of all the people who had counted on the 1830 revolution. To them we owe the
budget increase, and as a result the increase in taxes. . . . It is the legislative *belly*
which our collaborator Daumier has represented, if not in its entirety, at least in that
which is most characteristic.

By no mere coincidence, the assemblymen Daumier shows are generally big-bellied creatures, gross from self-indulgence and luxurious living. Flaubert, in *The Sentimental Education*, described them:

> Most of the men assembled there had served at least four governments; and they would have sold France or the human race to preserve their income, to save them-selves from any discomfort or embarrassment, or even through sheer baseness, through worship of force.

Daumier's thirty-five Assembly members are seated in four semicircular rows of the Assembly benches. The statesmen are caught as by a candid camera, in unposed activities, reading, sleeping, gossiping. If these are great men, as they thought themselves to be, Daumier shows them in pettiness. The individual portraits are capsule masterpieces—"heads modelled as largely as those of a Poussin painting" [15]—as one would expect from the creator of the maquettes and the portrait series just completed. The many figures are unified and coordinated within the circular lines of the benches and by the rhythmic interplay of whites (hands, faces, shirts) and blacks (clothes and hair). The compositional monotony of four circular benches of figures is adroitly and naturally broken by placing Prunelle, standing, before the benches at the right, his figure (mass) counter-balanced by the top hat resting in front of Thiers and the cluster of men (Guizot, Thiers, and another) talking together. "The largeness of Daumier's humor," David Rubens wrote, "is not in the paunches of the individual men but in the curve of the benches which repeats the wrinkles of the tight vests and makes a huge 'belly' of the whole scene." [16]

Daumier pitilessly exposed the prostituted Assembly to posterity: thirty-five politicians, once strutting in the public gaze, remain in men's memories through this print. This is their biography and their epitaph. Daumier im-mortalized their greed, stupidity, and smugness, their massive power and their profound corruption. Daumier says in effect what Lammenais later (1841) said of the Assembly, "What is this Chamber? A great bazaar, where everyone barters his conscience, or what passes for his conscience, in exchange for a place or an office." Before the law of 9 September 1835 completely silenced political criticism, Daumier had made his exposure and pronouncement on the subversion of parliamentary rule. It is his political *Dunciad*.

Daumier's biographical and historical summation is more than criticism, satire, and indictment, more than a mere footnote to Marrast's great phrase or to Philipon's puns. *The Legislative Belly* is a superb lithograph. Edmond About, in 1867, exaggerated when he described it as "a masterpiece of the same order as the Sistine Chapel," but his enthusiasm has a germ of justice. Like so many of Daumier's lithographs, this print hangs on the wall not because of its satire but because of its pictorial power, its aesthetic delight.

CHAPTER FIVE

L'Association Mensuelle

HILIPON AND DAUMIER had hit their target. Protected though he was by his ministers, Louis-Philippe was well aware of the attack. Often it amused him; often it hurt. "I have been," he wrote, "the victim of what Voltaire called the printed lie, a cowardly and perfidious weapon which strikes often though one may not see whence the blow, a weapon whose wounds never heal because they are poisoned." He laughed, he winced, and he did nothing to mollify his attackers. Had the government shown any genuine sign of fulfilling the hopes of the July revolution—through a broadened franchise, lowered taxes, fair representation—the partisanship of the Republican press would not have been so bitter or so violent. A witty, tolerant, and intelligent man personally, Louis-Philippe was the victim of his greed—hence "Gargantua" and the budget—and of his laziness—hence maintenance of the status quo. In his privileged position he failed to have an adequate understanding of the betrayal felt by the men who had fought at the barricades and had so prepared his passage to a little-deserved throne. But this bitter betrayal gave force to every word and every print which Daumier and his colleagues hurled at the King and his ministers; it was the fortissimo theme of Philipon's two journals.

The government's reprisals through raids, seizures, and trials were violent evidence of Philipon's and Daumier's effectiveness. Another form of evidence, less painful and costly, and even flattering by imitation, was *La Charge*, a magazine created in 1833 and sponsored by the government.[1] Copying the editorial pattern established by Philipon in *Caricature*, *La Charge* carried text and

lithographic prints intended to offset the Republican attacks and to ridicule the attackers. The anonymous editor wrote (19 May 1833):

> There is running throughout the Parisian world an epidemic disease against which they have forgotten to establish sanitary precautions. . . . This epidemic is called journalism. . . . Periodicals pustulate; it is a regular pest; the air is impregnated with them. Soon each inhabitant of Paris will put out his own paper.

This diatribe referred to *Caricature* and *Charivari*.

Philipon's reaction was Philiponic. He said, in later years:

> When we founded *Caricature*, we had thought that this language, entirely new in France, most suitable to the national character, would soon be popular among us, as it had long been among our [English] neighbors. Our success surpassed our hopes. We may say it without vanity for it is a patent fact. The moment one of the ministry's organs announced the publication of caricatures sketched in a spirit opposed to ours, [it] proclaimed loudly that the grease crayon was henceforth a powerful instrument.[2]

La Charge floundered along for a year, attracting little attention, its text dull beside the verbal fireworks of Philipon and its lithographs pedestrian in contrast to Daumier's precise and powerful cartoons. *La Charge* may have been founded from conviction, but it failed to carry any. Only because it was intended to stop the Philipon-Daumier assault does it receive notice today.

II

MOST OF DAUMIER'S TIME between February 1832 and January 1834 was devoted to his portrait series of the Assembly, fifty plates which left him but little time for the single prints taken from daily events.[3] Once his gallery was completed, however, Daumier was ready for reassignment. Immediately Philipon put him on the most important of his several projects, L'Association Mensuelle.

L'Association Mensuelle (Print of the Month Club) was Philipon's scheme to raise money for his mounting debts. The Society for the Freedom of the Press, of which Lafayette was a member, had been founded to help the Republican papers, but funds were short; between 2 August 1830 and 1 October 1834 in Paris alone there were 520 press trials with 188 condemnations totaling 106 years in prison and 44,000 francs in fines. Philipon himself, with six judgments against him and three convictions adding up to thirteen months in prison and 6,000 francs in fines, had need of every franc he could possibly find. One hundred years ahead of his time, Philipon, through his L'Association Mensuelle, offered subscribers a large lithographic plate each month, composed by *Caricature* artists and printed on fine paper. The plates were to be political, for Philipon ironically intended to pay for his attack by further attack. L'Association Men-

suelle published twenty-four plates; Daumier's print, *The Legislative Belly*, was the eighteenth in the series.

The full, fascinating story of L'Association Mensuelle has recently been told, with full reproductions, by Edwin de Bechtel in *Freedom of the Press and L'Association Mensuelle, Philipon versus Louis-Philippe* (1952). The first seventeen prints were composed by Grandville, Forest, Desperret, Julien, and Traviès—most of them by Grandville with Forest's collaboration. All of these prints are important in documenting Philipon's fight against Louis-Philippe in 1832–33, and they are interesting to the historian if not to the art critic. Here is brass-knuckle fighting. Grandville, who had been on the July barricades, was an ardent Republican. He attacked the King with a ferocity and a freedom which no government could long tolerate. One print, bordering on sacrilege, showed Talleyrand, in his former office of Bishop of Autun, elevating the Sacred Host-Pear before the prostrate and adoring peers. Another showed the *guisquetaires* searching a lithographer's shop for seditious material, a scene then commonplace in the *Caricature* offices. With each month's print Philipon included a detailed interpretation of the plate, identifying characters and clarifying allusions so that all might understand. These comments were as rasping and raw as the prints they accompanied.

L'Association Mensuelle would have been a minor if interesting chapter in the history of political journalism had its record rested on Grandville's work alone. As political attack it is excellent, but as art—less so. Topicality strangles design. Grandville crammed too much into his prints, crowding the scenes with figures and symbols to the neglect of his composition. The prints are to be read, not relished. They tell us a lot—too much—but they do not tell us enough aesthetically. Then Daumier created five plates, ending the series with the masterpiece *Rue Transnonain*. In passing, it is worth comparing *The Legislative Belly* with Grandville's technique. Daumier had faced the same problem of technique—how to arrange a large number of figures in a pleasing design—and had mastered it. While making a beautiful arrangement he also said a great deal. He used thirty-five men, made thirty-five pregnant comments on those unstately statesmen—but by grouping them harmoniously he transcended the topical points of his print and arrived at a larger, universal meaning. Grandville composed philippics. Daumier, with no loss of journalistic adroitness, composed works of art.

Daumier's second print for L'Association Mensuelle was a comparative failure. *Very Naughty and Very Mighty Legitimist Brats* (D132; February 1834) is dull, with no compelling subject or theme. No satisfactory explanation has yet been given of why Philipon and Daumier wasted time and space to show the Legitimist children in the nursery, unless it was to suggest to the Monarchists that loyalty to such a cause was infantile and frivolous. These frail children might, then, have been intended as a metaphor of sentimental royalism.

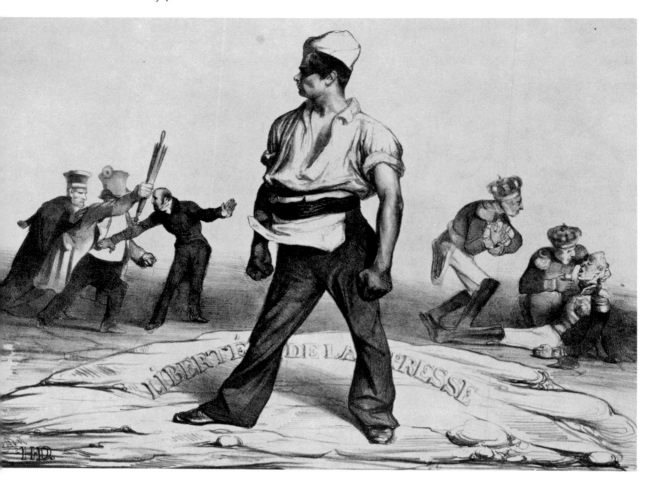

PLATE 18 *Freedom of the Press*
Courtesy of the Art Institute of Chicago

Daumier's plate is cleanly composed in his "large" manner, but the triviality
of the subject weakens the effect.

Daumier's third plate (D133; April 1834) returned to an important subject
and recovered the mastery of *The Legislative Belly*. Freedom of the press was then
a sore subject to Philipon's staff. Grandville had already drawn lithographs of
press seizures by government hirelings, anecdotal prints which were photo-
graphic in detail. Daumier now summed up the very spirit of the freedom of the
press (Plate 18). On a mound (Freedom of the Press) in the foreground stands
the muscular, open-shirted figure of a printer, fists clenched, feet spread in a
defiant attitude. In the right rear is the injured, recumbent figure of Charles X,
knocked out by the fist (1830 revolution) of the hero on whose liberty he had
encroached. In the left rear, Louis-Philippe is advancing toward the worker,

brandishing his umbrella threateningly. Persil urges him on, but the more liberal and prudent Odilon Barrot restrains him. The caption read, "Do not meddle here." It is (although scholarship has missed the reference) Daumier's pictorial version of Marrast's statement before the Chamber, 10 April 1833: "If it is war against the press, you will perish."

The composition is a simple triangle in depth. The eye moves from the central heroic figure back to each of the rear groupings, returning ever to the muscular worker, who dominates the scene like the colossus he is. Baudelaire justly wrote, "Every detail of that press-man is modelled and executed in the manner of the great masters." [4] Proletarian art for the next century was to copy and coarsen the figure, making him a stereotype.

III

THE DEATH OF LAFAYETTE on 20 May 1834 gave Daumier the subject for his fourth plate (D134). Mourned by the common people everywhere, Lafayette had long been a symbol of democratic liberty. His death at that moment was a disaster for the Republicans, who would within a single year lose their leaders and, shortly after, be suppressed by government action. Appropriately, *Charivari* devoted an entire black-bordered issue to their dead hero.

But Lafayette's death created an ironic problem for Louis-Philippe. Long his friend, indebted to him for his crown, Louis-Philippe had nevertheless dismissed the old man as head of the National Guard three years before (removing a Republican threat of arms), at the same time piously expressing the greatest friendship and admiration. Now he was forced to pretend to mourn while secretly rejoicing. The Republicans well knew that his tears were stage tears; Grandville showed the King ordering the cook to save the onions for the next day's ceremonies so that he could bring forth tears, and he drew another plate showing a triumphal dance at the Palace.

Lafayette's death also presented a strategic problem to Louis-Philippe: the possibility that riots might break out during the funeral parade. Not long before there had been serious trouble at the funeral of General Lamarque, when a mourning people had rioted. The King's solution was a master stroke. He ordered a State funeral, which was the honor all Republicans felt was properly due Lafayette. By this move, however, Louis-Philippe made sure that under the guise of ceremony the military would be out in force to put down any incipient riots. Once more the King scored over Lafayette and the Republicans; the status quo was maintained.

Daumier's print of the occasion showed that he was not deceived by the Pear's stratagem. The picture honoring a hero's death became an exposé of the hypocrisy and guile of the Pear. *The Funeral of Lafayette* (Plate 19) is in Daumier's favorite pattern: a triangle in depth with a heavily accented foreground figure

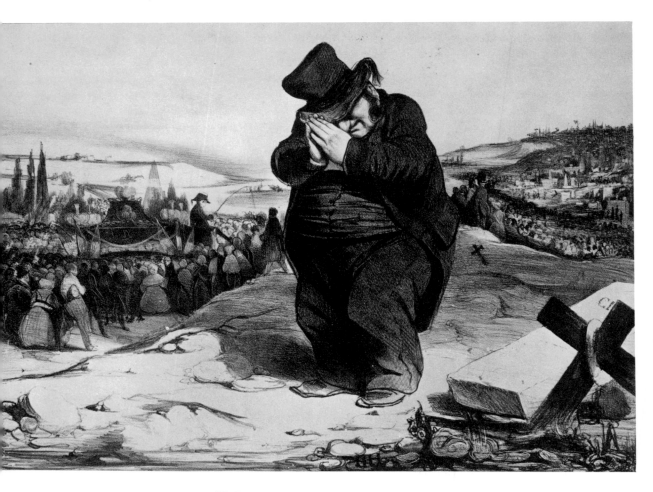

PLATE 19 *The Funeral of Lafayette*
Courtesy of the Art Institute of Chicago

and vignetted scenes in the rear (D134).[5] The black-garbed, fat King stands
front center, his pudgy hands before his face, in pretense of mourning, partly
concealing the triumphant smile on his face. In the left rear the funeral cortege
winds its way to the right where Lafayette is to be buried. The King's sly, half-
hidden smile, a monstrous burlesque of bereavement, gives cruel edge to the
words he utters: "You're done for, old chap." The hands hiding the face are an
echo of Armand Carrel's words in *Le National* (21 May 1834), "Hide yourselves,
Parisians! The funeral of a true friend of liberty is passing by!"

IV

IRONICALLY, the more successfully Philipon and his staff fought the government
the more certain was their defeat. The very success of *Caricature* and of L'Asso-

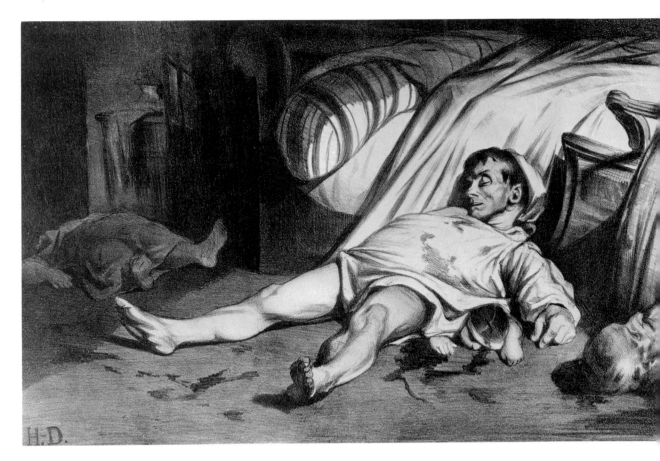

PLATE 20 *Rue Transnonain*
Courtesy of the Art Institute of Chicago

ciation Mensuelle was responsible for their destruction. First of all, the government eliminated the print-sellers by voting a stamp act, requiring that all loose prints have a government stamp placed directly on them. This meant defacing the print and destroying its value. Thus L'Association Mensuelle was forced out of operation, but in its swan song came Daumier's most illustrious lithograph: *Rue Transnonain* (Plate 20).

Poverty, protest, rebellion, and suppression lie behind Daumier's *Rue Transnonain*. By refusing to face the problems of poverty and unemployment, the Juste-Milieu brought about in time its own downfall. Guizot and Louis-Philippe would not listen to their own more perceptive assemblymen, such as Lamartine, who warned them, "The Proletarian question is one that will cause the most terrible explosion in present-day society, if society and government fail to resolve it." [6] Another humanitarian-poet, Victor Hugo, in that very year, 1834, cried out:

You are quarrelling about the question of whether the buttons of the national guard should be white or yellow. . . . Gentlemen, consider this. The majority of the people are suffering. . . . The people are hungry. The people are cold. Poverty is driving them to crime or vice. . . . What do these two ulcers [hunger and poverty] prove, if not that the body social suffers from impurities in the blood-stream?

Sadly, in the headlong rush for power and wealth, the words of the two poets went unheeded, the general attitude being phrased by Guizot: "The workers must realize that their only salvation lies in patient resignation to their lot."

Forcing the workers to submit to their lot, the Chamber ruled on 10 April 1834 that all secret societies must come under the direct surveillance of the government. Aimed at the newly formed clubs, such as the Society for the Rights of Man, which were the nuclei of the fast developing trade-union move-ment, this "law of associations" meant complete emasculation of these societies. To accept the law was indeed to accept a "patient resignation to their lot."

Trouble broke out first in Philipon's native city, Lyons, among the silk-workers who had long pleaded and struggled for decent wages and working conditions.[7] Neglected by their employers and their government, they had in desperation formed the new societies where at least they could talk, and scheme, and dream. The "law of associations" caused them to explode into riot. Their famous motto, "Let us die if we must, but let us die fighting" (inspiring Liszt to his composition, *Lyons*), became their battle slogan as for four bloody days they fought the soldiers, with bare hands and paving blocks against bullets and bayonets, a resistance as heroic as it was futile.

Paris, too, became a city of assassinations as resistance sprang up in a few workers' districts. These small riots were quickly suppressed by the extra troops which the government had foresightedly summoned for such outbreaks. It was toward five o'clock on the evening of 14 April that members of the 35th battal-ion (noted for brutality), thinking that some sniper had fired on them from number 12 Rue Transnonain, burst into the building and slaughtered most of the inhabitants. In sheer blood lust they used bayonet and gun-butt to murder old men, women, and children. Eyewitness accounts tell appalling stories of wanton sadism.[8]

> Now days are dragon-ridden, the nightmare
> Rides upon sleep: a drunken soldiery
> Can leave the mother, murdered at her door,
> To crawl in her own blood, and go scot-free.*

Yeats's words apply: "scot-free" indeed; the Assembly passed a vote of thanks and a reward to the brave gendarmes who perpetrated the murders. Daumier's

[* From "Nineteen Hundred and Nineteen," reprinted with permission of Mr. M. B. Yeats and Macmillan & Co. Ltd. (London), and The Macmillan Company (New York) from *Collected Poems* by William Butler Yeats, copyright 1928 by The Macmillan Company, renewed 1956 by Georgie Yeats.]

personal recognition was a large and bitter woodcut[9] showing Louis-Philippe under a nun's cowl begging alms for the "poor soldiers who had suffered in the Rue Transnonain," indicating a scorn as strong as that shown by Stendhal, who wrote that even the evils of trade "are better than cutting the throats of peaceful citizens in the Rue Transnonain or, what is worse, and even more base, justifying such things in pamphlets like these we are peddling." [10]

The murders of the Rue Transnonain would have receded into history had not Daumier seized the event for his last print in L'Association Mensuelle (D135; July 1834). Such murder would not lightly be overlooked; the Parisian public was profoundly shocked—the Rue Transnonain house became accursed, and for years no one would rent rooms in it. It was the sort of event, murder by government support, a raw display of bestial killing, which although recurrent in history remains in the minds of men to haunt and disturb.

In releasing the print, Philipon described it:

> This lithograph is shocking to see, frightful as the ghastly scene which it relates. Here lie an old man slaughtered, a woman murdered, the corpse of a man who, riddled with wounds, fell on the body of a poor child which lies under him, with its skull crushed. This indeed is not caricature; it is not a *charge*; it is a page of our modern history bespattered with blood, a page drawn with a powerful hand and dictated by a noble anger. In creating this drawing, Daumier raised himself to a high eminence. He has made a picture which, though executed in black on a sheet of paper, will not be the less esteemed nor will it be the less enduring. The murders of the Rue Transnonain will be a permanent blot of shame on all who allowed them to happen. This lithograph which we cite will be the medal struck at the time to perpetuate the recollection of the victory won over fourteen old men, women, and children.

Closeness to the event and his friendship with Daumier in no way clouded Philipon's perception. Every word of his summary holds good. From the moment the print appeared it was admired by the people; crowds stood in front of Aubert's shop window to see it. Immediately, government agents seized the stone and all available prints, giving the lithograph a rarity which has only increased its commercial value to collectors. Today it is one of the most prized of all lithographs.

Daumier had not composed hastily. The crime occurred in April, and the print did not appear until July. His care in general conception and in specific detail is apparent even in photographic reproduction and diminution. The drawing is impeccable; problems of anatomical construction, foreshortening, and balance are mastered. The tones of the print are marvelously rich, recalling Renoir's dictum that "Black is the queen of colors," and Baudelaire's tribute, that Daumier handled black and white so that one almost saw it as color.

A terrible event gave rise to Daumier's lithograph. The figures in this timeless picture once had a local habitation and names. The central male figure is

probably that of M. Hué, and the child beneath him his son. The woman at the left is possibly Madame Godefroy. One may read the detailed and documented story as gathered in depositions, but this is not necessary, finally, for the student of art, for the connoisseur of prints. Daumier's scene stands alone, not needing the structure of historic detail to carry it. It arose from horror, but it is not limited or made loathsome by it. It is "pitched past pitch of grief." "In this cold garret," Baudelaire wrote, "there is only silence and death." Out of the murders of the Rue Transnonain, the *Rue Transnonain* was created, and a terrible beauty was born.

Rue Transnonain looks backward to Goya's *Disasters of War*, or, better, to his *Executions of 3 May* showing the slaughter of Spanish peasants by French soldiers. *Rue Transnonain* also looks forward a century to Picasso's *Guernica*, which arose too from the wanton and senseless destruction of the innocent by paid murderers. In such masterpieces, human protest, the *saeva indignatio* that lacerates the heart, has reached ultimate expression.

CHAPTER SIX

The Death of *Caricature*

HE APRIL 1834 RIOTS, which had culminated in the massacre of the Rue Transnonain, had been quelled by decisive police action. The government was weary of continuing outbreaks and was determined to stop them at once and for all time. Republican leaders by the score were seized and held for trial. It was decided to try all of the men at one time, at one place, and before the same judges—a monster trial[1] violating the Charter, which had guaranteed that "No one shall be withdrawn from his natural judges," and which had further decreed that "It shall not be allowable to create extraordinary commissions and tribunals upon any pretext, or under any domination whatsoever." The decision to try 121 men from all over France before the Chamber of Peers in Paris made the trial a legal farce.

Furthermore, to hold such a large trial it was necessary to erect a special building in the Luxembourg gardens, adjacent to the Chamber of Peers; during the months of building the prisoners were unjustly and cruelly confined in Sainte-Pélagie. Cynical but honest, Talleyrand said, "Death is building that barrack."

The prisoners realized that they were being railroaded, that this was not a legal trial so much as a political one, and that the Juste-Milieu was trying to break up a party rather than to enforce laws. They planned their defense. From Sainte-Pélagie prison, they wrote:

> What we have to do is not to maintain our cause in the judicial trial, but to achieve a political victory; it is not our heads that we have to defend, but our ideas. Let us

teach Europe; let us teach the world what kind of faith is ours, and for what princi-
ples we have chosen to play the formidable game. What matters it, that our enemies
have vanquished by the sword, and may complete their success by the scaffold; we
shall be the victors, if it remains demonstrated that upon our side were truth, love of
the people, and justice.[2]

The trial began on 5 May 1835. Since it was obvious that they had no chance
against a stacked jury, the prisoners used every obstructionist tactic they could
invoke, including outcry and noise which frequently broke up the sessions and
which delayed the conclusion of the trial for nine months. Their tactic of dis-
order was one they would not willingly have chosen—for these were men of
training, intelligence, and ability—but one which was imposed upon them by
the gag rule of their judges. Daumier sardonically cartooned (*Caricature*, 14
May 1835; D116) the courtroom, showing a defendant before the bar, his arms
held by two guards, a gag about his mouth, while the judge says, "Go ahead
and speak, you are free, you have the floor" (Plate 21). Daumier's print carried
a second reference, however—the gag around the mouth of the prisoner was
also the gag being placed on the newspapers, a point made clear by the state-
ment in the same issue that since 17 January 1831 *La Tribune* had been con-
demned to forty-nine years in prison and 157,000 francs in fines.

Daumier's most effective attack on the trial was once again a portrait series
on the men of power; in place of the prostituted Assembly, there were the
prostituted judges. This time he made no maquettes, but instead attended the
trials, observed closely, and drew the subsequent portraits from his remarkable
memory. This is described by another eyewitness and Republican propagandist:

> Nothing could be at once more strange and more striking than the aspect of this
> assembly: on the one hand, dignitaries with bald heads and sinking frames, the fire
> of whose eyes, wellnigh extinct, had become reanimated for the moment by the com-
> bined effects of fear and of passion, frail representatives of a half-century of glory
> and of shame; celebrated, most of them, in the annals of diplomacy or of war, some
> of them infamous in those of treason; on the other, men of various conditions in
> life, and differing not less in intellect and in education, but thrown together by the
> chances of civil discord; some of them good, some bad, but all alike radiant in
> youth and daring; making with scornful levity, a jest of the danger impending over
> them; far less concerned at the position in which they stood than were the specta-
> tors, and prepared rather to heap condemnation on the judges, than to be themselves
> condemned.[3]

There were 164 peers and 121 prisoners present—more judges than defend-
ants! Daumier made no attempt to portray all of the judges but selected the most
important for his cruelly accurate, scornful portraits. He also made a number of
prints of the defendants. The contrast between judge and prisoner implied by
Blanc's words above is evident in Daumier's portraits. The trial was really an

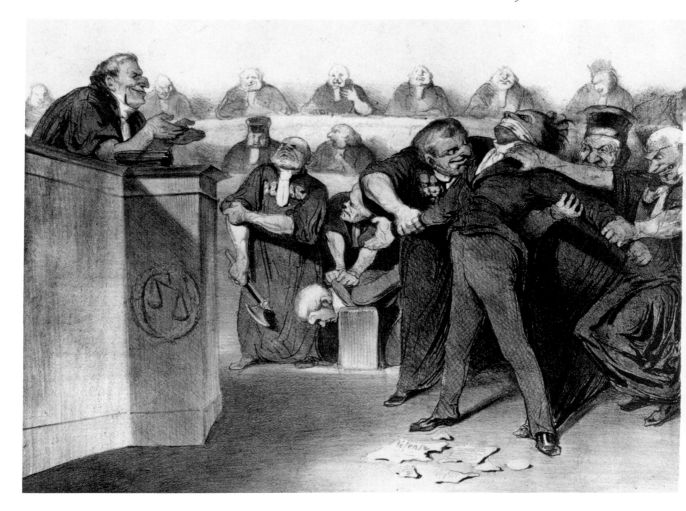

PLATE 21 *You Are Free to Speak*

attempted repression of the youthful, progressive spirit which was challenging outworn ways.

The first portrait, perhaps the finest, is of Count Barbé-Marbois. He had, Louis Blanc wrote, been "brought into the Chamber in his arm-chair, his head covered with a black cap, and his person enveloped in a dressing-gown." So Daumier saw him and drew him, with his stiff limbs, his raddled countenance, his senile somnolence. Other portraits are as cruel in their honesty. Girod de l'Ain is little more than a huge belly in an embroidered uniform. Count Jérôme-Siméon and Napoléon Lannes are both shown sleeping in boredom. The Count de Montlosier and Count Mathieu Dumas are eating and drinking—"Wretches hang that jurymen may dine." All of the portraits serve to illustrate the defiant

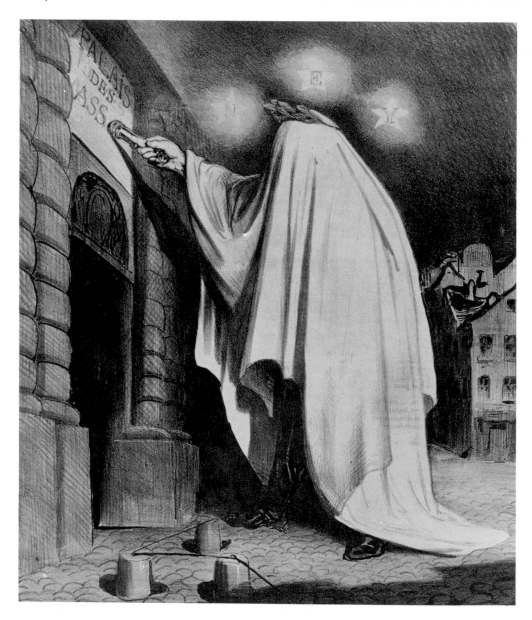

PLATE 22 *The Phantom*
Courtesy of the Art Institute of Chicago

words of the prisoners at the bar: "The infamy of the judge is the glory of the prisoner."

Daumier's most destructive satire on the April trials, however, was "The Phantom" (D115). A tall, hooded figure is knocking with his baton on the building erected for the trial, which carries the title over the portal, "Hall of Ass– "—the clipped word being, of course, "assassins," or some form of it (Plate 22). No Frenchman could miss the point. In 1815 the same Chamber of Peers had condemned to death Ney, the great Marshal of France, an unjustified act of legal murder. In Daumier's suavely executed print, Ney returns to haunt his guilty judges, who again are abusing their power.

With this print Daumier abandoned the April trials, which dragged on for months until the court at last condemned the men to exile or imprisonment. Shortly before the conclusion of the trial, several of the leaders, Marrast among them, escaped from Sainte-Pélagie, to the delight of the Republicans and the wrath of Guisquet's officers. The Republican party, however, was effectually disarmed.

II

MEANWHILE OTHER EVENTS had brought the Philipon–Louis-Philippe struggle to a head. Daumier's term as a political cartoonist under Philipon was rapidly running out, for the stormy career of *Caricature* was almost ended. The April trials left no doubt in anyone's mind that the government would soon use some incident as an excuse for a law against the press. Such an event came unexpectedly, horribly, and soon, with Fieschi's abortive attempt to kill Louis-Philippe.

Each 30 July it was the King's custom to honor the Glorious Revolution with a parade, though this had become an affront to the Republicans. At ten o'clock in the morning of 30 July 1835, accompanied by his sons and staff, Louis-Philippe proceeded along the crowd-lined streets. As he reached the Boulevard du Temple, a volley of shots from the upper story of a nearby house left the steet littered with dead and dying. The King, who was the intended target, was unharmed, although two of his sons were slightly wounded. To the admiration of the crowd, the King coolly and courageously continued on his way.

Meanwhile the police had caught the fleeing culprit, an anarchist, police spy, and jailbird named Fieschi. He had constructed an "infernal machine" of twenty-five gun barrels on a frame, so designed that all might be fired at once with a raking fire to cover a wide target. Homemade and inadequate, the gun failed, two of the barrels exploding and wounding Fieschi himself. The death of fourteen innocent citizens and the wounding of many more left the French people stunned and outraged.

Historians have not been able definitely to connect Fieschi's crime with the Republican leaders.[4] He himself persistently denied any outside assistance, aside

from his immediate allies: Morey, Pepoi, and Nivade. Nevertheless, as the expense of the construction of an infernal machine could scarcely have been met by the ragged Fieschi himself, outside support must be assumed. Furthermore, the Republican papers at this time had become violent in the extreme, some suggesting and others urging the death of the King. Regicidal remarks appeared even in *Caricature*. One cartoon showed an infernal machine of *Caricatures* firing on the National Assembly. Philipon also printed a special issue of *Charivari* in red ink, with a long article, "Monarchical Catacombs," listing those killed in the crime, and with a caricature of the King surrounded by corpses, titled "Personification of the gentlest and most humane of systems." One might suggest that although Fieschi's act went far beyond the limit which intelligent Republican leadership would allow, the crime represented a widespread wish-fulfillment, and that there was considerable sympathy with Fieschi's intended purpose if not with his means or his bungling. It could be said that Fieschi dared to do what they would have liked to do. Fieschi was tried, condemned, and executed. By the time of his trial, the September Laws prohibiting political and antigovernment attacks had been passed, so satiric commentary on the trial was denied to Philipon and *Charivari*. But the paper reported the trial at length, and Daumier made several plates of Fieschi and his associates. The Fieschi portraits are of unusual interest, showing the tense tortured face of a madman, reminiscent in insight and artistry of Géricault's pictures of human derangement.

Fieschi's mad act of course hastened government action against the opposition press. Already the seizures and trials had silenced *La Tribune*, which had ceased publication on 12 May 1835, having been seized 111 times and condemned 20 times, with a total of 157,630 francs levied in fines and sentences of 89 years in prison. But after the Fieschi incident the government had a clear case. The Duc de Broglie told the Deputies on 4 August:

> Anxious for her King, for her institutions, France lifts her voice and demands protection for the government . . . it is for her that we come to propose measures which alone seem to us suitable to reassure her and to put out of danger the person of the king and the constitution of the State.

Guizot also addressed them:

> There is a press which we hold unconstitutional, as radically illegitimate, as infallibly fatal to the country and to the July government; we wish to suppress it; it is the Carlist and Republican press. That is the purpose of the law.

Then he reproved the Republicans directly:

> In your hands, liberty becomes license, resistance becomes revolution.

Created from a revolution fought primarily to free the press, the Assembly now passed an act to curb that press. On 9 September 1835 it decreed:

Any sketch, any engravings, lithographs, medals and prints, any emblem of any sort or kind whatsoever they may be, may not be published, shown, or offered for sale without the authorization of the Minister of the Interior in Paris and the Prefects of the Departments. In case of offense . . . [they] may be confiscated and the publisher will be condemned by a correctional tribunal to imprisonment from one month to a year and a fine of from 100 to 1,000 francs. . . .

That was it; that was enough. Freedom of political expression vanished from France for the next thirteen years.

III

PHILIPON NEEDED NO SPECIAL COURIER from the Court to warn him of the overtaking storm. He took in sail. *Caricature*, he ordered, was to be liquidated: "It will continue to flourish in the person of its heir presumptive"—that is, *Charivari* would continue, but all political commentary must stop with the issue of 18 August, three weeks before the deadline. The debut of *Caricature* in 1830 had been disarming. Its farewell, 27 August 1835, was contrastingly explosive. "We believe," wrote Philipon, "that we have put out a periodical which will be consulted by all those who wish to study and write about the first years of Louis-Philippe's reign," and he generously gave the credit to his collaborators whose friendship had made his directive task simple. Philipon scornfully made up this last number from the very laws killing the magazine, using the official words of the government to speak in their own ironic condemnation. Readers might see for themselves what this best of republics had given its citizens: the illegal trial of defendants en masse, increased cautionary bail, publishers' personal deposit of 100,000 francs as guarantee of proper behavior, no attacks whatsoever against the King or any of his official acts, no mention of the word Republican, and crushing fines for failure to respect these repressive requirements. The "reign of terror in ideas"—Lamartine's phrase—was again in full force.

Philipon included in this issue an anthology of the former promises made by the Great Men—Persil, Thiers, Guizot, and Louis-Philippe—placing once more on record the phrases and rhetoric so disastrously unfulfilled by political reality. The chief refrain was, of course, the sentence, "Henceforth the Charter will be a fact." As a contrast with these phrases, this deceit, Philipon added words of encouragement, quoting Lammenais, "Prepare your spirits for [this new] time, for it is not far off, it is approaching."

The climax of this defiant issue of *Caricature* was Daumier's print, "They certainly had a lot of trouble killing us" (D130). Three men killed in the struggle of 1830 speak from their tomb (Plate 23). Looking toward the rear where soldiers are stamping out the last of the rioters, these strongly drawn figures, a dominating foreground triangle, contrast in their vigor with the puppet-like soldiers in the distance killing innocent citizens in the streets. In effect, these men say, "We who have died salute you who are dying." This picture is a fit

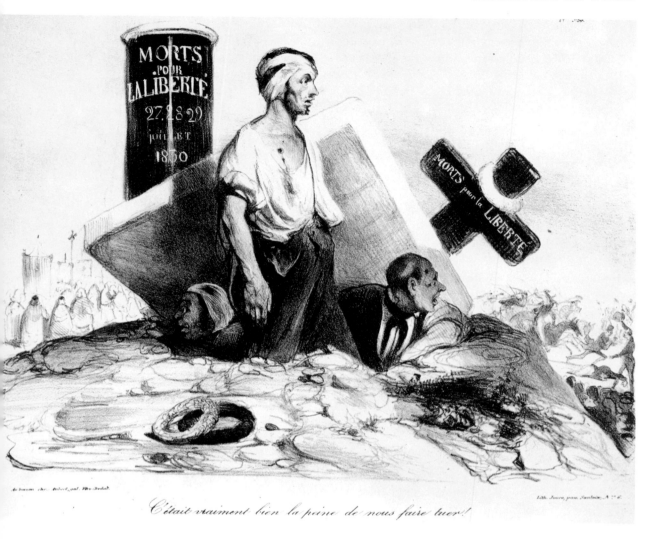

C'était vraiment bien la peine de nous faire tuer!

PLATE 23 *They Had a Lot of Trouble Killing Us*
Courtesy of the Art Institute of Chicago

epitaph for the men who had fallen five years before on the barricades of Paris.
It was Daumier's farewell to old friends; it was also his farewell, for more than
a decade, to political cartooning.

Caricature died not with a whimper but a bang. However, France fell back
into political lethargy; in Lamartine's famous *mot*, she "became bored." The
swift-flowing current of political freedom was dammed, though thirteen years
later the dam would burst, the current would again flow with similar turbu-
lence, and Daumier would be on hand to record the event. Meanwhile he and
Philipon and all the others on *Caricature*, while they chewed the dry crust of
defeat, could only hope.[5]

CHAPTER SEVEN

Robert Macaire

OW CARICATURE had become a heroic memory, a file of ten volumes on library shelves, a classic of satirical journalism. A fighter and not a weeper, Charles Philipon survived by adaptation, and Daumier with him. "They killed a journal," Philipon later wrote, "which appeared weekly. I replied to them with a journal which appeared daily."[1] This daily was, of course, *Charivari*.

The King and his Assembly were now guarded by the censor; what was left for the wit of Philipon and the crayon of Daumier? Everything else—the whole world to see and to draw.[2] Philipon listed satiric fields:

> Moral, literary, theatrical, artistic, industrial, medical, surgical, agricultural, somnambulist, anabaptist, etc. The field, believe me, is rich, very rich everywhere, in vices, in absurdities, in swindling, in follies of every kind.

For Daumier the contemporary world was infinite, inexhaustible; it released his finest powers. From the streets of Paris and from the people he saw every day as he strolled along, taking down all in his "semi-divine memory," Daumier drew his riches as from an open bank.

What was this world of the Juste-Milieu, politically, economically, artistically? Politically, France was comatose, curbed by its King—a condition already recorded by Daumier in *The Legislative Belly*.

Industrially, on the other hand, all was activity and progress. "Enrich yourselves,"[3] Guizot urged his Chamber members in 1843, and they did. France sprouted a profusion of factories, railroads, ships, and banks. Uncontrolled by

69

law, a laissez faire economy ran wild as fortunes were made overnight (and many as rapidly lost). The population increased more than thirty per cent in the first half of the century. Paris doubled in size. It was all exciting. Vigny exclaimed, "I do not know whether it is evil, all this, but it is beautiful, it is magnificent! One feels in the bottom of his soul that an entirely new world is being forged in this flame." The industrial revolution had brought its critical problems but it had also opened infinite possibilities. Because of its wealth, Vigny called it a "society based on gold."

In the world of the arts and the mind, France was electrically alive, with a creative activity unmatched in Europe. France's political and moral narcosis stimulated a noteworthy body of humanitarian protest against what Georges Sand called "this infamous maxim which governs the world; everybody by himself, for himself." Others joined her in an outcry against the social injustice she portrayed in her novels. Most important, perhaps, was Victor Hugo, especially in *Les Misérables*, but the poems of Lamartine and Lammenais and the historical writings of Michelet and Quinet prepared an intellectual atmosphere receptive to the revolution inevitably to come. It was a fertile period of social dreaming, with the Utopian idealism of Saint-Simon, Gabet, Fourier, and Proudhon. Like the America of the same era, it was "an age of ferment." In art there was the intoxicating color of Delacroix, in music the new sonorities of Berlioz. The Assembly had sold out the revolution, but in the world of the mind there was, above the popular work (Scribe, Augier, Labiche, Paul de Kock, Ducray-Duminil) common to any generation, a creative achievement which, Gautier predicted, would "make its mark in the future and be spoken of as one of the great dramatic epochs of the human mind." The familiar opening words of *A Tale of Two Cities* apply also to these years in France: "It was the best of times, it was the worst of times. . . ." It was Daumier's world.

For a time Daumier groped. He began several projects, none important, few finished. The best was a human zoology. Philipon wrote:

> Daumier proposes to reproduce the types of faces, clothing, and costumes peculiar to the various classes which constitute the ornament of society. This series, along with Grandville's *Grotesque Parisians* and Bouquet's *Pagan Stupidities*, will form in *Charivari* a complete physiognomy of the most intellectual and gracious of nations.

Daumier shared this series, *French Types* (D260–270), with Traviès. His eleven subjects were The Errand-Boy, The Tailor, The Public Stenographer, The Banker, The Man of Leisure, The Cook, The Restaurateur, The Coiffeur, The Wig Maker, The Art Student, and The Butcher. By the time Daumier had reached "The Butcher," Philipon had come up with a more ambitious series. This was *Robert Macaire*.

Although Philipon and Daumier now had found in the world at large inexhaustible resources for their gibes, they also had discovered that political

habits and inclinations do not die easily. The legal and legislative victories of the King and his party rankled. How could they retaliate?

By indirection they direction found. The September Laws had forbidden direct criticism of the King and his ministers. These laws said nothing about criticism of the very spirit of the regime, the vital force of the 1830's: its expansive materialism. The Juste-Milieu was vulnerable even though Louis-Philippe ruled inviolate. The Pear was forbidden fruit, but the tree from which it sprang was a permissible target. Louis-Philippe's group could be fought by metonymy. So Daumier and Philipon once again collaborated in a campaign of ridicule and laughter worthy of the finest French satiric genius.

II

HOW SATIRIZE A WHOLE SOCIETY? How best deal with an enormous abstraction? How reduce such complexity to direct, simple statement? By personification and symbol—and the symbol was ready at hand for Daumier's experienced powers of exploitation, the picaresque stage figure of Robert Macaire. As one critic wrote at the time:

> Follow a bit, I beg of you, the marvelous transfiguration of the man and at the same time the marvelous transfiguration of the *œuvre*!—Robert Macaire is first of all a melodrama; then the melodrama becomes a comedy; then the comedy becomes a caricature, and the caricature becomes transformed in the imagination of Philipon and under the crayon of Daumier in a heroic epic.

Robert Macaire and Bertrand were the creations of three hack dramatists, Antier, Saint-Amand (Jean-Armand Lacoste), and Paulyanthe (Alexandre Chaponnier), in a five-act play, *L'Auberge des adrets*, performed at the Ambigu-Comique, 2 July 1823.[4] The leading role in this miserable melodrama, Robert Macaire, had been assigned to Frédérick Lemaître, then a young actor (later to prove the greatest in the French theater since Talma). Robert Macaire's straight man, Bertrand, was played by Serres. The tawdry drama disgusted Lemaître, and the first performance elicited catcalls and hisses. On the second night, Lemaître without authorization audaciously transformed his role from a conventional bandit of melodrama into that of a buffoon, a blackguard with humor and dash, a witty scoundrel who could laugh at himself and his victims—in other words, a parody of the stereotype as originally written. The first-night failure became a mild triumph for Lemaître and the troupe. The audience, prepared to experience the *frisson* of terror, instead rocked with laughter. Through gesture and intonation, for few words were altered, Lemaître saved Macaire for the future.

The figure and costume of Macaire had been discovered by Lemaître one day when, roaming the streets of Paris, he saw an insouciant and eccentric

clochard (tramp).[5] Lemaître adopted a similar costume, ragged pants much patched, battered top hat, eyepatch, neckerchief, and cane.

Robert Macaire would have been forgotten, however, had not Lemaître, in 1834, searching for a stage vehicle, decided to adapt the old scoundrel to the Juste-Milieu. Collaborating with two of the original authors, Antier and Pauly-anthe, Frédérick Lemaître constructed a comedy in which two unscrupulous scoundrels trick each other. The fake Baron Wormspire, boasting of his wealth, negotiates with Macaire, also vaunting wealth, for his "daughter," really his mistress, to marry Macaire. The verbal sparring between the rascals made the play a smash hit at the Folies Dramatiques, 14 June 1834.

One more step was needed to make Macaire a national symbol: the intervention of Philipon and Daumier.[6] Philipon's creation of Macaire was as inspired as his earlier invention of the Pear, but it would have been nothing without the genius of Daumier. In later years Philipon generously praised Daumier's graphic realizations of an idea handed over to him:

> But when one gave Daumier a legend to realize, how he executed it! Look at the political caricatures from 1830 to 1835! Look at Robert Macaire! Let's withdraw the reproach of lack of imagination which we just made of the author of thousands of charming compositions. What does it matter where the first idea of the artist comes from? In fulfilling it with so much art and with such great variety, has he not made it his own? Don't dispute it with him, it truly belongs to him.[7]

The public has, rightly, persisted in giving the artist the final credit. "It is Daumier," wrote Camille Pelletan, "who gave him flesh and bones, and in some way the breath of life." [8]

Philipon's and Daumier's collaboration was immediately successful. The first print appeared on 20 August 1836 and the series extended to 100 pictures, concluding 25 November 1838. The first fifty plates were gathered and published in 1837 for thirty francs; later the first eighty were combined for forty francs; and finally in December 1838 the entire series was gathered in a large portfolio which in black and white sold for forty-five francs and in color for fifty-five francs. They were pirated in Belgium, and the fictive creature Robert Macaire became common property, a universally known symbol.

Macaire's operating principle was a blend of Vanderbilt's famous "The public be damned" and W. C. Fields's "Never give a sucker an even break." Take what you can get by any means you need—but take it. Abandon scruples and act expediently, for the moment, and for the golden opportunity. Balzac's Vautrin, a figure based on Robert Macaire, summed up the age:

> There is no such thing as principle, emergency is everything; there are no laws, but only circumstances and emergencies in order to direct them. If principles and fixed laws existed, nations would not change them as easily as we change our shirt. A man cannot be expected to be more virtuous than a nation.

(Vautrin's advice was being given to Rastignac, Balzac's great character who by deliberately adopting Macairean tactics becomes rich and powerful in the Juste-Milieu.)

Although Robert Macaire embodies an unscrupulous strategy and satirizes a society rather than a person, nevertheless personal reference was made in the very appearance of Macaire. Louis-Philippe was the center of the Juste-Milieu, Macaire was its satiric symbol; therefore, Macaire must physically bear a resemblance to the Pear. Frédérick Lemaître had in his stage costume established the similarity in 1834 and Daumier transferred it to the lithographic stone. In the first print, Macaire wears the familiar ragged costume of the stage Macaire, but on his head is the (battered) top hat, long a stock symbol for the King. The famous cotton umbrella is clutched in the hand of Bertrand, who is made to look like the gaunt-faced Guizot, Louis-Philippe's right-hand man. Parisians could not miss the hint. The censor could not reasonably object, for the Macaire costume and properties had long been established in the theater, even before the Juste-Milieu, and Daumier's cartoons stayed close enough to Lemaître's original creation to avoid the charge of royal reference. Macaire was not, of course, intended as a one-to-one equation with Louis-Philippe; he was rather more, a symbol of the realm itself, the synecdoche of Society.

All of this was made clear by Philipon in *Charivari* (20 August 1836):

Robert Macaire has disappeared from the theater. M. Thiers does not want it performed any more. But this character remains as the most reliable personification of the period. On the Exchange, in politics, in industry, in literature, and even in philosophy, one discovers everywhere Robert Macaire and Bertrand, meaning the swindler and his confederate. There flourishes everywhere the bonus, the public monument, the expected dividend, the model contract, the economic journal, the collection for the benefit of the poor, and, above all, the excellent collection of sheep ready to offer their backs to the shears of the shearers. But since this censorship, instituted to protect virtue and morality, forbids us to satirize political Robert Macaires, it compels us to take on the social Macaires.

We now propose to publish a gallery in which the numerous varieties of this last species will successively appear. Our plate today is the beginning. It is dedicated to those bankers, philanthropists, or contractors whose cash boxes, like prisons, are ever ready to receive but never to render up.

Daumier's opening print (D354) illustrated Philipon's words. Macaire confides to Bertrand, "I adore industry. If you wish we will start a bank, but a real bank! Capital: one hundred millions of dollars, and one hundred millions of billions of shares. We will smash the Bank of France, we will sink the bankers, the charlatans, we will sink everybody." "Yes," says Bertrand, "but what about the police?" Macaire cynically answers, "How stupid you are! Does one ever arrest a millionaire?" (Plate 24).

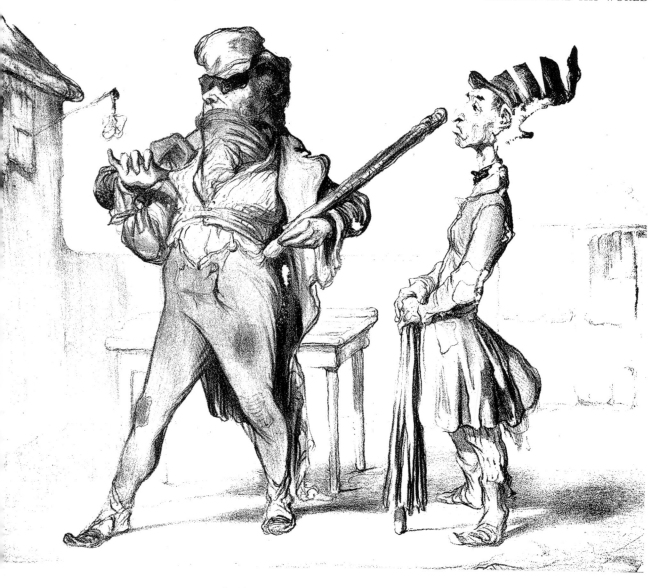

PLATE 24 *I Adore Industry*
By permission of the Harvard College Library

"I adore industry" was the key phrase of the series—the industry of factories, mines, railroads, and other exploitable sources of money. The Juste-Milieu adored industry also, even as it adored the fruit of industry, the five-franc gold piece bearing the image of Louis-Philippe. Macaire was created to echo the newly arrived industrialism which had brought with it prospects as alluring, as seemingly inexhaustible, and as exploitable as the New World had offered to

sixteenth-century Europe. With this new industry, a new type of person was called for, or perhaps an old type to be made over for the new development: the promoter.

Macaire is the promoter *par excellence*. He dreams extravagant schemes to enchant, seduce, and fleece the public. He is the Confidence Man in an endless variety of confidence games. Unprincipled, unscrupulous, he is the entrepreneur who cares nothing for consequences but seeks merely, at the right moment, for the quickest exit when balance sheets are called for. He is pure verbalist, whose alluring prospectuses have less substance than fairy tales. He sets no limit to his dreams.

Although a master of ruse, Macaire lacked method. Each print had to be complete in itself; no story was carried along from one plate to the next, as in a modern cartoon strip. In each picture Daumier concentrated a situation to which Philipon's words gave a "story" which the imagination of the reader could extend as he wished. From print to print Macaire changes, appearing as stock promoter, lawyer, restaurateur, bookseller, philanthropist, banker, matrimonial agent, gigolo, and so on. Anticipating in satire and equaling in excellence the *Men of Justice* series of ten years later, the Macaire-as-lawyer prints are among the most interesting. In one (D363), Macaire the lawyer congratulates his client on their victory. The client complains, "It's about time . . . a trial which has lasted ten years and which has ruined me." Macaire: "Better late than never." Client: "And what's the cost?" Macaire: "Here you are: the court awards you 12,000 francs. We have 13,000 in expenses. You owe me more than 1,500 francs." Client: "But I'm losing 1,500 francs." Macaire: "Yes, but you have won your case." Such wit is, of course, the creation of Philipon, but Daumier does all that design can do to carry out the meaning. Ironically, it is "merely" illustration which has outlasted the text it served.

A new swindle appears in each print. Macaire has more appearances than Melville's chameleon Confidence Man; he has that character's wit and his pleasure in deception, but is free of his Timonism. Macaire's very fluidity adds to his effectiveness as a symbol. What, after all, is more mercurial, shifting, elusive, and ubiquitous than the Confidence Man, the Operator? Macaire was the avatar of a timeless type, in our day the five per center in Washington (or Paris or London), the lobbyist. Huckster and Macaire are virtual synonyms, linking our century with the nineteenth. But Macaire's ancestry is ancient, if not honorable. He is the clever servant of ancient comedy. In French tradition, and certainly uppermost in Daumier's mind, he is Molière's Scapin, the servant-clown, subject of one of Daumier's finest paintings, who delights in stratagem for stratagem's sake.

Satirizing bourgeois society and bourgeois energy, Macaire himself is not bourgeois. The typical nineteenth-century bourgeois is Monsieur Prudhomme (Mr. Cautious), the cartoon and stage creation of Daumier's old friend, Henri

Monnier. Macaire and Prudhomme are antipodal. Prudhomme is cautious and
meticulous although without true conscience. He is a low-grade Polonius. His
belly is stuffed with food and wine; his mind is equally stuffed with platitudes
and self-conceit. Although like Macaire in caring little about means, unlike
Macaire he is concerned with realizable ends, that is, with status, and will not
risk everything in a glorious gesture, as does Macaire. Prudhomme lacks spirit;
he is to be laughed *at* but never *with*. He is an unmitigated fool, to be written
down, like Dogberry, as an ass. He is Bully Bottom and Monsieur Jourdain,
while Macaire is Falstaff and Scapin and W. C. Fields. Prudhomme's speech is
stuffy and sententious, funny only because so stupid, cliché chained to cliché
endlessly, almost like pages torn from Flaubert's *Dictionary of Accepted Ideas*.
Macaire's speech, on the other hand, scintillates, overwhelms one with pun and
word-play, slyly shifting slogans at need, parodying the platitude dear to
Prudhomme. Prudhomme respects the law because it protects his goods and
chattels; Macaire is outside the law and defiant of it, the rebel and the outlaw,
the "Mephistopheles of the gutters." Prudhomme is a pillar of society, but
Macaire would topple the pillar just to hear and to see the crash. Prudhomme is
stasis, Macaire is movement. Prudhomme's idol is property, but Macaire de-
lights in acquisition as pure operation and not as end. As Jules Claretie sum-
marizes, "Robert Macaire personifies an entire epoch."

One of Daumier's wittiest touches is in the seventy-eighth print (D433).
Macaire leans over the artist who is preparing a stone for *Charivari*. "Monsieur
Daumier," he says suavely, "your Robert Macaire series is a charming thing.
The accurate painting of the thieves of our period. ... It is a faithful
portrait of the host of confidence men one finds everywhere, in commerce, in
politics, in the countinghouses, in finance, everywhere! The scoundrels must
certainly wish you well . . . but the esteem of honest men has been earned by
you. . . . You don't yet have the cross of honor?—That's beastly."

This droll comedy—as when the actor speaks through the frame to address
the audience—is doubly ironic, for the "Daumier" addressed is the image of
Philipon. By his witty montage Daumier reminded his readers that the Macaire
series was a collaboration. Philipon, as we have seen, later gave generous credit
to Daumier for Macaire, and here, earlier, Daumier gaily reminded the readers
of Philipon's important role. Daumier's fair play notwithstanding, posterity
remembers mainly the role of the artist.

It is difficult for us to feel the full force of the Macaire vogue since not only
do we have a different society but no single symbolic summation of our time
exists. Casper Milquetoast and Charlie Chaplin's little tramp are excellent em-
blems for parts of the twentieth century but they are scarcely central and focal as
Macaire was to his age. Balzac tried, in Vautrin, to produce a play about him;
Thackeray in 1839 wrote a highly appreciative essay on Macaire [9] and may even
have taken hints from it for his creation of Barry Lyndon. Macaire of course

PLATE 25 *Crispin and Scapin*
Photo Bulloz

appears constantly in *Charivari* in all kinds of casual and incidental references, a
convenient prototype, a fruitful universal allusion.

Daumier's *Robert Macaire* is a series now neglected save by a few. Daumier
himself deplored the assignment because he felt that it was illustrational,
chained to Philipon's text. Nevertheless it was far from useless effort on his part;
it was no ignominy to have collaborated with Philipon. Daumier's collaboration
was really conquest, picture erasing pun. To have amused a nation with its
own image and to have made immortal a symbol of an epoch is no little ac-
complishment. Furthermore, drawing the dozens of Macaire prints sharpened
and deepened Daumier's understanding not merely of the inglorious side of his
own age but of the limitations of men and women in a materialistic society. Nor
would he ever completely abandon Macaire; the scoundrel turns up now and
again down the decades in Daumier's work, either openly, or transformed and

heightened on canvas, above all in *Crispin and Scapin* (Louvre). Here the mauve
and lavender tones, called for by the stage lighting which he was realistically
recording, create a cunning and terrifying effect of rascality as Scapin whispers
his misleading phrases into the ear of his master (Plate 25). In this painting the
topicality and immediacy of Macaire are fused with the wit and timelessness of
Molière and Scarron.

CHAPTER EIGHT

Daumier at Home

IVING HAS ALWAYS BEEN ECONOMICALLY PRECARIOUS for the artist, especially in an industrial society, and so it was in Daumier's century. To produce "serious art"—that is, to paint —the artist might, if he were one of the lucky few like Ingres or Delacroix, find state patronage or private sponsors. Without these he was constrained to turn to hack work, mainly journalism and illustration. Daumier's alternatives were to paint and starve or to draw cartoons and live.

The *Charivari* cartoons proved to be a series of contracts which burdened Daumier for most of his life. One of these contracts, 2 February 1839, has been preserved and gives us a glimpse of his economic situation then; it is fairly representative of his career.[1]

M. Dutacq had replaced Philipon as owner of *Charivari*. He negotiated with Daumier for a monopoly of his lithographs for a period of from six to nine years, a contract which might be broken by either party only after three months' notice. Daumier agreed to do a minimum of 100 prints a year, a maximum of 200, all of the size and the social genre of *Robert Macaire*. For each print he was guaranteed fifty francs, with a down payment of 2,000 francs against the first 200 prints. Not a princely offer, it nevertheless assured Daumier a low-level security and allowed him some time for other work—woodcuts and illustrations, and even, perhaps, some spare time in which to paint.

Daumier apparently did not always receive the same fifty francs per print, and at times he earned but forty francs. Further evidence must turn up to clarify

79

these variations. Even while signing this present contract with Dutacq, an earlier and less profitable contract had yet to expire. A scrap from Daumier's notebook for September 1839 shows that he then received only forty francs per print. His own record further shows that he had finished fourteen stones and had redrawn another because the stone had broken in the press (for which he received a further twenty francs), so that he had made 580 francs from lithographs and a further 40 francs from two woodcuts: total, 620 francs. This was a living well above the poverty line, comfortable for a man of his simple needs. Once when a friend expressed concern about Daumier's lack of money, he answered philosophically, "What more do I need? Two fried eggs in the morning, and in the evening a herring or a cutlet. To that add a glass of Beaujolais, some tobacco for my pipe, and anything more would be superfluous."

II

THE TWO WOODCUTS at twenty francs each which Daumier recorded in his notebook point to an artistic interest new to Paris in 1839: the woodcut. Daumier had designed woodcuts[2] as far back as November 1833 when he drew a frieze of the *Charivari* staff, portrayed as an orchestra, as a headstrip for the paper; he followed this with four more headstrips showing, respectively, four, six, seven, and ten heads of the ministers (Plates 26, 27, 28), the paper's chief targets. Daumier also drew a number of large political woodcuts as a parallel to some of his lithographs during 1834–35. Woodcut illustration, however, did not become really popular until about 1838, and, once again, it was the fertile intelligence of Philipon which was largely responsible for the vogue. Restlessly seeking to enliven *Charivari* after the September Laws had taken away some of its intellectual verve, Philipon found a physical means of enhancement, altering the appearance of the magazine by the addition of small woodcut illustrations, rubrics and marginal ornaments. Other papers adopted the practice and book publishers greatly increased the use of woodcuts for illustrative purposes, since it was cheap, efficient, simple, and attractive. It was felicitous and appropriate for Balzac to address Charles Philipon in 1841 with the accolade, "Duke of Lithography, Marquis of the Sketch, Count of the Woodcut, Baron of the *Charge*, Knight of the Caricature," et cetera. Daumier became one of the Count's serfs.

For the artists, woodcuts were an easy way to make an extra twenty francs. Daumier merely drew his sketch directly on the woodblock and left the labor of cutting to the craftsmen hired for that purpose by Aubert's shop. Inevitably, of course, the final picture was affected by the skill or ineptitude of the cutters so that there is considerable variation in the quality of Daumier's woodcut sketches. Nevertheless, no matter who the cutter was—Birouste at the best, an anonymous hack at the worst—the mark of Daumier's draftsmanship is instantly

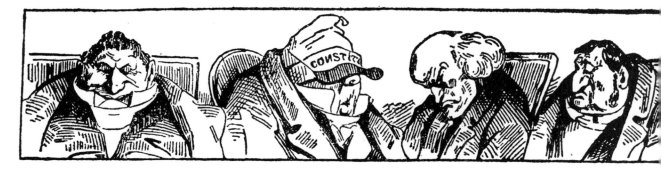

PLATE 26 Headstrip from *Charivari*
By permission of the Harvard College Library

PLATE 27 Headstrip from *Charivari*
By permission of the Harvard College Library

PLATE 28 Headstrip from *Charivari*
By permission of the Harvard College Library

apparent. To study the countless little woodcuts dotting the books and periodicals of the early 1840's, a large number of them drawn by the Daumier circle—Trimolet, Monnier, Gavarni, Grandville, Johannot, Vernier—is to exercise one's eye and taste in an amusing game (whose is which?) and to discern the difference between talent and genius.

Many of Daumier's finest woodcuts were printed between 1839 and 1841 in the little *Physiologies*, issued by Aubert, which were a two-year fad in Paris.[3] Flaubert in *The Sentimental Education* refers to their vogue. They were Philipon's conception. The first was published 22 August 1839, and dozens followed. They were duodecimo volumes of either seventy-two or ninety-six pages. Each book dealt with a single phase, or character, of Parisian life. There is a *Physiologie* of the Lawyer, the Poet, the National Guardsman, the Lecher, the Concierge, and so on. Each was written by one of Philipon's friends—Balzac, Albert, Rousseau, and Huart among them—and was decorated with head- and end-pieces, chapter rubrics, and marginal woodcuts. In some of them Daumier's sketches play only a minor part, in others a major role—as in the Porter, the Poet, Robert Macaire (of course), and the Traveler. The woodcuts were company stock and were frequently used later both in *Charivari* and in other publications by Philipon and Aubert.

The *Physiologies* were the inevitable outgrowth of nineteenth-century interest in science—especially as seen in the work of the classifying scientists, many of them Frenchmen, like Buffon, Lacépède, and the Cuviers—and in the great popularity of the Paris zoo, the Jardin des Plantes. Appropriately, if somewhat ironically, the term had been given currency in France by Brillat-Savarin's celebrated *Physiologie du goût* (1825), and by Balzac's *Physiologie du mariage* (1826).[4] Systematization became the fad. By metaphor, France and the French fell into classes as clearly and as neatly as the other caged animals. A poet or a lawyer was as amenable to definition and labeling as a lion or a wolf. The most important literary consequence of this metaphor was *La Comédie humaine*, in which Balzac arranged French society in a socio-scientific manner. In the Foreword to *La Comédie humaine* he said, "Society makes of man, according to the environment in which his activity is exercised, as many different species as exist in Zoology." Balzac even wrote one of Philipon's little books, *The Physiology of the Man of Property of Paris and the Provinces* (1841), a volume which gains interest because it includes nine woodcuts (B561–569) by Daumier. With the exception of Daumier's powerful woodcut of Père Goriot (B736), it is the best reminder of the relationship of these two nineteenth-century giants.

Although Daumier's curtailed series *French Types*, drawn shortly after the September Laws and clearly under the suggestion of Philipon, was in a sense a forerunner of the *Physiologies*, the booklets really had their inception in *Charivari* in an illustrated article by Louis Huart, an editor. This later became a book titled *The Paris Museum, Physiological, Picturesque, Philosophic, and Grotesque Accounts of the Strange Animals in Paris and the Suburbs, to follow the Works of M. de Buffon.*

The book had 350 woodcut illustrations, all contributed by *Charivari* artists.

One of the finest of all the *Physiologies* was on the Concierge (1841). Written by James Rousseau, it was an amusing account of this terrifying, powerful harridan, still a power in Paris apartment life, and Rousseau's words were enlivened by fifty-nine of Daumier's sketches (B502–560) which, fortunately, fell into the hands of two skillful cutters, Deschamps and Tazzini. It was a book to please both the mind and the eye. Most of the booklets were badly written, but then they were journalistic and not literary efforts, ephemeral products at best save for the occasional contributions of Daumier and Gavarni and Balzac.

Another important outlet for woodcuts was the anthology or album. Three collaborative books in particular display Daumier's draftsmanship and also afford a panorama of mid-nineteenth-century woodcut illustration, since each volume contains a lavish gathering of sketches from the large Aubert circle of artists. *Historiettes et images* (1841), for example, has 700 woodcuts by many hands to accompany the text by *Charivari* editor Maurice Alhoy. *Némésis médicale illustrée* (1840), "a baddish medico-poetical publication," has mordant sketches (B336–364) by Daumier, such as that which impressed Baudelaire:

> One of them, which deals with cholera, represents a public square flooded, overwhelmed with light and heat. True to its ironical custom in times of great calamity and political upheaval, the sky of Paris is superb; it is quite white and incandescent with heat. The shadows are black and clear-cut. A corpse is lying across a doorway. A woman is hurrying in, stopping up her nose and mouth as she runs. The square is deserted and like an oven—more desolate, even, than a populous square after a riot. In the background can be seen the silhouettes of two or three little hearses drawn by grotesque old hacks, and in the midst of this forum of desolation a wretched, bewildered dog, starved to the bone, with neither thought nor aim, is sniffing the dusty paving-stones, its tail stuffed between its legs.[5]

A book which was intended to attack Orfila, a famous doctor of the day and one of the first to use medicine in the detection of crime, its value is preserved today by Daumier's masterly sketches and not by the lumbering satire or the reputation of the doctor attacked.

The third book, *La Grande Ville* (1842), is a fine survey of a city. Even without Daumier's contributions the book would deserve a place on a collector's shelf, but the artist's sketches (B644–701) give it an extra dimension. One critic, William M. Ivins, Jr., has dared to say that "nothing done on wood since the day of Dürer and Holbein is of greater merit and possessed of stronger lasting qualities." There is, he adds, "an almost psychic penetration into the very soul of the many layers of society of the time."[6]

III

AT THE TIME OF HIS 1839 CONTRACT with *Charivari*, Daumier was living at 12–14 Rue de Buci just off the present Boulevard Saint-Germain. Nobody knows exactly when he moved from there or, more important, exactly when he began

residence at 9 Quai d'Anjou on the Ile Saint-Louis. Perhaps it was in 1841 at the time of the hitherto untold Branconnot incident.[7]

On 26 July 1841 Daumier borrowed 110 francs from a M. Branconnot in order to pay for some new furniture. Two months later, 13 September, when the loan fell due Daumier had to tell Branconnot's agent, M. Levasseur, that he could not pay the debt. Levasseur took the matter to court. On 14 December the Tribunal of Commerce of the Seine ordered the artist to pay the sum. When Daumier failed to follow its order, the Tribunal then approved the seizure of Daumier's goods, 4 January 1842, consisting, apparently, of most of the furniture in his apartment. The expropriated items were one dining-room table, a large buffet, six cane-bottomed chairs, one horse's head and one plaster horse, one living-room mirror, a three-cushion divan, a beechwood buffet; from the living room, one table, an armchair, a flat-topped table in white wood; and from the bedroom, six chairs, a chest, and a mahogany table (the bed was left).

Daumier had not willingly let the goods go, fully intending to pay the loan and recover his possessions. On 18 February he wrote to the bailiff, M. Fumet, "Monday I will send fifty francs on account on the bill I owe you, don't do anything further in the meantime." A month later, 18 March, he again wrote, "It is impossible for me to give you the money for a week, do me the favor of waiting until that time when I will be in a position to end this Branconneau [sic] business." Still the payment did not come. On 11 April Fumet, accompanied by the bill-poster, posted twenty-five notices in Paris that on 14 April at the Hôtel des Commissaires-Priseurs, in the Place de la Bourse, the furniture of Daumier would be sold. Whether Daumier finally found the cash to forestall the sale is not known. He had followed, albeit unwillingly, the advice of his friend Balzac, who once told him, "If you wish to get ahead in the world, get in debt."

The Ile Saint-Louis where Daumier lived from 1841 (?) to 1863 was ideal for him, an Eden. At once retired and central, it was at that time a section isolated from the mainland except for footbridges, so that there was virtually no wheel traffic. It was, in effect, a quiet village, a world apart. And economical. The old seventeenth-century buildings had been converted into apartments which rented cheaply. Here Daumier was within ten minutes of the Louvre, near the Palace of Justice, and close to the Latin Quarter. The Ile Saint-Louis as it was in those days has been best described by Daumier's neighbor and friend, Geoffroy-Dechaume:

> The Seine becomes a peaceable country stream bordered by trees, with an extensive beach. . . . In the distance the inhabitants sleep on the green bank. . . . The horses which they water, solid work beasts, emerge from the river in massive sculptures. The bare-legged children run about; the fishermen are transfixed. Laundresses bending under their burden mount the stone stairs. Workers and bourgeois, elbow to elbow, contemplate the backwash of the boats. All this against a background of whitish houses, red and gray, from the quays, with their uneven roofs and their irregular windows.[8]

Anyone familiar with Daumier's paintings will recognize instantly the source of most of his subjects—his immediate surroundings. Daumier had the peace of the suburbs while living close to the heart of the city.

Daumier's apartment was on the top floor of 9 Quai d'Anjou. Needing an atelier, he had the clever idea of transforming the attic into a studio. He had a window knocked into the roof and the walls plastered, and the result was a large bare room exactly right for his purposes for which he did not need to pay additional rent. The landlord was considerably put out when he realized that here was rentable space which he had not had the wits to exploit and about which little could now be done. On several occasions he pleaded with Daumier to consider increasing his rental payments, to which Daumier, naturally, much like Bartleby the Scrivener, would gently reply, "I prefer not to."

This atelier has been described by Théodore de Banville.

> It is impossible to imagine a place less luxurious, more severely bare, from which all ornaments were rigidly proscribed. On the walls, painted in a quiet clear gray, nothing was hung except an unframed lithograph of the *Pariahs* by Préault. A square, black stove in varnished sheet-iron, some benches set against the wall, some stuffed portfolios spilling over with sketches so that they could no longer be closed—that is all one saw in the large studio, gray and clear, except for the little table on which Daumier worked his stones.[9]

The results during those next twenty years showed that it was enough.

Quiet though the Ile Saint-Louis blessedly was, it was also a sociable place for Daumier, who was a sociable man. His closest friends all lived near him on the Ile. Steinheil and Trimolet lived on the Quai de Bourbon, while Daubigny, Jeanron, and Geoffroy-Dechaume also were nearby. Next door to Daumier was the famous Hôtel de Pimodard, where Boissard de Boisdenier and Baudelaire lived. A wealthy dilettante, Boissard had many talents and much charm. He played the violin well and painted even better, having been accepted at the Salon. He extended his hospitality to the more original, often less well-known, artists of the day, including his Ile Saint-Louis neighbors. It was in his apartment that Baudelaire indulged in the famous hashish-smoking parties described by Théophile Gautier, which called forth amusing cartoons from Daumier. Delacroix strolled over frequently to visit.

Daumier was recognized by these men, and by very few others, for what he was, a great artist. The rest of the world saw him as a cartoonist. He was a favorite in this circle, and, although quiet in gatherings, usually content to smoke his beloved pipe and to listen, he could hold his own in conversation. Baudelaire scornfully said that "With two or three exceptions, which need not be named, most artists are, it must be confessed, simply very clever animals, pure artisans, with the brains and intelligence of the village or hamlet," but from this sweeping condemnation he excepted Daumier. Baudelaire's admiration for the artist was deep and perceptive, and there can be little question that

his famous aphorism "One must be absolutely contemporary" was inspired partly by the practice of Daumier and by Daumier's own aesthetic aphorism, "One must be of one's own time." [10] It is a pity that Baudelaire, or some Boswell, made no record of these gatherings, that there was no one to note for posterity their gaiety and wit.

There were also the convivial gatherings at the Brasserie Andler, a café and social center at 28 Rue Hautefeuille, close to the Seine. Here every Thursday artists and writers met to eat, drink, and socialize. The leading spirit in these gatherings was the robust and hearty Courbet, a Falstaff of good cheer, drinking prowess, and sociability, a significant new painter rocking and shocking the bourgeoisie with his realistic canvases of stone-breakers, peasant funerals, and the like. His superb portrait of Madame Andler, *La Mère Grégoire*, now in the Chicago Art Institute, is his proper tribute to the hospitable café.

Among the habitués were Daumier and his friends Bonvin, Corot, Barye, Champfleury. Here was born in riotous and ribald discussion the Realist movement in nineteenth-century art. Courbet was its great program painter and rallying point, while Champfleury and Duranty were the chief publicists and propagandists. These unrestrained discussions contributed much to later lithographs in which Daumier at once laughed at Courbet's bombastic self-advertising and at the same time attacked Courbet's critics for their obtuseness. [11] After all, Courbet and these other men were his devoted friends, his admirers; they were, in a sense, his own pupils, for from his cartoons they had learned the basic lessons of the best realistic art, how to record actuality and how to transcend it.

All of this constituted Daumier's immediate, personal world. Within it he moved unobtrusively, observing, recording the sights of Paris in his amazing memory, puffing his pipe contentedly, and drinking, often deeply, wine and beer. As he himself said, with all this and with his art, anything more would have been superfluous.

IV

DAUMIER COMPLAINED BITTERLY about having "to pull the heavy cart," meaning his eight lithographs a month for *Charivari*. His friends all tried in various ways to help him. In later years they found some buyers for his paintings; they instructed him in the economics of art; and they found him jobs. One example of this concern is told by Théodore de Banville in connection with a woodcut for *Corsaire* in 1848. [12] Banville was still unknown, not yet having established his reputation as a writer of elegant light verse. Working on the staff of the satirical journal *Corsaire*, he was an admirer of Daumier but had not yet met him. The headstrip of *Corsaire*, designed some years earlier by Tony Johannot, had become so worn that it needed replacement. Banville proposed Daumier for the assignment. Virmaître, the editor, at first said no, regarding Daumier as a

"bloodthirsty savage," and sarcastically added, "You do well! You find great men as though it rained them, and geniuses cost you no more than they do your beloved Balzac, who sees them everywhere, even among the honorable society of porters."

Banville prevailed, however, and was authorized to ask Daumier to design a new headstrip for 100 francs. Never having met the artist, Banville set out in elation on his diplomatic errand. He found Daumier in his studio working over a stone, humming Kettly's round, "Happy dwellers in the beautiful Swiss valleys." The "profound stupidity" of the song seemed to intoxicate Daumier.

Banville explained his errand, apologizing for the 100-franc figure. Money, however, was not the reason for Daumier's immediate refusal. He simply did not want to draw such a design. He said that he was tired of making woodcuts and wanted no more of them; he could translate his thoughts only through the lithographic crayon, while the black lead would not obey him. Also, he had acquired a horror of woodcuts because nine times out of ten he was betrayed by the graver. Banville little heeded these excuses but urged Daumier to undertake the commission for him and for his colleagues, an ardent group of enthusiasts who would not be happy without something from the artist's hand. Daumier then spoke bluntly:

> Listen, there is nothing I wouldn't do to oblige you except this sketch, because, although it doesn't matter, it will inevitably be idiotic. What the devil do these allegories mean which have neither head nor tail? Do you think that a magazine is a ship and that a pirate is a writer? but, no matter how they interpret it, you always end up with the same banality: a journalist who writes with a cannon, or a soldier who fights with a pen. None of that. . . .

Having spoken, he hummed another round.

Banville persisted; Daumier again refused, going into yet another Kettly round. Then he explained to Banville,

> I work from morning to evening, because I have to, but basically I am lazier than a thousand snakes. And when I am busy at the daily chore to which I am condemned, then my laziness suggests to me the most astounding inventions. If you are bent on having the sketch, and if I am weak enough to promise it to you, you cannot imagine to what trickeries, what subtleties, what mean fictions I will resort to avoid keeping my word.

To which Banville replied,

> As for me, I will invent strategy against strategy, and then it will be like the heroes out of the *Iliad*.

DAUMIER: Then you will be more annoying than an editor?

BANVILLE: Precisely.

Daumier was dumfounded by Banville's reply and hummed yet another Kettly round. Eventually he yielded before Banville's persistence. From this

time on, Banville haunted Daumier's studio, and it turned out just as the artist had predicted. Daumier became more fertile with lies "than the industrious son of Laertes." For instance, he would maintain that the sketch was finished but needed a few more strokes and could not yet be shown; or, again, that he had a troublesome lithograph to finish but, that done, he would devote himself to the woodcut. "And the worthy, the good, the honest Daumier," said Banville, "became, thanks to my indiscretion, as fictive and inventive as a regiment of dentists!"

The end of this droll impasse came suddenly, unexpectedly. One day, before the surprised eyes of Banville, Daumier took out a fresh woodblock and in an hour, with Banville watching in charmed silence, Daumier improvised the sketch for *Corsaire*. It was, Banville said, "an absolute masterpiece." In the foreground of the pirate ship were the Robert Macaires, the lawyers, the corrupted, falling thunderstruck, cut in two, bowled over like puppets; and in the distance, on a quiet sea amidst a cloud of smoke, one could see the little brig whence had come the cannon shot which had struck down all these scoundrels.

Banville was delighted. He embraced Daumier with rapture, seized the sketch, and rushed to Virmaître's office, arriving out of breath and trembling. "Success," he said as he thrust the woodblock under the editor's glare. Virmaître disapproved. "Indeed, it is terrible, it says nothing. I would a hundred times prefer the pirate holding the pen, while his ship vomits fire from the portholes. I will not use that fabrication." Banville and his colleagues protested that Daumier's sketch was marvelous, but to no avail. Finally, pale with rage and humiliation, Banville said, "Since this sketch doesn't please you, let me have it. I will pay for it and keep it for myself." But Virmaître replied that having ordered it he would pay for it, and it disappeared into a drawer.

Daumier seemed calm over the rejection. "What," he asked Banville, "you are surprised over such things as this? My dear poet, to be certain of pleasing, wouldn't it be necessary to be a music box, a barley-sugar pipe, or a wax figure?" With this direct, but poetic, criticism of the taste of his time, Daumier dismissed the entire business.

This is the story as told by Banville, and it is unquestionably true in general. He may have slipped up in a detail or two; the following July 1848 letter from Banville to Daumier says,

> Sir and Friend, Will you ask M. *Lavoignat* to go as soon as possible to the *Corsaire* office, between noon and four o'clock? It is understood with the gentlemen, who will be delighted that your sketch will be engraved. . . . The sketch and the price are perfectly suitable and they are sending the payment to me tomorrow morning. I will bring you the money tomorrow evening, and thanks a thousand.

This indicates that the work had not disappeared in Virmaître's drawer, never to be seen again. Perhaps the solution to the seeming contradiction is that Vir-

maître had the block cut, a sketch run from it, and then rejected it from a proof
copy. (It must have been an excellent print, for Lavoignat was one of the best
cutters in the business. A painter as well, he was a good friend of Daumier,
who painted his portrait [National Gallery in Washington, Chester Dale
Collection].)

V

ABOUT DAUMIER'S FAMILY LIFE virtually nothing is known; certainly little has
been discovered about his wife. Married to a self-effacing man, she played an
equally self-effacing role. We get but fleeting glimpses of her through the
records, through some letters Daumier wrote to her one summer when she
went to the seaside on holiday, from a painting recently identified, and from a
photograph recently published.

The records are brief. Marie-Alexandrine d'Assy was born 22 February
1822, and so was fourteen years younger than her husband. Her father was a
glazier, which suggests that Jean-Baptiste Daumier had gone back to his trade
after the failure of his poetic attempts, or had at least sought the society of the
craft in Paris. At the time of her marriage to Daumier, Marie-Alexandrine d'Assy
was twenty-four years old, a dressmaker, living at 6 Rue du Portour-Saint
Gervais (then in the 9th, now in the 4th arrondissement).

Daumier and Marie-Alexandrine were married 16 April 1846, in a wedding
officially witnessed by the writer Dacier, the artist Philippe Bernard-Léon, and
Monsieur A. Soubeyron. Daumier's mother, then living at 8 Rue de l'Arbre-Sec,
attended the wedding. There is no record of the couple having any children. Six
months before Daumier's marriage, his young sister gave birth to an illegitimate
child named after him, but otherwise the name of Honoré Daumier is peculiar to
the painter.

Philippe Jones[13] has ingeniously suggested that "Didine," as Daumier called
his wife, was pictured by him in a *Charivari* lithograph, 21 July 1842 (D679),
showing a couple retiring to bed. The man says, "Well, my Didine, have we
danced enough?" She: "Don't speak of it; my legs are shoved up into my
body." He: "Then take off your stockings and get into bed." She: "Good grief,
no, I'm too bushed." Studying the lithographs closely, Jones dates the liaison
from 1839 because of the first appearance then (followed by many) of a young
woman with plain features, oval face, snub nose, small mouth, and finely arched
eyebrows, like the Didine of the 1842 lithograph. These prints are scarcely
court evidence, but undoubtedly the couple had known each other some time
before the official wedding in 1846.

The painting and the photograph of Madame Daumier have recently been
identified.[14] The canvas was in Dr. Gachet's collection at Auvers, and shows

Madame Daumier in her later years, corresponding to the photograph of her in widow's weeds sitting before the Valmondois house where her husband died. Both painting and photograph show a charming lady of fine features, smiling, her eyes alive with intelligence, a kind of advertiser's image of lovely old age.

On 6 August 1849 Daumier paid two francs to get a passport for travel within France.[15] Three days later, on Thursday, he and his wife and a Madame Muraire and her two children took the diligence for Langrune, a small Normandy town on the coast near Caen. They arrived on Friday. Settling his wife and the party in lodgings, Daumier then returned to Paris on Sunday. Next day he wrote to Didine assuring her of his safe return and informing her that he had visited her mother to report events. The letters which Daumier wrote to Didine during her holiday are erratic in spelling and punctuation but charming in their concern for her welfare, evidence of the deep attachment of husband and wife.

Either Daumier wrote few letters or very few have been preserved. Undoubtedly a number will turn up as private collections come into the market. But Daumier lived as a spectator and not as a participant; his friends were close to him and he had little occasion for formal writing. These notes to Didine make us regret his silence, since it is through the accumulation of such documents that the voice and presence of the actual man is best felt.

CHAPTER NINE

Daumier's Methods

So in detail they, the crowd, are beautiful.
WILLIAM CARLOS WILLIAMS
"At the Ball Game"

SO FAR WE HAVE COVERED but a few years of Daumier's prints, a large body of work but still only the beginning, a mere one-tenth of the total output. It would be well before proceeding further to comment on four of the familiar generalizations about Daumier as an artist: (1) "The works of . . . Daumier have justly been described as complementary to the *Comédie humaine*" of Balzac; (2) "This chap [Daumier] has Michelangelo in his system"; (3) Daumier's handling of light is Rembrandtesque; (4) "As an artist, what distinguishes Daumier is his sureness of touch."

The connection between Daumier and Balzac was made by their friend Champfleury, who said, "The crayon work of Daumier will remain as the finest painting of the bourgeoisie, with the *Comédie humaine* of M. de Balzac. The bourgeoisie have had in them two severe historians." [1] The connection lies in subject matter and their feeling toward it. They were only acquaintances, not close friends, traveling in different social and political circles. Each had an insatiable interest in Paris and her people. Balzac had early adopted his program: "French society was going to be the historian. I had only to be its secretary." Daumier shared the secretarial task.

Through both men the age has been preserved, transmitted. Daumier's immense assemblage of lithographs and woodcuts is matched in magnitude and detail by Balzac's library of stories; Daumier's graphic record of gesture and figure is equaled by Balzac's enormous catalogues of physical detail. Each has been termed a realist, but each was, as Focillon first pointed out, a visionary.

With each there is a feeling for life and a vastness of vision which carries and orders the multiplicity of things observed and recorded. Daumier gains in the comparison because of his unpretentiousness, his directness, his omission of the irrelevant, and because his work sprang from the daily cartoon assignment, the routine, rather than from a grandiose plan almost Rastignacian in calculation. If Daumier is, finally, more moving, it is perhaps because of quietness joined to power, in the efficiency by which he employed his means to achieve satiric and artistic ends. Both Daumier and Balzac saw, felt, and produced greatly. They did not imitate or influence each other in any important discernible way; their being linked together resulted from interesting coincidences and parallels.

The connection which critics make between Balzac and Daumier is one of subject matter and vision, primarily. Since, however, Daumier was a graphic artist, his relationship to Michelangelo and Rembrandt, which helped him to find his own style, and the very nature of that style, are matters of more importance. What, in other words, was Daumier's method, what was his manner?

It is interesting that it was Balzac who first noticed Daumier's mastery of form reminiscent of Michelangelo when he said, "This chap has Michelangelo in his system"; and years later, the painter Daubigny, visiting the Sistine Chapel, cried out, "Why this is Daumier!" Without doubt the manner of the great Italian master was imposed upon Daumier the art student by his first art preceptor, Alexandre Lenoir, whose admiration for Michelangelo was near idolatry. Lenoir must have set his pupil to copying the Louvre *Slave*, among other works, as well as his own collection of prints of the Italian masters. It would be possible to assert that small details such as the upraised arm, the bent knees—two of Daumier's favorite compositional gestures—were derived from Michelangelo, but what is more important is the general effect on Daumier of the greater artist's feeling for form—bones, muscle, and flesh—and of his monumentality. There are Daumier pencil sketches no more than two or three inches square which haunt the memory with their sense of vastness and grandeur.

Daumier's other master was Rembrandt,[2] from whom he learned much in the handling of light and the use of rich color. A vivid demonstration of this debt is in the watercolor, *The Butcher* (Fogg Museum, Harvard). As Bernard Lemann has shown, this painting (Plate 29) must have been done about 1857 when the Louvre acquired Rembrandt's magnificent large canvas, *The Side of Beef*. Few paintings in the world can compare with Rembrandt's masterpiece; Daumier's modest effort is indeed a humble, delicate echo, but its very quietness, simplicity, and directness have their own appeal.

The difference between Daumier and Rembrandt in their draftsmanship deserves mention. Both were, of course, masters. Rembrandt preferred to draw quiet scenes, in which the motion is less dynamic than in Daumier's work. His etching "Christ before the People" is a crowd scene, but the effect is quiet, or motion frozen. Daumier's crowd scenes seem almost to move before the eyes, in

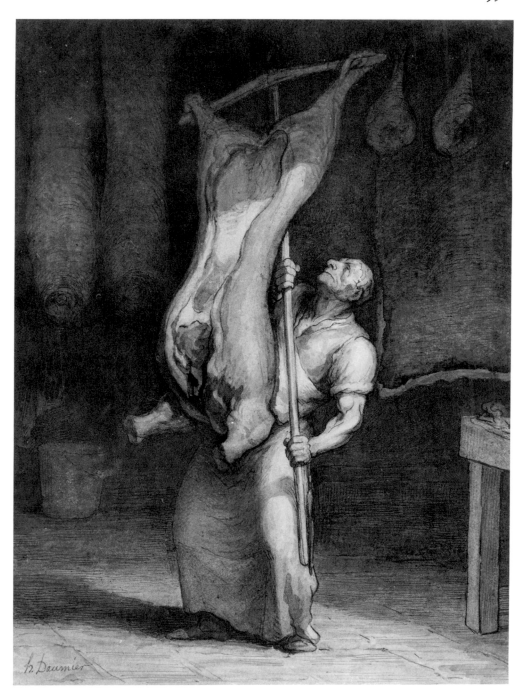

PLATE 29 *The Butcher*
Courtesy of the Fogg Art Museum, Harvard University,
Grenville L. Winthrop Bequest

strong rhythms. Rembrandt's line is brooding, suggesting inwardness, provoking contemplation; Daumier's is stabbing, energizing, dancing. Van Gogh included Daumier in his statement that "Some artists have a nervous hand at drawing, which gives their technique something of the sound peculiar to a violin, for instance." [3]

Other artistic origins have been suggested for Daumier. Certainly Rubens and the Dutch painters came to his attention significantly, as we shall see later. Adhémar has shown that the little-known Boilly taught Daumier much about drawing the human face, especially grimaces, and that Charlet, Raffet, and Grandville early taught him the art of lithography. Préault taught him sculpture. His good friends Huet, Cabat, and, above all, Jeanron painted in ways which Daumier approved, drew from materials which they all agreed were the proper concern of serious artists. Nevertheless, all these minor influences vanished early, leaving scarcely a trace as Daumier's vigorous personal style established itself. Daumier sloughed off his imitations early and completely; his style is his own.

What exactly are the secrets of Daumier's style? What is "Daumieresque"? It is the combination of movement, power, simplicity, and certainty. Certainty above all. Baudelaire saw this first and with finality: "As an artist, what distinguishes Daumier is his sureness of touch. He draws as the great masters draw." From a multiplicity of experiences and visual appearances he unerringly selected the significant detail, the appropriate and revealing gesture, cutting away irrelevance or idle decoration. "The right nose, the right brow, the right eye, the right foot, the right hand," Baudelaire said. Because he drew these selected details with such certainty and accuracy, some critics have carelessly labeled him a realist. If realism means fidelity to fact, then the term fits, but if it is *only* fidelity, then it is false. Drawing the *right* nose, the *right* brow, and so on, is beyond fidelity; it requires selection. Daumier was no camera; he was an artist, choosing carefully, enhancing, enlarging, and illuminating facts in a way program realism will not permit. He makes objects stand out in their intensity and their purity with an absolute quality noticed by Henry James, achieving "a certain simplification of the attitude or gesture [which has] an almost symbolic immensity. His persons represent only one thing, but they insist tremendously on that, and their expression of it abides with us, unaccompanied with timid detail. . . . Whatever he touches acquires relief and character."

Examples by the thousand illustrate this. A man out of funds stands in the snow staring hungrily into a restaurant window. It is comedy first of all, but it is also cold and hunger. A couple on vacation sit yawning in the living room as rain pours outside. They are bored, the picture is Boredom—but we are not bored, only delighted. Two old gaffers move down the street arguing, children play by the Seine, a poor family eats its evening soup—that is all, and it is enough; it is everything. Each of these sketches is simple, certain, and final.

Daumier's simplicity and certainty intensify his power. Lacking a formal education, he had learned about life from the streets, from experience. It is easily said that this is the best school, but it is not so to an imperceptive person. Daumier was one on whom nothing was lost. With his "quasi-divine" memory joined to his masterly draftsmanship, Daumier was better off without the fripperies of formal schooling, the kind of intellectual baggage which often tripped up Delacroix and Ingres (while, to be sure, often inspiring them). Learning directly, Daumier saw directly. What T. S. Eliot said of Blake applies equally well to Daumier:

> He was naked, and he saw man naked, and from the centre of his own crystal. . . . He approached everything with a mind unclouded by current opinions. There was nothing of the superior person about him. This makes him terrifying.

II

DAUMIER'S PRODUCTIVITY WAS ENORMOUS. Between 1836 and 1848 he drew more than 1,600 lithographs as well as hundreds of woodcuts. In forty-two years his total was 4,000 lithographs, an average of 95 a year; to this add 1,000 woodcuts, several hundred paintings, and some excellent sculpture. The output is staggering in quantity alone; it is also impressive in its quality. It was the work of a man who called himself "lazy." None of the work, however, bears any sign of slovenliness or haste. Even though he said that turning out eight plates a month was a wearying burden (likening himself to an old drayhorse pulling a cart), Daumier was always a conscientious artist, seeking ever to strengthen and subtilize his drawing, even if only in preparation for the anticipated day when he would be free to do nothing but paint. He never fell back on a facile formula.

Daumier did not make preliminary sketches for his prints. He waited until he knew what he wanted and then drew directly and rapidly on the stone. He composed in his head, never using a model but trusting to his memory. Models bothered him.[4] On one occasion he asked Daubigny where he might see some ducks to draw in a picture. Daubigny led him to a river where ducks were paddling about. After they had watched for a while, Daubigny asked Daumier whether he didn't want to make some sketches for reference. Daumier turned to him with a smile. "You know that I can't work from a model; I must do it from memory." It was by this method that Daumier screened actuality, eliminating the inessential and digressive—it was a system to ensure directness, purity, and certainty.

In his studio Daumier kept several stones ready. From time to time he would make a few strokes on one or another of them, using a stub of old grease crayon so short that it seemed almost like an extension of his fingers. Often he would seem to be doing nothing whatever. As he "loafed," his single sign of abstraction and concentration was his soft humming of music hall tunes. Then,

suddenly, he would go to one of the bare stones and in a short time draw a completely composed and carefully considered picture, all the preliminary selections and rejections of early drafts having taken place in his head. "Like a Chinese painter," wrote A. Hyatt Mayor, "Daumier must have had to sit still until the clearing of his inner eye discharged an accumulated energy into a few lines flowing deliberate and free."[5] These stones were not done frivolously; Daumier confessed that when he had finished a good stack of stones, he found it necessary to rest.[6] His studio was confusion with the litter of artists' gear, but from this came the order of his art.

Many people first making the acquaintance of Daumier's prints err in over-emphasizing the legends. Many of them were not written by him. It is safe to say that most of the longer ones were *not* his, although the ideas may frequently have been suggested by him. The terse, short legends of the later years which are often nothing but titles are unquestionably his. In any case, the legends have little real importance. Daumier generally composed his pictures around an idea, a scene, or a person; the suggestion might come from an editor, from his wife, or from his own experiences. His friends felt free to offer suggestions. Bousard, 18 September 1854, wrote:

> Papa Daumier, I have some times given you caricature subjects, here is a joke which was told me the other day, I thought that you might be able to do something good with it. A bourgeois carrying a melon under his arm jostles a gamin who says to him, "Take care there, Mr. Saint-Denis." I believe that the subject is worth fifteen centimes which the present will cost you.

The charge was of course facetious, ironically low, since Bousard was a wealthy man. Another letter, undated, from M. Camelou said:

> I suggest for the picturesque causticness of your crayon the following composition: An Auvergnat with bare feet wears on his shoulders a pair of water buckets and carries in his hand a basket of coal. Jehovah, white-bearded and covered with his old blue mantle, appears to him and tells him, in presenting to him some shoes in the form of monstrous feet: "You will earn your bread by the sweat of your feet."[7]

Even in Camelou's French the joke was no good, and Daumier did not take the suggestion.

When several stones were completed, Daumier would send them by messenger to the *Charivari* offices in the Rue du Croissant, a narrow street crowded with newspaper offices and printers' shops. The printer would run off several trial copies. One went to the editor, who was paid eight francs for writing an appropriate legend. Sometimes this editor had Daumier's scribbled suggestion to work from, often only the picture. *The Waters of Grenelle* (D915), a print from the Rosenwald Collection in the National Gallery in Washington, shows the fate of one picture in being transferred to newsprint (Plate 30). The joke-legend had been scribbled beneath Daumier's picture by an editor, who submitted it to

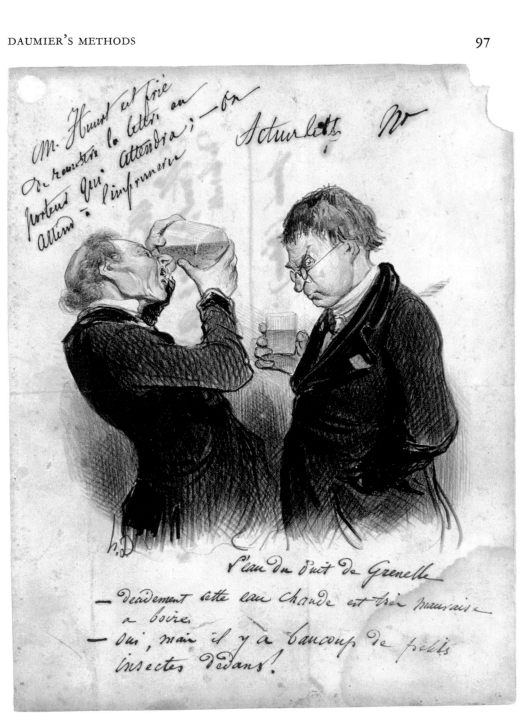

PLATE 30 *The Waters of Grenelle*
National Gallery of Art, Washington, D.C., Rosenwald Collection

the editor-in-chief with the following direction: "M. Huart is requested to return the proof by the messenger who will wait for it;—they are waiting for it at the printer's." On the proof of another print (D827) the puzzled caption writer penned, "I have written Daumier to send you the idea for this one, if he has so much as an idea!" On another the frantic editor scrawled, "What the devil does one write for this picture?" To appreciate the man's problem one has but to glance at many of the prints, imagining oneself in his place. What, for example, could be done with a beautiful print showing two men strolling in close conversation along the Seine—with no indications of any special "story"? These editors did the logical thing; they wrote a legend at once topical and witty, tied to some recent story in Paris such as the new comet, table-tapping, the tailor's bill, crinoline dresses, badgered parents. Stock themes and subjects recurred annually, and were always safe and sure comedy: bachelor fussiness, fighting husbands and wives, cuckoldry, the city man in the country, the provincial in Paris, drunks, high prices, and always the weather. To these eternal and universal situations the editors applied the eternal and universal jokes.

Another "before-the-letter" copy of the print would be sent to Daumier for his inspection. Having taken great care in composing his cartoon, he did not wish to have it botched in the printing. On one proof (D999) he wrote in protest, "My dear Dutacq, I do not understand why you should receive proofs so frightfully pulled as this; . . . in your and my interest, you should watch that the stones not be massacred in this fashion."

An artist and not a verbalist, Daumier in general cared little for the legends,[8] remarking, "If my drawing tells you nothing, it is bad; the legend won't make it any better. If it is good, you will understand everything unaided, and so what good is the legend?" On another occasion he told Duranty, "One does not draw a word, one draws a gesture, an expression."[9] Daumier, of course, was right. The legends dim with time and the pictures grow stronger. With several Daumier prints on the wall you can see the slow, steady diminution of the words and the contrary magnification of the compositions. This is the test which separates mere cartoons from works of art. There are very few jokes you return to the seventeenth time with increased pleasure; there are countless Daumier prints which give intensified and renewed delight.

III

CRITICISM BLANCHES before the task of describing 4,000 lithographs and 1,000 woodcuts. Space mercifully forbids it. To select specific prints for special discussion is to discriminate among masterpieces, but such favoritism is imposed on the biographer. It is perhaps most useful to select three or four of the main series, letting them serve as examples of the incredible wealth of social, narrative, ideological, comic, and aesthetic resources buried in the pages of *Charivari* and other periodicals.

The *Charivari* system was to have each artist carry along two or three series at a time, under such large titles as *The Happiest Days of One's Life*, *Bohemians of Paris*, *The Bathers*, or *Teachers and Students*. In this way each cartoonist was allowed great freedom while at the same time some coherence and coordination was imposed. Each series exploited the special talents of a particular artist. To Gavarni went the grisettes and the soft, sensuous boudoir scenes; to Cham was handed the immediately newsworthy; to Beaumont young love; to Daumier the lawyers. (Such a division tends to falsify the real latitude and the boundary-crossing which often took place.) The system also accorded with the then popular notion that everything in the world might be classified, pigeonholed, in the way the scientists were doing. Finally, the series system was commercially sound, allowing Aubert to gather an especially fine set into an album or portfolio, print it on good paper, and sell it in the shops to collectors. The works of Daumier published in this way are most satisfactory to get (it is assumed that "before-the-letter" copies are for the most part either in the great libraries, especially the Bibliothèque Nationale, or in the hands of rich collectors) since the impressions are finer and the paper is not underfaced by letterpress on the reverse side, as with the *Charivari* printings.

One point can scarcely be overemphasized. It is only from a long study of hundreds of prints, *seriatim*, that one comes to appreciate Daumier's genius in its full variety, power, and depth.[10] Fortunately, many American museums are well stocked with Daumier lithographs and they are also generous about showing them. Unfortunately, not many persons avail themselves of the chance to make this survey. Nevertheless, at a small cost anyone may own several Daumier prints, even the better ones, and in recent years portfolios of reproductions have been issued which faithfully reflect the originals.

Seen singly, seen quickly and casually—as the newspaper reader saw them in Daumier's day—the lithographs are funny, as most of them, until the last years, were meant to be. Seen closely, often, and reflectively, they are serious. Beneath their surface satire, or in that satire, they are serious comments on human life, and more important, they are serious as artistic forms. The comedy recedes before one's gaze like the smile of the Cheshire Cat before Alice. Without considering the paintings, both Baudelaire and Henry James called Daumier a serious artist, meaning that he had sketched into each print a feeling—for essential moral truth, for human life, for men and women in their repetitious daily rounds in the ant heap of Paris—which underlies and far transcends the caricatural jest. Daumier "had such a vision of the street as the street hardly understands"—a vision that made Paul Valéry conclude,

> The ensemble of his caricatures gives the impression of a dance of the morally and intellectually dead. All the professions, all the passions, all the innumerable forms of folly, of baseness, and of blackguardism are evoked by his crayon. All society is there, scoffed at as never before in pictures.[11]

CHAPTER TEN

The Great Series

of the 1840's

OBERT MACAIRE is a theme with variations. Though each plate of the 100 in the series is independent, each gains by relationship to the rest. Several of Daumier's groups have this unity, this closeness, in which a single, large, important comic point is repeatedly driven home. Others, on the contrary, are so loosely combined under a vague title that individual relationships to one another are lost.

A few of the coordinated series demonstrate the social and intellectual power as well as the comic genius of the modest, quiet Daumier, who, if he seemed mute at social gatherings, spoke forthrightly in his art. It may be argued that a set like *Robert Macaire* owes its intellectual structure to other minds, mainly Philipon's, but this point is met by the fact that the Daumier-Philipon association broke up in 1840 with Philipon's sale of *Charivari*, and by the more important point that Daumier never merely followed a hint—he personally expanded each idea, made it his own, and gave it plastic form. Taught by Philipon, Daumier had learned his skill in political and social satire. In *Charivari* Daumier was no puppet dutifully fulfilling orders. He was allowed wide latitude because the editors respected his insight and judgment. Indeed, Pierre Véron, his last editor, learned to accept Daumier's prints as they came in even if he often thought them too frank to meet the eye of the censor. *Charivari* consulted with Daumier; it did not dictate to him.

II

AT LEAST TWO OTHER SERIES among the 1840 cartoons merit as detailed consideration as *Robert Macaire*. The first is *Ancient History* (D925–975), Daumier's assault on the citadel of neoclassicism; the second is *Men of Justice* (D1337–1374), most coveted and most popular of all the Daumier series.

Baudelaire wrote, "In 1843, '44, '45, an immense interminable plague-cloud, which did not come from Egypt, settled over Paris. This cloud vomited forth the neo-classics which however were more effective than several legions of locusts." Baudelaire's "plague-cloud" perhaps referred to the public pleasure in the French archaeological discoveries brought in 1843 to the Louvre, but the cloud had had its beginnings earlier, in literature and art at any rate, with the increased popularity of Ingres and with the debut of Rachel, actress of classical roles of the French style. It had its origins ultimately in bourgeois taste, with its fondness for the conventional and the known, for the comforting and the unchallenging, for the Distant and the Past.[1] This taste for ancient and foreign things was not exclusive to one nation but was shared by the ruling bourgeoisie in England and in France—and in America, too, where Emerson attacked it in "Self-Reliance," and Thoreau said, "Ancient History has an air of antiquity. It should be modern." Daumier indeed made it modern.

Ancient History first appeared on 22 December 1841 and continued to January 1843. Its subject was the classic pantheon, its theme the folly of pastiche and imitation. The absurdity of Daumier's parade of Greek and Roman gods and heroes is in the tradition of Aristophanes and Scarron, through Shakespeare's *Troilus and Cressida,* and even akin to *The Boys from Syracuse.* Daumier's intentions were well described by *Charivari*:

> Vico said, and M. Edgar-Quinet after him: "In art as in philosophy, the true interpretation of the facts is not apparent to men until several centuries have elapsed." This austere and profound statement is eminently applicable to the plastic arts. The Greeks understood but one side of nearly all the heroes which they carved: the frigid elegance, the stiff nobility. The life, the movement, the intimacy —all that was completely lacking to them. Only Phidias touched lightly on these qualities, but after him statuary was impoverished, only restirring old fires, until at last it came to Apollo Belvedere, the stiffest, the silliest of all the white marble gods.
>
> Since then that statue has served as the traditional type; it has been agreed that one should always represent the bourgeoisie of Rome and Athens with spindly legs, knees without kneecaps, hairdressers' heads, and without any of the characteristics of life. This is called idealizing a hero; petrifying would have been more appropriate. Since then all modernists have had a horror of the Greeks and Romans. M. Ingres is the worthy interpreter of this oldish aspect of beauty. For the newish aspect, one is indebted to a gracious and strong talent, inspired and thoughtful, which has reforged the chain of living art broken with Phidias.

Thanks to Daumier, thanks to *Charivari*, which has encouraged him in his studious researches, this lack has been repaired. Ingres and Daumier, those Siamese twins of beauty, that medal of which Daumier is the face, these are the names which our century will proudly present to future generations who demand of it a whole genius.

Alone, without a scientific mission, Daumier has toured Greece, getting inspiration there where a lovely memory was associated, weeping wherever a touching tradition awaited him. Sketching night and day, he finally discovered the primitive Greek spirit of which we give the first proof in "Menelaus the Conqueror."

We realize that, as with all new translations, this chaste and naive composition will find more than one detractor. Perhaps some ignorant ones will reproach Helen for a certain gesture which, in our perverted civilization, signifies something other than modest remorse. Very well! This gesture is full of local color, and Daumier saw the descendants of the Hellenes perform it with a charming grace before a Bavarian monarch, a proof of the respectfulness which the gesture has always held in that poetic country.

To praise the martial appearance of Menelaus and all the nobility of this work, *Charivari* chooses to announce to its intelligent subscribers, and that means all of them, that mythology, *the golden age*, Greek and Roman history, in sum, all antiquity, will be just as faithfully translated by Daumier. A sublime collection, a superhuman monument, whose true title should be: *"The Heroic Age Disclosed."*

Exposure of the high and mighty was second nature to Daumier by now. Trained for this work on lesser men, when he had pilloried the heroes of *The Legislative Belly* in all their pettiness and their grossness—in their actuality, that is—now his imagination seized upon the great of antiquity, of myth, in *their* human imperfection. Homer had humanized the gods; Daumier may be said to have (in Melville's word) *dayalized* them. All men are mortal, even Socrates, and all heroes bear the same burden of imperfection.

As *Charivari* indicated in its announcement, the first lithograph represents the spirit of all fifty in the *Ancient History* series. "Menelaus the Conqueror" (D925) haughtily leads his recaptured Helen from burning Troy to the ship, but that eternal symbol of beauty is here an aging, dumpy hausfrau, lagging reluctantly behind him, thumbing her nose indelicately at her potbellied husband. The legend, from Bareste, describes Helen as "more beautiful than ever from modesty and love." Daumier mocks "the face which launched a thousand ships"—this one could well wreck those same ships (Plate 31).

Most of the Greek and Roman gods and goddesses and heroes have their turn on the stage. "Narcissus" (D947), a scrawny creature propped on his hands, stares lovingly into the pool at the image which should have frightened him (Plate 32). The defenders of Thermopylae (D926) returning from their triumph are sway-backed, big-bellied men reminiscent of a provincial veterans' parade, far from the Apollo Belvedere which *Charivari* said was the common nineteenth-century association with the ideal Greek figure and which was regularly

PLATE 31 *Menelaus the Conqueror*

PLATE 32 *Narcissus*
Museum of Fine Arts, Boston, Babcock Bequest

reproduced by David in his heroic paintings and by his follower Ingres. Rather, these troops might well have served with Falstaff at Shrewsbury. The beloved Odysseus (D938), returned to Ithaca, sleeps in his great bed while Penelope, no beauty, stares dotingly at her toothless, snoring hero. Knobbly-kneed Aeneas (D941) meets Dido in Hades, her plump bosom transfixed with the suicidal sword, probably Daumier's mockery of the rapturous lyricism of Berlioz' *Trojans*, just as Oedipus and the Sphinx (D967) is a parody of the famous 1808 painting by Ingres which had been a provoking factor in the Daumier-*Charivari* attack. Sappho (D973), reluctant to leap from her cliff, is shoved by her boy attendant. Similarly, all fifty of the series are satisfyingly and ceaselessly comical. It is worth noting that the essential reason these cartoons endure repeated study, yield increasing pleasure, lies not in their parodic gaiety but rather in the high quality of their draftsmanship. In "The Fall of Icarus" (D955), we see the peasant form of Daedalus, seated lower right, staring through his telescope at the distant Icarus, upper left, sprawling through space like a stuffed doll (Plate 33). There is, one muses, nothing inherently funny about such an event, but we nevertheless smile at the physiological deformations, smile too at the anomaly of the telescope. But after all this amusement, we retain the lithograph on our wall because of Daumier's superb handling of luminous space (opposed to the realistic bodies) and not because of the intended and successful journalistic joke. Description fumbles the humor and the acknowledged artistry of these pictures.

Accompanying each picture as legend is a quotation from some classic or neoclassic text, so that some of the comedy lies in the dissonance between text and picture, rhetoric against reality. In "Minos" (D974), the legend is comic self-reference:

> Happy the pale human who in this black refuge
> Arrives when Minos is reading *Charivari*;
> He is certain to be absolved, for everyone knows that any judge
> Is disarmed when he has laughed.

The most penetrating contemporary comment on *Ancient History* was written by Baudelaire in 1857:

> The *Histoire ancienne* seems to me to be important because it is, so to say, the best paraphrase of the famous line *"Qui nous délivrera des Grecs et des Romains?"* [Who will deliver us from the Greeks and the Romans?] Daumier came down brutally on antiquity—on false antiquity, that is, for no one has a better feeling than he for the grandeurs of antiquity. He snapped his fingers at it. The hot-headed Achilles, the cunning Ulysses . . . they all of them, in fact, appear before our eyes in a farcical ugliness which is reminiscent of those decrepit old tragic actors whom one sometimes sees taking a pinch of snuff in the wings. It was a very amusing bit of blasphemy, and one which had its usefulness. I remember a lyric poet of my acquaintance—one

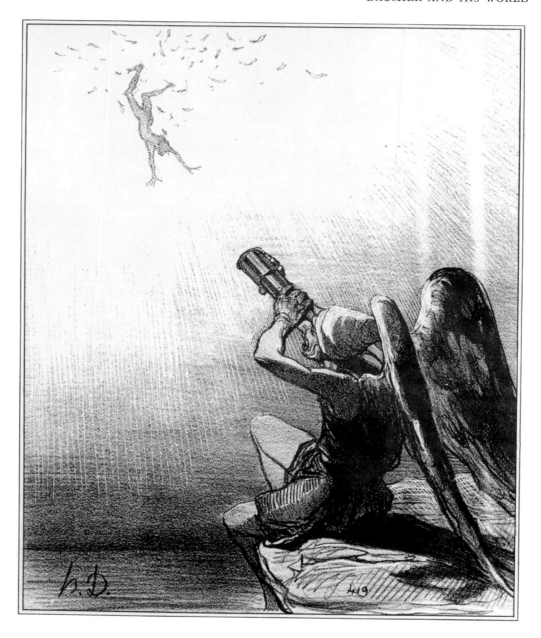

PLATE 33 *The Fall of Icarus*
Museum of Fine Arts, Boston, Babcock Bequest

of the "pagan school"—being deeply indignant at it. He called it sacrilege, and spoke of the fair Helen as others speak of the Blessed Virgin. But those who have no great respect for Olympus, or for tragedy, were naturally beside themselves with delight.[2]

Over forty years after *Ancient History* was printed it was mentioned in the *Goncourt Journal* (17 April 1888) with admiration as a model of special and necessary satire.

"One must be of one's own time." Daumier's dictum seems obvious enough today, perhaps, but it ran against the current of both European and American mid-nineteenth-century taste. David, head of the classic school in France, wrote to one of his pupils, 22 June 1820, "Hurry, hurry my good friend, if you don't have your Plutarch yet, and choose a subject known to everyone; that is important." It is exactly what he had done in *The Rape of the Sabines*, or in *Brutus and His Sons*, or in the other enormous canvases now in the Louvre, magnificent exercises of a genius but paintings which we regret when in the same museum we come across his *Self-Portrait* (what is more contemporary, less "known to everyone" than that?), a small canvas which catches the eye and the heart and remains in the memory as an example of what a great artist can do when he forgets his own classicist program and paints for himself, of himself. David's most distinguished follower, Ingres, target of the *Charivari* attack for more than two decades, was creating brilliant, dead paintings like *The Apotheosis of Homer*, but was unwittingly assuring himself a firmer place in the affection of posterity by his truly great portraits of his contemporaries, such as the well-known *Monsieur Bertin* in the Louvre. Even Delacroix was led astray by his education and painted the historical and literary past and the contemporary far and distant; but he succeeded in spite of his subjects, finally enchanting modern critics with his less pretentious work, such as the watercolors, or the Chopin portrait, or his self-portrait. Curiously, the "great" artists (i.e., well known in their own day) have proved great in the memory of men mainly to the extent that they observed Daumier's dictum, "One must be of one's own time."

Deriding the middle-class prejudice for classical myth as mere love of ornament—architectural, theatrical, literary—and as little more than intellectual souvenir hunting, Daumier well remembered Angélique's words in Molière's *Imaginary Invalid*, "The ancients, sir, were ancients, and we are people of today." Tradition is to be respected but not idolized. Ortega y Gasset wrote,

> There is only one way to dominate the past, the realm of things that have perished: to open our veins and inject some of our blood into the empty veins of the dead. This is what the reactionary cannot do: treat the past as a form of life. He pulls it out of the sphere of vitality, and, thoroughly dead as it is, he places it on its throne so that it may rule over our souls.

Even before *Ancient History*, Daumier had in several prints attacked the threatening "plague-cloud" of classic legends. These cartoons place Daumier

PLATE 34 *Phèdre: "Mon cher, mes javelots"*

in the midst of the noisy battle then raging between Romanticism and classicism. Romanticism had of course temporarily won the day when in 1830 Victor Hugo's *Hernani* had triumphantly survived the noisy fights which disturbed its opening. But the victory of Romanticism, cause of the young, liberal intellectuals, was only momentary. Romantic turbulence scarcely soothed the tired banker or the businessman, who preferred the confections of Scribe and Ponsard, or the neoclassic dramas of Corneille and Racine which he had known all his life. Surcease for the bourgeoisie came in 1838 when a new actress, the young Rachel, revitalized the old classics of the French drama, animating the lines all Frenchmen had learned in their lycées. Daumier made of Rachel's success the occasion to ridicule the absurdity of ancient forms, including costumes, piously retained in an industrial society. In *Faces from the Tragic Drama* (D900–904), in 1841, he sketched scenes from these plays, realistically drawing the too-human actors and actresses spouting their fine phrases (Plate 34). The tubby little tenor playing the stalwart hero always provokes a smile from the critical spectator. *Charivari*, 28 June 1843, in connection with Daumier's tragic theater cartoons, said:

Daumier has long felt the need to lend his support to the resurrection of tragedy: toward this end he has sketched the handsomest characters and the most beautiful scenes from the classic theater. The ancient expression has never been shoved farther than in these portraits where relive the beloved features of the Greek and Roman heroes. Before this album, the reaction started by Mademoiselle Rachel was incomplete; Daumier can claim the glory of fulfilling it.

The last stage in the struggle of Romanticism against neoclassicism came in 1843 when Victor Hugo's Romantic sword-and-cloak drama *Les Burgraves* failed completely while the neoclassic play by Ponsard, *Lucrèce*, won a great success. Daumier drew a print (D1004) of Hugo before the Théâtre Français, staring upward at a falling star (Plate 35). The legend beneath says, "Hugo, viewing the heavenly vaults of the Lord, asks why the stars above have their queues when the Burgraves have none?" In another print (D1010), he showed Lucrèce, a tall stately matron, distaff in hand, moving solemnly forward while the little Burgraves of Romantic drama flee before her in rout. The legend reads, "In our time, Lucrèce, by the happiest Fate you have broken the cruel shackles. Not content merely with spinning her distaff, she has sent the old Burgraves a-scurrying." From this moment Romanticism in the theater held a minor place; Hugo himself turned to fiction for a creative outlet.

Daumier returned from time to time to the absurdities of the classic theater, but his most amusing, even rambunctious, attack on neoclassicism came in 1852 when Ponsard's *Ulysses* was successfully presented at the Théâtre Français. It was a music drama, the score by Charles Gounod, the orchestra conducted by Jacques Offenbach (who later composed *La Belle Hélène*), and was one of the most charming and lightest of all spoofs of classic myth. The story told of Ulysses' return to Ithaca and his meeting with old Eumaus, Penelope, and the suitors. At once Daumier combined with Louis Huart in a rollicking parody called *Ulysses, or the Pigs Revenged, a scrambled-singing-tragedy, but notwithstanding written in verse, or approximately, and dedicated to the butchers. Words translated from Ponsard by Huart. Costumes designed by Daumier.* First printed in *Charivari*, the burlesque was then put out in book form and was so successful that it went into a second printing almost immediately. In their version the pigs act as the chorus, and in Daumier's woodcuts (B774–785) his Greek heroes are, as in *Ancient History*, unbeautiful real people in ancient robes, modern actors trying to wear Greek robes. The parody indicates that Huart and Daumier had a lot of fun. It was not the artist's last attack on the fake-heroic.

Baudelaire insisted on the seeming paradox that Daumier was truly classic, and he was of course right. Daumier's virtues are the classical ones. His art is economical, clear, powerful, and direct. He arranged his forms in patterns honored by previous masters. Degas told George Moore, "If you were to show a Daumier to Raphael he would admire it, he would take off his hat, but if you were to show him a Cabanel he would say, with a sigh, 'that is my fault.'"[3]

PLATE 35 *Hugo and the Heavenly Vaults*

III

FOR DAUMIER the caricatural climax of the 1840's was *Men of Justice* (D1337–1374; March 1845–October 1848), his most popular, most sought after, and most reproduced cartoon sequence.[4] Narcissistically, it has always been a favorite among the lawyers themselves. Daumier was not the first to satirize the law nor would he be the last, since the law has always been fair game for caricaturists, verbal or graphic, from Juvenal, Chaucer and Rabelais, Molière and Shakespeare, to Dickens and Shaw, Forain and Gropper. Daumier's inspiration in his mockery of the court, outside of firsthand experience, was his beloved Molière, whose words in *That Scoundrel Scapin* furnish a summary legend to all of Daumier's many prints and paintings of lawyers.

> Think of the devious ways of the law, the appeals to higher courts, the wearisome procedure, the swarms of rapacious creatures who'll get their claws into you—serjeants, attorneys, counsellors, substitutes and remembrancers, judges and clerks! Any of these gentry is capable of knocking the bottom out of the best case in the world, for the merest trifle. A bailiff can serve a forged writ and you'll be sunk without knowing a word about it. Your attorney may come to terms with the other side, and sell you out for ready money. Your counsel may be bribed so that he's not there when he's wanted, or if he is there, he may get up and blather and never come to the point. The registrar may issue writs against you for contumacy. The recorder's clerk may purloin your documents, or the recorder himself refuse to record what he ought to record. And if you use every possible precaution and get by all this, you'll find the judges have been got at and turned against you by bigots or women. Oh, my good sir, if you can at all, keep out of that sort of purgatory! It's hell on earth to be mixed up with the law—the very idea of a lawsuit would make me pack up and fly to the ends of the earth.[5]

Daumier's deep dislike of legal entanglement, critics have said, dated back to boyhood when as a messenger boy for the attorneys he had reluctantly served their imperious commands, storing up antagonism and hatred which were later to find an outlet in his art. He had other and more recent reasons for his dislike, however. For his print of "Gargantua" he had suffered trial, fine, and imprisonment. In 1841 the bailiffs had seized his household goods and sold them at public auction. He had little reason to love legal action.

But Daumier had an aesthetic reason for drawing the lawyers in his lithographs, and, later, in his paintings: they played into his talent for handling contrasts of black and white, of chiaroscuro. The law courts in the Palace of Justice are gray and somber; the costumes of the lawyers are black, relieved by white. Thus they allowed rhythmic patterns in the prints similar to those he had composed in *The Legislative Belly*. The sheer physical reality was as congenial to Daumier's artistic sense as was the subject to his satiric intelligence. The very medium is here part of the meaning. As Valéry wrote, "But how black and white

sometimes penetrate the soul more deeply than painting and how a work reduced to the play of light and shade touches us more profoundly than the whole palette—this I cannot satisfactorily explain." [6]

There was also an intellectual, a philosophical, reason for Daumier to attack the lawyers. The Glorious Revolution of 1830 had brought them to power. This Philipon saw as early as 3 February 1831, when he wrote in *Caricature*, "the government is the 'smooth talkers';.we are governed by lawyers." An instrument in control of the few, protecting their rights, the law discriminated against the unpropertied many, the poor. The law had given the powerful middle class security which revolutions could shake but not topple, and had furnished it with a solid foundation of sanctified contracts and title deeds. As the manipulator of these contracts, the lawyer was, as Fournel said, "the king of the epoch."

Daumier's roving, relentless eye caught the lawyers in thirty-seven different situations and impaled them in thirty-seven prints for this series. Whatever one says about them in general, however, applies also to the hundreds of similar prints which Daumier untiringly turned out during the decades to follow. And above all, such comments apply to the frightening and beautiful legal paintings of the 1850's and 1860's when, the comedy muted, the lawyers are shown in mysterious lights and colors like the lower circles of the Inferno, and the legal profession is shown as Molière described it, "hell on earth." In *Men of Justice* the tragic and the horrible are concealed and the comedy is predominant, but it is surprising, on study, how few real changes Daumier had to make when he moved from his cartoon study of the law to his canvases.

Daumier gave his genius freely to the prints, which offered the legend writer a feast. The jests beneath the pictures are generally amusing and undoubtedly their sardonic and cynical nature faithfully reflects Daumier's point of view as well as *Charivari*'s. But the final inutility of the legend is shown in the greatest of the series, which carries as a title simply, "The Great Staircase of the Palace of Justice" (D1372). Everything is said implicitly, in graphic terms. The setting of the picture had long been familiar to Daumier, who lived within five minutes of the courts; it was described superbly by Balzac in *César Birotteau*:

> Few persons have noticed the majesty of that stairway, admirably placed as it is to produce a solemn effect. It rises, beyond the outer peristyle which adorns the courtyard of the Palace, from the center of the gallery leading, at one end, to the vast hall of the Pas Perdus [Hall of Lost Causes], and at the other to the Sainte-Chapelle— the architectural monuments which make all the imposing edifices in their neighborhood seem paltry. The church of Saint-Louis is among the most imposing buildings in Paris, and the approach to it through this long gallery is at once somber and romantic. The great hall of the Pas Perdus, on the other hand, presents at the other end of the gallery a broad space of light; it is impossible to forget that the history of France is linked to those walls. The stairway should therefore be imposing in character; and, in point of fact, it is neither dwarfed nor crushed by the architectural

splendors on either side of it. Possibly the mind is sobered by a glimpse, caught through the rich gratings, of the Place of the Palace of Justice, where so many sentences have been executed. The staircase opens above into an enormous space, or antechamber, leading to the hall where the court holds its public sittings.

In Daumier's print (Plate 36), two lawyers are descending these stairs: Age looming large in front, arrogant and ruthless and experienced, followed by Youth, the newcomer to the law, who is as proud and pompous as his elder, but also somewhat silly. In the upper left-hand corner, a small figure mounting the stairs neatly balances the composition. The picture is as hard as granite in its satire, and moving in its certainty, in its compositional simplicity and perfection. It is one of Daumier's finest achievements; turned out for *Charivari* readers, it was supposedly, like most newspaper cartoons, to be soon forgotten.[7] Baudelaire was right, Parisians did not know that a great artist was working for them.

The high point of Daumier's pictorial treatment of lawyers, however, is the large number of watercolors and oils, frequently reproduced, that he painted during the years 1852–70. To the unique and characteristic draftsmanship are added the delights of color and light—once again the word is "Rembrandtian"— with which Daumier bathed his characters, a sinister refulgence as realistic as one of his lithographs and yet as romantic as a Delacroix painting of a scene from Dante. Universally popular and universally acclaimed, these oils and water-colors received their first and perhaps finest praise from the *Goncourt Journal*, 15 March 1865:

> I saw the other day in passing along the Rue Taitbout some terrifying water-colours by Daumier.
> These represent the inner circles of the law, the lawyers' meetings, the parade of the judges in the somber depths of the gray enclosure, lit by the daylight from a judge's chamber, by the grim light from the corridor of the Palace of Justice.
> It is washed with China ink, sinister and of a funereal black. The heads are fright-ful, with grimaces and with laughs which terrify. These black men have, I know not how, the ugliness of those horrible antique masks in a clerk's office. The smiling advocates take on a corybantic appearance. There is something of the satyr in those macabre lawyers.[8]

Men of Justice began on 28 March 1845 and continued to October 1848, eight months after the 1848 revolution and almost four months after the revolutionary victory had been hopelessly compromised by the wrangling of the lawyers in the Provisional Assembly who were preparing the new, and absurd, Constitu-tion. With the Republic in grave danger, Daumier could have found no reason to dilute the density and bitterness of his commentary on the law. If anything, the satire intensified as the great series moved to its conclusion. "Let the world see," Daumier seems to say. Beneath their beautiful flowing robes these were,

PLATE 36 *The Great Stairway of the Palace of Justice*

alas, but mere men, corrupted by the power placed in their hands, made selfish and unprincipled by the property and wealth they controlled. Expose them to the nation under the searchlight of satire and there might be hope for reform. It was a desperate hope, and Daumier still had sufficient faith in human institutions to fight for his ideals.

But even before the blunders of the Provisional Government in the spring and summer of 1848, legal corruption had made headlines throughout France. There was the scandal of Monsieur Teste, a one-time minister but now President of the Court of Cassation. In May 1847 he was charged with receiving a bribe of 94,000 francs for granting a salt mine concession. Found guilty, he was condemned to three years in prison and loss of civil rights. The Teste case shocked France; *Charivari* particularly saw the scandal as an example of the decay rotting the pillars of the Juste-Milieu. Daumier's legal series, then, had special timeliness—the lawyers were imitating his prints.

The corruption exposed among the lawyers was found to be equally present in 1847 in the aristocracy; its pillars were also rotten. In August, a peer of the realm, the Duc de Choiseul-Praslin, brutally murdered his wife at the instigation of his mistress. With memories of 1789 to prompt them, a crowd surrounded the Duc's house to prevent his escape. Subsequently he took arsenic and died before he could be brought to trial. Other scandals followed immediately. Comte Mortier in a fit of madness tried to kill his children, and Prince d'Eckmuhl stabbed one of his mistresses. These dramatic events made it clear to Frenchmen that the law, the military (for General Cubières, former Minister of War, had been implicated in the Teste case), and the aristocracy were tainted.

Clearly the House of Orléans was tottering, but its head could not admit its potential collapse. Lamartine warned Louis-Philippe, "If royalty continues to act as it has, instead of revolutions of liberty followed by counterrevolutions of glory, you will find that you may have the revolution of the public conscience and the revolution of contempt." To such threats, Thiers jeeringly answered, "A revolution! It is very clear that you don't know the government and its power. I know it; it has ten times more strength than any troubles which could possibly erupt." And when Tocqueville asked the Prime Minister, Guizot, "Do you not feel that a breath of revolution is in the air, that there is a storm on the horizon, and that it is advancing toward you?", Guizot could only answer stubbornly that neither he nor the King saw cause for concern.

Sensitive to political and social events, Daumier's reaction to this turbulence was strikingly prophetic. Champfleury records, 30 June 1847:

> Last Sunday I was talking with one of the strongest men of these times, you will be surprised, I mean Daumier, a caricaturist; he tells me that the Rue Saint-Denis is disturbed. If the bourgeoisie participate, the business is serious, for they are the royalty of today.[9]

The political sensitivity suggested by Champfleury's anecdote perhaps raises the vexing question of Daumier's precise political position. This is not to be found in verbal statements but is implicit throughout his art. As a satirist he jeered and jabbed at all subjects, friends and foes alike being victims. In general, of course, his sympathies lay with the "people," he himself being quite clearly one of them, separated from them only (but how powerful that "only") by his art. He was, like a good satirist, sharply critical of "the lie of Authority" (Auden's phrase), pillorying the men of privilege and position. His spectator role, as against partisanship, was shown in his amused report to Jeanron from Sainte-Pélagie prison, when he watched with interest and amusement the feverish demonstrations of both camps, Left and Right, without himself participating. There is no evidence that he was an active party man, but many of his friends were active and there is every reason to view Daumier as sympathetic to the liberal causes even if he failed to carry a gun or to man the barricades in 1848 and 1871— although he may have done so in 1830. Who knows?

As Daumier feared, but also perhaps hoped, the bourgeois intransigence, demonstrated in the protest banquets held throughout France and now announced for Paris, provoked trouble to the extent, surprisingly, of sudden revolution. Ironically it was bourgeois protest to their bourgeois King which was responsible for the Republican return to power. *Charivari*, 16 February 1848, incisively criticized the government, which had permitted sixty banquets elsewhere but now feared the Paris banquet as a menace to public safety. It was the ban and not the banquet which set off the explosion. When the National Guard, stronghold of middle-class power, rebelled against the commands of its King, his regime collapsed in classic conformity to the oldest of clichés—like a pack of cards.

CHAPTER ELEVEN

The 1848 Revolution

UNPLANNED AND UNEXPECTED, like most revolutions, the 1848 revolution erupted rather than evolved.[1] With hindsight the historian neatly charts causal relations and routes events in an apparently inevitable sequence, but the men and women who live through them are always unready and must proceed from the chaos and infinite multiplicity of the immediate conditions.

The troubles in France came to a head when the bourgeois liberals called for a large banquet to be held in Paris on 22 February 1848. An alarmed government banned the meeting. Republican newspapers called for a protest procession for the same date, but this too was banned. Nevertheless, on that day crowds gathered in the streets and proceeded toward the Tuileries. Soldiers blocked the way. Feelings flared and heated words were exchanged. Suddenly a shot rang out, followed immediately by a volley from the soldiers' rifles. Soon the street was littered with wounded and dying citizens. That night the protestants loaded fifteen of the dead onto a wagon to be carried about the streets in a menacing torchlight procession designed to stir up the citizens of Paris. Rebellion if not revolution was in full cry. Early the next day Louis-Philippe dismissed Guizot, but it was too late to placate an aroused people. "Why," said one worker, "should he merely substitute one scoundrel for another?" But it was the failure of the National Guard—the militia founded by the middle class—to fight against their fellow citizens which convinced the King

that all was lost. After fruitless discussions he abdicated in favor of the Comte de Paris, and fled with his family by coach to the Channel, then to England.

Crowds stormed the National Assembly on the morning of 28 February, where Lamartine, chairman of the moment, subdued them by his eloquence and by the announcement that a provisional government was in the process of formation, adding, "In the name of the French people, monarchy of every form is abolished without possibility of return."

A second cycle of political cartooning began for Daumier. On 2 March 1848 the government, for the moment a blend of all parties, decreed, "All condemnations for political and press offenses are annulled," and six days later it confirmed what everyone had assumed—"The September Laws of 1835 are abolished." These declarations were made official when the new Constitution was adopted in November. Now after thirteen years of strict censorship the French press once again burst into unrestricted speech; new journals were created and the old established periodicals roused to new life. During the days of the 1848 revolution *Charivari* had reported the turbulent events with obvious excitement and anticipation, but the paper was unable to print appropriate lithographs (which had of course to be made days in advance of deadlines) to cover the news, so it resorted to woodcuts from regular stock or to new ones hastily and crudely designed for the moment—none of them by Daumier.

Daumier's first political cartoon in this new aura of freedom was "The Gamin in the Tuileries" (D1743; 4 March 1848). It was a scene from the revolution itself. More than 60,000 persons had converged upon the Palace of the Tuileries to celebrate the flight of the King. Surprisingly and creditably, very little looting took place, but the crowd lined up to take turns sitting on the royal throne—after all, they, the people, were now the rulers. Flaubert described the scene in *The Sentimental Education*:

> They entered an apartment in which a dais of red velvet rose as far as the ceiling. On the throne below sat a representative of the proletariat in effigy with a black beard, his shirt gaping open, a jolly air, and the stupid look of a baboon. Others climbed to sit in his place.

One of the "others" was Daumier's friend Champfleury, who recorded, "Seated on the throne I smoked my pipe, one of the first."[2] Daumier, too, may perhaps have taken his turn.

"The Gamin in the Tuileries" (Plate 37) shows an adolescent in military garb, with "the stupid look of a baboon," slumped deep in the throne, crying out to the crowd, "Christ! how one sinks." The picture was fact, the comedy symbolic. Now, says Daumier in effect, the Throne belongs to the people; there they are seated, and thus they rule. Formerly the Throne had "sunk" the people, but now it has just sunk its recent royal occupant. The people themselves, being no longer sunk by the Throne, are at last at liberty to sink into

PLATE 37 *The Gamin in the Tuileries*

it and enjoy it. The play of ideas implied in the print is tellingly made by Daumier's draftsmanship.

Daumier's second celebration of the revolution, "The Last Council of the Ministers" (D1746; 9 March 1848), is purely symbolic, patriotic sentiment. Marianne, or France, with the Phrygian cap of the Republic on her head, enters the council room in a radiant light. The terrified and surprised ministers, Thiers among them, tumble over one another in trying to flee through the window. Dividing the picture into two triangles, Daumier places the jumbled politicians, like tangled serpents, in dark crayon on the left, in contrast to the openness and spaciousness of the upper right with the single luminous figure of the Republic (Plate 38). It is an excellent icon of the revolution, and although it lacks the color and bravura of Delacroix's *Liberty at the Barricades*, chief memorial of the 1830 revolution, it serves well as a political celebration. "The Last Council of the Ministers" greatly impressed the historian Michelet, who wrote to Daumier:

> I recall another sketch in which you made clear even to the simplest the right of the Republic. She enters her house; she finds the thieves at the table who fall over backwards. She has the power and the authority of the *Mistress of the house*. There she and her rights are defined for all. She alone is *at home* in France.

II

As for his former foe, Louis-Philippe, Daumier displayed a decent restraint.[3] *Charivari* asked him for some cartoons directed against the erstwhile monarch, but he protested: "They want me to satirize Louis-Philippe, and I don't want to do it." He was right and *Charivari* was wrong. A good satirist does not flog a dead horse; he deals with living issues and with large principles rather than with petty personalities—if he is, like Daumier, generous. Philipon held the same opinion as his old friend when he wrote in his new *Petit Journal pour rire*, 11 March 1848, "We like Papa Louis-Philippe, as is known, but he is no longer to be feared, and we blush to see mud thrown at him." Daumier summed it all up, saying, "The business is finished. He has had his accounting."

Nevertheless, Daumier did draw three cartoons about the flight of the King, which if particular in reference have also a largeness and a force, almost a pity, that absolve them of pettiness.

The first of the three (D1744; 7 March 1848) shows us fear in a handful of dust as the aged King, umbrella in hand, steps from a gangplank to the safety of English soil. Beneath his arm is a cashbox. The apt and allusive legend reads, "All is lost—save the cashbox" (Plate 39). No Frenchman could miss the reference. Three hundred years before, Francis I had cried, "All is lost save honor," and the phrase had become an undying catchword. During the 1830's, the celebrated clown-mime Odry, in a sketch called *Les Saltimbanques* (*The Clowns*, or *The Acrobats*) had twisted the line to "All is lost except the cashbox," which was

PLATE 38 *The Last Council of the Ministers*

then a satiric jab at Louis-Philippe's and France's loss of honor in not going to
the aid of beleaguered Poland. *Charivari* had used Odry's adaptation as late as
16 August 1845, associating it with fleeing monarchs, a prophetic anticipation
which Daumier, or one of his editors, now made use of. Writing in 1845,
Charivari had said,

> The superb exclamation of Bilboquet . . . *"let us save the cashbox!"* will henceforth
> be the refrain of all great political men misunderstood by their compatriots who are
> compelled to seek refuge in a foreign land and a stone pillow for their head—a

PLATE 39 *All Is Lost—Save the Cashbox*

tough lot indeed. When these unfortunates write to their friends about their cross-ing or flight, they will inevitably begin their letter saying, "All is lost, except the cashbox." It will ever be a bit of a solace.

The equation of the King's honor with a cashbox was lethal. A phrase once heroic in the mouth of a king is in time parodied by a clown. Through the cartoonist the phrase becomes once again the phrase of a king who has been a mountebank. The meaning compressed in Daumier's lithograph is caustic.

Less intricate, perhaps, but equally savage, and even better as a summation

of the entire Juste-Milieu ("Enrich yourselves") was Daumier's second carica-ture (D1745) of Louis-Philippe. It is in the form of a large coin, or medal, bearing the dewlapped profile of the King. Frequently during his reign, Louis-Philippe had had medals and coins struck off bearing his image. Now it was Daumier's privilege to present him with the last medal which his grateful country could bestow: the five-franc piece, fit emblem of the Best of Republics, of the Macaireism rampant during eighteen years of (to Republican eyes) mis-rule, of a society which Balzac's Vautrin said "no longer worships the true God, but the Golden Calf! That is the reign of your Charter, which bases politics on property only. Isn't that as much as to say to the subjects of your king: enrich yourselves?"

Daumier's third print (D1749) was unpublished during his lifetime. It is simple and sober. No legend was written for it, nor was one needed. Louis-Philippe and Guizot, both exiled in England, gloomily regard each other, reflecting on the whirligig of Fate. It was Daumier's last twist of the knife; its nonpublication may perhaps have been the result of his own request.

III

"IT IS DIFFICULT," wrote Rilke, "to walk in the mire of Liberty." France was to find this out in the next three years. Proudhon, a radical theorist, said that he regarded the 1848 revolution with horror because nobody was ready for the problems which it created. Working with Philipon on *Caricature* and *Charivari*, Daumier had documented the degradation of revolutionary idealism between 1831 and 1835. Now, separated from Philipon and working with different editors, Daumier saw and drew another degradation of revolutionary idealism, when with different actors but greater ineptitude a democracy fumbled its political opportunities in the fierce struggle of power factions motivated by ignoble passions rather than by genuine idealism. Between 1848 and 1852, from Lamartine's provisional assembly to the coup d'état of Louis-Napoleon, Daumier saw and described the great disintegration.

For a brief period Republican hopes were high that an enduring Republic could be constituted which would guarantee universal suffrage for men and which would institute basic reforms to wipe out the gross inequities then pre-vailing. Ironically, the chief obstacle between the Republicans and their objec-tive was the bourgeoisie, the very class which had provoked the revolution and had brought the Republic into being. The middle-class leaders became alarmed at the monster they had uncaged. The timid grocer and the small businessman soon longed for the security they had had when Papa Louis-Philippe had run the country for his children. These bourgeois preferred injustice to disorder.

As has happened before and since, the middle-class *rentier* created the specter of Red Riot, of the red menace. Daumier mocked these middle-class

PLATE 40 *The Dangerous Children*

tremblers in a number of prints, especially in the series entitled *Alarms and Alarmists* (D1761–1767; 7 April–7 June 1848).[4] To their apprehensive eyes every bush seems a bear. Children playing soldiers and marching with wooden swords (D1762) terrify an elderly couple into precipitous flight (Plate 40). In another print (D1761) the lighting of the lamps suggests to a jittery female that Paris has been set on fire by the anarchists. Flaubert, probably using Daumier's

lithographs as source material for his fiction, described these Parisians in *The Sentimental Education*:

> There was again Socialism! Although these theories, as new as the game of goose, had been discussed sufficiently for forty years to fill a number of libraries, they terrified the wealthier citizens. . . . Then Property rose in their regard to the level of Religion, and was confounded with God. The attacks made on it appeared to them sacrilege; almost a species of cannibalism. In spite of the most humane legislation that ever existed, the spectre of '93 reappeared, and the chopper of the guillotine vibrated in every syllable of the word "Republic," which did not prevent them from despising its weakness.

Gibing at this timidity, *Charivari* praised Daumier's cartoons on these milquetoasts, saying, 15 July 1848, "Daumier believed that he had killed the alarmists, but he flattered himself overmuch. Our caricaturist's sketches have not yet been able to effect the disappearance from Paris of the creatures who delight in the most horrifying news."

Around such situations, from such events, on such themes, and in such a climate of feeling, Daumier drew some of his most memorable and attractive prints. We see those prints first in terms of their contents, their comedy and wit, their social satire, but none of this topicality should keep us from appreciating the artistry of the sketches. Daumier's skill is brought strongly to one's attention by a comparative study of cartoons of the same events by other cartoonists in France; against such a foil Daumier's skill shows fiery off indeed. Glance at Gustave Doré's cartoons on the identical subjects, printed in Philipon's *Petit Journal pour rire*, to see how Daumier's draftsmanship gives transcendence to what would otherwise be ordinary, evanescent.

IV

DAUMIER'S SATIRIC AND ARTISTIC GIFTS are remarkably blended in the lithographs he now composed bearing on the subject of the new woman. The 1848 revolution gave flame to feminist hopes. Daumier had already pilloried the intellectual and reformist female in *The Blue Stockings*, the brilliant and always popular series (D1221–1260) which had run in *Charivari* from January to August 1844 (Plate 41). The subject then had been the feminist movement, which had gained considerable headway in France during the 1840's, just as it did elsewhere, in England and the United States especially. Because of *The Blue Stockings* Daumier has been charged with an unsympathetic attitude toward women, a notion which is refuted by paintings like *The Laundress* or *The Third Class Carriage*. Such a charge ignores the strategy of satire, which is to mock and not to praise. If any attitude emerges which may be defined as Daumier's, it is a dislike of the antifeminine woman, the enthusiast, a natural target for the satirist's laughter.

PLATE 41 *The Blue Stockings*

Daumier was admittedly conservative, but he was one with his newspaper, for
Charivari reported with frequent and satiric glee the accounts of the "emancipa-
tion for women" meetings held during 1848, accounts which, corroborated by
other newspaper versions, bear lively witness to the turbulence and, often, the
absurdity of their sessions.

Daumier now caught the feminists in their political activities as he had
previously shown them in their cultural aspirations.[5] In one of the best (D1769)

PLATE 42 *The Divorcées*

of his new series, *The Divorcées*, he shows a woman (Jeanne Derain?) addressing a meeting (Plate 42). She leans far over the podium, her right arm dramatically extended outward to make an impassioned rhetorical point. The women below crowd tumultuously around the stage, stirred by her words. The dramatic triangle of figures, caught in sharp slanting lines, captures the confusion and

disorder which characterized those feminist rallies, faithfully reported and laughed at in the columns of *Charivari*, where Daumier's pictures were appearing. The speaker cries out, "Citizens, the rumor is spreading that divorce will be denied to us . . . let us unite here and now to declare that *La Patrie* is in danger." The composition of this cartoon, often praised and reproduced, is rendered all the more impressive when one compares it with another print on the same subject, which appeared in *Charivari* at almost the same time, by Daumier's colleague Beaumont. Although both compositions are basically the same, the softness of Beaumont's tones and the more delicate strokes of the crayon combine to produce a roomful of delicate, seductive ladies more like kittens than like the frenetic females described by contemporary journalists and drawn by Daumier.

Prints like these were, however, child's play for Daumier, who had thrown himself into a new career—painting.

CHAPTER TWELVE

Daumier's Emergence

as a Painter

RTISTIC AS WELL AS POLITICAL FREEDOM flowered
in France as a result of the 1848 revolution. To a man like
Daumier, at odds with academicism in the arts as well as with re-
action in politics, the opportunity had come to try to break into
the circle of painters, now to be judged by new and liberal critics.

And yet Daumier had always been a painter. As a young
man studying painting under Lenoir and others, he had had a
professional career in mind. As a cartoonist serving on the staff of Charles
Philipon he had struggled to keep up a painting career; and in the 1840's he
remained active at his easel even though the greater part of his energy was con-
sumed by the *Charivari* contract. It had been a disheartening struggle, for before
1848 no entry of his had been selected by the Salon, and he had apparently made
no sales except for that early painting, the sign which he and Jeanron had painted
for a midwife.[1] No surviving painting with a date before 1848 may with
certainty be ascribed to Daumier.

The search for information about the early years of Daumier as a painter has
yielded thin results to students, but there can be no question that Daumier
struggled along, thinking of himself as a painter. (When he became a prisoner
in August 1832 at Sainte-Pélagie prison he was listed as a "painter.") This is
reflected, too, in some of the lithographs of a serious nature which he printed
between 1831 and 1835, genre studies which may have been black and white
versions of unsold paintings in his studio.[2] *Caricature* of 9 October 1834
printed an advertisement for a Daumier watercolor entitled *The Village Cabaret*.

We also know that Daumier was connected with an art community formed by Meissonier, who enlisted Steinheil, Trimolet, Daubigny, and the sculptor Geoffroy-Dechaume, as well as Daumier, to agree formally, each initialing the agreement, to support one of their membership for a time sufficient in which to create at least one elevated work of art.[3] The group was held together by a shared conviction that "art should be the great moralizing influence of society." The first lot fell to Trimolet, who then painted *Sisters of Charity Distributing Soup to the Poor*, which won the 1839 Salon gold medal but was not sold and brought him no commissions.[4] Steinheil and Daubigny had their turns next, but the community scheme collapsed before Daumier's chance came round.

Daumier's sardonic comment about the lack of success of artists in the Juste-Milieu, or at any other time, is found in his *Charivari* print (D146; 6 May 1833) showing a studio, with unlit stove, in which two artists are dancing to keep warm. The caption reads, "Wood is expensive but the arts aren't doing so well." *Charivari* went on to say, "M. Daumier reveals in this sketch the state of the arts under our beloved monarch: miserable and abandoned."

From 1835 until 1848, Daumier was probably no less busy trying to break into the world of "serious art," but records are completely lacking. The Ile Saint-Louis circle of friends, which included most of the earlier group (except for Meissonier, who had gone on to great popularity), still held exalted views about the place of art in life. They believed that art was more than mere ornament, that it should be a means of cultivating the best instincts of mankind. Such faith was far from the Bohemianism commonly associated with the advanced French art circles of the 1840's.

These artists, Daumier among them, were active in art propaganda. Their chief target was the restrictive Salon, which tended to accept paintings only of certain types or by certain name painters. Clément de Ris expressed their views late in 1847 in a stinging pamphlet, *Concerning Tyranny in the Arts and the New Examining Jury for Works Presented at the 1847 Salon*. Meeting at the Hôtel de Pimodan, Ary Scheffer, Decamps, Dupré, Delacroix, Barye, Jeanron, Charles Jacques, Théodore Rousseau, and Daumier discussed the conservatism of the Salon and recommended the election of an independent, unrestricted Salon. Early in February 1848 preparations were made for just such a free Salon. This never took place because the February revolution brought these very men to power, giving them control of the official Salon, which had already opened; they immediately changed and freed it in accordance with their beliefs.

The reopening of the official Salon in this free manner must be largely credited to Jeanron. During the three days of rioting and revolution, he had made it his duty to guard the treasures of the Louvre, to see that the crowds did not loot the building. With the revolution achieved, Jeanron was made Director of the Louvre, and he set himself the task of announcing the new freedom,

accepting and hanging the flood of paintings submitted, and opening the Salon with as little delay as possible. It was a come-one-come-all exhibition. *Charivari* reported that many of the best artists had withheld or withdrawn their work in annoyance at this overdose of freedom, not wishing to have their work hanging side by side with that of any Sunday dauber. The newspaper insisted that nevertheless there was as much good work in the freed Salon as there had been in the judged one, that the visitor might see, for example, fine paintings by Corot and Delacroix, and that Jeanron had included some of his own freshest and best work.

Having won a considerable victory for freedom in art, the same group of liberals, led this time by Barye, Diaz, and Couture, petitioned the provisional government to see that all officials whose direct activities concerned the fine arts should be chosen by a general assembly of the artists themselves. Lamartine agreed to this and an association of artists was formed. Decamps chaired the weekly meetings of the special committee on painting, of which Daumier was a member.[5]

The first step in the provisional assembly's encouragement of art, and in the celebration of France's formation as a Republic, was a nationwide competition for an image, either painting or sculpture, of the Republic, to replace the portrait of Louis-Philippe in the Hôtel de Ville and to serve as a symbol of the new state. The competition requirements were simple and clear: a composition of one main figure, with attitudes and gestures left to the inclination of the artist. Twenty prizes were to be awarded, and from these prize winners a final screening would take place.

Courbet and Bonvin, Daumier's friends at the Brasserie Andler, urged him to submit an entry. He agreed to try, and worked on his sketch during early spring. It was hung with those of 900 competitors at an exhibition opening 27 April 1848 at the Ecole des Beaux-Arts. The showing attracted large crowds but the critics roundly condemned it. Of the twenty sketches selected, Daumier's canvas, number 361, was eleventh. No first prize was ever offered. Maybe aesthetic distaste stopped the competition, but one suspects that Cavaignac's cannon killed the project as surely as it killed many of the rioters the following June in the streets of Paris.

Daumier's sketch of *The Republic* was of course only a preliminary study (Plate 43). Thanks to Moreau-Nélaton, it was preserved and later given to the Louvre, where it now hangs. Appropriate to its abstract subject, "The Republic Nourishes and Instructs Her Children," the central figure is simple, strong, and large in conception though small in size. The Republic is represented as a stately female seated majestically on a kind of throne, clutching the tricolor in her right hand. Two naked children lean forward to suck from her generous breasts, while a third sits at her feet reading a book. She is modeled in Daumier's sculpturesque manner and has magnitude. She also has mystery, owing to the

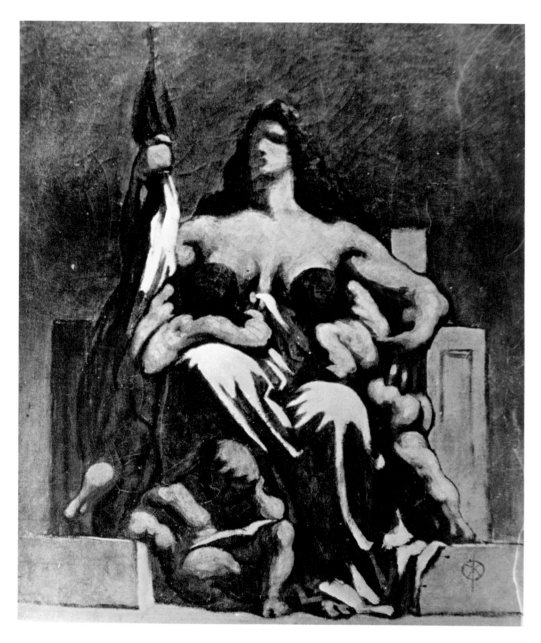

PLATE 43 *The Republic*
Photo Bulloz

somber, mysterious light from the low-color palette Daumier here employed. The figures are carefully grouped in a pyramid. The nearest "source" for Daumier's structure is Andrea del Sarto's *Charity* in the Louvre, which Daumier certainly knew, but Andrea's Madonna is an insipid, pretty weakling compared with the heroic Marianne. As a matter of fact, Daumier had already drawn a picture like this for the wall of a room in one of his early lithographs.

Although Daumier claimed that allegory was distasteful to him, here he mastered his disinclination by giving physical solidity to the figures—there they are, living, no matter what they are supposed to "represent." Also, for this assignment Daumier had to draw an inactive figure; he had to stress *stillness*, although all of his practice, and indeed his talent, lay in the depiction of action realistically recorded. It is no special wonder, then, considering these two difficulties, that Daumier never finished the work but left only this preliminary study. Sketch or not, it merits its honored place in the Louvre.

The critics thought the competition a failure. *L'Artiste* flatly described it as a mess. But in the midst of the general condemnation there were words of praise for Daumier. Champfleury singled out *The Republic* as being "simple, serious, and modest," and a proof that "Daumier can stand with Delacroix, Ingres, and Corot, the only masters of the present French school." He also noted sarcastically that this sketch was necessary, if for no other reason, to show Frenchmen real greatness, because "not more than fifteen people had had the insight to perceive it in the caricatures—although it was there for the beholding."

Against the serene majesty of *The Republic* must be placed the dramatic power of *The Uprising* in the Phillips Memorial Gallery in Washington. No one knows when it was painted; the subject allows a wide nomination of possible dates, from the Glorious Revolution of 1830, the 1848 revolution, the bloody days of June 1848, and the coup d'état of 1851, to the holocaust of the 1871 Commune.[6] To each and all of these events *The Uprising* serves as an appropriate memorial (Plate 44). Its universal and timeless applications are, of course, obvious. Not all critics fully accept the canvas as Daumier's, mainly, it seems, because the picture does not appear in the Champfleury catalogue of the 1878 Daumier exhibition. However, it would take strong evidence, or arguments, to counteract the judgment of critics as eloquent as Focillon and Mather regarding the genuineness of this work, and it would take even stronger evidence to counteract that provided by the canvas itself. Remembering, as we must, that many of Daumier's canvases were unfinished at the time of his death and that hack artists finished them for the market, one may perhaps explain uncertainty about this work, in any of its details, as being aroused by a few incidental touches possibly from some second and later hand. Certainly as a whole and in most of its parts, *The Uprising* is Daumier's work; it is in fact among his masterpieces.

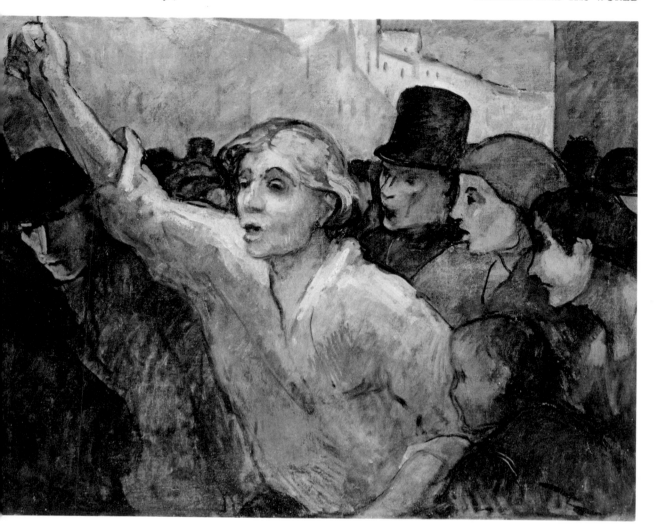

PLATE 44 *The Uprising*
The Phillips Collection, Washington, D.C.

Any other attribution must produce an artist with the painting genius, even the style, of Daumier himself. Duncan Phillips has vividly described the painting:

Daumier's "The Uprising" is not only one of the greatest paintings of the 19th century but of all time. The titanic genius of its plastic power is worthy of comparison with the Michelangelo of the brooding Jeremiah. It reveals a wild, magnetic John the Baptist of a man, following his remote vision while a hypnotized crowd follows him. He has a scholar's brow and a dreamer's eyes but his open mouth shouts violent words, or sings a marching song. Daumier's parables were never literary, never allegorical. All the meaning is contained compactly within the dyna-

mics of the design. In "L'Emeute" the surging torrent of the people is constructed in a thrusting wedge. Yet what is universally symbolic in the theme required for its composition the containing corners, the vertical mass of the dark wall at the upper right and the balancing and buttressing dark shadows at the lower left. Thus we have not a fragment of a dramatic film but a symbol of all pent up indignation. The arm of the leader is stretched out dynamically to his clenched fist. There the long street of old houses seems to fall back as the people move forward. The molten, volcanic tone and the rough-hewn drawing and modelling, bearing down only on the crucial contours, this is as it had to be, the only possible equivalent in paint for a malleable, evolutionary world. . . .

The leader of Daumier's revolution is the eternal nomad of the questing spirit. Blind to the immediate consequences of his words and acts, haunted by the future, he is the anonymous standard bearer of innumerable battles without name. And he is pure fire. The followers, so sketchily yet so revealingly indicated, are like fluttering moths fatally attracted to the magnetic flame. It was nothing less than genius for the artist to carry to a most vivid realization the leader's spent body and fascinating face, leaving the crowd in suggestive outline. Those people are the waves of self rule, of self reliance, the epic movement in the history of freedom.[7]

Far better than Meissonier's pedestrian *Barricades*, painted for the 1848 revolution, Daumier's *The Uprising* serves as the graphic symbol for the birth agonies of the Second Republic.

Although Daumier was apparently unprepared to send any pictures to the revised Salon of 1848, he was nevertheless ready in 1849 with a fresh painting, evidence of the strengthened and revitalized interest in his career as artist. This canvas was *The Miller, His Sons, and the Donkey*. La Fontaine's familiar fable served him more as stimulus than as source, for his painting is scarcely a mere illustration for the poem. The miller, his sons, and the donkey are simply three shadowy figures far in the background, scarcely seen because of the three dancing, buxom women who happily dominate the picture. One of them carries a basket of fruit on her head, a symbol of fertility. The lush lyricism of the color and the line startle the student accustomed solely or primarily to the black and white lithographs or to the low-keyed tones of most of Daumier's better-known oils. A writer in *Charivari* said, 1 July 1849, "H. Daumier, whom you believe to be only an amusing caricaturist, has made an excursion into the land of Rubens and of La Fontaine which places him in the rank of our best painters."

The gaiety of the painting suggests a symbolic meaning: that the dancing women are celebrating the arrival of Republican government, and the disappearing figures in the rear of the canvas are figures from the recent political years, the donkey even being allowed, for a fleeting moment, to represent, say, Louis-Philippe.

Similar in tone, even more under the influence of Rubens, was Daumier's next painting, a gouache, *The Drunkenness of Silenus* (Calais Museum). The same joyousness is seen in the fleeing women and the pursuing satyrs, all in a kind of

sexual exuberance which expresses the general delight of Daumier and his friends over the turn of political events.

The gouache was favorably received. It later interested the Goncourts, who had Trichon do a large woodcut of it for their magazine. More immediately, Champfleury, now acting as art critic for *Charivari*, described Daumier as "a talent of the first order, a superior man who has just come to the brush for the first time." And although one literal-minded commentator might pointlessly quibble, said Champfleury, that Daumier had interpreted La Fontaine "too freely" in the first painting, he felt rather that "Daumier was born forceful. He creates, and continues without wishing to linger over the caresses of form." In a second review Champfleury summed up his personal opinion by saying (*Charivari*, 22 July 1849), "Henceforth Daumier is of the family of masters. Let him not trouble himself too much about the old masterpieces, let him search within himself, and he will produce some good painting." These words were both friendly and prophetic.

Holding an official connection with the government in power, in which even some of his loyal friends served, Daumier was in line for one of the many commissions being assigned to painters and artists.[8] Jeanron used his influence to arrange an assignment, and in September 1848 Charles Blanc, Director of Fine Arts, addressed "Citizen Daumier, painter" as follows:

> I have the honor to announce that the Minister of the Interior has commissioned you to execute, at the expense of his Department and for approximately one thousand francs, a Picture of which you should submit [first] a subject and also a sketch for the approval of the administration.

A few months later, 10 February 1849, Charles Blanc wrote again to Daumier to tell him that the price had been increased to 1,500 francs and to urge him to submit his subject and sketch.

Daumier's subject was *Magdalene in the Desert*. Presumably he responded soon with the sketch now remaining, for he was then paid half of his fee, and in May the second half of the fee was paid although Daumier had not yet begun work on the full-scale painting. On 17 May 1850 and again on 24 July he was promising to deliver the finished work by the following September. But the painting lingered as an unfulfilled promise, although the original oil sketch has survived and is now in a private collection. Daumier also received an official command to paint a portrait of Adolphe Crémieux, who was Minister of Justice from 24 February to 7 June 1848 as well as a lawyer for *Charivari*, but this commission too seems never to have been completed.[9]

Daumier continued to paint, although with the election of a new Assembly and with the resurgence of important political problems and fears he was forced to draw his lithographs with the old frequency. He was able to send two paintings and a drawing to the Salon of 1851. *Don Quixote at the Wedding Party*

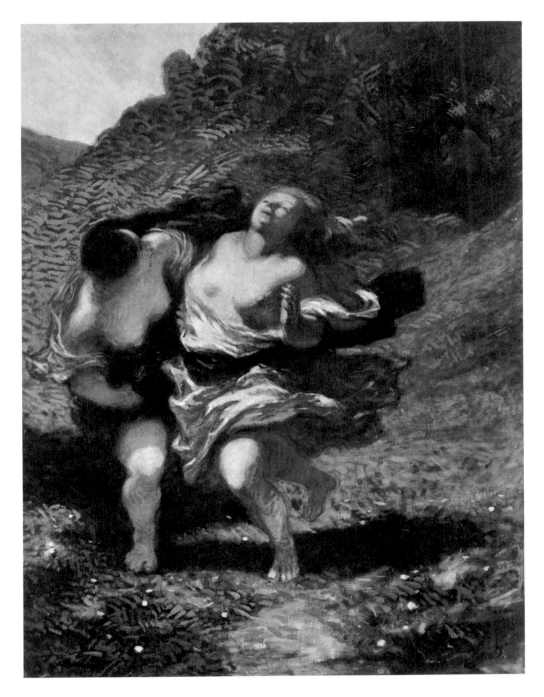

PLATE 45 *Nymphs Pursued by Satyrs*
Bequest of Miss Adaline Van Horne, 1945, Collection The Montreal Museum of Fine Arts

has disappeared, but the second canvas, *Nymphs Pursued by Satyrs* (Plate 45), attracted favorable attention; the painter Claude Vignon wrote that "The efforts of Daumier are too remarkable not to be warmly encouraged."

From this period on for almost all the rest of his life Daumier would continue to paint, even though for much·of this time he would be tied to the eight lithographs a month for *Charivari*. During the 1850's there were to be the studies of lawyers and the butcher paintings, among others, until in the 1860's Daumier was to achieve a few great works.

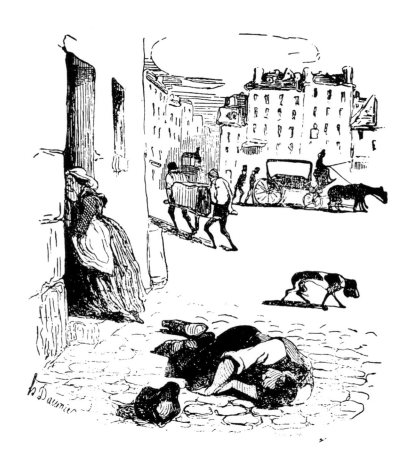

CHAPTER THIRTEEN

Ratapoil and Napoleonism

VENTS WOULD NOT ALLOW Daumier to paint in peace. The political sky had darkened fast, and *Charivari* needed all of his political insight and satiric power to attack the new royal danger to the Republic. Louis-Napoleon now took the center of the stage, and Daumier, this time unaided by Philipon, exposed the peril with the same verve which he had shown in his fight against Louis-Philippe.[1]

During the spring of 1848 the Provisional Assembly, a congress of all the political parties, had tried ineffectually to meet the acute unemployment crisis caused by the influx from the provinces of workers hoping somehow to profit from the new deal. The failure of Louis Blanc's National Workshops to deal with the economic situation provoked the workless men to riots. The provisional government met this danger decisively, ordering Cavaignac, military director of Paris, to repress the rebellion. He ordered out the cannon to fire on the half-starved rioters. The fighting lasted for three days, 23 to 26 June, killing 400 men; with 3,000 subsequently imprisoned, exiled, or executed, the rebellion was crushed. It was a sanguinary, Pyrrhic victory for the forces of order, because genuine social reform became impossible in the open division between the masses and the middle-class assemblymen.

The cannon had restored order in the streets; in a few months order in government was restored by a new Constitution, a paradoxical document which guaranteed the death of the Republic it was designed to preserve. By containing the government within a single chamber and by allotting the chief power to a

president while limiting his office to but one term of three years, this Constitu-
tion was an open invitation to a coup d'état and a dictatorship. The Duc de
Broglie called it a "work which drew back the limits of human stupidity," while
Thiers described it as "the most foolish, absurd, and impractical of all those
which have governed France." Both were right, as events soon proved.

After the new Constitution, a new Assembly. This time it was not a prostitu-
ted one, but merely stupid. Remembering his great portrait series sixteen years
before, Daumier now created a series on the parliamentarians of the Second
Republic. *The Representatives Represented* (D1796–1885; November 1848–August
1850) differed from its great predecessor by being more journalistic and less
artistic. Daumier prepared no maquettes to be used as models; now his crayon
had a mastery enabling him to rely on memory rather than on model. He drew
the heads of his sitters carefully but placed these heads on small bodies, decora-
ting many of the prints with symbols appropriate to the subject. Victor Hugo
(D1861), for example, is shown with his gleaming baldish head inclined in pro-
found thought, poetically "possessed," while his small torso and legs stand on a
large stack of his own books. Daumier seems to imply that Hugo was not
politically "possessed," that he operated from literature rather than from
political reality. The entire series of parliamentarians and its more anecdotal
sequel, *Faces of the Assembly* (D1947–1977; October 1849–February 1851), con-
stitute a fine record of a forgotten regime, but they suffer from comparison with
Daumier's portraiture of the prostituted Assembly sixteen years before, and the
two series lack a single, concentrated masterpiece like *The Legislative Belly* to lift
them from the confines of journalism into the realm of art. Within those con-
fines, however, they display many fine comic strokes.

Working fast and prolifically now,[2] after the idle (lithographically) months
of 1848, Daumier drew yet another series counterpointing the littleness of the
assemblymen against their supposed greatness. *Parliamentary Idylls* (D2050–
2065; September 1850–February 1851) exposes the mighty ministers in the guise
of fauns and satyrs, gamboling away the hours while the Republic was rapidly
approaching the brink of ruin. This is *Ancient History* reversed, modern men in
classic settings. These little creatures fiddling while Paris burned are gay and
completely trivial.

II

THE CONSTITUTION WAS ABSURD, the statesmen unstatesmanly. A third subject,
involving the other two, now became dominant in Daumier's cartoons: the presi-
dential campaign and the President himself. The career of Louis-Napoleon Bona-
parte, nephew of the great Emperor, became the chief concern of Republicans
in France, and furnished a narrative continuity to Daumier's prints from 1849
to 1851. The success of this careerist was, as John Stuart Mill once said, "one

of the most striking instances in history of the power of a name." It is a phe-
nomenon worth close study. Daumier versus Louis-Philippe has received much
attention; an equal interest attaches to the struggle of Daumier versus Louis-
Napoleon.

"France," Lord Roseberry once observed, "in chill moments of disaster . . .
will turn and warm herself at the glories of Napoleon," a criticism which is
perhaps a variation of Heine's observation that the name of Napoleon was a
point d'honneur with Frenchmen, who, "apart from all republican peculiarities,
are by nature altogether Bonapartist."

Briefly, the Napoleonic myth, or Napoleonism, holds that Napoleon Bona-
parte was the savior of France, bringing her to glorious heights of military, polit-
ical, and social achievement, and that only the opposition of wicked men
prevented him from achieving liberal reforms and installing genuine republican
institutions in France. "If only Napoleon were back again! I remember. . . ."
The myth was planted by Napoleon himself at Saint Helena, where, concerned
for his historic reputation, he wrote and gave interviews reiterating these points.
By the time of his death the myth was well started and ready for expansion,
and, eventually, for political exploitation.

During the 1820's, under the Restoration, Napoleonism flourished, given
body by the memories of Napoleon's veterans, by the paintings of David, Gros,
and Vernet, by the lithographs of Charlet and Raffet, by the popular songs of
Béranger, and by the incantatory repetition of emotive words like *gloire*,
honneur, *patrie*, and *L'Empereur*. During the 1830's Louis-Philippe would have
been happy to see the legend fade, but was forced to go along with it. He hoped,
however, by homeopathic means to cure the fever. Consequently he placed
Napoleon's statue on the Vendôme column. For this Daumier made a little
woodcut showing a Napoleonic veteran staring at the monument, hand over
heart, saying, "Ah! what pride in being a Frenchman—while looking at the
column." A few years later Louis-Philippe, again yielding to pressure, had the
body of Napoleon brought back to France, to "the banks of the Seine to rest
among the people I so well loved." It was a great day for the French when in
1840, with elaborate pomp and ceremony, the body of Napoleon Bonaparte was
interred in the Invalides.

III

UNTIL 1848, HOWEVER, the cult of Napoleonism was a harmless memorial, a
patriotic sentiment, the melodious name of Napoleon an affecting magical
abracadabra. Napoleonism did not become politically dangerous until Louis-
Napoleon, exiled in England, found the chance to exploit his name in his
advance to power. Persistent, he had tried twice to "invade" France, but each
expedition was an ignominious failure, a comic-opera parody of a comic opera,

which made him seem a clown rather than a threat. On one landing, he had
tied to the mast of his ship a Napoleonic "eagle"—the bird was really a vulture—
a symbolically interesting variation which Daumier and other cartoonists did
not miss. When Louis-Napoleon was finally allowed into France, after the 1848
revolution, Daumier's "The Napoleonic Channel Boat" (D1754) showed him
seated, in his uncle's cocked hat, being towed across the channel by a vulture.

But, curiously, Louis-Napoleon's failures were perhaps his shrewdest suc-
cesses. By encouraging the clown image, he disarmed the people, causing them
to feel he was harmless and malleable. Returning to France in 1848, he maneu-
vered cunningly among the various political groups, employing bribe, threat,
innuendo, and promise to win men to his side. In person he seemed ineffectual.
One critic called him a "melancholy parrot," and many were taken in by the
awkward, unprepossessing, mumbling man with a comic moustache and a magic
name. Royalists, Ultra-Catholics, and moderate Republicans alike saw him as a
cat's-paw and gave him their support. "They thought he would be a tool,"
Tocqueville wrote, "and a tool that they could break. The folly of clever men
is wonderful." Even such a cunning strategist as Thiers thought that here was a
puppet of which he could be the master. Ever the enemy of Thiers, Daumier
drew several cartoons of this strutting little man in his Warwickian role of king-
maker. Daumier documented "the folly of clever men" in their push for power.
Both Victor Hugo, now editor of *L'Evénement*, and Emile Girardin, editor of
La Presse, are shown in a Daumier print holding a tray on which Louis-Napoleon
is precariously balanced. Daumier also drew a number of plates showing his old
enemy Dr. Louis-Désiré Véron,[3] another opportunist Daumier held in con-
tempt, conferring with Louis-Napoleon and pretending to act as manager for
his political campaigning.

The campaign for the presidency was heated, but the results were a stagger-
ing victory for a name. On 10 December 1848 France gave Louis-Napoleon
more votes than all the other candidates combined. He was, said Proudhon, "if
not the product of the national *will*, at least . . . that of the national permission."
On taking the oath of office the new President said:

> The votes of the nation and the oath which I have just taken control my future
> conduct. My duty is clear. I will fulfill it as a man of honor. I shall regard as enemies
> of the country all those who endeavor to change by illegal means that which France
> has established.

By these boomerang words Louis-Napoleon prophetically condemned his own
action of three years later, the coup d'état, and declared himself the enemy of his
country. For Daumier and *Charivari*, aware of his dictatorial designs, he was
already so. Events in France had now centered on a single man, as Louis-
Napoleon gathered power and moved to the inevitable coup d'état. The elec-
tion was an omen of empire. For millions a new Napoleon seemed desirable;

for Daumier and the Republicans, the situation was detestable. Once again Daumier's cartoons have a beginning, middle, and end because the events which they mirror made up a drama whose inevitable finale came the night of 2 December 1851 with Louis-Napoleon's violent assumption of power.

IV

WHEN DAUMIER HAD DRAWN THE PORTRAITS of the assemblymen of the Juste-Milieu he had first made clay heads to serve as models. Now, sixteen years later, he made a statuette to serve as the focus for his new cartoon campaign. In both instances one may see an ironic equivalent to the primitive practice of using the enemy's image to kill him. Instead of pins, Daumier used plaster and a grease crayon.

Daumier's statue was *Ratapoil*, the symbol of Napoleonism. It became a favorite emblem for the *Charivari* cartoonists and writers, with columns of Ratapoil letters and dispatches ironically reporting on the progressive knavishness of Louis-Napoleon's *agents provocateurs*. There were more than 100 Ratapoil cartoons by Daumier, and dozens by other artists.

Ratapoil was descended from Robert Macaire. The name was apparently Daumier's coinage and seems to mean "Ratskin"—at any rate it suggests something loathsome, bloodless, as drawn in the many cartoons. The pose of Daumier's statuette is almost identical with Dantan's *charge* of Frédérick Lemaître as Robert Macaire,[4] and Daumier's Ratapoil assumes the rakish position of his ancestor in more than one cartoon. Ratapoil, nearly eighteen inches high, is a slender, baroque figure, leaning on his staff nonchalantly, alertly (Plate 46).[5] He wears the top hat of Macaire but sports the moustache and goatee of Louis-Napoleon. "It is," wrote Meier-Graefe, "a wild figure, made up of hollows, which against all probability is instinct with the most amazing vitality." At first glance the figure is gay, inoffensive; a second glance shows him as sinister, menacing. Similarly, Ratapoil's supporting staff first seems merely the cane of the Parisian dandy; close attention shows it to be the thick club with which Louis-Napoleon's agents controlled the hired rabble at parades to cheer for "the Emperor." Far from being an insouciant *flâneur*, Ratapoil is the seedy agent of evil. And as Robert Macaire had been created out of Louis-Philippe, so Ratapoil unquestionably had sprung from the person of Louis-Napoleon. Karl Marx described the President-Emperor in words which fit Ratapoil:

> An old and crafty roué, he looks upon the historic life of nations, upon their great and public acts, as comedies in the ordinary sense, as a carnival, where the great costumes, words, and postures serve only as masks for the pettiest chicaneries.[6]

The sculpture of *Ratapoil* was made before October 1850, when first he appears in a lithograph (D2035).

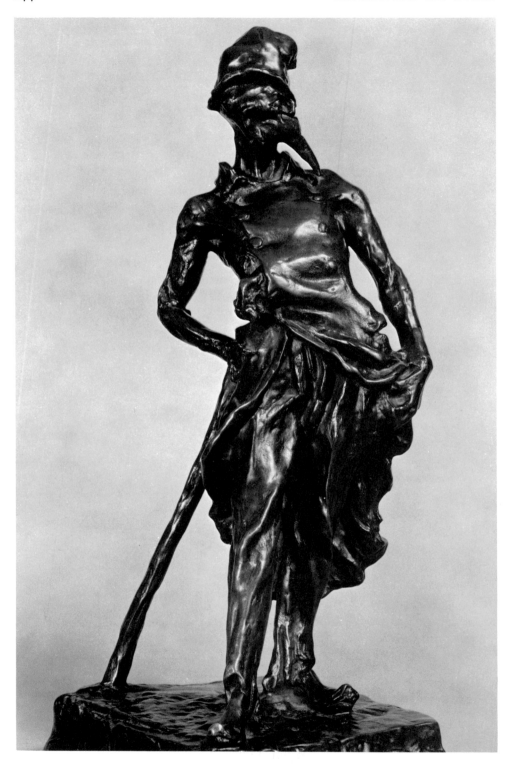

PLATE 46 *Ratapoil*
National Gallery of Art, Washington, D.C., Rosenwald Collection

Ratapoil was no hastily constructed statue or idea. Daumier's first biographer, Arsène Alexandre, tells the story of Michelet's first meeting with Daumier and of his discovery of the *Ratapoil* statue:

> The artisty was working in his studio; this particular day he was modeling in terra cotta a statuette the idea for which had long haunted him. The door opened, a small man entered quickly, with large gestures, asked in a hushed voice: "You are Daumier?" and knelt before the astonished caricaturist. In this posture, he began to praise in a loud voice the great talent of the cartoonist, his genius as a thinker, his powerful sense of justice; all great words which, addressed to him, struck for the first time the ears of the lithographer. Daumier, with a gaiety which concealed his emotion, raised up his visitor and begged him to stay a while, in a tone which helped to dispel shyness. The two men then talked, exchanging their thoughts, expressing their hopes and their hatreds, and thus began a deep and durable friendship.
>
> In the course of the conversation, Michelet's glances rovingly moved toward the work which the artist had interrupted, and after a quick examination, he cried with enthusiasm, "Ah! You have hit the enemy directly. There is the Bonapartist concept forever pilloried by you!"

V

THE ELECTION RESULTS alarmed Daumier and *Charivari* as they saw the forces of reaction strengthened, the road to empire opened. Nor did their opponents, the propagandists of the Right, fumble their work. They skillfully played on fears of the "Red Specter," the fear of the Left, constantly pressing for more and more restrictive laws so that property might be respected and business held stable. Socialist intellectuals, such as Louis Blanc and Proudhon, were played up as terrifying anarchists. Daumier showed Proudhon in one lithograph (D1983) as a jack-in-the-box which has just sprung up to terrify Thiers. Cham, Daumier's colleague, in a long series of cartoons later published as an album, rang the changes on Proudhon and his famous statement, "Property is theft," a remark which had done little to endear him to men of wealth or to allay their fears.

The Republicans themselves split, one group going to the Right and becoming a party of order. This group began to attack the freedom of the press and to urge repressive laws. Daumier had little sympathy for turncoats. He attacked with special energy his old enemy Thiers, whose small body and owlish features made him favorite cartoon copy. Daumier shows him (D2002) dragging a huge club, "Laws against the Press," toward the reading figure, heroic and luminous, of "The Press," in preparation for killing her. Again and again the Lilliputian acts of Thiers were the target of Daumier's ridicule. His greatest animosity, however, was toward the Ultra-Catholic party, most reactionary of all the French political groups and rapidly becoming the leading power in

France under the unprincipled adroitness of Molé, Falloux, and Montalembert. Tocqueville said, "The present regime is the paradise of the envious and the mediocre."

Daumier's fears of Louis-Napoleon were again justified by the Italian campaign. Though in his youth Louis-Napoleon had risked his life fighting for the Italian people, he now allowed himself to be persuaded by the Ultra-Catholic party to send a French army into Italy to fight the people led by Mazzini and Garibaldi; the French were to "protect" the Pope and the Church. The operation was clearly unconstitutional since it had been declared illegal to use French power against the liberty of any people, and the cynical frankness of the brief campaign outraged the democratic minds of France. One of Daumier's finest cartoons showed King Ferdinand II of Naples (D2142) looking from his balcony toward a street of damaged buildings littered with the bodies of Italian citizens—"King Bomba," the autocrat ironically and outrageously made secure by a Republican army (Plate 47). When the censor objected, Daumier drew another version (D2143) in which he removed most of the corpses and substituted three gibbets, repaired the ruined houses, and put a big belly on King Bomba. The cartoon delighted Michelet, who wrote to Daumier, 2 September 1851, "I am delighted, dear sir, to see you enter upon this new manner. Your *best of kings* is true Tacitus: terrible and sublime. . . . Speak to me of King Bomba, of the Pope, and of Nicholas. They're my men!" [7]

In regard to affairs in France there was equal consternation among lovers of liberty. Louis-Napoleon allowed Falloux, leader of the Ultra-Catholics, to push through an educational bill which conferred on the Church the control of education, and which also went far in the suppression of a free press and in the breaking up of trade unionism. Throughout France liberal teachers, most notably Quinet and Michelet, were dismissed from their posts. Daumier responded with a print of "Gorenflot Replacing Michelet at the Collège de France," showing the bloated, repulsive friar lecturing only to the proctor and the empty benches, where formerly Michelet had packed the hall with the enthusiastic and admiring young students of Paris. Michelet was of course delighted and wrote to Daumier, 21 March 1851:

> You have, my dear sir, rendered me a great service. Your admirable sketch, distributed everywhere in Paris, has clarified the question better than ten thousand articles. It is not only your verve which strikes me, it is the singular force with which you state the question. . . . I anticipate pleasurably the coming of a time when the government, being the people themselves, will certainly call upon your genius. Several [cartoonists] can please, but you alone—you have the power. It is through you that the people will be able to speak to the people.

Earlier, Daumier had had a moment of political victory to record: the election on 10 March 1849 of three true Republicans as Assembly members—

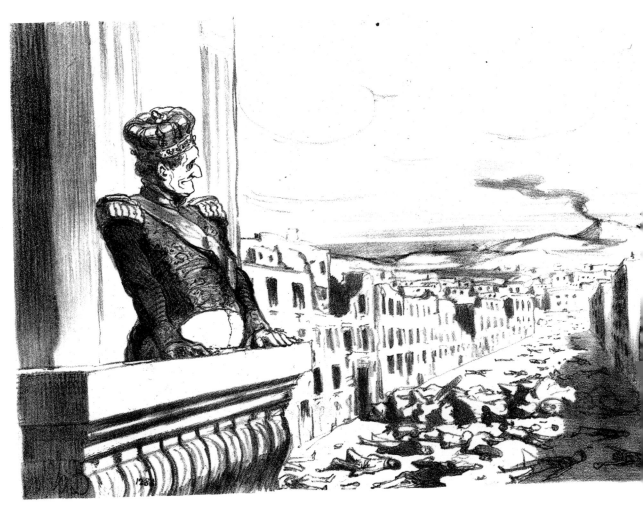

PLATE 47 *King Bomba*
Collection Benjamin A. and Julia M. Trustman, Brandeis University

De Flotte, Vidal, and Carnot. In "The Feast of Belshazzar-Véron" (D1997) Daumier showed Dr. Véron, owner of the reactionary *Constitutionnel*, and other banqueting leaders drawing back in fright at the names of the three Republicans which had just disturbingly appeared on the wall. Unfortunately the modest Republican success only encouraged further repression by the ultra-conservatives, who quickly pushed through a bill to curb universal suffrage so that the people could not indicate their sometimes disturbing wishes. Louis-Napoleon allowed the bill to go through although he had more to gain by a direct vote from the people at large than he did from the support of the Assembly. Divide and conquer was his instinctive strategy, and he callously allowed this

disqualification of almost one-third of the voters of France by a decree passed on 31 May 1850. Lamartine said bitterly, "The more I see of the people's representatives the more I love my dogs." The entire *Charivari* staff agreed.

Daumier and his colleagues watched the swift-moving events in dismay. Speaking at Tours, President Louis-Napoleon had soothingly said, "Trust in the future without thought of *coups d'état* or insurrections; for coups d'état there is no excuse." Such an assurance was most unassuring. The mere mention of coups d'état was the sign both of the public fear and of the President's own wish. The coming event had already cast its ominous shadow.

Had Louis-Napoleon been certain of continuing presidential power he might have been satisfied. Indeed, he tried to persuade the Assembly to cancel the article in the Constitution which limited his term to three years, but the assemblymen were so divided that they could not muster the large majority required to effect the change. Everybody—especially the *Charivari* staff—knew that Louis-Napoleon was going to grasp for power, that if legitimate means failed he would employ the illegitimate. He made frequent visits to the provinces to show himself to the people, to revive their interest in the name, and to suggest that he was a refuge and strength in a country torn by insecurity and division. At Caen he told the Normans, "What the people acclaim in me is the representative of order and a better future." He was the man on the white horse.

All of this and more Daumier sketched in his lancing lithographs. One print (D2123) shows in the foreground a military review with Ratapoil leading the cheering, his men's clubs raised high in a menacing arch, while beyond it the procession parades robotlike, subservient to the President (Plate 48). Possibly the lithograph refers to an inspection, 11 September 1850, when "in the midst of this usual ceremony a cry was raised, by about a dozen men, which found an echo in many voices, of 'Vive Napoléon! Vive l'Empereur! à bas Cavaignac, la Garde Mobile, et la Garde Nationale!'"[8] Or again (D2028), Ratapoil administers the oath of allegiance to a group of thugs, who repeat, "I swear to beat up every Parisian who won't shout with me 'Vive l'Empereur.'" Another (D2117) has Ratapoil whispering insinuatingly in a peasant's ear, "If you love your wife, your fields, your calf, sign up; there's not a minute to lose!"

And so events were channeled to his profit by Louis-Napoleon, and the tocsin sounded by Daumier and *Charivari*. Paris and all France waited for the Empire to arrive. On 1 December 1851, while Paris was asleep, the plans of Morny—the brains behind Louis-Napoleon—were swiftly put into effect. The army, subservient to the President, was strategically placed to repel riots; the opposition assemblymen were rounded up and imprisoned. Twenty-six thousand citizens were sent or fled into exile, the most famous, of course, being Victor Hugo, who hurled his magnificent rhetoric at "Napoleon the Little" from his retreat on the Channel Islands. Paris awoke on 2 December to find itself

PLATE 48 *The Day of the Review*

without a Republican government and knew the establishment of the Empire would be only a matter of time. Gustave Courbet, the painter, said that he took to his bed and vomited for three days, which is probably his normal exaggeration but good political criticism.

Louis-Napoleon knew his name and its strength. "How can I not vote for this gentleman, I whose nose was frozen at Moscow?" said one peasant,

speaking for many. Louis-Napoleon ordered an immediate plebiscite. The result was an overwhelming victory, more than ten million votes for him and less than a quarter of a million against. Thiers said flatly, "The Empire is achieved."

Speaking at Bordeaux, Louis-Napoleon tried to allay the fears of France: "There are some who may doubt, but I say 'the Empire means peace,'[9] for France desires it; and when France is satisfied, the world is at rest." Years later—when the press censorship had lifted, when memories of the Crimean War and the disastrous Mexican campaign were recalled, and as telegraphed casualty lists were coming in from the Franco-Prussian War—Daumier and other cartoonists found "the Empire means peace" a sardonic reminder to the French of what their votes had approved, when they consented to trade the Republic for a stable stock market and "joyfully loaded liberty with chains."

CHAPTER FOURTEEN

Daumier's Dreary Cart

VIOLENT, LIGHTNINGLIKE in its quickness, the coup d'état completely overwhelmed resistance. "There remains to be explained," said Karl Marx, "how a nation of thirty-six millions can be surprised by three swindlers, and taken to prison without resistance." It happened in one night in Paris, and the rest of France was notified by post. The country adjusted quickly to the new regime, with, in fact, a certain relief. "Order now reigns in Poland." Order reigned, however, at the expense of the imprisonment, exile, and flight of thousands of citizens, little celebrated in their suffering. Most critics date Daumier's bas-reliefs, drawings, and paintings of *The Fugitives* to the 1848 June uprising, but it would seem more logical, more apt, to date them from the time of the terrible exodus of 1851–52.

The theme of *The Fugitives* deeply interested Daumier, to such an extent that he sculptured two bas-reliefs which were in effect models for his paintings. His originals have disappeared but Geoffroy-Dechaume made two plaster moulages which have been preserved; from one of them five bronzes were made. The two plaster moulages were sold at the Galerie Charpentier in 1960, the better, less worn one going for 130,000 new francs, the other for 65,000. The Geoffroy-Dechaume family has reserved the right to make ten copies from each of the two original plaster moulages, so that these versions may some day be available to museums and collectors.

The artistic composing intelligence of Daumier can be seen at work by a close study of one of the bas-reliefs (Plate 49). Hastily regarded, the bas-relief

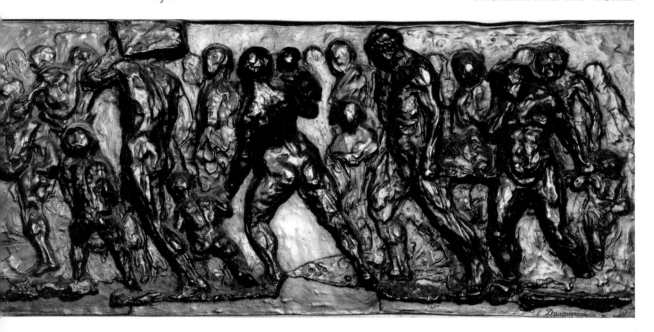

PLATE 49 *The Fugitives* (bas-relief)
The Minneapolis Institute of Arts

first seems merely a file of random figures; closely studied, it reveals a pattern of motion. The right-hand figures move toward us, coming *from* their homeland. The left-hand figures move on, *away* from us. In the center the strongly modeled mother holds one child with her left hand, another in her right arm. She is the center of the composition but she does not divide it so emphatically as in the second bas-relief.

The second bas-relief forcefully sharpens the composition, making firm what was formerly tentative, bringing out meanings before only muted. Now the right-hand figures move toward us more directly, the left-hand ones move more clearly away. There is a strong, emphatic curve of human forms, and what was formerly merely massive becomes vast, filled with increased meaning. Now the central female figure divides the two groups but also serves to bridge them; she is the pivot of the composition, and her turning gives motion from the right to the left where in the other version the rhythm had been sluggish or static. If the exile theme be read into the composition closely, she is the modulating figure between the group sadly leaving the old, and the group hopefully moving to the new, and thus she is pivotal both in structure and theme. She is a fit companion to Daumier's other great female figures in *The Republic*, *The Laundress*, and *The Third Class Carriage*.

In both bas-reliefs Daumier's mastery in modeling the human form is fully realized. The key figures in high-relief are massive and monumental, bearing

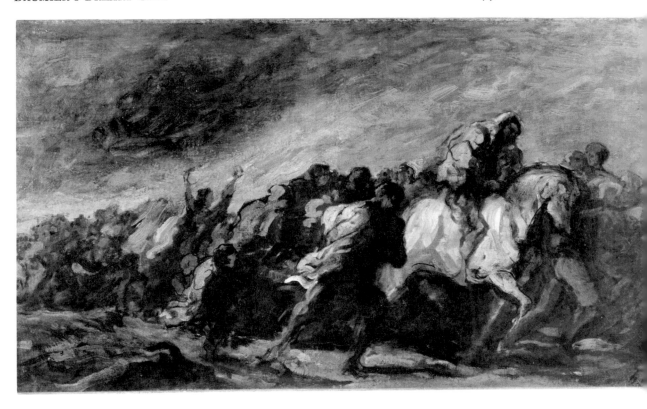

PLATE 50 *The Fugitives* (painting)
The Minneapolis Institute of Arts

rocklike weights, like an Atlas or a Sisyphus. The lesser figures in low-relief are
the generations of mankind, even as in the paintings, for although these ver-
sions of *The Fugitives* may possibly refer to the political persecutions of Louis-
Napoleon, they refer more significantly to the universal condition of man.
What is has been and will be. Weight and woe, endurance and hope, the un-
known to the unknown.

Although the impression one gets from pictures of the bas-reliefs is one of
largeness, they are actually small (about $14\frac{1}{2}''$ high by $30''$ wide). Within this
narrow scope Daumier projects massiveness in a way which anticipates Rodin,
or, later, Matisse's great bronzes in the Tate Gallery (London) and his *Serf* in the
Art Institute of Chicago. They are among the few masterpieces of nineteenth-
century sculpture.

Little known, *The Fugitives* paintings are among Daumier's finest work.[1]
The one in the Reinhart Collection (Winterthur, Switzerland) shows a crowd
of people, on horseback and on foot, moving through a mountain pass from an
unknown place to an unknown destination. A second painting (Montreal

Museum) has a similar procession but with the figures reduced in number, with a greater sweep and more motion resulting from the simplification. In these, as well as in the third version (Petit Palais) and the fourth (Minneapolis Institute of Arts), the turbulent line of fleeing fugitives parallels and opposes the line of bare, desolate sky, somber and dark as their doom (Plate 50). The color in all four canvases is rich, deep, with an interplay of light and shadow reminiscent of Rembrandt, Daumier's painting master. More immediately and specifically, however, the composition is strikingly similar to the illustration which Daumier's friend Gustave Doré made, "The Burden of Pride," to illustrate Canto XII of Dante's "Purgatorio." In Doré's picture the figures in the lower half are weighted under great stones, and they move from the deep right forward and around a rocky pass, with Dante and Virgil the center figures. (The upper half of Doré's print has no relevance to Daumier's composition but seems to be a free use of the Night and Day figures in the Medici Chapel.)

II

WITH THE COUP D'ÉTAT, censorship was resumed.[2] Daumier took it hard. If one *has* to cartoon, as he reluctantly did, it is better to have something definite to shoot at. In satire a precise target is easier to hit than a vague one. Louis-Napoleon and the politicians were satisfyingly particular, society was elusively general. Now that President Louis-Napoleon was changing his skin to Emperor Louis-Napoleon, he had become taboo for caricature. Daumier once again turned from political battle to the streets of Paris, to draw the timeless triviality instead of the timely headline. Madame Daumier now hid the statuette of *Ratapoil* to prevent its seizure by Ratapoil's men—a concealment which symbolized Daumier's cartoon problem.[3]

The censor's restrictions irked Daumier. Frequently his prints were returned with remarks which made his face redden, made him mutter to himself in anger. Daumier disliked Louis-Napoleon so intensely that he could not bear to see him or to hear his name mentioned. Once, strolling with his wife and mother along the Champs Elysées, he heard the trumpets announcing the passage of the Emperor's party. When the women said that they wanted to see the sight, Daumier shouted at them in anger and hurried them down a side street. The face he had drawn so many times before he now could not bear to see.

The story of Daumier during the 1850's is seen opaquely because of the scarcity of details,[4] but what is known adds up to a decade of weariness and defeat. First there was the death of his father, Jean-Baptiste Daumier.[5] For years, one conjectures, the old poet had been unable to do much for himself or others, and early in January 1851 he was transferred to the insane asylum at Charenton outside Paris. He was not there long, however, for before the doctors could even examine him and draw up a dossier on his case he died. The mere record of

his passing, after a night of painful cries, of a cerebral congestion, is all that remains.

Daumier also lost an old friend in August 1853 with the death of Feuchère, who had drawn his portrait and, shortly before he died, had planned to collaborate with Champfleury in compiling a catalogue of Daumier's lithographs. Feuchère had been an art collector and was possibly one of the first purchasers of a Daumier painting. He had made Daumier an executor of his will. In this capacity Daumier arranged first for the funeral, then for the sale of Feuchère's art collection to raise money for the family.

If the Feuchère auction sale catalogue is accurate in its ascriptions, the collection was impressive, with drawings and paintings by such contemporaries as Bonvin, Charlet, Gavarni, Géricault, Raffet, and Jeanron; more important, a painting by Leonardo da Vinci; and drawings by Bellini, Rubens, Mantegna, Michelangelo, Perugino, Caravaggio, Poussin, Raphael, Ruysdael, and Andrea del Sarto. A sale of this magnitude today would make headlines around the world. The catalogue also listed several groups of Daumier prints, one painting of children picking fruit, and six drawings in crayon—all executed, said the compiler, "with the vigor which this artist puts in his work." Two letters to Daumier from the sale entrepreneur, M. Froment-Meurice, show that the estate netted 10,000 francs, of which 5,000 was invested, with Daumier's approval, on a long-term basis for the widow and children.

The negotiations with the lawyers took place at the end of August 1853. Daumier's activity as executor is indirectly reflected in some woodcuts he drew for *Charivari* shortly after, an interesting instance of his utilization of first-hand experience in his work. On 29 December *Charivari* printed a page of six woodcuts by Daumier, entitled "A Sale of Pictures at the Auctioneers." Daumier, in fact, had made the Feuchère sale into six compositions. In one, a purchaser is walking away, canvas under arm, muttering, "I'm certain that this time I've got a real Raphael. . . . I'll not sacrifice it for forty thousand francs." The fourth in the series shows an auctioneer holding up a painting, crying, "The frame alone is worth 100 écus." The dimly drawn picture within the frame (i.e., within Daumier's picture) suggests—wittily, if so—a Daumier oil of a young girl wading in the Seine, her mother watching, much like a Daumier painting which appeared at the Cognacq sale in Paris in 1954.

III

This is drudgery, day-labouring out life's age.
JAMES JOYCE
Ulysses

DAUMIER'S RESUMPTION of social satire meant once more the routine of eight lithographs a month on themes about which he had already cartooned hundreds

of prints, a labor now almost Sisyphean. Critics have been quick to find the cartoons of the 1850's "tired," and maybe they are, but those critics have never shown precisely where the tiredness is to be found, and one wonders exactly how that fatigue took form. The most important series immediately following the coup d'état were *Musical Sketches*, *Parisians in 1852*, *Everything One Wishes*, *Lawyers and Solicitors*, *Faces from the Tragic Drama*, and *The Public at the Salon*. These cartoons are as witty in their content and as skillful and pleasing in technique as the masterpieces of the 1840's. They delighted Daumier's celebrated admirer, Michelet, who found in them renewed strength and vitality:

> I do not know whether you have done anything stronger than the Bourse [D2341–2346; November–December 1852], and recently that effect, so naive, of the old people who discover the sun through the demolitions [D2276; 18 December 1852].
>
> And ourselves, dear sir, when will we see again through the wreckage of these hovels they have just built on the nose of France?
>
> What a consolation for you and me that nothing ages our country, that it is always young and powerful in its original genius, even while the hopes of the masses seem to have endured a moral eclipse.
>
> Preserve well, dear sir—preserve that marvelous youthfulness, that lively gaiety which is the sign of power. They are for us the precious token of rebirth. Each time that I see your sketches, although I may be sad, I sing in spite of myself the old song, Poland is not yet dead!

Michelet, obviously, saw increased zest rather than tiredness in the series. This zest is shown in new techniques with which Daumier experimented and in the heightened comedy of the cartoons which compensate for the frequent lowering of the purely "print" value. The Bourse series which Michelet cites is a good example. Daumier tried a device he had used effectively in *Parliamentary Idylls*. The characters are drawn with small bodies and large heads. They scurry, like bugs, about the banking and stock-market business. The other print praised by Michelet shows a man and wife delightedly looking at the new demolitions (the Haussmann rebuilding of Paris); he cries out, "Now my flower pot will get the sun. I will know whether it is a rosebush or a gilliflower!" The captions now become important, the relationship between legend and picture better coordinated. In other words, in these cartoons the artist sacrificed the suavities and the surfaces to the comic intention, becoming, in the twentieth-century sense of the word, more of a cartoonist.

However, Daumier alternated his old and new methods. During these years there are many "regular" prints—masterly, realistic accounts of scenes and people. In these there is also a difference, however. Now the emphasis is more on the outline. As Daumier reduces the physiological details, he is moving toward the skeletal structure of the last prints, the principle of "less is more." This difference may be seen in a print of 19 November 1852 (D2340). Three

bluestockings are talking about writing a novel, *Aunt Tom*, to compete with the popular *Uncle Tom*. In identically the same vein as *The Blue Stockings* of the 1840's, this print has a new simplicity of technique, such as in the handling of the draperies.

Tiredness? Is this because the paper used by *Charivari* had cheapened during the years to a dull white surface less satisfactory for lithographs? It is distressing to see caricatural masterpieces preserved only on such cheap, perishable news-print.

Tiredness? Perhaps it is suggested by the increasingly apparent contrast between the superb draftsmanship and the trivial subject. Such power should not have been wasted on such petty matters; a man doing a boy's job, Schnabel playing *Chopsticks*. The *Charivari* print for 21 November 1853 (D2457) shows a frightened hunter treed by his own fear rather than by the "savage boar" (a fat sow) rooting about below. The pig is carefully drawn, the face of the man perfectly mirrors his fear, and the landscape is equal to anything which Daumier's famous landscapist friends, François Millet or Théodore Rousseau, could have sketched. The prodigal waste of talent in these cartoons is heartrending, for most of the prints are buried, or at least reposited where few people will ever be able to appreciate them properly.

The eternal timeliness of Daumier's humor shows at its best in a print of 17 March 1852 (D2263). Three old crones in a hallway discuss in candlelight the earthquake at Bordeaux, caused, they fear, by the United States government allowing such quantities of earth to be dug out of California (Plate 51). Henry James called it a masterpiece, noting that "The representation of confidential imbecility could go no further." [6] He then cautioned, "I must repeat that it is absurd to pick half a dozen at hazard out of five thousand; yet a few selections are the only way to call attention to his drawing."

IV

IT IS CLEAR why Daumier's technique became simplified and concentrated, increasingly linear, as the years passed. He began painting during the daytime, while his evenings were devoted to the money-making *Charivari* cartoons. Now Daumier the painter becomes as important as Daumier the cartoonist.[7] Previous to 1848 he had expended most of his time and talent on his prints. He had lavished special care on the composition of the lithographs, which had to be his substitute for the painting he longed to do and could not. This is why we feel the truth of Baudelaire's observation that Daumier's "drawing is naturally colored. His lithographs and woodcuts awake ideas of color. His pencil contains more than just a black trace for delineating contours. He evokes color. . . ." This famous commentary is especially true of the first two decades of Daumier's prints; it grows considerably less true during the last two decades. The pearl

—Oui, madame Fribochon, il y a évu, il y a trois semaines, un tremblement d'terre très conséqu
Bordeaux, et pas pus tard qu'avant z'hier, entre minuit et trois heures du matin, j'ai ressenti des
sses qui ne sont pas naturelles dans mon lit... l'herboriste, m'sieu Potard, m'a expliqué ce Phénomèn
rétend que ça tient à ce que le gouvernement laisse trop creuser la terre en Californie et q
finira par nous jouer à tous un mauvais tour aux Batignolles!...

PLATE 51 *Three Women Gossiping*

grays, the velvet blacks, and the careful shading of the great series of the 1840's simplify to the sharper outlines, to the rapid, thrusting, single stroke. It is as though he deliberately separated, now, his daytime painting procedures from his evening lithographic compositions where he allows the powerful skeletal draftsmanship to serve his journalistic assignment.

For the biographer seeking order in multiplicity, what is missing during the 1850's is the single series, centrally symbolic, like *Robert Macaire*, where a national attitude is focused in a single character. Ratapoil was forbidden and Macaire was exhausted. There is, however, one character who appears frequently in Daumier's cartoons from this point on, the famous Monsieur Prudhomme, the pictorial and stage child of Henri Monnier, Daumier's old friend and collaborator on *Silhouette*, *Caricature*, and *Charivari*.[8] As early as 1830 Monnier had created Prudhomme, the middle-class Polonius emblematic of the fat bourgeois, a man full of good food and his own importance. There is in the Geoffroy-Dechaume collection an unpublished note from Monnier to Daumier, in which the actor says in full: "Come this evening to the Ambigu to pay me a little visit with the bourgeoisie." Unfortunately the note is undated, but it suggests that Monnier was perhaps playing Monsieur Prudhomme—a role which Daumier might, and would, record in a lithograph. *Charivari*, 13 December 1852, printed Daumier's portrait of Henri Monnier (D2347) at the Odéon in the role of Prudhomme, protesting, "Never shall my daughter become the wife of a scribbler" (Plate 52). With this print as a kind of claim, Daumier adopted the character for his own uses, an expropriation common in the *Charivari* circle. Ratapoil, Macaire, Mayeux (Traviès' then celebrated creation), and other figures were understood to be public property or designated for some special strategy. Their use was always a tribute to the original creator. Writers did the same. During the Paris Exposition of 1855 Arnould Frémy wrote a witty series of sketches in *Charivari*, letters from Monsieur Prudhomme to his son—a bourgeois Lord Chesterfield. Certainly Daumier's mastery warranted his appropriation.

The comedy of circumstances was no different in 1852 from what it had been ten years before. The contents of the cartoons had to be similar. There were the seasonal accidents of hunting and fishing (the buckshot in the seat of the breeches, the hunter stalking the hunter, the rabbit reveling before the exasperated hunter out of ammunition, the fisherman getting doused); there were the heat of summer and the cold of winter, the proprietors and the renters, the teachers and their pupils, anxious parents and bratty children, quarreling husbands and wives; there were the new fashions, such as the great crinoline hoopskirts; there were the terrors and contretemps of the trains; there was, to sum it up, the old always new, what Philipon had called "the inexhaustible richness of human ridiculousness," or what Baudelaire referred to more kindly in 1859, "Is there anything in the world more charming, more fruitful, of a nature more positively exciting, than the commonplace?"

PLATE 52 *Henri Monnier as M. Prudhomme*

But how does Daumier repeat his themes and not repeat his compositions? To be sure, plates have compositional and structural echoes—that was inevitable—but each print seems "new" and fresh and never a remake of an old print. "The New Year's Visit" (D2990; 23 December 1857) is a stock composition for artists, a pyramid, but the flow of tensions—as the child grips the father's hand, the father balances the child he carries, and the other child tugs at the coat—produce a rhythm of energy and motion which brings muscular response, a sensual pleasure. There is also, as in so many other prints, Daumier's fine use of the stair railing curving and moving down, to contain his picture and to vary the lines. Curiously, this picture of parent and children has basically the same structure as the great *The Republic*, the oil sketch Daumier had painted eight years before for the state competition. It is the same, but so different that resemblance is only in the skeleton concealed by the comedy.

V

THE PATTERN OF Daumier's social satire has already been discussed and illustrated at length in regard to his lithographs from 1835 to 1848. A similar study of the prints between 1852 and 1860 would be repetitious since the method remains the same; only the surface subjects change—and not all of them. Daumier failed to find satiric subjects equivalent to *Ancient History* or *Men of Justice* for his crayon. The fads and the follies of this decade are less significant. Social obsessions take on a new prominence as Daumier exposes spiritualism or the *gourmandise* which swept through France. *Horse Meat Gourmets* (D2776–2790), in 1856, for example, ridiculed the revived interest in horse meat as a table delicacy. Faddists issued elaborate recipes, and one distinguished scientist, Geoffroy Saint-Hilaire, even wrote a book on the subject.[9] The cartoonists, for Cham and Nadar joined Daumier, caricatured this misplaced zeal. Bony cultists—nabobs of bones (to borrow a phrase from Wallace Stevens)—smack their lips over equally bony old horses as though they were sleek beef cattle and future T-bone steaks. Horseshoes, nails, skulls, skeletons, liver pills, and stomach-aches become part of the grotesque comedy. Similarly, Monsieur Coste's scheme to breed fish and to plant them in French lakes and streams for the benefit of French fishermen evoked from Daumier a series, *Fish Breeding* (D2791–2797), in which the campaign is seen as absurd from the point of view of both fish and men. These prints doubtless diverted Frenchmen of the day; they could scarcely have much excited Daumier himself, to whom they were like five-finger exercises.

Possibly the greater triviality and the more eccentric nature of these subjects explain the "tiredness" which critics see in Daumier's prints of the 1850's. But it is hard to find Daumier nodding; the technical mastery remains, scarcely ever faltering. Proof of this is pleasantly found: Leaf through *Charivari* from 1852 to

1860, comparing the cartoons by Vernier, Beaumont, Cham, even Gavarni, and Daumier. They all draw the same society, similar subjects. Daumier draws them better; his prints you want to preserve. His mark is unmistakable and superior. Van Gogh wrote to Theo that "Daumier's drawings are so true that they almost make one forget the toothache." [10] ·

VI

SPECIALLY INTERESTING TO US a century later are the many plates satirizing the world of art, reflections of Daumier's awakened and increasing activity as a painter. The hasty finishing of the canvas before sending it to the Salon, the jury's problems of choice, the painter's agony in being rejected or his joy at being accepted, the philistines' gabbling about the pictures, the peacock prize winners, and the arrogant, bowed-to critics—all are Daumier's spirited reflection of his friends, himself, his world.

We even find hints of Daumier's own theory of art, and a Daumier aesthetic might possibly be built from a study of his art-world cartoons. Certainly his sympathies lay with the new Realism, especially with the new landscapists such as Millet, Rousseau, and Daubigny. They were his friends; he had taught them and they him. He shows the Barbizon painters working out of doors (D3428). An artist paints a tree while the watching peasant mutters to his wife, "What a fool he is, to be sure. He's painting an apple tree that bears no apples."

In another plate (D3439), a landscapist paints while immediately behind him is another painter copying him. "The first copies nature, the second copies the first." This is an excellent concentrated summary of the subject of imitators and epigoni. Daumier exposed, also, the philistine attack on art, and came loyally to the defense of Courbet and the new Realism. The best single print in the entire Realist-Classicist controversy of the nineteenth century is Daumier's parody (D2629) of David's two dueling warriors in *The Rape of the Sabines* (Louvre).[11] In Daumier's cartoon, two artists are dueling; one is a peasant Realist with a thick house-painter's brush, and his opponent is a slender, bespectacled intellectual, naked but wearing the classical helmet, his shield a palette and his sword a long, slender brush. The print is called, "Fight between Schools. Idealism and Realism" (Plate 53). In 1855 when the Universal Exposition had rejected Courbet's offerings, that undaunted self-publicist and great painter had rented his own hall, placing over the doorway the one taunting word, "Realist." Paris of course reacted loudly and gaily, and the press had a holiday as critics and artists larruped each other in the vigorous way which, fortunately, never vanishes from Paris life and which helps to keep Paris the art capital of the world.

Also new in Daumier's work of the 1850's were the lithographs and paintings which dealt with the world of the theater—the theater in itself and not, as

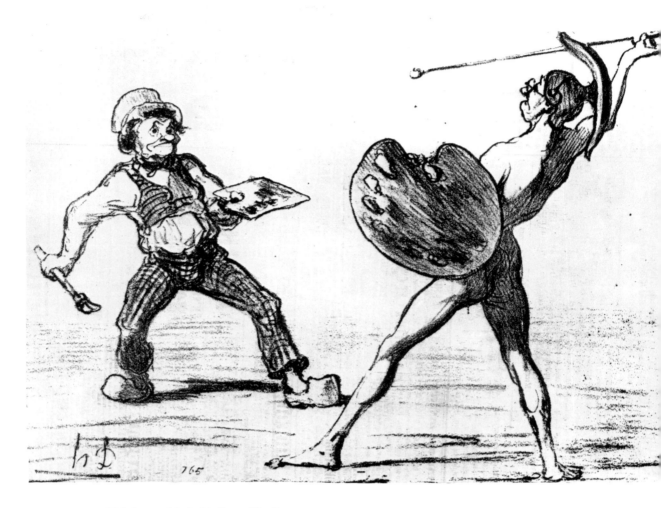

before the 1848 revolution, as the backdrop for a contest of intellectual attitudes known as Classicism and Romanticism.[12] As early as 1838, with the striking success of Rachel in reviving French classical drama, Daumier had ventured into the realm of the theater, to abstract from it the essential conflict between the realism of the actors themselves, as people, and the unreality of their roles. In *Faces from the Tragic Drama* he had contrasted the lined features, double chins, and bowed legs of the performers with their heroic poses and their resounding rhetoric. In all this, the theater was merely the arena, incidental to the intellectual-aesthetic opposition. Or, it was not the "theater" but rather the drama which then concerned Daumier, the drama on which, as Champfleury pointed out,

Daumier had been weaned when forced to listen to his father recite the limping lines of his neoclassical tragedies. *Faces from the Tragic Drama* have a secondary significance, then, as being Daumier's delayed revenge on parental pomposity, but the series scarcely constitutes an important paragraph in any discussion of "Daumier and the Theater."

With 1852, however, the theater became as important among Daumier's subjects as the law, artists, or Monsieur Prudhomme. Obviously he visited the theater frequently, but exact details are missing. Arsène Houssaye says that he often saw him at the Comédie Française, and that once when he asked him who was his master in painting, Daumier wittily and perceptively replied, "Molière," not merely because he was then painting many Molière scenes but because the spirit and the sensibility of the great dramatist were an echo of his own.

Banville tells us that Daumier had free passes for the Opéra Comique until an unfortunate mishap canceled the privilege. A stage-struck porter named Antoine once complained to Daumier of the great poverty which kept him from attending theaters. Daumier said to him, "The business can be arranged. I have passes for the theater, you have only to give my name at the box office, just say Monsieur Daumier. In this way you will be able to go as you wish to the Opéra Comique." Antoine then lamented that he lacked a proper black coat for an evening affair, and the obliging Daumier lent his. Thus equipped, Antoine set off. His way to the theater was dotted with tempting bars and he arrived at the Opéra Comique in high spirits. Delighted at the performance, the alcoholic Antoine gleefully punched his neighbor in the stomach, raised his voice to join that of the tenor, and stirred up such a fuss that "Monsieur Daumier" was ejected ignominiously from the building.[13]

Daumier missed nothing either on or off stage. His camera eye ranged the entire building, from the orchestra to the balconies, from the orchestra pit to the stage, from the prompter's box to the wings, and into the green room and the dressing rooms. (It even roamed into private homes when the rage for amateur theatricals swept Paris.) No one was omitted (e.g., D2697–2911), from the janitor and the doorkeeper to the actors and actresses, the director and producer, and above all the audience itself. It was not the drama which concerned him— except for Molière—but the human comedy and variety. There were also interesting technical and formal problems to delight and to challenge the ever experimental Daumier. There was the problem of variety-in-sameness. There was the strange theatrical light which flickered from the footlights to the actors, giving them an unreal, nightmare quality, and which also flickered back over the audience to show their shadowed countenances in a macabre *physiologie* (e.g., D2791).

If Daumier was "tired" in his art during the 1850's, the theater cartoons and paintings were, then, a search for novelty and variety. But they were more than that. They were an outlet, or rather an *inlet*, for Daumier in his growth in expe-

rience. The theater stirred and nourished reflections in him on the central prob-
lem of his art, the problem of reality. If this study pushes too hard the paradox
that Daumier the realist was a visionary, it nevertheless insists upon Daumier
the actualist. All the arts, painting and theater above all, run headlong into
the problem of reality, and their metaphysical overtones disturb and enchant
the reflective mind. What is the world, fact or fiction? Or both? Where does fact
shade off into fiction or fluid action solidify into fact? Is not Hamlet more real
than Amlethus? Is not fiction a fact in itself? Is not a dream a fact? Are not the
"cloud-capt towers and these our actors" but a dream, leaving not a wrack
behind? Issues are raised and lines of reflections are suggested in Daumier's
theater painting through the subtle color symbolisms, the manipulations of
light (the brilliance of the stage against the dark of the auditorium; the perspec-
tive from the boxes, from the orchestra; the scene in the orchestra), combined
with the inevitable, unerring draftsmanship wherein no significant bone or
muscle, no texture or mobility of the skin escapes him. To view these cartoons
and paintings only as comic superficialities or as decorative aesthetic objects (all
of which they are, of course) would be to miss much of what Daumier felt and
expressed.

"All the world's a stage" is an important theme of Daumier's art in the late
years. In 1852 alone, Daumier did 23 woodcuts and 30 lithographs dealing with
the theater. By the end of 1872, when he resigned from *Charivari*, he had com-
posed more than 200 pictures on the subject. Furthermore, some of his finest
canvases (*Crispin and Scapin* in the Louvre; *The Drama* in the Munich Neues
Pinakothek) are of the theater. At the Daumier exposition in 1878, a year before
his death, a strikingly high percentage of his output was from the theater: 17 of
the 139 watercolors and sketches, 16 of the 94 paintings.

In other words, Daumier's art not only became increasingly serious, with a
marked diminishment of the comic element, but it also became psychologically
and philosophically more exploratory and suggestive. An art intensely actual, it
became increasingly metaphysical. The theater scenes, the clowns, and the Don
Quixotes which followed are part of a consistent development and climax in
Daumier's mind and art.

VII

A MORE SIGNIFICANT SUBJECT, the Crimean War, furnished relief from the
routine cartoons. The entire nation, of course, roused to the tricolor; the war
was in part a vindication of national honor, an assault upon the most tyrannic
despotism in the civilized world. For once Daumier could support a cause which
Ratapoil sponsored.

The Crimean cartoons were a holiday for Daumier, offering him a new set of
symbols to juggle. With a few noteworthy exceptions, most of the prints have a

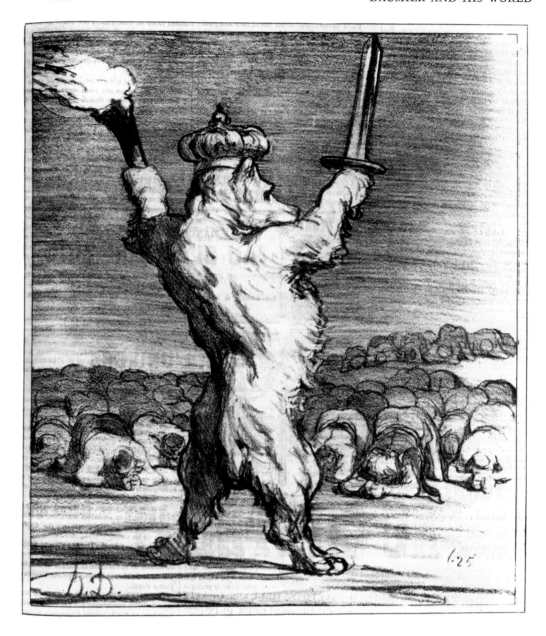

PLATE 54 *The Northern Bear*

levity in which the tragedy of war seldom intrudes. At least the tragic is only an
occasional variant, not a constant as it becomes in the cartoons related to the
Franco-Prussian War. In the latter the fighting took place on French soil; now
it was far away in the unbelievable land of southern Russia. But the few excep-
tions are arresting.

To us, of course, the Crimean cartoons are an academic exercise since their subject is mainly of textbook interest. Nor do we generally see the prints properly; they are as a rule shown only in reduced photographic copies, and the sweep and vigor of the originals is lost. With little, Daumier did much. The massive figure of Nicholas I, with his huge eyes, enormous belly, towering helmet, long mustache, and ornate costumes, lent itself well to Daumier's designs. Stock themes recur—the fondness of the Russians for eating candles was one, the use of the knout another. The series on the Cossacks is a dance of huge puppets acted against the broad imagined Russian landscape.

A few times, however, Daumier rises above the surface play to an abstract height which is memorable. In "The Northern Bear, Most Disagreeable Bear Known" (D2493), his art is most assured and powerful (Plate 54). A huge polar bear (Russia) is upreared on its hind legs, facing a multitude of peasants bowed to the ground before him. He wears the imperial crown on his head; in his left paw is a fiery torch, in his right a sword. The design is Daumier's old favorite— the strong central figure in the foreground, the small figures in the rear distances: mass and might set against smallness and space. The bear is superbly drawn; not even Delacroix surpassed, if he ever achieved, this mastery of the animal form. And all of this mastery and power is "wasted" on a cartoon to be forgotten the next day with the next print. The tiredness one sees in Daumier's cartoons is really a projection of the tiredness any thoughtful person feels regarding the costly diversion of great talent from ends equal to it in magnitude and worth. In this print Daumier made his subject great; instead of the ordinary stock symbol of Russia, employed by all his colleagues, this is a bear which, remaining the symbol of Russia, becomes also a symbol of ruthless power and tyranny, a force as uncaring and heartless as the bull of *Guernica*, or, better, as menacing and magnificent as Moby Dick.

Equally imaginative and potent—equally lifted above the levity of the rest— is "The Two Grand Dukes Attending the Battle of Balaclava" (D2533). On a rocky hill to the right two large birds of prey, the royal ribbon across their breasts, watch the slaughter taking place in the fields below, left. Vulturine and heartless, they await the results, after which they will have their rewards—bird-dukes and corpses coordinated in this terrible mockery of military folly (Plate 55). This picture does not jingle and dance like Tennyson's famous Balaclava poem; it has a somber rhythm which stays in the memory long after it is seen.

Two days later, 24 November 1854, *Charivari* printed Cham's treatment of the same subject.[14] Two dukes watch the defeat of their forces, one blubbering that he was promised a victory and that he is going to tell his father, the Czar (Plate 56). The composition is cluttered, the print no more than an amusing joke scarcely worth the effort to compose it. A few days later, Cham used the imperial vulture motif, the bird flying toward the battlefield where lie the wounded and dying. The picture is not funny; how could it be with such a horrible

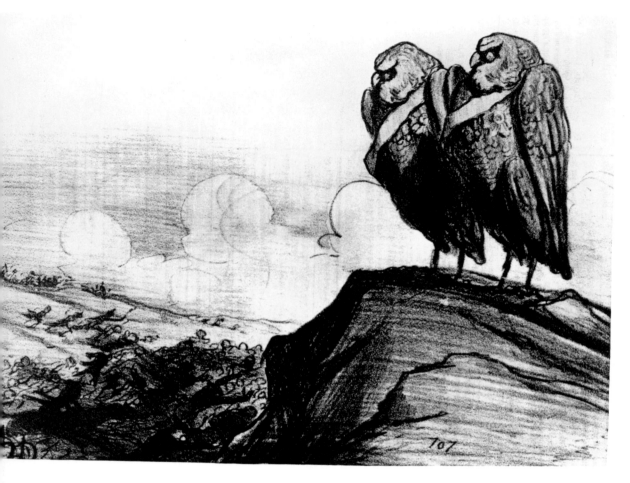

PLATE 55 *The Two Grand Dukes*

theme? Nor is it serious, the scrawny vulture being a banal parody. Falling
between two stools, the serious and the comic, and further damaged by a messy
technique, the print simply does not come off. Cham had learned his trade from
Daumier, but he had not learned the creative mystery. This distinction may be
obvious to us now but it was not so clear on 4 July 1868, when an enthusiast
writing in *Charivari* said about Daumier: "O great man, one-half of France is
yours, the other half is Cham's."

VIII

THIS INTERESTING OSCILLATION and interrelation in Daumier's work between
the comic and the serious, the realistic and the expressionistic, which gives a few

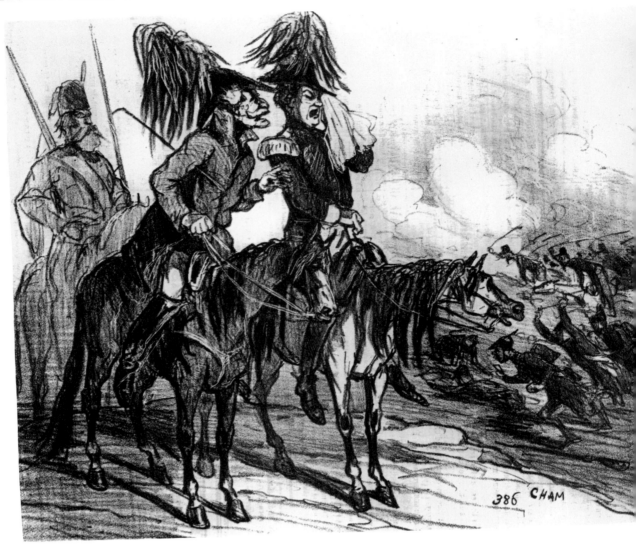

PLATE 56 *The Two Grand Dukes* by Cham

of the Crimean War prints a subtle biographical interest, is also found in the butcher cartoons of 1858. Early in that year the Paris butchers had lost their monopoly, and their counter-tactics to regain their status quo had upset the city's economy. It was a local event calling for the satiric *Charivari* treatment, and Daumier handled it with twelve prints (D3010–3021). But since he alone on *Charivari* touched the subject and since the ubiquitous and inexhaustible Cham, whose review-of-the-week woodcuts seemed to miss nothing that happened, neglected it, perhaps it might be suggested that the event was important to

Daumier simply because he was at that moment *painting* two sketches of the butcher at work, and now that they accidentally became newsworthy, he efficiently and economically used his sketches to help fulfill his newspaper contract. In any case, his painting of *The Butcher* (Plate 29), now in the Fogg Museum of Harvard University, can be compared interestingly with its cartoon counterparts.[15] The butcher, knees bent with his effort, pushing upward on a great side of beef, is repeated in a *Charivari* print (D3012) where the butcher reaches high to hook down the carcass, while the housewife, hands comically clasped, exclaims, "Sure, and lamb has gone higher . . . even the butchers themselves can scarcely reach it." Remove the editor's joke, take away the comic handclasp and perhaps even the housewife, print the picture on good paper, and you have an equivalent of the Fogg painting.

Whether Daumier's painting influenced his cartoons or vice versa is of course problematical. Also problematical, but relevant, is the relationship between Rembrandt's great painting, *The Side of Beef*, bought by the Louvre in 1857, and Daumier's butcher paintings and twelve butcher prints. Rembrandt was one of Daumier's significant teachers, and it is tempting to believe, as Lemann first pointed out, that Daumier's work was influenced by the Louvre acquisition. Daumier's watercolor echoes Rembrandt's mysterious handling of light. Daumier's significant differences are the addition of the butcher, enabling him to play in contrast the live muscular force against the inert mass, and the quietness of tone. Rembrandt's canvas is dazzlingly dramatic; the vivid reds and slashing flesh tones of the beef are bold beyond his century in their intensity of color. It is little wonder that Delacroix copied it, and that in our century Soutine painted the same scene in anguished violence. Nor is it surprising that Daumier, neither subservient nor slavishly imitative, adapted the subject to his own mood, to his own feeling for form and color. It is the same essential, physical meat, but the metaphors are different.

IX

WHEN SO MANY CRITICS feel this "tiredness" on the part of Daumier, it is best to seek in particular what they generalize. Throughout the decade of the 1850's there is a suggestion of Daumier's spiritual withdrawal from events. The coup d'état was a bitter blow. The Republic had failed, in good part because of its own folly, and Daumier's idealism was forced to face this shattering defection. Daumier resumed his comedy of manners, but his work fell off in quantity and, some critics say, in quality.

Daumier became more and more the painter. The powers released during the brief Second Republic could not be confined, and the canvases now familiar to art students began to accumulate. To live, he continued his cartoon duties, but procrastinating more and more until each deadline was imminent, and then,

only then, furiously producing eight stones in a single night. Daumier had reason to withdraw; he was *persona non grata* to the new government, as he had once been to the old. His house was searched for the subversive and insulting statuette, *Ratapoil,* and he who had so savagely and unambiguously attacked Napoleon the President could scarcely expect anything but suspicion and disapproval from Napoleon the Emperor.

Daumier was a man suspect, and it is to Baudelaire's eternal credit that at this period he dared to write in *Le Pays,* in 1857, his now famous article on Daumier, beginning with the words,

> But now I want to speak about one of the most important men, I will not say only in caricature, but in the whole of modern art. I want to speak about a man who each morning keeps the population of our city amused, a man who supplies the daily needs of public gaiety and provides its sustenance. . . . You will have guessed that I am referring to Daumier.[16]

This tribute, which furnishes almost the absolute basis for all subsequent evaluation of Daumier's prints (the paintings were not mentioned since the article was about contemporary caricaturists), startled and offended Paris with its daring and originality—startled, above all, with the idea that a mere cartoonist, a funny man, could even *be* an artist, at least within the cartoon medium. One critic scolded Baudelaire for omitting Cham, Doré, Marcelin, Guérin, and Randon, thus missing Baudelaire's central thesis, the cartoonist as artist. Baudelaire omitted these cartoonists because they lacked Daumier's unique gift, explained later by *Charivari*: "When he draws a print it is also a work of art." Himself prosecuted by the government, Baudelaire was guilty, too, of praising a proscribed man. Louis Martinet, director of *Le Courrier Artistique,* refused to reprint the article for fear of the censor and of the Emperor, a qualm not shared by *L'Artiste,* which reprinted it in 1858, thus maintaining its long tradition of friendliness to Daumier.

Perhaps what is meant by the charge of "tiredness" in Daumier's work in the 1850's is this subtle sense of discouragement which all the evidence suggests. Certainly Daumier had little reason for elation. The young art student and caricaturist André Gill came one day, the neophyte visiting the acknowledged master, only to be greeted with the discouraging words, "What! You wish to make caricatures! As for me, for the past thirty years I have hoped that each one would be my last." From the greatest of all caricaturists such words are ironic. They are the words of a tired man.

There were also physical troubles. An illness of 1858 almost killed Daumier. Baudelaire wrote to a friend, "I must excuse myself for not coming immediately to see you. I am on the Ile Saint-Louis, at Daumier's, who recently came close to death, and I am visiting with his wife. After dinner I will be at the Divan."[17] More than this has not been discovered.

Philipon, too, had been ill during 1858. Not knowing this, Daumier had called on him and apparently was turned away at the door. Philipon wrote him a note, previously unpublished, on 7 January 1858: "The slightest touch of cold lays me up for 10, for 15 days. . . . I was laid up when you came and did not see me. I do not want you to think that I do not wish to see you, so I am explaining what happened. I will always be delighted to see you when you care to visit." [18] Four years later, Philipon died and an important period of Daumier's life was concluded.

X

THE DIP IN DAUMIER'S FORTUNES during the 1850's reached its lowest point at the end of the decade. In poor health, weary of his cartoon load, Daumier by chance or by choice suddenly became free to pursue without interruption of editor or employer his artistic career. He left *Charivari* in mid-February 1860. Baudelaire, writing angrily to a friend, gives the basis for the universally accepted version that Daumier had been dismissed: "Think of Daumier, Daumier freed and kicked out of *Charivari* in the middle of the month and having been paid for only half the month. Daumier is free of all occupation except painting." [19] This statement is perhaps correct, but another interpretation might be considered. Baudelaire *might* have been speaking from insufficient knowledge, retailing unverified gossip; he might have heard that Daumier was no longer working for *Charivari* and then have assumed that his friend had been dismissed. Duranty quotes Daumier as once saying, "Let me be, I don't want to scrawl for you. I've had enough of parliamentary idylls, of national guards, of provincials at the fair, of fishermen, of over-decorated Souliches [a "Prince" from Haiti, then amusing Parisians], of candle-eating Cossacks; leave me in peace, I wish to paint. I must paint." Could the situation have been that Daumier had at last decided desperately to strike out for himself, to free himself from the "dreary cart," and to become, full time and known to the world, Daumier the painter? Certainly when he returned to *Charivari* later, that journal wrote about "our former collaborator Daumier, who three years ago quit lithography to devote himself entirely to painting." And when Daumier did return, he was given a celebratory banquet. The usually accepted version (Baudelaire's) that *Charivari* was so stupid and so cruel as summarily to dismiss its greatest name cannot be left unchallenged, even though it is more dramatic and highlights the downward slide of Daumier's fortunes at this time.

Daumier was hard up, but that was his constant condition. His friends, knowing that he had no financial reserves, rallied to help him find commissions, to sell paintings. Two unpublished and undated letters from J. Dupré to Daumier may possibly be from this time; in any case they are representative of

the efforts of the artist's friends.[20] The first (?), dated merely 11 February, reported the sale of five lawyer sketches, "to the great pleasure of those who have acquired them; I find them sold below their worth, but I did not dare to ask more in the fear of not succeeding. As to the sketch which remains with me, I will return it when you wish, if, between then and now, I have not been able to place it." The other letter apparently refers to that unsold sketch, this time sold and "the money to be sent shortly." Etienne Carjat, a young Republican journalist, artist, and photographer, wrote, 24 November 1862, in a similar helpful vein: "I recommend my friend Coquelin to you, of whom I already told you; try to find him a little masterpiece among your portfolios; you should not have to look very long for that."

Gavarni, then art editor of *Le Temps*, asked his old friend "to help him carry the burden of the magazine," but Daumier declined since it meant a renewal of the very cartooning which he had given up in order to paint. Baudelaire's letter announcing Daumier's dismissal showed a similar concern to help a friend, when he added, "Think of the Pharsalia and of Aristophanes. It is vital that he swing back up again like a pendulum. These two date back fifteen years. There is a great and a good business." The "great and good business" was an old proposal that Daumier be commissioned to illustrate Lucan's *Pharsalia* and the plays of Aristophanes, and Baudelaire felt that this would be a helpful moment to revive the plan. Nothing more is heard of this, but one suspects that Daumier again refused a friend's offer so as to guard his time for serious art as against illustration. This of course is regrettable; an Aristophanes illustrated by Daumier would be fascinating, his devastating realism complementing the satirical thrusts of the Greek comic writer. Both Daumier and Aristophanes had separately and rollickingly satirized Socrates and Bacchus. A collaboration across the centuries would have been fruitful.

XI

IN TIME, HOWEVER, Daumier could not turn down these odd jobs. Late in 1861 Etienne Carjat founded *Le Boulevard*, enlisting the support of Daumier's friends, Banville, Baudelaire, Champfleury, and the Goncourt brothers—and, soon, Daumier himself. On 18 February 1862 Carjat announced:

> Notice: Good news and good luck, both for the journal and for the public. The witty draftsman who has with the point of his grease-crayon composed fine, amusing satire for the past thirty years, will contribute two large sketches a month.

As part of the advance publicity for these lithographs, Carjat himself drew a lithograph portrait of Daumier (1 December 1861), and in a later issue (25 February 1862) printed Champfleury's essay on Daumier which would later be

part of the *History of Modern Caricature*, Champfleury's most important book. On 1 June 1862 Méry described Daumier as "the Molière of the crayon."

Daumier's *Boulevard* lithographs were carefully printed on white paper with no printing on the reverse side. Most of the pictures were serious, or at least less flippant than the average *Charivari* subjects. "Sunday in the Park" is of interest not only for its high quality but because the original stone, still ready for the press, is in the Boston Public Library (D3244). It is one of the few Daumier lithographic stones preserved, because the *Charivari* stones were usually scraped to make way for each new batch of prints. "Sunday in the Park" (Plate 57) is, as it were, a modest detail, stark and not sensuous, of the sort of thing done large and seductively by Seurat in *La Grande Jatte*. Or, more appropriately perhaps, it serves to illustrate T. S. Eliot's lines from "Spleen":

> Sunday: this satisfied procession
> Of definite Sunday faces;
> Bonnets, silk hats; and conscious paces
> In repetition that displaces
> Your mental self-possession
> By this unwarranted digression.*

Another print, "Nadar Raising Photography to the Height of Art" (D3248), shows Nadar in a balloon flying over Paris, his camera pointed at the city (Plate 58).[21] (Certainly history's first picture, or consideration, of aerial photography.) It is an amusing dig at his friend's two overwhelming passions: photography and ballooning. (The finest photographs we have of Daumier were made by Nadar, who used his camera to record Paris with the same comprehensiveness Daumier shows in his lithographs.) A print, "Inside the Studios" (D3246), has six collectors and artists admiring a painting on an easel, and is related to his drawing (c. 1862) of "The Critics," now in the Montreal Museum of Fine Arts. What is especially interesting is the possibility that the slim, standing, mustachioed figure, arms outthrust, is Dupré, Daumier's painter friend and agent, while the man stooping forward to squint at the easel is quite probably Daumier himself. Another print, "Landscapists at Work" (D3251), shows two painters sprawled comfortably on the ground in the shade of a tree (Plate 59). One suspects that this is a pleasant laugh at his Barbizon friends, Corot, Rousseau, or Millet, the print itself beautifully preserving the landscape which their idleness neglects.

The finest lithograph of these years, however, was *The Donkey and the Two Thieves* (D3253). It was a black and white version of the painting Daumier had made ten years before (now in the Louvre). The original stone of this masterpiece is also in Massachusetts, in a private collection.

[*Reprinted with permission of Farrar, Straus & Giroux, Inc. from *Poems Written in Early Youth* by T. S. Eliot. Copyright © 1967 by Valerie Eliot.]

PLATE 57 *Sunday in the Park*
Museum of Fine Arts, Boston, M. A. Evans Fund

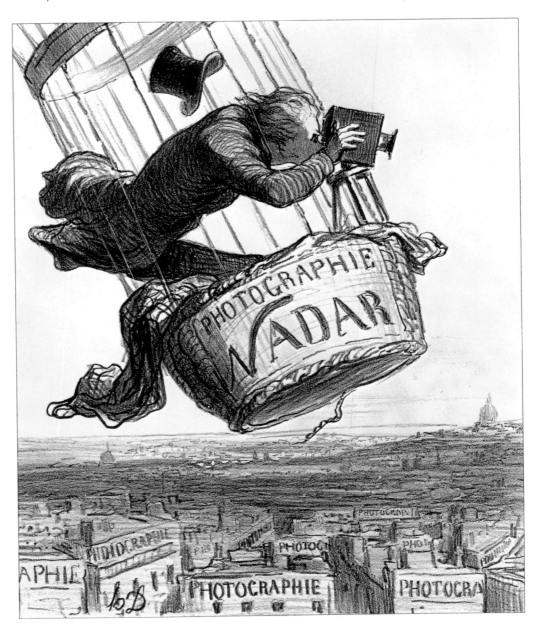

PLATE 58 *Nadar Raising Photography to the Height of Art*
Collection Philip Hofer

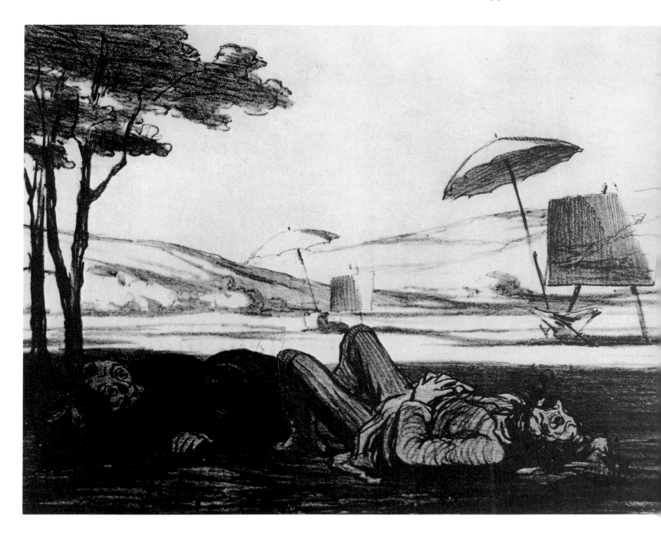

PLATE 59 *Landscapists at Work*
Collection Benjamin A. and Julia M. Trustman, Brandeis University

XII

FROM HIS WORK ON *Le Boulevard* Daumier could not have earned more than 600 francs, if that. It was only a matter of time and pride before he would return to *Charivari*. Late in 1862 Philippe Burty reported him as suffering "cruel penury," adding that he was unable to sell his watercolors even at the low price of fifty francs. On 16 December 1862, as shown in an unpublished letter to Madame Laubot, he was forced to sell some of his furniture, obviously in preparation for his move from the Ile Saint-Louis to the new artists' colony on Montmartre. The

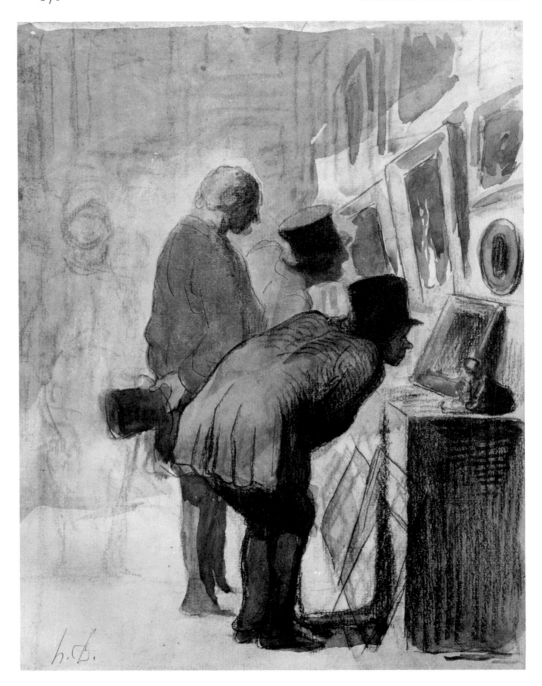

PLATE 60 *The Connoisseurs*
The Cleveland Museum of Art, Dudley P. Allen Fund

Daumiers took up residence first on the Boulevard Rochechouart, then at 26 Rue de l'Abbaye, and finally at 36 Boulevard de Clichy, where they stayed until 1869. At first some of his friends had difficulty finding Daumier, as a letter to him from Monnier shows, but eventually they discovered that they could find him at a café on the Place Pigalle, smoking his pipe and drinking his Beaujolais while he visited with friends and watched the passing show. Watched, and never grumbled at his lot. This is the man who, walking one day with Etienne Carjat through a poor Montmartre street, suddenly said, "We have our art to console us; but they, unhappy creatures, what have they?"

"Our art" for Daumier now once more probably included sculpture. He became friendly with Carrier-Belleuse, a sculpture student sixteen years his junior, a Republican recently returned from political exile in London. One of the *Boulevard* lithographs by Daumier was a portrait (24 May 1862) of Carrier-Belleuse. Undoubtedly it was at this period that Daumier made his self-portrait, a bust which Maurice Gobin rightly terms "one of the culminating points of his career." Handling the clay with considerable freedom—as the thumbmarks show—Daumier reveals himself smiling satirically, the ironic, detached, and loving spectator of the human comedy. The dynamic quality of this bust would not appear again in French sculpture, says Gobin, until Rodin's genius asserted itself. It should be noted that Rodin was an apprentice in the Carrier-Belleuse studio, and had undoubtedly met Daumier there. In later years, Rodin murmured on seeing Daumier's statuette of *Ratapoil*: "What a sculptor!"

Daumier's desperate attempt to shake off the shackles of journalistic art did not pay off in sales sufficient to maintain him. A few friends bought some of his work: Théodore Rousseau bought a painting for 1,500 francs. Giacometti, the biographer of Auguste Raffet, ordered a *Collectors*, and Daumier painted him sitting in his library, among works of art, looking at Raffet prints. Steinheil bought a painting for fifty francs. Daumier also had some pictures shown in 1861 and 1862 at the Louis Martinet Gallery, but these did not sell.

Daumier had no luck at the Salon in 1861, but in 1862 *The Laundress* was accepted. Chenavard, who was in charge of the hanging of the pictures, placed it high on the wall (the pictures were then hung close together, almost like tiles) so that it was almost impossible to see. Criticism was lukewarm. Paul de Saint-Victor in *La Presse* said that "the movement is just, the effect piquant, but I look vainly in this canvas for the imprint of that signature which has signed so many admirable prints; the brush must bring a chill to this lively talent." Another, Hector de Callias, saw in the picture "much intelligence, great adroitness in the contrasts, which makes one recall Gavarni's popular types." *The Laundress* remained unsold.

Capitulation to the "cartoon cart" was inevitable.

CHAPTER FIFTEEN

Daumier's Renaissance

HARIVARI'S DISGRACEFUL DISMISSAL of Daumier—if that was the way it happened—did not pay off. Cham's cartoons were adequate on the journalistic-comic level, but they lacked the rare quality of Daumier's work, which over the years had made the enduring reputation of the paper. On 18 December 1863 the editors wrote:

We announce with a satisfaction which will be shared by all *Charivari* subscribers that our former collaborator Daumier, who three years ago quit lithography to devote himself entirely to painting, has decided to take up the crayon which has brought him such success.

We present today a first plate from Daumier, and beginning today we will publish six or eight drawings by this artist who has a rare talent: when he makes a caricature it is a true work of art.

Théodore Rousseau said that the paper had done well. The staff held a banquet in honor of the return. *La Vie parisienne* alluded to the gay affair and printed an article by Champfleury praising the vigor of Daumier's crayon. They noted that had the banquet been publicized there would have been a thousand instead of a hundred participating. Such was the affection and appreciation that Daumier aroused among the discerning.

Daumier's first lithograph on his return, "Never Beer" (D3255), was a remarkable justification of *Charivari*'s concluding phrase—it is a work of art. A picture of an absinthe drinker talking to his beer-drinking friend, "No, never beer. . . . It's only absinthe that gives a man a lift," it concedes nothing in

180

draftsmanship and artistry to the various treatments of the subject made by "serious" artists (Cézanne and Degas, for example). Such a scene, along with those of the drama, drew strong praise from Vincent van Gogh, who wrote to Theo: "I am increasingly eager to see more Daumiers. He has pith and a staid profundity, he is witty and yet full of sentimental passion; sometimes, for instance in 'The Drunkards' ... I find a passion which can be compared to the white heat of iron." [1] Daumier continued with a few more similar studies before resuming the overt comic manner.

For the next two years, then—through 1864 and 1865—Daumier renewed the old task, the cartoon comedy of manners. Inevitably, unavoidably, and properly, the old subjects appear. These we know. With equal inevitability, since all his life Daumier refused to stay in the rut of a single style, the technique changed. Daumier's cartoon technique advanced to a new manner, affected by his persistent dream of being a full-time painter. Painting now became even more his main concern, lithography his living, but he made the latter serve the former. Working by day on his canvases and watercolors and by night on the lithographic stones for *Charivari*, Daumier often composed strikingly similar, almost parallel, studies in these different media. The orbits of comedy and seriousness often cross, often merge. Lithographs of the railroad coaches (e.g., D3273, 3298), of theater interiors (e.g., D3262, 3277), of café scenes (e.g., D3259, 3285, 3283), or of lawyers (e.g., D3278, 3288) are generically more than black and white treatments of subjects found in the paintings, and the cartoons are so "seriously" drawn that they *require* a legend to achieve a journalistic comic result. In these lithographs Daumier is clearly working with problems of space and especially of light which were troubling him in the more difficult and less familiar media of oil and watercolor. Speaking loosely, one may describe the lithographs of the two years following his return to *Charivari* as consisting frequently of sketches for paintings which he was composing for sale, many of which he indeed did sell; economically, however, the "sketches" sold, too, as part of his revived contract with *Charivari*, so that, as Baudelaire noted, the people of Paris could have the work of a great artist simply by buying the daily copy of *Charivari*.

This can be overstressed. Daumier was for the main part still the jester, and the larger number of the cartoons up to 1865 have the comic touch, to a greater or lesser degree, which keep them from being "serious" art. If at times Daumier blurred the boundaries between cartoon and art, on occasion he accentuated them, returning, for example, to his 1851 trick of drawing small bodies beneath large heads. With masterly draftsmanship he fixed forever an expression, a grimace, allowing the rest of the picture to dwindle off as comically insignificant, seeming thus to treat his human subjects as amusing bugs pinned to his drawing board, or as automata caught in the routines of Paris life. There is in this technique a lordly casualness as though the master were doodling. But they are

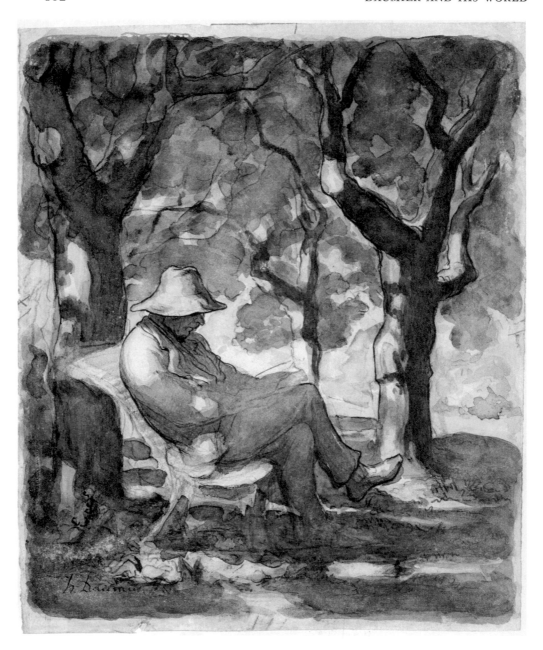

PLATE 61 *Corot Reading*
The Metropolitan Museum of Art, Bequest of Mrs. H. O. Havemeyer, 1929,
The H. O. Havemeyer Collection

doodlings one preserves—nor can they be forgotten. We sense, we *know*, that Daumier was doing a distasteful and repetitious duty, but we must concede mastery. These offbeat cartoons are, he almost says, "much ado about nothing" and "as you like it."

It is of the work of this period in the 1860's that Ivins wrote—speaking really for other critics:

> One is immediately impressed with three things, the suffusion of light, the great size of the pictures [they are not larger than most of the preceding ones], and the wholly amazing compositions. At last the problem of atmosphere has been solved as by no other maker of prints and by but very few painters. The prints are all gray, there are no violent contrasts of dead black and pure white, all through them light and air have their being. . . ." [2]

Perhaps the drawing of Corot reading (Plate 61) most clearly shows this newer, more "dappled" technique.

II

WITH THE 1863 MOVE to Montmartre and the return to *Charivari* that same year, Daumier's fortunes took an upward turn. His pictures began, slowly, to sell; discerning critics admired him; young artists of talent came to him in admiration: both Monet and Manet became his friends, and only shyness kept the young Cézanne from visiting Daumier's studio to pay his respects. Daumier himself was troubled by the new forces evident in painting; impressionism puzzled him. One day at a dealer's, looking at some canvases, he shook his head and demanded, "Who forces you to show such horrors?" Monet, who had overheard the question, later wrote, "I returned home that evening brokenhearted." Manet became part of the Daumier circle, and later the two men served on art committees together.

Another admirer, Bracquemond, tried one evening at Daubigny's place to reconcile Daumier to the Ingres manner, after Daumier had spoken slightingly of Ingres' treatment of historical subjects and had attacked the classical, or pseudo-classical, concept of beauty. Bracquemond countered, "How does it happen, Monsieur Daumier, that you, an imitator and copyist of the masters, have the same model as Ingres?" To the puzzled Daumier, Bracquemond then argued that Sudre's lithographic version of Ingres' painting, *The Sistine Chapel*, was similar in its handling of light and shade to Daumier's own lithograph, *The Legislative Belly*. Daumier was noncommittal: "You think so? I should look at it."

Now, receiving regular pay for the *Charivari* lithographs, and with his pictures beginning to sell, Daumier's financial position improved. Jean Cherpin has recently published a detailed report on one of Daumier's notebooks in which

the artist recorded his finances between 1864 and 1872.³ It corrects longstand-ing errors. *Charivari* now paid him 40 francs per stone, and Daumier profitably composed lithographs for the *Journal amusant*, which had been founded by his old friends Charles Philipon and Loüis Huart. He also made six sketches for *Autograph of the 1865 Salon* for which he received 100 francs.

More interesting was his success with collectors, to whom he sold 56 paint-ings and sketches between 1864 and 1868, including 14 to Beugniet, 4 to Madame Bureau, 6 to Delille, and 9 to Moureaux. A number of these were later lent to the 1878 showing of Daumier's work.

America's remarkable holdings of Daumier's works are explained by the perspicacity not only of the collectors but of their agents, notably of Lucas, who, living in Paris, bought for wealthy Americans from the circle of Corot's friends, Daumier included. Miss Agnes Mongan's discovery of Lucas' diary for 1864 shows his taste and Daumier's fortune:

26 February—called on Marcelle—not at home—looking up Daumier.

19 March 1864—carried drawing to Daumier—drawing to be finished in a week.

26 March 1864—at Daumier's, drawing not finished.

13 April 1864—met Daumier who told me that the drawing of the omnibus was finished.

28 April 1864—at Daumier's and ordered 1st and 2d class.

6 June 1864—note from Daumier . . . at Daumier's. Took and paid (200 fr.) 2 drawings 1st and 2d class Road—⁴

These sketches may be seen today in the Walters Gallery in Baltimore.

The notebook revealed by Cherpin dismisses, or alters, the familiar story of Daumier's ineptitude as a salesman. Albert Wolff, in *Figaro* (13 February 1879), relates how Daubigny advised Daumier to charge a prospective American pur-chaser the unusual (for Daumier) sum of 500 francs, but when the collector seemed pleased with the deal and then asked the price of a second sketch, the surprised Daumier stammered out his habitual price of 50 francs, thus disgust-ing the man, who left thinking that such low-valued work must be devoid of merit. The notebook lists successful sales, so that Daumier must have learned salesmanship. The notebook also changes considerably the long-maintained notion of a starving and totally frustrated artist. Between 1864 and 1868, accord-ing to this notebook, which certainly is not a complete record, Daumier aver-aged almost 400 francs a month, and he had the satisfaction of seeing his work sold to discriminating and distinguished collectors. If this was not the opulence enjoyed by his friend Corot, it certainly was not failure and lack of recognition. There is, for example, an unpublished letter from a man signing his name Ulric Richard Gesaix, asking Daumier to draw him a watercolor "of a superb sketch, already very old in date, representing Three Teasing Friends looking at an artist's painting, seated before his easel and enthusiastic about his own work—

a sketch engraved in a woodcut."[5] This is probably the familiar painting repro-
duced in Adhémar.

The success suggested by the notebook seems to connect with Daumier's
writing of his will, 21 March 1864, an act of a man of property: "I give and be-
queath to my wife Marie-Alexandrine d'Assy all that I own for her to enjoy as
her property from the moment of my death and to dispose of as she wishes
without anyone's having any other rights therein."[6]

III

As DAUMIER'S PICTURES SOLD, his name began to appear in the public press.
Champfleury, an untiring champion of Daumier since the 1840's, began to
gather several of his magazine articles on the history of caricature for publica-
tion in book form. Wanting something with which to introduce the Daumier
section, he wrote to Baudelaire, 24 May 1865, "You are full of Daumier and his
work. The poetry pertinent to this subject lies dormant in you . . . ; four verses,
ten, twenty as you wish." Almost by return mail—for the poetry on the subject
was waiting in Baudelaire—the poet sent the requested verses, adding the
clarifying sentence, "I meant that the satiric genius of Daumier has nothing in
common with the satanic; it is good to say this at a time when the portraits of
certain people, Jesus Christ for example, are altered by the fools who are com-
pletely myopic." Baudelaire's verses are a fine critical tribute:

> He whose image we place before you
> And whose art, subtle above all,
> Teaches us to laugh at ourselves,
> This one, reader, is a sage.
>
> He is a satirist, a mocker;
> But the energy with which
> He paints Evil and its sequel,
> Proves the excellence of his heart.
>
> His laughter is not the grimace
> Of Melmoth nor of Mephistopheles
> Beneath Alecto's torch,
> Which burns them, but chills us.
>
> Their laughter, alas! is
> Only a sad satire of gaiety;
> His shines forth, fresh and large
> As a sign of his goodness.

Castagnary said of Daumier, "I know no man whom praise upsets so much as this one; he always suspects that his friends overflatter him."[7] Maybe Daumier felt uneasy over Baudelaire's praise, his modesty blinding him to its justice; certainly he was bewildered by Baudelaire's remarkable critical essay discussing his caricatural genius. Champfleury, who knew both poet and artist intimately, wrote:

> The bizarre enthusiastic formulas of the poet troubled the artist who wondered with inquietude whether, in the glorious nimbus which he made shine above his head, the singular aesthetician had not skirted the fantastic and baroque. However sweet it is to be admired, Daumier feared the productions of the poet's brain.

IV

IN 1863 the urban Daumiers began to spend their summers in Valmondois, a village in the valley of the Oise, twenty miles north of Paris. Their Barbizon friends visited the area frequently to paint. Théodore Rousseau (who settled in nearby Pontoise) in a letter to his wife describes a visit to the Daumiers:

> We spend the evenings in all kinds of silly capers; poor Madame Daumier doesn't know what's going to happen next in such company; I proffered her an article of masculine clothing from my portmanteau to wear to protect her from our foolery; she refused it in her bashfulness.

François Millet and his wife also visited the Daumiers, and Corot was often there.

The Daumiers had been led to Valmondois by the influence of Geoffroy-Dechaume and Daubigny.[8] Daubigny had lived there as a child, and now as a famous painter he lived at Auvers, two miles south of Valmondois, in a house decorated by the art of his friends. He also had a houseboat for painting trips along the Oise. Geoffroy-Dechaume had been a lifelong resident of Valmondois. Undoubtedly these two friends encouraged the Daumiers to come there, first as guests, then as tenants, and finally as homeowners.

The valley of the Oise remains almost unchanged from Daumier's time. It treasures its memories of these great artists, including Cézanne's early visits, and above all the memory of Dr. Gachet and his care for the anguished Van Gogh, whose suicide at Auvers has made the area famous. Dr. Gachet's son (the generous donor of his father's collection to the Louvre) still lived, in 1953, in the family house at Auvers, a link between those great days and the present.

The Oise valley and the village of Valmondois are described by Arsène Alexandre, who visited there while gathering information from Madame Daumier for the first biography of her husband:

> In the valley of the Oise, amid a smiling nature, varied and luxuriant, surrounded by other villages which shelter behind the clumps of woods which rise in tiers

along the droll little hills, a village twists and winds curiously. It is an indifferent nook, but peaceful, discreet, and proper, where one can rest and reflect. Except for some estates a little more sumptuous . . . the closely shut houses have only a practical and parsimonious character which gives a common appearance to all the peasants' houses in all the villages round about. At the end of the principal street, just before it becomes open fields again, one of the houses is, if possible, more modest in appearance than its neighbors. . . . You enter and, at the end of a corridor, which runs beside a small kitchen, you find yourself in a rather large dining room, communicating by a glass door with the cheerful garden.

A very simple stairway, rising from the entry, winds upwards to a moderate-sized chamber which looks out on the countryside; a smaller one faces the street. Downstairs, one or two old cupboards, some crockery; in the bedrooms, rather modest furnishings, but on the walls the most beautiful richness: a number of sketches, studies, brightening the poor walls with all the radiance of art, ennobling them with all the majesty of intense labors.

The garden, which seems large, coming from this nest, is on an uneven slope; it has a few flowers, a few bushes, a few trees, a little grass. In walking across it, after fifty paces, one reaches the rear, where at the left [really right] corner sits a studio, a large shed glassed-in; it is a handsome room, full of gaiety and light, the *salle d'honneur* of this humble palace. There is nothing other than the art gear of an indefatigable worker; for ornaments preliminary sketches [of his lithographs], and in a corner, plaster medallions of Trajan's column; no luxury, no trifles, but, amidst this austerity, all the works begun indicate a ceaseless, intelligent activity. . . . The village is named Valmondois, and the little house is Daumier's.[9]

Daumier rented the house in 1865 for a term of nine years, at a rental of 250 francs a year, payable semiannually.[10] His first payment fell due on 1 October 1866. It was agreed that he might have a purchase option at some future date, the suggested price given as 5,000 francs. To make the place suitable for his work, Daumier had his landlord, M. Gueudé, build an atelier in the garden behind the house. It was to be eight meters long, six wide, and four high, with a casement window two meters long and two high for proper lighting. The roof and walls were plastered and the floor was paved with limestone. Until his retirement from *Charivari* in 1872, Daumier wintered in Paris and summered in Valmondois, and then withdrew to Valmondois. This was the house made famous by the charming, if inaccurate, story of Corot's gift to Daumier.

V

IN 1865 DAUMIER'S CARTOON CAREER took a new turn, finding new subjects and new forms—a new style—and in these later years Daumier rose to heights of cartooning unparalleled in the history of the craft.[11] This change and this achievement were directly related to the new liberalization in 1865 of French political activity, especially in regard to the restrictions against the press. It was the

relaxation known as the Liberal Empire, a slow, vegetablelike growth allowed by a tired, sick, and old Louis-Napoleon seeking the support of intellectuals so that he might carry out some desired reforms for France. Several events encouraged optimists. Late in the decade five old-line Republicans were elected to the Assembly. Several important political exiles were allowed to return home and take up their ordinary lives. On 17 November 1868, a fiery young lawyer from Marseilles named Gambetta unleashed a two-hour attack on the regime, an assault which passed without official reprisals. Daumier was especially gratified with the affair, not merely because he was a Republican but also because it fulfilled a prediction he had made several months before on meeting Gambetta at Carjat's house. Struck by the man's energy and intelligence, Daumier prophesied to Carjat, "I swear that he'll go far. He is one-eyed, but that doesn't prevent him from seeing with relentless clarity."

Given freedom to treat of political matters, Daumier quickly responded; restrained from dealing with particularities by the remnants of censorship, he perforce treated large issues, turning his attention from the parochial satire of purely French quarrels to a broader commentary on Europe. These prints of the last six years of Daumier's active cartoon career are for the most part above small partisan issues; they have a universal scope, an archetypal political significance recurrently applicable in history as the large follies of men repeat themselves in the political diplomatic circus. Many of the cartoons from this period are reprinted because of their undiminished timeliness, reminding us that Daumier, who during this period created the modern political cartoon, has never been equaled in the form he fashioned. This is not to denigrate the superb cartoonists of our time—Low and Vicky in England, Fitzpatrick and Herblock in America—or to belittle the cartooning skill of Daumier's own colleagues, Cham, Vernier, and Gavarni. But *Charivari* had penitently put its finger on the significant difference between Daumier and all other professional cartoonists.

There was another difference between Daumier and his contemporaries, a difference which also characterizes modern cartoonists. Daumier was serious; he now withdrew the cartoon from comedy (never entirely, of course), throwing away the wisecrack and the comic legend, relying for the most part on his own titles, terse signs only. Daumier was too concerned about the serious nature of events to waste his time in being merely the funnyman; his comedies of manners diminished as the clouds of war darkened over Europe. The threatening issues were too grave for flippant or facetious treatment. People and society he could laugh at; the follies of nations frightened him.

Even the trivial event which elicited jokes from his contemporaries was given a larger and serious twist by Daumier. For example, in 1870 the Roman arena in Paris was being excavated, and men like Cham made many jokes on this news item. With the Liberal Empire in mind and thinking back to the betrayals of 1830 and 1848, Daumier showed the "excavations of 2070" (D3792) when

posterity, in digging up the ruins of the National Assembly, finds the skeletons of Assembly amendments, plans for better laws, promised freedoms and reforms. This is not funny; it is pointed and grim. Or again, where others could make much comedy of the newly invented rapid-fire gun, Daumier showed it (D3711, D3713) as an election urn which has just mowed down the candidates on the field of political battle—a savage thrust at Louis-Napoleon's frequent use of the plebiscite to justify his dictatorial designs. Daumier was maneuvering close to the censor's scissors, but stayed just out of reach. In other words, he gave weight to the topical, using it as criticism and not as mere amusement.

Daumier's "last" manner is a draftsmanship stripped of all inessential, decorative detail. It is terse, stenographic, at times skeletal. A single line shapes an entire body, objects are sketched with a few sharp strokes which reveal but do not attempt to copy the object. These are cartoons in the modern sense of the word, omitting all sensuous surface detail which does not contribute significantly to the subject treated. All of Daumier's mastery of composition, all the resources of his "quasi-divine memory" are conscripted to serve these designs; they are rooted in and rise from an artistic training, experience, and talent which modern cartoonists do not have, or need. Linear and abstract, these late political cartoons differ vastly from Daumier's cartoons of thirty years before when he was in a sense painting through lithography. Concerned with economy of statement, Daumier uses not a single line more than is needed although every line is necessary.

The new technique came with a new content, with a new attitude toward political questions. Now Daumier's political references are abstract, depersonalized. From 1830 to 1834, and again from 1848 through 1851, he had drawn identifiable figures, the men of the Assembly. Now personalities almost disappear. People scarcely matter, except for Thiers (whose small, strutting figure was irresistible to cartoonists), Emile Ollivier, and Bismarck, and even they mean little in themselves but are symbols of high office, of power. In 1871, even with complete freedom to satirize the new Republic, Daumier's cartoons remain large and abstract, never focusing on the parts, the individuals, of the Bordeaux-Versailles Assembly. Their leader, Thiers, serves for the lot. Daumier, dealing with forces and powers, now draws symbolic figures, large personifications of War, Liberty, Peace, France, the Budget, Monarchy, Time, and Death, achieving a universality which renders them timely and topical today and tomorrow, as the same vast, terrifying problems recur—intensify and magnify—throughout the world. By metaphors at once simple and direct, but apt, Daumier gains thrust and edge and impact. The German helmet resting on Louis-Napoleon's tower, "Capitulation at Sedan," scarcely needs its stark legend, "The crown of his edifice" (D3811); it is a synecdochic summation of the humiliating collapse of the Empire, far barer but more biting and memorable than had Daumier merely drawn a picture of Louis-Napoleon facing

Bismarck in defeat. The scrawny vulture of the defeated Empire of 1870 (D3816) represents the death of all tyrannies, but remains also, spitted on the German sword, the Sedan defeat, and hangs appropriately above the fallen fleur de lis of 1830 and the Louis-Philippe umbrella of 1848. Even when Daumier draws an individual like Neyse, inventor of the rapid-fire rifle, he shows him staring over a field of corpses, his glaring eyes and skull-like face an image of Death itself. This is cartoon art with an intellectual concision every bit as intense as the technique with which it is drawn. Or, earlier, a circle of seated, snarling dogs (D3656) is seen wearing appropriate national hats, with the simple title, "The European Situation." Seventy years later Auden (unwittingly) quotes the cartoon in lines more famous than the print:

> And in the gathering of the dark
> All the dogs of Europe bark.

Through the cartoons of 1865 to 1871 we glimpse vividly the mounting tensions of Europe, when the newly intensified nationalism aroused national fears and swelled national budgets as wars and threats of wars increased. The rapid and ruthless unification of the petty German states by Bismarck meant the emergence of Germany as a world power, threatening not only the supremacy of France on the Continent but upsetting the whole balance of power in Europe and Asia. Daumier drew Europe balanced impossibly on her elbow on the point of a bayonet (D3552), and (D3566) trying to keep her footing on a rolling, fizzing bomb (Plate 62). Budgets appear under various symbolic forms in the cartoons, one of the best (Plate 63) showing Sisyphus struggling to push the great rock of the Budget up the hill (D3694). This print has been widely used in recent years in Europe and America.

The most important themes, however, are the precariousness of peace and the imminence of war. Daumier was not reassured by the customary clichés that armaments and diplomacy assured "peace in our time." Peace (D3633) bicycles on a cannon ("My velocipede," she gleefully brags), or she looks at her image in the mirror to see reflected a ferocious Mars (D3671). In 1868, Europe looks over her Christmas gifts; the toys about the tree are cannons and shot and bayonets (D3683). Raddled Diplomacy fondly gazes into the cradle where stands little Mars, armed and snarling, and says, "I put him to bed but he won't sleep" (D3505). For a brief interval in 1869 Daumier is diverted by Republican successes in the elections, but his sober, disillusioned summary of events is the picture of Man looking down at P-R-O-G-R-E-S, seven snails filing before him (D3738). Nor did Daumier deceive himself, as many Republicans did, that the liberalization of the Empire meant significant change; he saw it more accurately as Louis-Napoleon's attempt through small compromises to hold dictatorial control. At the end of 1869 Father Time identifies to 1870 the departing figure of 1869, "Reaction . . . pardon me, my error . . . Liberty" (D3754). Nor did the

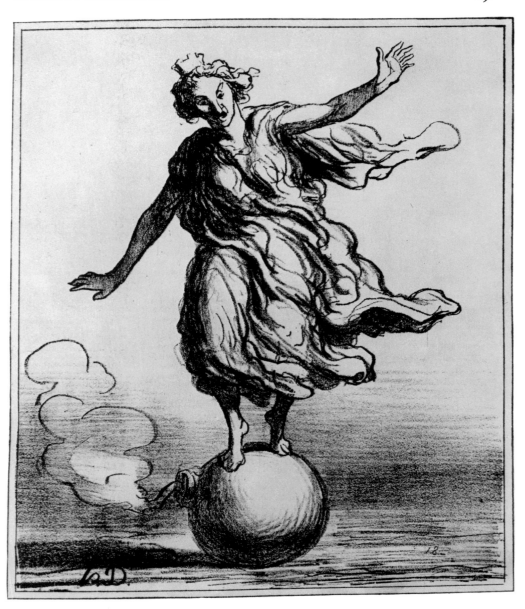

PLATE 62 *European Equilibrium*
By permission of the Harvard College Library

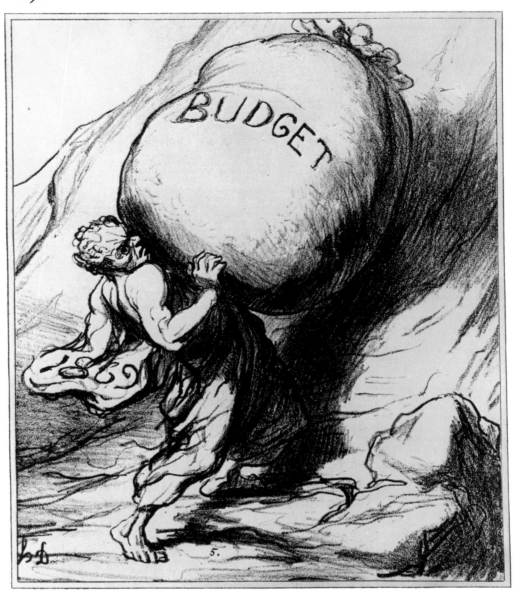

PLATE 63 *Sisyphus and the Budget*
By permission of the Harvard College Library

plebiscite of 8 May 1870 reassure Daumier, who had already seen the Emperor juggle plebiscites to consolidate his position. "Oh what a pleasure it is to be a voter" shows a rural voter torn by the four horses of No, Yes, Abstention, and Blank Vote (D3781).

VI

ONE EPISODE in the so-called liberalization of the Empire was the state's attempt to decorate Daumier in 1870. Thanks largely to the efforts of Etienne Arago, Mayor of Paris, Daumier was offered the cross of the Legion of Honor. He quietly refused it. As an enemy of monarchism and Napoleonism, his conscience would not allow him to accept ribbons from Ratapoil. At L'Isle-Adam, a few kilometers north of Valmondois, Courbet was offered the same honor. He refused it in a letter which was a blare of trumpets:

> Honor consists in neither a title nor a ribbon; it consists in actions and the motives leading to actions. Respect for oneself and for one's ideas compose its greatest part. I honor myself by remaining faithful to the principles I have proclaimed all my life; if I were to abandon them I should lose my honor in order to grasp its symbol.

Published first in *Le Siècle*, this letter was reprinted widely, attracted considerable attention, and elicited much praise. To celebrate Courbet's repudiation a gala banquet was held at the Restaurant Bonvalet on the Boulevard du Temple. Daumier attended, but to honor his friend and not to publicize himself. Courbet had visited him at Valmondois, asking him why he had not refused the ribbon with as much publicity as he, Courbet, had done. Daumier said simply, "I did what I thought I ought to do. I am content, and it is no concern of the public." Unable to understand such personal modesty, Courbet shrugged his shoulders in bewilderment, muttering, "One can never do anything with Daumier. He's a dreamer." But Daumier's refusal to Arago and his rejoinder to Courbet would have met with the approval of Baudelaire, who once wrote in his notebook, "If a man has merit, what is the use of decorating him? If he has none, he may be decorated, because this will give him a certain luster."

VII

THE WAR WHICH DAUMIER HAD CRIED OUT AGAINST finally came in the middle of July 1870, when Bismarck maneuvered France into a declaration of war unwanted by any but her leaders. Events moved with a nightmare speed which outstripped Daumier's crayon. Within a month Louis-Napoleon's army was crushingly defeated and he himself captured at the battle of Sedan. Amid the sorrow of national defeat the one consolation to Frenchmen was the immediate

declaration that the Empire was dissolved and the Third Republic born. Born to what? For she was helpless. Daumier drew a print of France standing between two cannons pointed at her, one labeled "Paris 1851" and the other "Sedan 1870" (D3808). This, said Daumier in the accompanying legend, was "The History of a Reign."

The German army marched across France to the very gates of Paris. The city held out in a long siege, cutting down its trees for fuel, killing the animals in the zoos and the rats in the streets for food, before capitulation to a token but humiliating occupation. Daumier made no prints of the siege; the cartoons drawn by his colleagues in other papers were not for him; he preferred silence. During the siege Daumier served on a commission, appointed by the artists, to look after the safety of art works in the museums of Paris. Similarly, a few months later he was a member of the arts committee of the Commune, serving with Bonvin, Corot, Dalou, Flameng, Armand Gaurier, Gill, Manet, and Millet—and Courbet. He protested when Courbet proposed to the committee the pulling down of the Vendôme column, a symbol of Napoleonism which many Republicans detested. Retaliation has its proper limits, but over the protests of Daumier and others, the Commune exceeded these limits and ordered the destruction of the monument. When, shortly after, the Third Republic took over Paris, it sought in turn to destroy all traces of the Commune, and among the worst acts of reprisal was charging Courbet the full expense of the column.

We have but few—and unimportant—Daumier cartoons of the 1871 Commune, none of its terrible blood bath. This was because of the repression of *Charivari* by the Commune, but one wonders whether a heartsick Daumier cared in any way to record this folly. It was left to his young friend and admirer Manet to create the finest artistic memorial of the Commune in the large lithograph, *Civil War, 1871*, a powerful print which owes much to *Rue Transnonain*, Daumier's great record of civil chaos.

VIII

DAUMIER'S WORK WAS ALMOST FINISHED with the establishment of the Third Republic in Paris. His favorite satiric target, Thiers, was made President. There is the story of a meeting at last between the two men—both from Marseilles— in which the old rancors and animosities were forgotten. Whatever his faults, Thiers was not petty in personal ways, and Daumier, as Forain said, was generous.

Daumier's long-pent-up anger at the Empire found fiery expression in some of his starkest, simplest, and strongest cartoons. "The Empire Means Peace" (D3814) merely shows some ruined, smoking houses and two corpses in the street (Plate 64). That is—all, and everything. "Napoleon Square" (D3824) shows a cemetery with four tombstones in the foreground memorializing those who had

PLATE 64 *The Empire Means Peace*
By permission of the Harvard College Library

PLATE 65 *Dismayed with Her Heritage*
By permission of the Harvard College Library

died (1) on the Boulevard Montmartre in December 1851, (2) at Cayenne, (3) at Lambessay, and (4) at Sedan. A low, beclouded harvest moon looks over the field of graves, much as Melville in *Israel Potter* has the full moon looking reflectively at the folly of the sea battle between the *Bonhomme Richard* and the *Serapis*. "An 1870 Landscape" (D3828) is even simpler: a cannon points out toward a bare landscape dotted with a few ruined houses to break the terrible emptiness. "Dismayed with Her Heritage" (D3838) has the same vast landscape, littered with corpses, with the foreground figure of France in mourning weeds, hands over her face (Plate 65). The simplicity and power of such a cartoon is beyond praise; it is an unforgettable experience. "Other Candidates" (D3844) uses the same vast landscape, but this time the foreground figure is France lying on her shield helpless, while the vultures in the distance approach the corpse. And a final print, in its compositional perfection perhaps the most dramatic, "Promethean France and the Eagle-Vulture" (D3847), shows France chained to a rock while the Napoleonic eagle (always, with Daumier, a vulture) gnaws at her vitals, the frenzied diagonal of the bird's wings and the body's extended arms counter to the diagonal of the body itself and the mass of rock (Plate 66). A masterpiece like this (and the others) has to rely for its preservation on the cheap *Charivari* paper. It is cause for despair.

Victor Hugo appreciated this work of Daumier, particularly one of the prints. In "A Page of History" (D3820) the eagle-vulture lies beneath Victor Hugo's *Les Châtiments* (The Punishments), the book into which the poet, in exile on the Channel Islands, had poured his fierce invective against "Napoleon the Little." A stroke of lightning from the sky has killed the bird. The bird impaled by the book refers to a passage from *Les Châtiments* in which Hugo had, seventeen years before, addressed the usurper Louis-Napoleon:

> . . . you say in your pride—
> I am going to be historic—
> No, rascal, the food of royalty is held from you. . . .
> Human rag, plucked owl, dead beast,
> You will remain outside, nailed to the door.

Hugo was delighted with the picture and immediately sent a copy of his book to Daumier, with a fine letter, 24 January 1871, saying, "You have made such a beautiful frontispiece for this book that it is now your's [*sic*] and I was waiting until you would honor me by sending it to me, but since you do not offer it, I give it to you. Your friend, Victor Hugo." [12] The two greatest foes of Louis-Napoleon, one a writer and the other an artist, are thus united in this print. Eight years later Victor Hugo readily accepted the honorary chairmanship of the committee which organized an exhibition of Daumier's work.

If Daumier's cartoons immediately after Sedan showed despair, they also showed courage, summed up in one eloquent print (D3843), again of amazing

PLATE 66 *Promethean France and the Eagle-Vulture*
By permission of the Harvard College Library

PLATE 67 *The Roots Hold Fast*
By permission of the Harvard College Library

simplicity of means and magnitude of effect: a tree reduced by storm to a mere trunk, and but one small branch still bearing leaves, with the legend, "Poor France! . . . the trunk is thunder-stricken [also, "riddled with cannon shot"] but still the roots hold fast" (Plate 67). This was the courage not merely of Daumier but of the entire country, as the German army moved irresistibly toward Paris and besieged the city for months before humiliating her with its token occupation.

The struggles to establish the Third Republic·form much of the burden of Daumier's last work. The maneuverings of the Jesuits, the hopes of the Orleanists and the Legitimists that they might resume power—these and related events are best preserved for posterity in the terminal prints of Daumier's long career. His last lithograph (D3937) shows Monarchy in her coffin, set against sheer blackness (Plate 68). The legend reads, "And all this time they have continued to affirm that she never was better." It is both simple and searing.

Michelet's admiration for Daumier found forceful expression as these late cartoons poured forth from the artist's grease crayon, and on 28 May 1869 he wrote his friend, "You were great, and you are sublime—the *Michelangelo* of caricature—This title will stick with you." [13]

IX

DURING HIS LAST YEAR ON *Charivari* Daumier tried two artistic experiments: he made a poster on commission,[14] and he made an etching.

The first came about as the result of a dinner at Boulard's house, where Daumier met a coal and wood merchant named Charles Desouches, owner of the Entrepôt d'Ivry (Warehouse at Ivry). Desouches needed a new poster for his business and showed Daumier one made in 1855 by Emile Bayard for another coal company. Working from Bayard's original, Daumier quickly sketched his composition, which was accepted and shortly after was lithographed (Plate 69). The coal man entering the kitchen has a big sack of coal (or wood) on his back; the delighted housewife raises her hands in pleasure. Simple as it is, its appropriateness is obvious. The original poster is a collector's item, almost unobtainable. The ten surviving copies appear in various states, constituting a complex bibliographical problem. Oddly, the poster is still used in Paris to advertise the same warehouse. An example may be seen on the Rue de Sèvres near the Rue de Rennes.

The etching also resulted from a dinner party. The evening of 29 May 1872, at the home of Charles de Bériot, a group of artists divided a copper plate into six rectangles, and while de Bériot played the piano the artists worked on the plate. Alfred Taiée drew a man at the piano (probably de Bériot himself) with a woman watching; Félicien Rops made a portrait of a woman in one rectangle and then

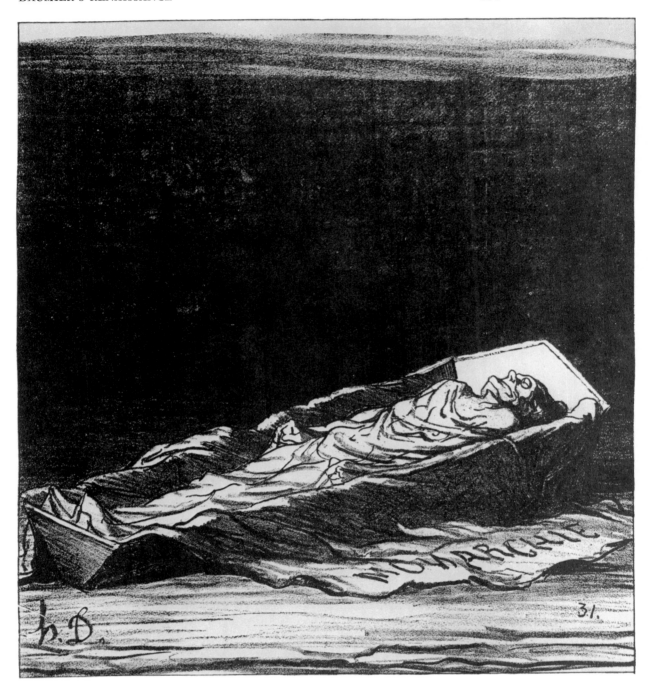

PLATE 68 *Monarchy Is Dead*
By permission of the Harvard College Library

PLATE 69 *The Charcoal Man of Ivry* (poster)
Museum of Fine Arts, Boston, Gift of George Mathias

PLATE 70 Daumier's only etching
Collection Benjamin A. and Julia M. Trustman, Brandeis University

repeated it in another; Harpignies, characteristically, contributed a Barbizon landscape; Daumier drew the head of an old man (Plate 70). One rectangle was left unfilled. The plate was later printed as the frontispiece of Champfleury's catalogue of Daumier's 1878 exhibition in Paris. Daumier tried no more etchings. Champfleury tells us:

> I was charged one day by the publisher Poulet-Malassis to ask Daumier for some etchings as frontispieces for some publications in preparation. Although this work was to be well paid, Daumier showed himself hesitant, timid, reluctant to work in a medium unfamiliar to him; in spite of the assurance I gave him that I would provide him a skillful engraver and relieve him of all the difficulties of manipulation, the artist refused.[15]

Despite Daumier's modest protest that the burin bothered his fingers, long habituated to the grease crayon, nevertheless the skillful and touching etching shows that he would have excelled in the medium suitable to his late drawing technique wherein the swirling lines build up the forms.

A few months after the poster and the etching, Daumier drew his last lithograph for *Charivari*, 24 September 1872. His retirement had come suddenly and sadly. For some time his eyesight had bothered him; at last it failed him. He told Pierre Véron, his editor, "I can't see any more. Today I drew a figure whose lines wandered so that I couldn't bring them together."[16] It was the announcement of the end of a career, and Véron records that Daumier could not prevent a tear rolling down his cheek.

CHAPTER SIXTEEN

The Great Paintings

ONE OF THE JUDGMENTS that can be made of Daumier is that he was a great painter. In comparing him to Rembrandt, Meier-Graefe called him "a painter so mighty, that no terms can exaggerate the greatness of his importance." It is therefore ironic how inadequately Daumier's paintings are known and appreciated. To the general public Daumier the cartoonist overshadows and obscures Daumier the painter and sculptor.

Paradoxically, Daumier was a great painter who produced very few great paintings. Rothenstein explains it:

This brings us to the consideration of a singular fact about Daumier, that although he was indubitably one of the great masters of the century, he has left no single masterpiece which, by itself, gives an adequate conception of his greatness. . . . One of the salient characteristics of the modern artist is his inability to bring his work to such a pitch of completeness as could his predecessors. Is it not possible that Daumier, who was so characteristically a modern man, should have suffered from this inability, and that, whatever his opportunities, he would never have brought his paintings nearer completion? Also, is it not possible, since his primary aim was a concise and forceful rendering of his subject rather than the creation of self-sufficient forms, that once this was fulfilled, he had no further incentive to make his work more complete? . . . But there is nothing sketchy about Daumier's brevity.[1]

One obstacle to public acceptance of Daumier as a painter is the unavailability of his work, which is scattered widely throughout the world. There is no

single large public collection of Daumier's canvases except for that gathered by Dr. Reinhart in Winterthur, Switzerland; even the Louvre has but five Daumier paintings, and not all of these are displayed at the same time. America is fortunate in having many paintings, but except for the five in the Phillips Gallery in Washington and the several in the Esnault-Pelterie collection in the Philadelphia Museum, they are widely dispersed in private and public collections. Furthermore, between the Philadelphia show in 1937 and the London one in 1961 there has been no large-scale exhibition of Daumier outside of France. Only the traveled specialist is able to see Daumier's serious work in sufficient breadth to form controlled judgments.

Perhaps another element in the neglect of Daumier as a painter lies in his subjects and techniques. During his lifetime his canvases were generally rejected at the Salons because they did not conform to the subjects then in style: historical, anecdotal, erotic. Quiet realistic portrayal of everyday French life was not wanted. Nor was the technique employed by Daumier then fashionable. He used no flashy brush work, no sensational tricks (gobs of paint, slick surfaces, virtuoso drawing), like the slashes of throbbing reds and blues used by Delacroix and Chassériau, for example. A simple man on the surface, Daumier had a subtle sensibility, and his color sense was extremely complicated. Daumier neither startles nor seduces. His paintings win friends and influence viewers more slowly than the work of other masters, but at the same time a Daumier painting seldom diminishes in our affections; rather, it expands and captures our imagination and pleasure as we live with it.

Daumier's paintings await a complete catalogue as well as a trained and informed criticism. Much has been done by critics to establish the Daumier canon, but the mystery of dating blocks significant attempts to discuss "development of style," the different periods, and other such matters. Daumier's work more readily divides into subjects than into style. He does not have a blue period, a cubist period, etc., like Picasso; he seems rather to have a theater period, a Don Quixote period, a genre period, etc., each long drawn out and actually a continuing interest (as his lawyers) rather than a "period." The full study toward which discerning students like Adhémar and Maison have been moving awaits final, or firm, answers to two questions: Which Daumier paintings and sketches are genuinely his work, either in full or in part? When were they created, or composed?[2]

The first question may perhaps never be satisfactorily settled since the essential requirement is that all the works now ascribed to Daumier be carefully examined by experts with the most sophisticated techniques of analysis. This utopianly assumes the complete cooperation of collectors and museums throughout the world. Marceau and Rosen began such an investigation, but they barely opened the subject, roiling rather than settling it. And even when the so-called scientific evidence is at last gathered, some ideal critic with deific detachment,

seismographic sensitivity, and encyclopedic knowledge must then evaluate the results, must venture final judgments in a field where finality is an *ignis fatuus*.

Equally difficult is the problem of dating the paintings. Possessing only a mere handful of the normal external records such as diaries, letters, Salon entries, reviews, and general gossip, one must lean heavily on similarities of subject and manner between the dated lithographs and the paintings, dubiously assuming simultaneous creation and hence identical dates. Such results are ambiguous; one works with hints and clues which get up and walk away like the wickets and croquet balls in *Alice in Wonderland*. Jean Adhémar has bravely attempted a chronology of Daumier's paintings and has brought some semblance of order out of chaos, but, as he himself admits, exactness is not always possible and approximations are generally the best that may be achieved. Even more recently, K. E. Maison has illuminated darkness.[3]

II

DAUMIER'S SUBJECTS fall roughly into eleven groups: 1) art collectors; 2) lawyers; 3) the theater; 4) portraits; 5) the socialities: eating, drinking, games; 6) the workers; 7) emigrants; 8) railroad scenes; 9) mothers and children; 10) clowns and acrobats; and 11) Don Quixote and Sancho Panza. These cover ninety per cent of his paintings in watercolor and oil. They are also the identical subjects favored by him over many years in his lithographs and woodcuts. In the paintings, however, the comic twist has entirely disappeared; here Daumier speaks seriously in searching metaphors, saying soberly and often somberly what he has seen and said thousands of times ironically and smilingly. Here, instead of treating man's small follies he deals with man's fate. The subjects seem the same, but the method and the medium, and so the feeling, are different. Nevertheless, every one of these paintings owes an immeasurable debt to the lithographs. If the Daumier genre paintings of the early 1830's were tinged with sentimentalism, this softness has disappeared in the paintings of twenty years later. The cleansing and clarifying experience of thirty years and three thousand lithographs of everyday reality—"One must be of one's own time"—had burned out the incipient sentimentalism of the early years. In his serious media, Daumier painted cleanly and directly the simple world which he knew well, capturing what Keats called "the holiness of the heart's affections." Here is a world of simple people reminiscent of paintings by Teniers and Jordaens, men and women drinking, singing, smoking together convivially—here is the health and sanity envied and praised by Baudelaire.

III

MOST FAMOUS OF ALL DAUMIER'S PAINTINGS is *The Third Class Carriage*,[4] a masterpiece preserved in three copies: the first is a watercolor, in the Walters

Gallery, Baltimore; the second, copied from the first, is a squared canvas (the squaring lines quite visible) three times larger than the watercolor version, in oil on canvas, in the Metropolitan Museum, New York; and the third, also a canvas, is in the Toronto Art Gallery. The Metropolitan version is the most often seen and most frequently reproduced, and, indeed, perhaps deserves priority in excellence.

One of the finest touches in Adhémar's excellent book on Daumier is his photographic reproduction of twenty different studies, made in lithograph, sketch, and painting, of travelers squeezed together in a train compartment; it is a good selection of Daumier's variations on a theme which had fascinated him ever since the early 1840's with the first extensive building and expansion of the railroad in France. Many dozens of his cartoons exploit the infinite possibilities for comedy (see, for example, D3299)—smoke and cinders, crowding, open and unheated carriages, noise, etc.—inevitable to train travel, and the equally enchanting variations of the visual possibilities—slanting lines of cars and railroad tracks, faces and figures in new and frightening situations. *The Third Class Carriage* (Metropolitan) is the artistic culmination, the climax, of a long experience and deep interest in the railroad (Plate 71).

The Third Class Carriage was a difficult subject for a composition. What, exactly, can one do with three rows of people enclosed in a box? At least when Daumier had drawn the rows of parliamentarians in *The Legislative Belly*, the rows had been curving. Now he again mastered both the technical and symbolic problems confronting him. The foreground row of figures becomes a broad pyramid. The forms are conceived in vast contours (the Michelangelo allusion is inevitable and necessary), and as Meier-Graefe noted, "It still bears the mighty thumb-mark of the sculptor." The predominant colors are brown (always a favorite with Daumier), pink-rose, and gray, with touches of green or green-blue, and the figures are enclosed with subdued tones which enhance, or evoke, the visionary aspect and power of the painting. Daumier laboriously, slowly, built up his forms, as Marceau and Rosen showed in photographic analysis, in thin glaze upon thin glaze of watercolor-like paint. The effect is not lyrical but rather is massive and sensuous.

The literary interplay of meanings in the painting is as carefully contrived, but natural, as the composition itself. The painting is at once realistic and symbolic—potently symbolic because it is so firmly grounded in actuality. The central figure of the grandmother is both an old woman and Age. Gnarled, worn, and weary, she stares neither at her family nor out of the canvas but into herself and down the years of her long life. She broods on the mystery of iniquity and goodness—for experience of both have lined her face—with the solemn grandeur of the lonely figure of The Adams Memorial. She is monumental in the manner of Daumier's sketch of *The Republic*, but more satisfactory to us because she is more real, not created in deliberate allegory.[5] "This is mortality, / this is eternity."

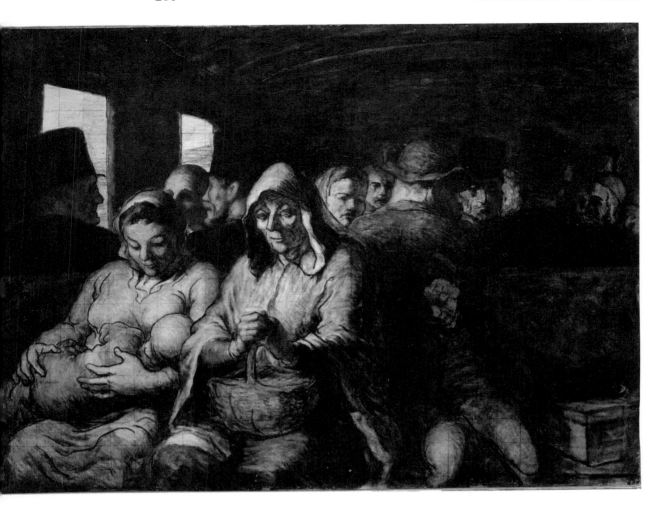

PLATE 71 *The Third Class Carriage*
The Metropolitan Museum of Art, Bequest of Mrs. H. O. Havemeyer, 1929,
The H. O. Havemeyer Collection

She takes on symbolic extensions and can, as Josephine Allen says, "take her place beside other magnificent figures of old age—The Cumean Sibyl by Michelangelo or Rembrandt's Old Woman Cutting her Nails." [6]

The sweet-faced mother nursing her baby is the maternal image, creativity, the life-force. The boy slumped on the bench asleep is innocence and childhood. The men and the women in the background are of various ages and professions. The rhythm of man's years is as clearly, if implicitly, expressed in these figures as in the words of Jaques on the seven ages of man.

Another counterpoint makes itself felt between foreground and background. The foreground voices the theme of loneliness. These four figures are, to borrow a word from Melville, "isolatoes." The grandmother is alone with her

brooding memories, death is near her; the young mother and baby are absorbed, as one unit, with physical being and animal love, which oppose the age-death of the grandmother; the sleeping boy is alone in his world of dreams. The background voices the theme of the "socialities"; men and women talk together, for the moment friends in their life-voyage, not strangers. The entire composition, seen intellectually and unaesthetically, has the purity and force of a parable with the actuality of the physical world as well. It is firmly fixed in space and time and yet transcends them.

This serious and rich painting is by the greatest of all comic artists, and there is no paradox involved. The comic vision in our time is inextricably entangled with the tragic; Daumier's comic art shades off, even in cartoons, again and again into serious, even tragic, suggestions. Now, openly, profoundly, like the later Rembrandt, Daumier gives full expression in *The Third Class Carriage* to a somber but sure affirmation of life, good and evil, wrung from the infinite ambiguities of human experience.

IV

THE MOTHER AND CHILD is one of the important subjects of Daumier's art, expressed in many drawings, lithographs (with comic overtones), paintings, and one fine statuette. It is perhaps best represented by the painting of *The Laundress* which hangs in the Louvre. A subject as old as history and as new as each birth, in religious terms represented in endless paintings of the Madonna and Child, here Daumier gives it secular form which, in his humanistic way, is as reverent as the overtly religious icons. Daumier painted what he saw every day outside his apartment on the Quai d'Anjou: the mother coming up the steps from the Seine, her laundry under one arm, helping her child with the other. (In some sketches she carries the child.) So important was the subject to Daumier that he made an affecting statue of a laundress and her child—now in the Walters Memorial Gallery in Baltimore (Plate 72).[7] The statue was probably that seen, or mentioned, by Poulet-Malassis in his journal for 14 January 1852:

> Baudelaire took me to Daumier's, Quai d'Anjou. . . . He [Daumier] also does sculpture. . . . I see a huge bacchanal in wax on the studio wall. Various sketches. A Magdalen, a laundress pulling a little girl along the quai in a high wind. A sketch of so sad a mood that one might think the enormous heap of laundry under her arm [is] on the way to the pawnbroker's.[8]

This statement is slightly obscure, since the word "sketch" (*ébauche*) may possibly refer not to a sculpture but to the sketch of a painting. Nevertheless, this need not change the date of 1852 either for the sculpture or for the pictures (for there are several versions of the scene). Certainly the sculpture was made at the same time as the paintings, for Daumier's practice was—as with the political

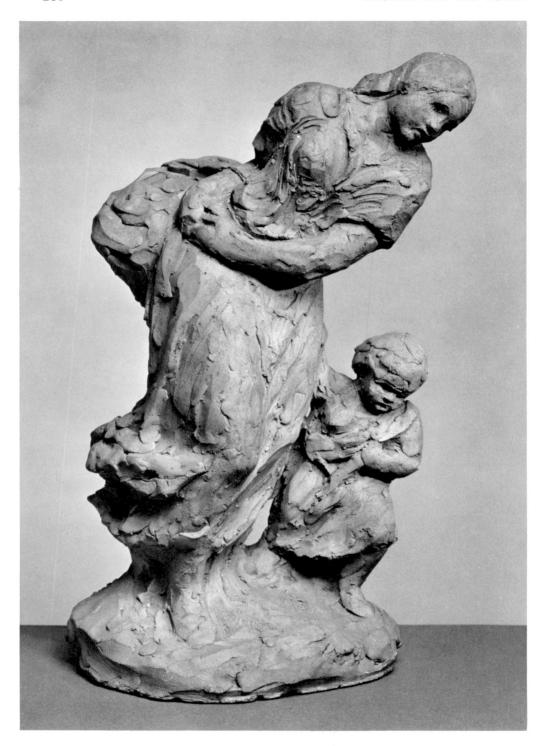

PLATE 72 *The Laundress* (statue)
The Walters Art Gallery

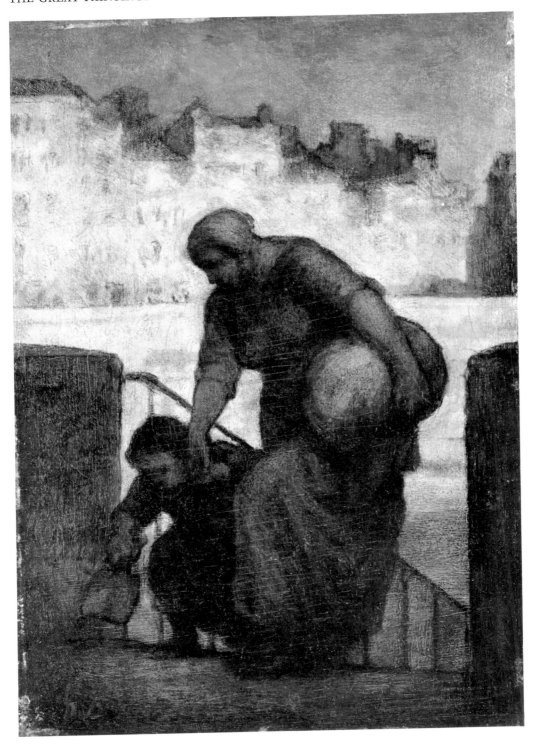

PLATE 73 *The Laundress* (painting)
Albright-Knox Art Gallery, Buffalo, New York, George B. and Jenny R. Mathews Fund

caricatural heads and with *Ratapoil*—to make a sculptural model for any work which he was to undertake over an extended period of time and in several versions.

In another painting of *The Laundress*, at the Albright-Knox Gallery, Buffalo, the mother's features are concealed, as are the child's (Plate 73). She is painted in low, rich, reddish-browns, massive and solid against the background of the whitish buildings across the river which set the human figures in somber relief. The waking city and the quayside constitute the canvas counterpart of Baudelaire's lines in "Morning Twilight." 9

> The dawn, shivering in her robes of rose and green,
> Advances slowly along the deserted Seine,
> And darkened Paris, rubbing her eyes,
> Seizes her work-tools like an old laborer.

Focillon wrote that Daumier "drew from the dust of the days the little fact which means nothing in our eyes, and he projects it into an absolute space where it acquires the enormousness of a symbolic representation." 10 His words imply *The Laundress*. Like the aged woman in *The Third Class Carriage*, the laundress-mother is at once reality and symbol. She is real, bearing the burden of her work and of her child; she is symbol, bearing the burden of life. She is the silhouetted, outlined figure popular in romantic fiction and painting, but Daumier saves her from platitude by making her solid, as real as the woman next door. She is, in a phrase of Faulkner's, one of the "lowly and humble of the earth, to endure and endure tomorrow and tomorrow and tomorrow." She is one of the insignificant who are significant. An urban counterpart of Millet's peasant woman, she has the advantage that her painter knew better how to handle light so as to convey immense mystery and magnitude in a small canvas. The effect, visually and symbolically, is large, monumental, and poetic.

CHAPTER SEVENTEEN

The Clowns, Don Quixote,

and Sancho Panza

ANY A GREAT ARTIST toward the end of a long and productive life crowds into his art summations and conclusions drawn from accumulated depths of insight and wisdom; Rembrandt's late portraits, Shakespeare's *The Tempest*, Melville's *Billy Budd*, Beethoven's late quartets, and even young Mozart's (he was old in musical years) *Requiem* are good examples of these compressed statements, which have often been described as personal as well as fictional testimonies. And frequently, in these later works, or even throughout the works preceding them, an artist, above all a novelist or poet, will bear witness, through subtle indirections, to the creative process beneath the work under construction, indulging in a kind of double talk, and, indeed, making the creation of his work part of the work itself. For instance, in *Moby-Dick*, Melville throws out many an open statement, as well as indirect clues, to the penning of his book, as in "The Spouter-Inn" where he describes a strange painting on the wall, using terms about the picture which are clearly apposite to his own novel. Witness Mann, Gide, and Proust in our own time. It would be an unimaginative critic who would dare question that in *The Tempest* Shakespeare wrote as much about himself

as poet as he did about Prospero as exiled but conquering Duke. In a similar way, Daumier in the great paintings of the 1860's is summing up the experience of a lifetime, both his convictions about the human condition and his reflections on his own career as artist. These revelations are made most aptly in the two great series which climax his work as a painter: *The Clowns*, and *Don Quixote and Sancho Panza*.

Daumier's identification with the clown* was longstanding, inevitable. The jester with his cap and bells, his quiver of arrows, had been the logotype designed by Grandville for the masthead of *Caricature* and *Charivari*, to represent himself and his colleagues in the charivari band, and it is but one step from this concept to *Mountebank Musicians* (Philadelphia Museum of Art, Esnault-Pelterie Collection) painted a generation later. Daumier and his *Charivari* friends knew well the great French clowns of the period, Odry and Deburau, mentioning them frequently in their newspaper, the clown citing the clown.[1] Furthermore, irked by the cartoon burden of having to be funny eight times a month, Daumier took a dim view of his career, which seemed to him to be a forced kind of clowning, gestures made on a newspaper stage to please an audience whose lungs were tickle o' the sere. It is therefore interesting, ironic, significant, and appropriate that when Daumier turned from his cartoon clowning to serious art, to painting, he made the clown's life the subject for some of his finest pictures. It was a profound identification.

II

> Hence it was
> Preferring text to gloss, he humbly served
> Grotesque apprenticeship to chance event,
> A clown, perhaps, but an aspiring clown.
> WALLACE STEVENS
> "The Comedian as the Letter C"†

THE CLOWN, OR THE FOOL, is a symbol with multiple meanings, protean in its forms. As old as recorded history, found among primitive tribes and in sophisticated societies, the clown has always been a profound emblem to men of their own condition, and so serves even more appropriately today as our machine

[*I use the word *clown* fully aware that it is unsatisfactory, but then no other single word is adequately descriptive. *Acrobat* is too limited, being primarily physical in reference; *acrobat-clown* is too awkward. *Entertainer* is vague. Maybe *jester* is as effective as clown, but if one will notice the terms in their contexts, keeping in mind that the underlying meaning of the word is the sense of the ridiculous, the sense of the absurd, there should be little trouble.]

[† From *Collected Poems of Wallace Stevens* (New York: Alfred A. Knopf, 1955). Reprinted with permission of the publisher.]

society threatens our humanity. Wallace Fowlie has persuasively argued that the clown is perhaps the major and most popular symbol in modern history, recurring frequently in literature and the arts. He is Pagliacci and Petrouchka, Charlie Chaplin's tramp and Emmett Kelly's sad-faced hobo; he is found in Rimbaud and Mallarmé, in Rouault, Picasso, Toulouse-Lautrec, and J. Alfred Prufrock ("Almost, at times, the Fool"). The clown is of interest because he poses profound problems about ourselves and about the very nature of reality. At first, he seems merely a creature on the stage, hired to amuse us, separated safely from us by the footlights or the frame; then suddenly the frame has disappeared and he is us, or we are he.

The clown must be the subject of a subtle and informed book; here his meaning may only be suggested in a few sentences. He must not be seen only in the sentimental tradition of *Pagliacci*, smiling through his tears, or in the absurd tradition of Hugo's *The Man Who Laughs*. Complex and varied, he serves as a mirror of our own simplicity and subtlety, he reflects our dreams and desires and despairs. Enacting the fantasies of mankind,

> [He] is a priest . . . performing a rite both in his own and in our behalf . . . the locating, naming, bringing to a head, and expressing a psychological element which has been causing trouble in the unconscious; a renegade element, which for the sake of self-integration . . . should be brought up to consciousness, released, to a certain extent experienced and consciously related, and so assimilated into the personality of the speaker.[2]

Like us, the clown is overwhelmed by the complexity of the world, which becomes alive and menacing, trees and buildings taking shape and movement to destroy him. He attempts to master the menace, to bring order out of chaos, to extract meaning from multiplicity. Re-enacting our plight, the clown is our scapegoat. He tries to feed the elephants but falls over the ropes; he suffers the custard pie and the pratfall. When the machine threatens, as in *Modern Times*, he fights it as his inevitable lot. Against the rigid forms imposed by society he retains, grotesquely but heroically, his resilience. The clown is man willing, even eager, to meet life tomorrow and tomorrow, to the last syllable of recorded time, although defeat is his final destiny. The clown is the comic Sisyphus; through him our rolling of the rock is revealed, re-enacted, and made endurable. The clown is the comic catharsis.

III

DAUMIER'S FIRST, MOST NATURAL IDENTIFICATION with the clown was in his role as entertainer. Both, as it were, played upon a stage. That "All the world's a stage" had been realized long before Jaques gave the idea its most memorable form, and it is almost an archetypal metaphor, but Daumier gives it new force through

PLATE 74 *The Clown*
The Metropolitan Museum of Art, Rogers Fund, 1927

plastic means. In *The Clown*, a charcoal drawing in the Metropolitan Museum, the clown is the barker, trying to attract people into his show by gestures and speech, while behind him the drummer punctuates his pitch with arresting beats (Plate 74).[3] "And that clown," wrote Elie Faure, "with the painted face and the great living gesture has something about him resembling an archangel opening and shutting the gates of paradise and hell."[4] To this picture, and many others, Baudelaire's apostrophe might serve as an epigraph:

> Starving clown, show your attractions
> And your laughter drenched in tears one does not see
> To drive away the spleen of the vulgar herd.

If this picture, however, can yield to a word analysis, it must be left to a skillful critic to make; all we can do here is to marvel at the swirl of lines from which the characters emerge, realizing how they capture and reveal the intense energy and action of the clown to attract an audience. The drawing is magnificent.

This is true also in *Les Saltimbanques*, which is in the Victoria and Albert Museum (Plate 75). The acrobats are ready to begin their act—or have they just finished? The crowd is clustered before a distant booth. The acrobat-clown troupe, a family, is clustered at the left in a pyramidal construction rising from the child playing on the ground, up to the father, standing, his face toward the crowd at rear right. The picture divides into two triangles of light and dark. Both pyramid and triangular division of the picture were favorite devices of Daumier and here they are manipulated naturally, delicately, and firmly—essentially a conservative composition, but satisfying. The two triangles create a tension of idea, or feeling, between them, an opposition of themes, such as actor *vs.* public, society *vs.* isolation, seriousness *vs.* frivolity, etc. Castagnary wrote in *Le Siècle*, 25 April 1878: "We know nothing sadder or more poignant than the *Saltimbanques* of Daumier," and seventy-five years later a casual passer-by seeing this drawing asked, "Why should such a simple drawing move one so profoundly?" Why indeed? But it does.

Equally affecting is the watercolor drawing of the same family, *Mountebanks Changing Place* (Wadsworth Athenaeum).[5] Three acrobat-clowns—man, wife, and son—are walking through the city, presumably having finished a performance. Their scant equipment is held in their hands. Their faces are gaunt and tired, their figures bowed. Behind them rise the buildings of Paris, a stone prison from which they cannot escape (Plate 76). The design is simple: two interpenetrating triangles, bare buildings and three people realistically drawn, but the resulting composition is far beyond realism. Here is Daumier the visionary, piercing through the daily event to a poetic sense of man's journey through life. Satisfyingly and firmly real, it is also as allegorical as Everyman. The terrifying, saddened sense of human isolation, even within a family, is simply and powerfully evoked, as it is also in Picasso's celebrated *Saltimbanques* (Chester Dale

PLATE 75 *Les Saltimbanques*
Victoria and Albert Museum. Crown Copyright

Collection), which shows five people staring out with nothing behind them but a bare sky—the painting which inspired one of Rilke's *Duino Elegies*.

IV

It might seem that too much emphasis is given here to sketches and watercolors, discussing them as seriously as though they were paintings. Daumier drawings, personal or public, justify this consideration. Drawings may be put in

PLATE 76 *Mountebanks Changing Place*
Courtesy Wadsworth Atheneum, Hartford

two classes: the "working" drawings which an artist makes for his own pleasure and reference, and the "finished" drawing which he makes for public display. The "working" drawing is of course more intimate; it directs the attention of the beholder to the artist himself, to the artistic act, to the manual dexterity exhibited. The "finished" drawing is less personal, more removed, deliberately composed, and often retouched; it is a public presentation. To the trained eye, however, the "working" drawing will have a strong attraction, because it is close to the sensibility of the artist. Daumier's lightest sketches have this special appeal. Claude Roger-Marx has repeatedly asserted that in these informal sketches, made for his own personal needs, Daumier is more himself, more revealed, and more the master than in the lithographs or the paintings.[6] The jotted sketch reveals more than the formal design; in its freshness and frankness, its directness, it has delicate charms which rise from the spontaneous but educated draftsmanship. Daumier could not make a false line, and there are notational sketches in which by a few quick strokes, an instinctive use of the pencil, he surprises a scene or an object, arresting it for eternity. (*The Running Boy* [National Gallery, Washington] is a superb example of this sort, a work which one takes to heart more readily than some of the greater works or more complicated paintings which are its neighbors.)

The clown sketches are for the most part "finished" ones, arranged carefully within a frame, complicated by forms in significant relation to each other (several "working" sketches brought together, as it were).

Curiously, Daumier's finest clown pictures are, for the most part, watercolors and sketches rather than oil paintings, although a few canvases treat the subject. The best, the *Crispin and Scapin* in the Louvre, uses the footlight glow to surround the figures in lavender light, which gives the painting a nightmarish quality (Plate 27). Another, a clown's head (Sydney Brown Collection, Switzerland), is a strong psychological portrait, the whites of the costume and make-up accentuating the uncertainty, the anxiety, the withdrawn character of the sitter, a half-smile twisted on his lips for the audience, all of this set against a black background.

It was the publication of *Les Saltimbanques* in *L'Art* in 1878 which elicited a sensitive appreciation from Henry James, who wrote,

> It exhibits a pair of lean, hungry mountebanks, a clown and a harlequin beating the drum and trying a comic attitude, to attract the crowd at a fair, to a poor booth in front of which a painted canvas, offering to view a simpering fat woman, is suspended. But the crowd does not come, and the battered tumblers, with their furrowed cheeks, go through their pranks in the void. The whole thing is symbolic and full of grimness, imagination, and pity. It is the sense that we shall find in him, mixed with his homelier extravagances, an element prolific in indications of this order that draws us back to Daumier.[7]

"Grimness, imagination, and pity"—these describe all the clown-acrobat pictures.

As a student of the grotesque, and so of the clown, Daumier, seismograph of so many nineteenth-century spiritual tremors, came almost inevitably to record the greatest, the noblest, of all absurd heroes: the lanky hidalgo enacting his personal fantasies across the expanse of Spain.

V

"AT LAST," wrote Paul Valéry, "Daumier became enamored of Don Quixote." "At last" must be amended; Daumier's interest in Don Quixote had been of long standing, dating back at least to an 1839 *Charivari* woodcut (B179),[8] and to his painting *Don Quixote at the Wedding Party*, exhibited at the 1851 Salon but now lost. It was probably in 1863 that the publication of Gustave Doré's immediately and immensely successful illustrations for Cervantes' novel encouraged Daumier to compose the watercolor sketches, the oil paintings, and the lithograph of Don Quixote and Sancho Panza which are the apogee of his artistic career. Stendhal once said, "The discovery of Don Quixote is perhaps the greatest moment of my life," and Valéry in effect affirms the same for Daumier.

In their admiration for Don Quixote, Daumier and Stendhal reflected their age. *Don Quichottisme* was a strong sentiment in nineteenth-century France, attracting either the simple or the sophisticated. In *The Crime of Sylvestre Bonnard*, that suave ironist, Anatole France, acknowledged this as he described the figures of knight and squire on the head of Bonnard's cane, and concluded, "We all have in us a Don Quixote and a Sancho Panza to which we listen, and though it be Sancho who persuades us, it is Don Quixote who compels our admiration. . . ."

Other artists expressed similar affection.[9] Fragonard made nineteen drawings of the Don which in their creative freedom from the literal text and in their fine draftsmanship are the authentic anticipation of Daumier.[10] In 1836–37 Daumier's *Charivari* colleague, Tony Johannot, drew hundreds of charming woodcuts for the new Viardot translation which became standard in France. Grandville drew another set no less graceful and appealing. Strongly attracted to literary subjects, Delacroix painted Don Quixote, as did Decamps and Nanteuil. All these men were friends of Daumier, and another, Balzac, remarked, "I am like Don Quixote. I like to defend the weak against the strong." Finally, the pages of *Charivari* frequently used Don Quixote as a symbol of their libertarian-humanitarian crusade, their tilting at political windmills.[11] The Daumier circle was one of Quixotics.

That Don Quixote was Daumier's secular saint is proved, if proof is needed, by the words beneath his second woodcut of the subject (B972):

Cheers! Bravo! Hip! Hooray! It's him, really him, always brave, generous, magnanimous, imprudent. He has changed his lance for the modern weapon, the pen, to pierce the follies, the vanities, the platitudes which revolt his great soul.

Rosinante herself, forgetting her past fatigues, is infected by the fire of enthusiasm and makes her old bones rattle beneath her dried-up hide. Heh! Don't you know, Knight of the Rueful Countenance, that our mills have iron gears dangerously different from the blades of your day? That doesn't matter? March always, and the maimed themselves will applaud you, perhaps.

Study Daumier's paintings with these words in mind, with their social and ideological implications both for the period and for the artist.

As one who had designed more than 3,000 lithographs attacking "the follies, the vanities, and the platitudes" of a sheeplike society, as one who had charged recklessly at the windmill-giants of the Legislative Belly and the National Assembly, and as one who had hunted the valleys of the Juste-Milieu for a tyrant and had found him, in 1848, to be nothing but a dead donkey, Honoré Daumier had every right and every reason to identify himself with Don Quixote.

Daumier chose the subject of Don Quixote and Sancho Panza because of its profound personal relevance. His sketches and paintings of that picaresque pair are in effect mirror images of himself, revealing at once the tragicomic dimensions of the novel and the mind and heart of Daumier himself. Heine's testimony serves well as a gloss to Daumier's pictures:

> Perhaps you *are* right—and I am only a Don Quixote. . . . He wished to restore decaying knighthood; I, on the other hand, want utterly to annihilate whatever has survived from that period. And thus we act from diametrically opposite points of view. My colleague mistook windmills for giants; I, on the contrary, see in our giants of today only ranting windmills; he mistook leather wineskins for mighty wizards; I see in our modern wizards only leather wineskins; he mistook every beggar's inn for a castle—every donkey driver for a knight, every stable wench for a lady of the court;—I, on the other hand, look upon our castles as disreputable inns, on our cavaliers as donkey-drivers, on our court-ladies as common stable-wenches. Just as he took a puppet-play to be a noble affair of state, I hold our affairs of state to be wretched puppet plays. But as doughtily as the doughty Knight of La Mancha I fall upon the wooden company.[12]

A deeper interest, however, philosophical rather than political and humanitarian, is involved in all of Daumier's art, and above all in the Don Quixote–Sancho Panza pictures. This is the problem of *reality*, the problem central in art, in literature—in life. In the story of *Don Quixote* and its two main characters, Daumier found a striking symbolic summation of his own dualistic view of reality. To Sancho Panza reality is actuality, the daily world of hunger and cold, of physical objects which bruise and maim, an intractable world in which abstract thought plays little part. In the thousands of lithographs and woodcuts of Paris life Daumier had portrayed this actuality to such a degree that critics have repeatedly, if wrongly, labeled him a realist, and doctrinaire realism of the middle and late nineteenth century, reacting to Davidian classicism as exemplified

by Ingres, may well be traced to Daumier's daily cartoons, to the work which taught an entire generation of artists that the everyday sight, the small object, was fit subject for a beautiful picture.

It is the fusion of the two symbolic figures, the Idealist Don and the Realist Sancho, in his own art and life which makes the personality and achievement of Daumier particularly impressive. We have saints, and heroes too, with all their ideals and dreams and unworldliness, but we seldom find them with the practical understanding, the simple goodness, and the Philistine common sense of Sancho. They usually lack the corrective irony. In an artist this is equally rare, especially in a great satirist. Lucian is savage, Swift misanthropic ("I loathe and detest that animal called man"), Smollett petulantly angry, Hogarth all roast beef and hearty insensitivity. The symbolic sense of globular Sancho and his lanky master are made one, the contraries fused, in the very career of Daumier, of which these last paintings are the artistic treatment. In the sketch of Don Quixote tumbled from his horse (Reinhart Collection, Winterthur), bare bottom in air (to Sancho's solicitous horror), Daumier tersely and sardonically sums up the results of his lifelong ride on the Rosinante of Art and Republicanism.

Daumier's very freedom in the drawings of Don Quixote and Sancho Panza is part of their excellence; they become a new creation rather than pastiche. His pictures are not illustrations. An illustrator would have roamed through the book selecting episodes; in the main, Daumier confined his attention repetitiously to the attack on the windmills, the assault on the sheep, and the discovery of the dead donkey. These famous scenes clearly had special significance for him.

To appreciate Daumier's freedom, compare his work with that of Johannot or Doré. They were illustrators, and their pictures are "mere" (although excellent) illustrations. Such was the artists' duty to their publishers, but such also was the limit of their talents. (Doré's life, for example, was saddened by his total inability to achieve success as an artist, to free himself from illustration.[13]) They had only to underline the comedy, to accompany and not to overpower the words. Under no contract and with no thought of textual accompaniment, Daumier worked freely, releasing Don Quixote and Sancho Panza from the printed page to move independently, with enhanced grandeur, in sketches and paintings which words would only distract. Daumier charged these two characters with an expressive content purely his own. In this freedom, however, he never concealed his subject in technique and virtuosity, like his friend Monticelli, whose *Don Quixote and the Wedding Party* (Louvre) buries the scene in a swirl of gold and bronze and scarlet almost as abstract and fluid as a Pollock canvas.

The finest sketches and paintings in Daumier's *Don Quixote* series are those which show the Don and Sancho riding from darkness into light toward some

PLATE 77 *Don Quixote and Sancho Panza*
The Metropolitan Museum of Art, Rogers Fund, 1927

adventure. The lean, bony Rosinante and the dumpy Dapple underline the comic, ironic correspondence of the two steeds to their grotesque masters. Always the Don rides ahead, seeking the enchanters and giants which surely await his fierce justice; Sancho reluctantly brings up the rear, longing for home and fireside but, through doglike devotion, is drawn in the wake of the dream. Idealism is supported by the homely realities. Even in a charcoal and india ink sketch (Metropolitan Museum), Daumier conveys the majesty and mystery in this delightful dialogue of character and philosophy (Plate 77).

In the Courtauld Institute painting, we have the same situation, now heightened by the subtle and skillful manipulation of browns, by the symbolic use of landscape (mountains and valleys) through which the two seekers ride to find adventure, wrongs to redress. Even when hung in the Tate Gallery in a room brilliant with impressionist canvases, Daumier's near-monochromatic painting asserts its supremacy by its masterful interworking of technique and meaning.

But the most striking of all the Don Quixote paintings is seldom seen: *Don Quixote and the Dead Mule* (the late Baron Gourgaud Collection, Paris). Originally painted for Daubigny's house at Auvers to balance a Don Quixote painting by his dear friend Corot, Daumier's picture is a narrow vertical panel in which the Knight and Squire emerge from the background mountains directly toward the beholder, or toward the dead donkey at the bottom of the rectangle (jacket illustration). To most people, trained or conditioned by Daumier's other treatment of the same subject—a horizontal panel with diagonal lines and action, and dark, low tones, a Rembrandtian palette (Metropolitan Museum)—the Gourgaud version comes as a shock with its light and delicate, almost pastel, tones, with its airiness. The prevailing colors are gray, wine, and lavender. Toward the bottom the dead donkey lies horizontally across the path of the riders, outlined tersely in a few black strokes on a canvas the lower half of which is "untreated" with the gummy, dark ground then almost mandatory for painters. The long vertical diagonal of the mountain moves into the Don's lance and down the shadow of Rosinante's leg; this is opposed by the diagonal which falls from the other corner onto Sancho. Daumier, we know from Baudelaire, had trouble finishing his paintings, because he patiently built them up in layer upon layer of thin washes. Here he has worked freely, lightly, allowing his masterly draftsmanship and a more delicate color pattern to take over. The roseate dawn out of which the Knight rides is in striking contrast to the bloated corpse of the dead animal. Light and life against sterility and death, the knightly quest and the wasteland through which the road lies—this is the meaning heightened by the unexpected, economical technique of the painting.

Lionello Venturi has this to say:

> ... *Don Quixote and the Dead Mule* resulted in being more of a suggestion than an affirmation of light and shade rendered by drawing. The drawing is here broken, there emphasized, elsewhere fading into nuances; it is open drawing always susceptible to atmospheric variation. It is the drawing of a colorist, not the closed drawing of a plastic painter. Daumier's contemporaries clearly perceived that his draughtsmanship was naturally colored, and that it evoked ideas of coloring, so intimately absorbed were the splendors of light and the depths of shade wrought in his drawing. From a logical point of view all this may appear as sheer nonsense. But feeling and imagination have a coherence of their own, which is parallel to the logic of thought, without identifying itself with it. One must realize that coloring, like plastic form and draughtsmanship, is, in art, a *way of feeling*. ... There is, for instance, the way of feeling draughtsmanship as a suggestion of color, as a color synthesized in light and shade, schematized in white and black; and there is the way of feeling draughtsmanship as contour spread out and graduated in order to transform a surface into a relief. The first way leads to pictorial form ... [and] is Daumier's way, as it is the way of Titian, Rembrandt, and Goya. Thus Daumier, the draughtsman, perfectly realized his coloring in his drawing and initiated a new type of vision which in France contributed greatly to the development of modern art.[14]

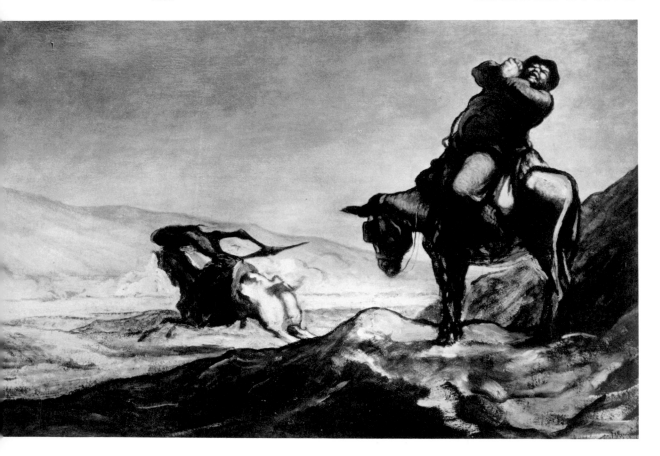

PLATE 78 *Don Quixote and Sancho Panza Attacking Sheep*
M. Knoedler & Co., Inc., Mr. and Mrs. Charles S. Payson Collection

It is perhaps not fanciful to trace some of the lightness, the grace, and the freedom of Daumier's *Don Quixote and the Dead Mule* to the house for which it was painted, to the devoted and discriminating friend, Corot, who painted the companion piece to Daumier's panel. Certainly Daumier's other memorable painting of the subject—the canvas in the Metropolitan—is a "finished" painting, from a somber instead of a radiant palette, made with the public instead of friends in mind. Writing to a friend on 30 September 1872, Daubigny proudly proclaimed that he had "a superb Corot and a Daumier." [15]

The spirit of competition at Daubigny's house in Auvers is seen in Corot's painting. It is a large canvas (Cincinnati Museum), a landscape with two tiny figures seen dimly in the distance. Close study of the painting has shown that those figures were put there as a joke, for they are a Don Quixote and a Sancho Panza painted into a small area of the canvas which had been rubbed out to take the addition. The two figures are either Daumier's own work, or they are

Corot's friendly imitation-parody of Daumier's conceptions of the characters. Knowing this, we can date Daumier's and Corot's canvases fairly closely. Corot spent the spring of 1868 recuperating from a serious illness at Daubigny's house in Auvers. With the help of his artist friends Daubigny proceeded to cover all available space with their work. Daumier, close by at Valmondois, helped merely by producing a masterpiece.

Don Quixote is the symbolic summit of Daumier's artistic career. Physically, Cervantes' characters have found their ultimate form, for Daumier has stamped their true appearance so indelibly that Chaliapin, playing the role of the Don in a film, modeled himself on Daumier's creation, and even a master like Picasso has drawn the immortal pair in forms almost copied from Daumier. Symbolically, Daumier projected in these pictures his view of himself and of his role in society. Utilizing Cervantes' creations, Daumier had at last a picaresque pair dear to his own heart, not useful merely for satiric comment. Robert Macaire and Bertrand had been fictional mechanisms with which to ridicule mercantilism and the Juste-Milieu; Ratapoil and his stooge Casmajou had served to attack Louis-Napoleon and Napoleonism. Don Quixote and Sancho Panza were on a higher plane. Appropriating and transforming the greatest of comic creations, Daumier shaped profound symbols, multiple in reference and meaning. Elie Faure eloquently wrote,

> That little ass crushed under the weight of that fat peasant, and that skeleton-like horse which could carry no more weight than that of the thin knight, express physical poverty and vulgarity crossing a desert of ashes. But the inner spirit of man marches forth there to wrestle with God.

Every phrase of Don Quixote's famous confession might have been properly spoken by Daumier for himself:

> This can I say for myself, that since I have been a knight-errant, I have become valiant, civil, liberal, affable, patient, a sufferer of toils, imprisonments, and enchantments; and though it be so little awhile since I saw myself locked up in a cage like a madman, yet I expect, by the valor of my arm, Heaven favoring, and Fortune not opposing, in a few days to see myself king of a realm in which I may display the gratitude and liberality enclosed in this breast of mine.

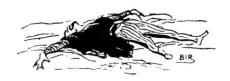

CHAPTER EIGHTEEN

Terminus

OLLOWING HIS RETIREMENT from *Charivari*, Daumier lived for only seven more years. A simplified and sentimentalized picture of these last years has become standardized and stereotyped in the biographies. This picture shows Daumier suffering from physical infirmity, reveals him poor to the point of poverty, and tells of Corot's gift to him of the very house in which he had lived for more than nine years and from which he was supposed to be evicted. All three simplifications are questionable, although the first, that of his physical health, seems closest to the often recounted story. Daumier's eyes were bad and there were perhaps other infirmities, but nevertheless the few anecdotes we have of these years show, save for the eyes, a man enjoying his friends, his surroundings, his artistic success. The simplifications about Daumier's poverty and about the Corot gift need new examination.

The most famous of the Daumier myths is that of Corot's surprising gift. The legend began early and meets most of the general information: Corot was wealthy, both from inheritance and from his success as a painter; Daumier had been poor most of his life and was, the tradition stresses, still poor. What more understandable than that the generous Corot should tactfully and unobtrusively have presented Daumier with the very house from which he was to be evicted— in order, said Corot, to annoy the landlord! It may seem presumptuous to lay the rude hands of fact upon such a pretty story, but it must be done, not so much to destroy the tale as to test it. It survives in three versions, all at odds with the actual record, which was hitherto unknown.

The first and most familiar version of the tactful-gift story was originally printed by Jules Claretie in *Peintres et sculpteurs*, the first series, dealing with artists who had died between 1870 and 1880. Claretie's version should be given in full:

> This characteristic way [of discreet charity] is how Corot bought, without saying a word, for Daumier, become old and blind, a little house at Valmondois on the road from Auvers, and how he led the poor, admirable artist beneath the rustic roof and said to him smilingly: "Here is a little house where one might willingly stay and paint pictures, isn't that so?"
>
> "Ah! I well believe it!" Daumier answered, "only I don't have the house and I no longer have my eyes."
>
> "Your eyes will come back, and as for the house, my dear Daumier, stay here. Have your easel brought here. It is yours. Take care of it!"
>
> And the good Corot perhaps held out to Daumier this letter, which has been preserved and which sheds honor on both artists.
>
> "My old comrade,
>
> I have at Valmondois, near the L'Isle-Adam, a small house which I don't know what to do with. It occurred to me to offer it to you and since I found the notion a good one, I went and had it registered to you at the lawyer's.
>
> I don't do this for you, it is to annoy your landlord.
>
> Yours!
>
> COROT"[1]

The story should have been suspect because Daumier had been living in the house for years and did not have to be led to it. Furthermore, the letter has never been seen by subsequent scholars. On the other hand, there was no special need for Claretie to have fabricated such a letter, so perhaps there had been some communication which he was quoting from memory, faultily.

The second version was told in the *Histoire de Corot et de ses œuvres*, by Etienne Moreau-Nélaton, "from the documents collected by Alfred Robaut." This reads:

> His charities were always characterized by discretion. The way in which he extended a helping hand to his friend Daumier is delicate and touching.
>
> Daumier lived at Valmondois, in a poor hovel where his aging ailments were miserably sheltered. His landlord, sporadically paid, allowed him to freeze from the cold of the damp walls. Corot, struck with pity, had his room fixed up and paid for all the necessary repairs, then he said to Daubigny, as a neighbor who could conduct negotiations of this sort: "Now we must annoy that scoundrel of a landlord: buy the house, here is the money."
>
> When Daumier heard the news, tears came to his eyes. Shortly afterward he selected, as an acknowledgment, one of his lawyer pictures to express his feelings; and Corot was delighted, calling it his good fortune. "It will be before my eyes to my last hour," and he said in showing it to Geoffroy-Dechaume on his last visit, "This picture does me good."

The third version was told in 1888 in Arsène Alexandre's biography of Daumier. It had Corot visiting Daumier, and on his being told that Daumier was returning to Paris to live, he innocently asked, "You want to give up your little retreat? Don't you like it?" Daumier confessed his inability to pay the rent and his imminent eviction. Corot continued: "But it's yours!" Uncomprehending, Daumier stared at his friend, who then relieved his bewilderment by explaining, "Without doubt it is yours; at least if these papers don't lie." He then thrust the title deed into Daumier's hands and the ownership was a *fait accompli*.

All three versions have the generosity of Corot and the gratitude of Daumier as common denominators, as well as the secrecy and surprise. However, the secrecy of purchase would have been impossible. In order to transfer the title directly from Gueudé to Daumier both men would have had to be present to sign the papers. The transfer could not have been made without Daumier's knowledge, or without his signature.

The facts are these. The nine-year rental contract of Daumier with Gueudé was drawing to an end. On 12 March 1874 Daumier and his wife, in the presence of Emile Lefort, a notary in L'Isle-Adam, paid 3,500 francs to Louis-Alphonse Gueudé, mason, and his wife, Marie-Anne-Constance Romaru, for purchase of the property which they had rented since 1865 and for which they had secured a purchase option in the rental contract. The title transfer runs to ten single-spaced pages, in typescript copy, of legal text which may be summed up most simply by saying that Daumier bought the property—not Corot, not Daubigny, only Honoré-Victorin Daumier. The house could not have been bought by Corot in the way the stories say.

Nevertheless, the very fact that the stories arose so soon after Daumier's death, and that no one seems to have denied them, argues for their general validity. What the discovery of the bill of sale shows is simply that the final negotiations were Daumier's, that he personally handed over the sum of 3,500 francs, and that he signed the deed of sale. It is perhaps plausible that Corot did in effect buy the house in that he may have made the legal arrangements and then had Daubigny in some way tell Daumier that it was "done" and that the house was his, only that he must, as a matter of form, come along and sign the document. That is to say, the surprise confrontation may have taken place but rather with the house as "practically" purchased, needing but a squiggle of the pen on Daumier's part to make it complete, a signature which Daumier, overcome by the generosity and tactfulness of his friend, could not refuse.

There is in the Geoffroy-Dechaume collection an unpublished letter, unfortunately undated, from Daubigny to Daumier which says, "Geoffroy will be seriously angry after what he replied to you if you do not live in the Valmondois house[.] Madame Daumier must have misunderstood Madame Geoffroy's reply, and you will do well not to yield to M. Martin[.] I am going to tell him that there is nothing to decide." Murky as this note is, it may possibly have to do

with the purchase of the Valmondois house; if so, we might suggest that it touches on the attempts of the group (Corot, Daubigny, and the Geoffroy-Dechaumes) to persuade Daumier to accept the gift of the house—that they have requested him to sign the documents, that everything has been arranged, that the money is ready and the documents are drawn up, and that all that is needed is his consenting signature. The phrase "There is nothing to decide" seems to be the sort of pressuring statement used to a friend to make it difficult for him to refuse some proposition, to make him feel that a refusal would be really to embarrass and discomfit true friendliness and honest intentions. It is, then, perhaps possible that Corot did everything but actually buy the house; that is, he made the legal arrangements, had the money ready, and then arranged that Daubigny (or himself?) approach Daumier, who, surprised with an almost accomplished act, could not refuse.

II

IF THE ACTUAL FACTS of the purchase were distorted, it now seems that the report of Daumier's economic position has been similarly misrepresented by the biographers. Evidence has accumulated to show that Daumier was not miserably poor, a starving and neglected artist. He was moderately well off. Jean Cherpin has described in detail a notebook kept by the artist between October 1875 and July 1876, in which Daumier jotted down the sales of sketches and paintings for the period.[2] He sold rather well. Collectors such as Arosa the banker, Count Doria, the Rouart brothers, Corot, Daubigny, and others were purchasing his paintings and sketches. In that short period he sold pictures and sketches which realized the impressive sum of 6,450 francs. This in itself was sufficient to pay for the house and still leave 2,950 francs for living expenses, certainly ample for Daumier and his wife, people of simple tastes and demands. Add to these figures the annual pension of 1,200 francs from the state, doubled near the end of Daumier's life, and, estimating his monthly income at 650 francs, biographers must accept Cherpin's informed conclusion: "The truth is otherwise [than tradition has had it]: he was a painter and so considered; he knew fame, he sold a number of his canvases, his sketches, and his watercolors; he sold them profitably. He lived in comfort, surrounded by a circle of admirers and friends."

Certainly if matters were going badly for Daumier, he did not show it. Writing to Laubot, 8 April 1873, on returning 100 francs of a 1,000 franc loan, he said, "We aren't doing badly, except for an eye trouble which hampers in a very annoying way all my little negotiations, which seem to want to take on a better appearance now than in the past." He was, of course, referring to the successful sale of his paintings.

His eyes, however, were another matter. On 21 June 1873 *Le Monde illustré* wrote that Daumier's eyes were troubling him, the basic trouble being the

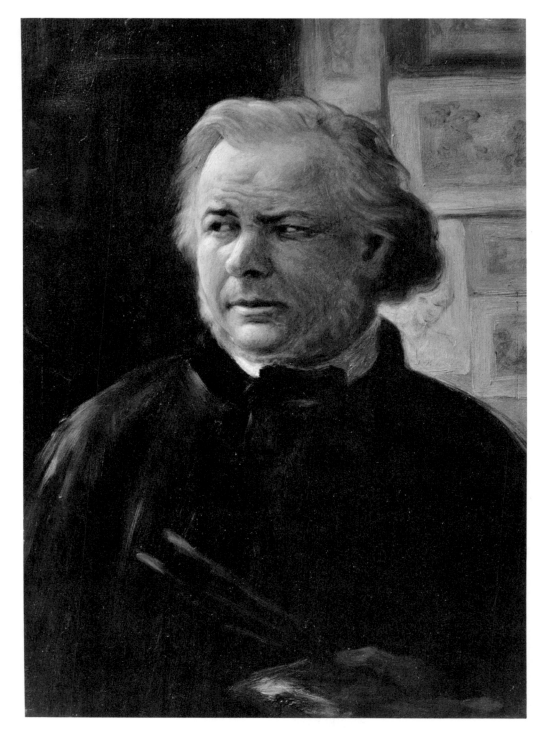

PLATE 79 Portrait of Daumier by Daubigny
Reproduced by courtesy of the Trustees, The National Gallery, London

weakness of one eyelid so that the eye was closed. Philippe Burty, a collector of Daumier paintings, wrote a pathetic story on the reverse side of Daumier's *Justice Pursuing Crime*: "I had exchanged a Delacroix for this rather old sketch by Daumier. It was not signed. Geoffroy-Dechaume took it to Daumier, who was pleased. He wanted to sign it, but the poor great artist was so nearly blind that it was necessary to hold his hand and he was not able to add a message." [3]

There was also the grief attendant on the death of friends. Michelet died in 1874, Corot and Millet in 1875, and Daubigny in 1877. [4] Jeanron was in financial ruin and Daumier helped him out by giving a *Saltimbanques* for sale at his benefit, 22 May 1876.

To counteract these woes, there were the convivial occasions. When Claude-Anthyme Corbon was elected a senator in 1876, Daumier attended, along with Bonvin, Daubigny, and Geoffroy-Dechaume, the banquet given in his honor. Then there was a gathering at Daubigny's place in Auvers, when the host sang Dupont's *Les Foins*, festive song and fellowship which mirror several of Daumier's fine paintings of the socialities, even to the rich cabbage soup on the table. [5] A visitor to Valmondois saw Daumier and reported to his wife, "Valmondois is still the most beautiful country in the world, and its inhabitants are charming. . . . I saw there Daumier who is always working like an old chaw-of-tobacco which he is."

A light story, related by a visitor to Valmondois some six months before Daumier's death, shows an interested and alert Daumier, caught in a momentary comedy of confusions. The unknown visitor wrote to Victor Thauriès:

> We had just spoken of Béziers, from where the Daumier family had come; and of the divine Horace, a translation of which I carried under my arm.
>
> "By the way, my young friend," Daumier said to me, "what do you think of *Vagnière* [*sic*]?"
>
> Undisconcerted and indeed finding it quite natural after discussing Béziers and Horace that Daumier wished to speak to me about the Latin poet, our compatriot Vanière (the French Virgil, author of *Proedium Rusticum*), I set about telling him all that I could about this Biterrois native of Béziers. Naturally, for good reasons, I gave no quotations. I spoke to him about the bust of Vanière sculptured by David d'Angers, and of the nose of the said bust which for my part I had considerably caused to darken from having formerly caressed it with schoolboy fingers at the bottom of the museum step.
>
> Daumier's bewilderment was complete. "That's funny," he said, "I didn't know that David had modeled the head of a *German*."
>
> "How's that!" I cried. "Vanière a German! Never on your life! He is Biterrois, as Biterrois as your ancestors!"
>
> "Is it possible! I am so ignorant!" the caricaturist added, disturbed. "Furthermore, it seemed to me that this Vagnière [*sic*] was not of the same generation as David. I am mistaken, that's clear. I didn't even know that he had written verses,

above all Latin verses. I knew the gentleman from his famous *turlututu*!" And then, seeking a half-forgotten rhythm, Daumier grimaced like one of his own creations modeled with a stroke of his thumb, and he comically sang the opening bars of the Pilgrim's March from *Lohengrin*. *He* had meant *Wagner*![6]

Some months later, Thauriès added, Daumier, recollecting the comic misunderstanding, laughed until the tears came to his eyes.

Thauriès remembered another story, told by Daumier as an illustration of the vanity of artists and as a joke on his generous friend and neighbor Daubigny. It seems that a landscape painter devoid of artistic merit came to Daubigny, whom he had not previously met, and pleaded with the famous artist to use his influence so that the luckless painter's Salon entry would not be refused. He pleaded his poverty, his family, etc. A quick glance at the painting made Daubigny despair of such a request, but since the poor devil persisted, Daubigny finally picked up his brush and with a few strokes considerably improved the daub, hoping. . . . The day of judgment came; the committee unanimously rejected it save for Daubigny, who pleaded for it, suggesting qualities not really there. Surprised, his colleagues asked, "How can you concern yourself with such an inept work? Is this a caprice or are you deluded?" Daubigny answered, "But gentlemen, I assure you that there is something in the painting; you are unnecessarily severe." His dauntless rear-guard struggle saved the painting. Daubigny then came from the committee room to meet the waiting artist, and said to him with some pride, "You have succeeded." "Aha," cried the dauber, "I knew for a fact that it was a good painting," and without one word of thanks to his savior, he strutted away in elation. Thauriès reported of Daumier's narration, "He did not tell it, he *lived* the story."

Thauriès also told, in concluding these uncollected memories, of Daumier, accompanied by a friend, returning to his house one night, when a little bird fell in front of them. It was late, so the friend agreed to keep the bird overnight, in a bird cage, until the next day when they might find its nest. "The next day, at dawn and with the impatience of a child who has not slept, Daumier asked with solicitude for news of the swallow and readied himself so as to return it to its 'desolated' family." "Who would have suspected," Thauriès asked in closing, "that the creator of *Robert Macaire* might one day provide, because of his touching tenderness for the birds, an elegiac motif for the makers of sentimental romances?"

During these years Daumier was becoming a public figure, accumulating the honors consequent to increasing recognition—a pension from the state, visits from admirers, consideration from the press. For instance, on 15 February 1874, he received a letter from G. Puissant, mentioning the return, undamaged, of several of his lithographs, with the explanation of why he had held on to them for so long: "For some time I have been charged with making your portrait for the *République Française*, in a series entitled, *Characters and Portraits*."[7] The

letter grumbles in a friendly way, indicating the affection and esteem in which Daumier's friends held him, and which they would soon demonstrate in the first public showing of his works in lithography, sculpture, and painting.

III

THE FINEST TRIBUTE to Daumier's art came in 1878, the year before his death, when his friends insisted on a Paris exhibition of his work. An honorary committee was formed with Victor Hugo at the head.[8] Daumier's closest friend, the sculptor Geoffroy-Dechaume, was in administrative charge of the exhibition, assisted in his secretarial duties by Maindron. Through letters to collectors and by an appeal to Daumier himself they brought together a show filling—crowding—two rooms at the Durand-Ruel Gallery, 11 Rue Le Pelletier. The first room displayed 112 lithographs (changed weekly); the second, 10 of the 1832 busts (lent by the Philipon family), 140 drawings, and, most important of all, 94 canvases. Champfleury prepared the catalogue, a document which is now the cornerstone of the Daumier canon. Any Daumier work without a history that can be traced to this list must undergo rigorous examination before being accepted by critics and collectors.

To the Paris critics the show was a powerful shock and a revelation. They had long known Daumier the cartoonist and were prepared to enjoy the lithographs retrospectively. But the critic of *La Petite République Française* (26 April), Emile Bergerat, after lavishly praising the show, referred to Daumier as "This Titan who used all his strength against the pygmies." As several other critics did, he selected *The Third Class Carriage* for special citation. Camille Pelletan, the critic for *Le Rappel*, agreed that this canvas was a masterpiece, a sample of Daumier's special genius, of his modernity—in contrast to all other nineteenth-century painters (the landscapists excepted). "He has made a great and powerful translation of contemporary manners; he has drawn the true aspect of things; [in] a style of nearly classic grandeur but above all with an entirely modern reference." Pelletan wrote four important articles for *Le Rappel* (1 February, 19 and 23 April, and 31 May), full of detailed, warm appreciation. Paul Sébillot, in *Le Bien Public* (23 April), lauded the "unknown painter" for his ability to see the great side of little things, and surprisingly and perceptively noticed that the landscape in one of the Don Quixote paintings had a "savage grandeur." Several of the critics were surprised to find that Daumier, an artist in black and white, was also a great colorist. Philippe Burty's opinion, sustained in four columns of *La République Française* (1 May), that Daumier was a "classic," probably represents the consensus of the critics.

Daumier doubtless found some pleasure in the discriminating appreciations from the newspapers and from his fellow artists. Degas came to study the

exhibition and praised Daumier as the equal of Delacroix. To draw a leg like Daumier, he said, requires forty years of study. Goncourt visited the showing and wrote in his diary, "With Daumier the bourgeois reality reaches an intensity which is fantastic," a criticism similar to one made much later by Valéry. Gambetta, the statesman, admired especially the paintings of the lawyers, finding that he recognized several of the faces, only to be told by Geoffroy-Dechaume that Daumier had not visited the Palace of Justice in more than ten years. Gambetta's error was, of course, a compliment to the essential and universal quality of Daumier's art.

For the mass of the people, said the artist Berthall, the Daumier exhibition was a revelation. Unfortunately, however, the "mass of the people" stayed away in masses, more interested in the Exposition in Paris than in art. Despite the enthusiastic reviews, the attendance was small. The committee statement, signed by Geoffroy-Dechaume, shows that the expenses ran to 12,700 francs and the receipts totaled only 3,190 francs, thus leaving a deficit of 9,510 francs, for which the committee had to go into its own pockets.[9]

There is no record that Daumier himself visited the show. Nor would it have availed him much to do so. He had been forced to undergo an operation for cataracts on his eyes and for the two months preceding the opening he had been deprived of sight. It is possible that he recovered sufficiently to see his collection before the exhibition closed; certainly it is to be hoped.

Shortly after the exhibition ended, Daumier received a letter from the director of the Beaux-Arts, announcing, "I have the honor to inform you that Monsieur the Minister has just decided that the annual pension you enjoy from the Fine Arts treasury should be raised from 1,200 francs to 2,400 francs beginning 1 July 1878."[10]

IV

DAUMIER HAD BUT A SHORT TIME to enjoy his increased income and status. On 8 February 1879 he suffered an attack of apoplexy which left him in great anguish. Just before midnight on 10 February, he died, attended during his last moments by the Daubigny brothers (sons of Charles), Geoffroy-Dechaume, and the faithful Didine. Doctor Vanier from L'Isle-Adam was summoned. When he arrived, he examined Daumier and pronounced him dead, but with the doctor's very words Daumier seized the hand of Geoffroy-Dechaume in a passionate grip which proved to be his farewell to the world.[11]

The funeral was held at one o'clock on Thursday 13 February in Valmondois. Formal notices had been sent to friends, and more than two hundred people, many from Paris, attended the simple ceremonies. According to

Daumier's own wish his body was taken directly from the house to the hillside cemetery, not stopping at the church. M. Bernay, mayor of Valmondois, praised Daumier the Republican, and both Champfleury and Carjat spoke affectingly about Daumier the man and the artist. André Gill was unable to attend but his verses in honor of Daumier were read. Geoffroy-Dechaume was overcome with emotion and could not speak.

The Minister of Fine Arts had telegraphed the state's offer of twelve francs toward the funeral expenses and further offered to have the body transferred to Père Lachaise cemetery in Paris for later interment. This offer of transferral was finally accepted by Madame Daumier. The city of Paris donated a plot. The afternoon of 15 April 1881 the body of Daumier was disinterred and rested the night at Valmondois, guarded by a state official. The next day it was placed in Père Lachaise cemetery close to the tombs of Corot and Daubigny. Champfleury and Carjat spoke.[12] The scene was described officially by the police officer attending for the state. His report to the Sûreté Nationale read:

> The transfer and reburial of the remains of the caricaturist Daumier, Honoré-Victorin, born in Marseilles in 1808, died in Valmondois, Seine et Oise, 1879, took place today at Père Lachaise cemetery.
>
> Beginning at 1:30 P.M. a hundred people gathered before the cemetery. About 200 people followed the wagon up to the burial spot. There were about 30 women among those attending. All the people seemed to be journalists, painters, etc. Several were decorated.
>
> Two manuscript discourses were read at the grave. The first [was] by M. Pierre Verron [sic] of *Charivari*. He retraced the life of the deceased and his part in the journal in which he had collaborated.
>
> The second discourse was by M. Carja[t]. It likewise retraced the life of the deceased, praised his republicanism, his integrity, and his generosity to those who suffered. He cited the phases through which Daumier had passed since 1830. He said that he took the people's cause, which he at that time believed to be victorious, then in 1848 and on December 2 he was imprisoned by the Decembrists.
>
> He always had the esteem of everyone. He always defended the people against exploitation by the bourgeoisie. He spoke also of the Rue Transnonain massacre, and said that with his crayon Daumier had made more than one despotic minister blanch. He paid his farewells and said that he brought with him his regrets and those of his friends.
>
> Another gentleman whose name is not known spoke some words of praise on his own part and for his many friends.
>
> A gentleman from Valmondois said his farewells to the deceased as well as for those of his friends from the region where he had died and who had known how to appreciate him.
>
> The crowd then dispersed. No incident took place.

A document to amuse Daumier the ironist.

A public subscription for a tombstone brought a mere 1,382 francs, so that only the plainest of stones was bought.[13] Today one may read with difficulty the memorial lines, which are slowly wearing away into illegibility:

<div align="center">

PEOPLE

HERE LIES DAUMIER, A GOOD MAN,

GREAT ARTIST, GREAT CITIZEN

</div>

The judgment is more enduring than the stone on which it is carved.

NOTES

INTRODUCTION

1. Michael Sadleir's *Daumier, the Man and the Artist* (London, 1923) is an appreciative essay rather than a biographical study. Bernard Lemann completed a doctoral dissertation on Daumier at Harvard University in 1936 that has remained unpublished, although he decanted some of his research into articles referred to in these notes. Professor Oliver Larkin's vigorous book, *Daumier: Man of His Time*, came out in September 1966, but it makes no original use of archival materials, and its approach is, quite naturally, more that of the art historian than is my discussion. There are three French biographies: the "official" one by Arsène Alexandre, *Honoré Daumier, l'homme et l'œuvre* (1888);* Raymond Escholier's *Daumier, peintre et lithographe* (1923, revised 1930); and Jean Adhémar's *Honoré Daumier* (1954). Adhémar's book is the cornerstone for all present study of the artist, containing a fine introduction, a detailed chronology, a reprint of the 1878 Daumier exhibition catalogue, reprints of several contemporary notices of Daumier's work, a bibliography, and 174 full-page illustrations, many of them, unfortunately, in poor color reproduction.

CHAPTER ONE

1. The birth certificate is printed in facsimile in Delteil, I [iii], and in A. Grass-Mick, *La Lumière sur Daumier* (Marseilles, 1931). Grass-Mick includes a picture of the house in which Daumier was born, and this picture is printed also in *Arts et livres de Provence*, No. 8 (1948), facing p. 128. Gaston Picard's "Daumier père et Daumier fils," *Revue mondiale*, CXC (1929), 68–72, is a thin piece now superseded by Bernard Lemann, "Daumier père and Daumier fils," *Gazette des beaux-arts*, 6th ser., XXVII (1945), [297]–316, an excellent, detailed study, but one which needs the additions found in *Arts et livres de Provence*, *supra cit*.

* Unless otherwise indicated, the works referred to in these notes were published in Paris.

There is no up-to-date study of Jean-Baptiste Daumier, but it is hoped that Jean Cherpin, whose knowledge of the Daumiers in Marseilles is unequaled, will supply this some day. I have resisted the temptation to write such an account, although I was almost lured after going over the Jean-Baptiste Daumier manuscripts owned by M. Seuillerot in Paris. Daumier "fils" is my concern.

2. See Joseph Billioud, "Les Huit Quartiers plébéiens de Daumier," *Arts et livres de Provence, supra cit.*, pp. 120–22.

3. Now owned by Jean Cherpin, the marriage license was shown at the Daumier exhibition held in 1958 at the Bibliothèque Nationale (Item 246). Among other exhibits were Jean-Baptiste's baptismal record (Item 245); his passport for Paris, dated 29 March 1815 (Item 247); many of his literary manuscripts, some of them unpublished (Items 253–254); and his death record (Item 244).

4. In the Preface to *Un Matin de printemps, poème* (1815). There is a copy of this rare imprint in the Metropolitan Museum of Art, given by Carl Schniewind.

5. See J[ean] C[herpin], "Trois lettres inédites de Chevalier Alexandre Lenoir." *Arts et livres de Provence*, No. 18 (1950), pp. 30–32. In the same issue Cherpin, "Les Logis de Daumier," p. 37, gives the early addresses of the Daumier family in Paris, along with other details of these years.

6. The letters of Jean-Baptiste Daumier and his wife are in André Quaintenne, "Peines d'argent," *Arts et livres de Provence*, No. 8 (1948), pp. [93]–94. Apparently Jean-Baptiste's financial troubles were constant; I have seen papers of a lawsuit against him dated 1808, in which he was being sued for £300.

7. Most interesting, perhaps, was the performance and the publication of *Philippe II* in 1819. It was a five-act play in verse and sold for two francs. Jean-Baptiste wrote in the Preface: "When I undertook this work, I knew so little about dramatic literature that I did not even know the names of Schiller and Alfieri. Among the other authors who had produced or intended to produce a piece for the French stage on the same subject, Compiston wrote the first, which I discovered when I was well into my third act, and I determined not to cancel it. My library, the fruit of my little economies, was not very large; the choice of books had been a matter of chance rather than the result of knowledge about the writers. I had no one to teach me; all my relatives were in the same profession to which I had been born, and because I had drawn some poetic pictures in *A Spring Morning*, I believed myself capable of writing a tragedy." He did admit to having read Racine and ruefully added that perhaps he should have followed him as a model.

8. A. Hyatt Mayor, "Lithographs," *The Metropolitan Museum of Art Bulletin*, VII (1948), 89.

9. See pp. 154-55.

10. Most of what is known about Daumier's early years in Paris comes from Champfleury, *Histoire de la caricature moderne*, 3rd ed. (n.d.); and, even more important, Duranty, "Daumier," *Gazette des beaux-arts*, 2nd ser., XVII (1878), [429]–443, [528]–544, especially the last three pages.

11. For data on Alexandre-Marie Lenoir (1761–1839) see Louis Courajod, *Alexandre Lenoir, son journal et le Musée des Monuments Français, 1878–1887*, 2 vols. (1888); and an article by De Lanzac de Laborie, "Alexandre Lenoir et le Musée des Monuments Français pendant la période Napoléonienne," *Revue des questions historiques*, XCIII (1913), 26–52. There is also a brief account of Lenoir in *The Lenoir Collections of Original French Portraits at Stafford House*, autolithographed by Lord Ronald Gower, M.P. (London, 1874). Lenoir's special passion for Michelangelo and the Sistine Chapel is found in *Observations scientifiques et critiques sur le génie et les principales productions des peintres et autres artistes les plus célèbres de l'antiquité, du moyen âge, et des temps modernes* (1821), especially p. 5 and immediately following, where he describes the *Last*

Judgment as the greatest of all works of art. These words were written about the time that Lenoir was instructing Daumier.

12. There were, of course, many minor influences on Daumier; he learned from his friends as well as from the giants of the past. Grandville, Charlet, Raffet, and Traviès all "taught" him, and there was the fruitful influence of Louis Boilly, whose many drawings of facial effects pleased Parisians then as well as now, and whose prints are still selling at the *bouquinistes* along the Seine. For Boilly, see Docteur Cabanès, "Louis Boilly et ses 'grimaces,'" in *La Médecine en caricature*, ed. P. Longuet (1927); and Jean Adhémar, "Daumier et Boilly," *Arts et livres de Provence*, No. 2 (1955), pp. 18–20. See also Henry Harrisse, *L. L. Boilly*, 3 vols. (1898).

13. For a bibliography of the literature on lithography see C. Kampmann, *Die Literatur auf Lithographie von 1798–1898* (Vienna, 1899); and *Catalogue of an Exhibition Illustrating a Centenary of Artistic Lithography, 1796–1896*, at the Grolier Club (New York, 1896). A charmingly written and well-illustrated history was done by Joseph and Elizabeth Pennell, *Lithography and Lithographers* (London, 1915); see also M. Mespoulet, *Images et romans, parente des estampes et du roman réaliste de 1815 à 1865* (1939). Good surveys are easily available in Henri Béraldi, "Exposition de la lithographie," *Gazette des beaux-arts*, 3rd ser., V (1891), 479–96; Henri Bouchot, *La Lithographie* (1895); and Paul Leprieur, "Le Centenaire de la lithographie," *Gazette des beaux-arts*, 3rd ser., XV (1896), 45–57, 147–62.

14. Henri Focillon, "Visionnaires—Balzac et Daumier," *Essays in Honor of Albert Feuillerat*, ed. Henri M. Peyre (New Haven, 1943), p. 209. The article, pp. 195–209, is important in Daumier criticism.

15. See Duranty, *op. cit.*, for most of the details in this paragraph. Daumier's initial dislike of lithography recurred when it seemed to him to block his career as a painter. Nevertheless, Daumier's lithography was, as A. H. Mayor has said, responsible for his becoming a great artist, meaning, of course, that Daumier sublimated his passionate desire to paint by creating on the stones the forms which his fate kept him from putting on canvas for so long. This is a paradox that must constantly be kept in mind. Carlo Rim, in "Le Cinquantenaire de Daumier," *L'Art vivant* (15 February 1929), pp. 166–72, says that in 1823 "Daumier sold his first print to a music publisher," but he gives no source for the statement.

16. Modern scholarship has discovered five lithographs published in the 1820's, all signed "H. D." They have been attributed to Daumier, who was at that time a mere boy.

The first three date from 1822, when Daumier was fourteen, and were printed by Engelmann. The first, "Sunday," deposited for license on 16 August, shows three soldiers standing in front of a booth at a fair, watching the antics of a dressed-up monkey. The second, "I am a Guard at the Town Hall," deposited 13 September, again has three soldiers, this time before a village town hall, with the mayor sitting nearby. Both prints are uninteresting, derivative in style and technique, in the manner but without the merit of Charlet. The third print, "The Promenade at Romainville," deposited 20 December, is equally inept and awkward. That these prints treat subjects later used by Daumier is true, but then that could apply to almost any print on a social subject because Daumier's topical range was enormous.

Two years later, in 1824, two more prints signed "H. D." were published, this time at Lasteyrie's press. The first, "I opened the door," deposited 19 May, was probably an illustration for a story. It is no better than, if as good as, the 1822 prints. More interesting, however, is the second, "The Reduction of the Fifth," deposited 4 May, because of its topical reference: Prime Minister Villèle's project for reducing the percentage rate on incomes. As a print it is very poor, but were it clearly proved to be Daumier's, it would then take its place as his first political cartoon and thus attain biographical if not artistic interest. The very fact that the print is political in subject might argue against Daumier's authorship, for he probably had not yet met Charles Philipon, who trained him, goaded him, in political satire.

One argument for ascribing these five lithographs to the young Daumier is their incompetence—they must have been composed by a beginner—but the weakness of this position is obvious. Ineptitude is not the prerogative of youth but is possessed by many older people who pass themselves off as artists. The second argument for Daumier's authorship that is hard to resist is the fact of the initials "H. D." If we could only find another "H. D." turning out lithographs at this date, we would relieve Daumier of this burden. Arguing against Daumier's authorship is the silence from 1824 to 1830. Having once tasted the delights of publication, would not Daumier have composed many more prints, signing them "H. D." for friends and relatives to see, with the vanity of a young novice seeking status among his superiors? Daumier's candidacy for the authorship of these five "H. D." prints must be tabled until further evidence turns up. Nescience, if not skepticism, is in order. (See Edwin de Bechtel, "Les Lithographies de jeunesse," *Arts et livres de Provence*, No. 8 (1948), pp. [50]–56.)

CHAPTER TWO

1. The literature on the 1830 revolution is of course extensive. A recent summary is in John Plamenatz, *The Revolutionary Movement in France, 1815–1871* (London, New York, and Toronto, 1952); see also Raymond W. Postgate, *Revolution 1789 to 1906* (Boston and New York, 1921); G. Lowes Dickinson, *Revolution and Reaction in Modern France*, 2nd ed. (London, 1927); and the excellent chapters, written from a pro-Republic point of view and therefore useful for understanding Daumier's attitudes, in the *Cambridge Modern History*. It must be remembered that the view of events put forth in this present study is presumably Daumier's, or that of his Republican friends; it is not necessarily that of modern judicial historiography, although there is much variation in viewpoints today.

2. In 1830 the Republicans were not an organization. The very name was new. They were but a sentiment, a feeling, and a passion surviving from 1789. See Georges Weill, "Les Républicains français en 1830," *Revue d'histoire moderne et contemporaine* (1899–1900), pp. 321–51; Georges Weill, "Les Républicains et l'enseignement sous Louis-Philippe," *Revue l'enseignement*, XXXVII (1899), 33–42; Lucien de la Hodde, *Histoire des sociétés sécrètes et du parti républicain de 1830 à 1848* (1850); and Tchernoff, *Le Parti républicain sous la monarchie de juillet* (1901).

3. Paul Thureau-Dangin, *Histoire de la monarchie de juillet*, 3rd ed., 7 vols. (1889–1904), II, 130.

4. Quoted in Louis Blanc, *The History of Ten Years, 1830–1840*, 2 vols. (London, 1844), I, 385.

5. Detailed information about the Paris press during the reign of Louis-Philippe (and later) is in Henri Avenel, *Histoire de la presse française* (1900); Eugène Hatin, *Histoire politique et littéraire de la presse en France*, Vol. VIII (1859); Eugène Hatin, *Bibliographie historique et critique de la presse périodique française* (1866); Henri Izambard, *La Presse parisienne* (1853); Ernest Mersan, *La Liberté de la presse sous les divers régimes* (1874); Edmond Texier, *Histoire des journaux* (1850); and Georges Weill, "Les Journaux ouvriers à Paris de 1830 à 1870," *Société d'histoire moderne: Bulletin des séances* (1904), pp. 146–47. The first and fifth items are particularly important.

6. Most of my information about Philipon's early years comes from a letter which I discovered in the Bibliothèque Nationale, written to Nadar and supplying biographical information for Nadar's magazine. This lengthy and lively letter has since (1952) been made use of by scholars, but no one has gone on to write an article, much less a book, which Philipon well deserves.

7. None of the press historians mentions Philipon's part in *Silhouette*, but there is the evidence of his statement in *Caricature*: "*Silhouette*, which I founded, never had this kind of trouble, and it was nothing other than my *Caricature* under another title."

8. For caricature in France during the nineteenth century I recommend the following: Arsène Alexandre, *L'Art du rire et de la caricature* (1893); Emile Bayard, *Caricature et les caricaturistes* (1900); Henri Béraldi, *Les Graveurs du XIXe siècle. Guide de l'amateur d'estampes modernes*, 12 vols. (1885–92); André Blum, "La Caricature politique sous la monarchie de juillet," *Gazette des beaux-arts*, 5th ser., I (1920), [257]–277; François Courboin, *L'Histoire illustrée de la gravure en France*, Vol. III (1926); François Courboin, *La Gravure en France, des origines à 1900* (1923); François Courboin and Marcel Roux, *La Gravure française. Essai de bibliographie*, Vol. I (1927); Armand Dayot, *L'Histoire contemporaine par l'image d'après les documents du temps, 1789–1872* (1905); Armand Dayot, *Journées revolutionnaires, 1830, 1848, d'après des peintures, sculptures, dessins, lithographies, médailles, autographes . . . du temps* (1910); Armand Dayot, *Les Maîtres de la caricature française au XIXe siècle* (1888); Raoul Deberdt, *La Caricature et l'humeur français au XIXe siècle* (1898); Paul Gaultier, *Le Rire et la caricature*, 2nd ed. (1906); John Grand-Carteret, *L'Histoire, la vie, les mœurs et la curiosité par l'image, le pamphlet et le document (1450–1900)*, Vol. V (1928); Léon Rosenthal, "Les Conditions sociales de la peinture sous la monarchie de juillet," *Gazette des beaux-arts*, 4th ser., III (1910), [93–114], [217]–241, [332]–354; Léon Rosenthal, *La Gravure* (1909), especially Chap. 2, pp. [340]–387, with the bibliography on pp. 384–87; Robert de la Sizeranne, *Le Miroir de la vie. Essai sur l'évolution esthétique*, 1st ser., "Le Rôle de la caricature," pp. 79–146; Robert Ashbee, *Caricature* (London, 1928); Arthur B. Maurice and Frederick C. Cooper, *The History of the Nineteenth Century in Caricature* (London, 1904); James Parton, *Caricature and Other Comic Art in All Times and Many Lands* (London, 1878); New Burlington Galleries, *Exhibition of a Century of French Caricatures, 1750–1850* (London, 1939).

9. The only way, of course, really to know this fine magazine is to leaf slowly through its ten volumes, reading the satirical articles and studying the prints. Any serious student of caricature, of Daumier and his friends, of Charles Philipon, or of Louis-Philippe's early years as King will find such a survey profitable. For descriptive or bibliographical material see Henri Béraldi, *Les Graveurs du XIXe siècle*, IV (1886), 115–19 (and also pp. 121–33 for *Charivari*); André Blum, "Le Centenaire de 'La Caricature,'" *Revue de l'art ancien et moderne*, LVII (1930), 303–6; Jules Brivois, "'La Caricature' de 1830–35 publiée par Charles Philipon. Notes bibliographiques," *Revue biblio-iconographique* (1899); M.M., "Louis Philippe in Caricature," *More Books* (Boston Public Library), XVIII (1943), 336; Charles Malherbe, "'La Caricature' de 1830. Notes bibliographiques," an offprint from *Bulletin des bibliophiles*, in the Bibliothèque Nationale; A. Geoffroy, "'La Caricature' de M. Ch. Philipon," *La Curiosité universelle* (26 May, 2, 9, 16 April 1888); Georges Vicaire, *Manuel de l'amateur de livres du XIXe siècle, 1808–1898*, II (1895), 46–82, 82–87 (for the prints of L'Association Mensuelle), and 87–111 (for the other caricatures connected with Philipon and Daumier).

10. Born Jean-Ignace Isidore Gérard at Nancy in 1803, Grandville early in his career adopted the pseudonym of his father, a miniaturist, from whom he derived his artistic interest and his detailed and painstaking style, sharp and clear and finicky. Grandville first attracted public attention as a lithographer with *Les Metamorphoses du jour* (1829), seventy-three prints which portrayed human beings with animal heads presumably appropriate to their characters. Balzac possibly had Grandville in mind when he wrote in Chapter I of *The Quest for the Absolute* about "Certain theorists who have a fancy for discerning animal resemblances in human countenances, [and who] have discerned in the long, rather than oval, face of Balthazar Claes, the likeness of a horse." These totemistic pictures, derived directly from Charles LeBrun (see Lucien Metivet, *La Physionomie humaine comparée à la physionomie des animaux, d'après les dessins de Charles LeBrun* [1916]), became associated with Grandville's name although he made many other kinds of prints, such as straight political caricature, book illustrations, etc. More than any other artist of his day, Grandville explored and exploited the world of dream and fantasy, and there are critics today who see him as a forerunner of Surrealism.

For a short time Daumier emulated Grandville; between 1830 and 1832 at least three of his prints are in the patented Grandville manner: long processions of figures drawn with sharp clarity, with animal heads on human bodies. Having tried his hand at this, Daumier soon shifted to his own technique and manner.

The practice in *The New York Review of Books* of including a number of Grandville wood-cuts in each issue has made his name known in our decade. However, a modern scholarly study of Grandville's life and works is much needed. For those works available, see Charles Blanc, *Grandville* (1854); Laure Garcin, "Grandville, visionnaire, surréaliste, expressioniste," *Gazette des beaux-arts*, 6th ser., XXXIV (1948), 435–48; Docteur Cabanès, "Un Grand Caricaturiste visionnaire: Grandville," in *Autour de la vie de bohème* (1938), pp. [179]–204; Charles de Meixmoron de Dombasle, "J. J. Grandville," *Mémoires de l'académie de Stanislas*, Nancy, 5th ser., XI (Nancy, 1893), 300–39; Pierre Mac Orlan, "Grandville le précurseur," *Arts et métiers graphiques*, No. 44 (15 December 1934), pp. 19–25; Sven Sandstrom, "J. J. Grandville," *Konstrevy*, XXX (1937), 41–54.

11. A thorough study of the Pear is a scholarly necessity. Among the various manifestations of the Pear was a most unusual book, *Physiologie de la poire, par Louis Benoit, jardinier* (1832), which furiously and relentlessly attacked the King by ringing all the possible and impossible changes on the Pear theme, all the puns. It was written by Sébastien Benoit Peytel, whose trial for the murder of his wife moved Balzac and Gavarni to plead clemency for him from the King. See David James, "Gavarni and His Literary Friends," (diss., Harvard Univ., 1942), pp. 40–63.

12. In Henri Avenel, *op. cit.*, p. 348.

13. *Les Poires faites à la cour d'assises de Parie [sic] par le directeur de "la Caricature," vendues pour payer les 6,000 francs d'amende du journal "le Charivari."* This imprint in the Bibliothèque Nationale (fol. Lb 51. 1065) is apparently unique.

CHAPTER THREE

1. Grandville was the prominent, leading cartoonist at the beginning; two years later Daumier gained the ascendancy. A rough count shows that Grandville composed 109 cartoons, Daumier 100, Traviès 55, Bouquet and Desperret 29 each, Benjamin 12, Raffet 14, Philipon 10, and Monnier 6.

2. Sulpice-Guillaume Chevallier was born 13 January 1804 in Paris and died there 24 November 1866. Early in his career he adopted the pseudonym of Gavarni, after a region in the Pyrenees, by which he was known to his age and to posterity. He once enjoyed a fame and popularity surpassing Daumier's, but his reputation has since declined. Colleagues for decades, Daumier and Gavarni as the most skillful cartoonists of their time were generally linked together by commentators, beginning with Champfleury, *Histoire de la caricature moderne*, 3rd ed. (n.d.), pp. 302–10. Their differences, however, are more important than any fortuitous likenesses. Gavarni's art was delicate, generally feminine in effect, serpentine and subtle, whereas Daumier's art was forceful, masculine, economical in means, and direct. In one sense Gavarni was more parochial than Daumier because he tied his pictures to topics and scenes which date, or which are dependent upon the legend and the local allusion. In contrast to Daumier, Gavarni cherished his legends, composing them himself, delighting in the verbal nuance as much as in the graphic. The subjects of the two artists were generally different. Both, to be sure, dealt with the human comedy in general, but Gavarni in many of his series treated of the lives of the women of the demimonde, and the world of fashion, as a rule avoiding the political subjects dear to Daumier. The two men generally did not travel in the same social groups, but they apparently felt no antagonistic sense of rivalry, no animosity. On the contrary, Gavarni boasted

of Daumier's supreme skill with the grease crayon, and when Daumier was turned away from *Charivari*, he offered him work, which Daumier refused, on *Le Temps*. An interesting man in mind and sensibility as well as in his role as an artist, Gavarni has frequently been written about, but he should now have a modern scholarly study made of his life and art. David James's doctoral dissertation at Harvard University, "Gavarni and His Literary Friends," 1942, is unpublished. See Edmond and Jules de Goncourt, *Gavarni, l'homme et l'œuvre* (1873); Paul-André Lemoisne, *Gavarni, peintre et lithographe*, 2 vols. (1924–28); Charles Holmes, *Daumier and Gavarni*, with critical and biographical notes by Henri Frantz and Octave Uzanne (London, New York, and Paris, 1904). A large Gavarni exhibition, with an excellent catalogue, at the Bibliothèque Nationale in 1954 reintroduced the man's art and life (through many manuscripts) to the present generation of Parisians, and a few years earlier Londoners had had an opportunity to see some of his work: *A Selection of Lithographs by Daumier and Gavarni*, with an Introduction by Gilbert White (London, 1946).

3. Charles Joseph Traviès de Villers was born in Zurich in 1804 and died in Paris in 1859. A cartoonist of a rank well below Daumier and Gavarni, he nevertheless had considerable satiric skill. His most famous creation was Mayeux, the humpbacked figure whose coarse witticisms directed against the upper middle class and the aristocracy made him a favorite with the French masses. It is difficult today to understand the popularity of Mayeux, such has been the change in what is acceptable as humor. Maybe a new study of Traviès, rumored to be in preparation, will explain this mystery. For studies of Traviès, see the general books on French caricature listed in the notes to Chapter Two. See further, Félix Meunie, *Les Mayeux, 1830–1850. Essai iconographique et bibliographique* (1915); Cornelius Veth, "Uit de ongeving van Daumier: C. J. Traviès als lithograaf," *Maandblad voor beeldende kunsten*, XI (1934), 201–10; and *Caricatures sur Mayeux*, 2 vols., Bibliothèque Nationale, Tf. 52 and 53.

4. It may have come sooner than has been suspected. There are several early, unsigned prints in *Caricature* in a style different from Grandville's, Traviès', *et al*. For instance, who drew "The Donkey Laden with Relics," 6 December 1831, a satire on the civil list (as was "Gargantua") and based on a fable by La Fontaine? I suggest that it is by Daumier, but it would be difficult to prove, or, like some of the early ascriptions, once accepted, hard to disprove.

5. The riots and their consequences, including the visit of the Duke of Orléans to Lyons, are told in detail in Louis Blanc, *The History of Ten Years, 1830–1840*, 2 vols. (London, 1844), I, 525–44.

6. *Ibid.*, p. 578. The Republican outrage over the burdensome civil list is described in pages 577–82.

7. This is a wishful assumption on my part. I can find no real evidence for dating *Le Célèbre Gargantua*. Experts whom I have consulted incline to give it a date in the 1830's, but they can give no specific reason for doing so. Neither Mathias nor Sabourin de Nanton in their books on the Epinal pictures even mentions the woodcut.

8. His official report is in the Archives de la Seine, Préfecture de Police, 2ème division, 2ème bureau.

9. In the Musée Carnavalet. Translated in Bernard Lemann, "Daumier père and Daumier fils," *Gazette des beaux-arts*, 6th ser. (1945). Philipon's note in reply is owned by Jean Cherpin and was shown in the Daumier exhibiton of 1958 in the Bibliothèque Nationale (Item 258).

10. Archives de la Seine: Archives de Sainte-Pélagie, No. 353, Fo. 119.

11. This letter to Jeanron, written hastily and with misspellings and errors in punctuation, was first printed by Arsène Alexandre, *Honoré Daumier, l'homme et l'œuvre* (1888), pp. 54–55. It was in the sale of *Précieux autographes composant la collection de Monsieur Alfred Dupont*, 2nd part, 18 and 19 June, 1957, Item 46; the major part of the letter is transcribed there, with a photograph of the first page. (I am indebted to M. Dupont for allowing a transcription to be made.)

For Philippe-Auguste Jeanron (1808–1877), see Madeleine Rousseau's article in *Musées de France bulletin*, VIII (1936), 109–13, 144–45.

12. The Bibliothèque Nationale has a file, apparently unique, of the *Gazette de Sainte-Pélagie et de toutes les maisons de détention*, published from January to December 1833, and containing two specific references to Daumier. The issue of 3 January gives his cell number. The information on the "art" in his cell is also from the *Gazette*. For Sainte-Pélagie in general see E. Couret, *Le Pavillon des princes. Histoire complète de la prison de Sainte-Pélagie* (1895). I have drawn details about the prison and about Prat and his assistant from a series on Sainte-Pélagie printed in *Charivari* in 1839–40. The account of the Carlist and Republican rites comes from Bérard, *Sainte-Pélagie en 1832. Souvenirs* (Nantes, 1886). Bérard's imprisonment coincided with Daumier's. See also in the Bibliothèque Nationale, *Les Francs-maçons à Sainte-Pélagie, à tous leurs frères* (1833); and *Grande Découverte d'une grande conspiration!!!! histoire sérieuse, titre pour rire. Lettre à quelques amis de la prison de Saint-Pélagie, an 3 de la quasi liberté* (1833), which I would like to attribute to Charles Philipon, since it has so much of his characteristic verve and impudence. But Philipon would not have remained anonymous, not he.

13. Nothing much has been made of this important event by biographers and scholars, although Adhémar, Lemann, and Sergent have known about it and have referred to it in passing. For details about Pinel, see René Semelaigne, "Une Maison de santé sous la monarchie de juillet," *La Chronique médicale*, XVIII (1911), 369–78, from which I have taken some details, and also his *Aliénistes et philanthropes* (1912), pp. 271–72.

CHAPTER FOUR

1. It should be remembered that during this period Daumier drew many other cartoons, outside of this planned series of portraits, arising from the events of the moment. These prints were anecdotal, narrative, and satirical in character, in which, as Meier-Graefe wrote, "the gesticulation of the ministerial hands, the contours of His Majesty's belly, suffice to inflame a form of dialectic whose power of representation must be stigmatized as diabolic." ("Honoré Daumier—Fifty Years After," *International Studio*, XCIV [1929], 22.)

2. Quoted in Louis Blanc, *The History of Ten Years, 1830–1840*, 2 vols. (London, 1844), II, 161.

3. Until fairly recently critics have thought that there were thirty-six busts, because this was the number which Philipon's grandson sold to M. Le Garrec. For these thirty-six and for Daumier's sculpture in general, see Maurice Gobin, *Daumier sculpteur, 1808–1879* (Geneva, 1952); but consult also Eugène Bouvy, *Trente-six bustes de Daumier* (1932); Gustave Geoffroy, "Daumier sculpteur," *L'Art et les artistes*, I (1905), 101–8; three articles in *Arts et livres de Provence*, No. 8 (1948): Charles Mourre, "Bustes et personnages," pp. [97]–100; Berthe Le Garrec, "Les Bronzes parlementaires," pp. [101]–102; Maurice Gobin, "Sur l'art de Daumier, dessin et sculpture," pp. [57]–61; and, in the same magazine, No. 18 (1950), pp. 23–27, Jean Adhémar, "A propos des bustes"; and also Charles Perussaux, "Un Sculpteur nommé Daumier," *Les Lettres françaises* (31 January–6 February 1957).

4. There is a large collection of Dantan's portrait busts, or caricatures, in the Musée Carnavalet in Paris. See Louis Huart, *Galerie des charges et croquis de célébrités de l'époque* (1839), which has prints of many of these busts, with accompanying texts by Huart, Daumier's editor on *Charivari*. See also Beaumont Newhall, "Dantan: Rediscovered Daumier of Sculpture," *Art News*, XLIII (1944), 12–13; and the basic study of Dantan by Janet Seligman, *Figures of Fun* (New York, 1957).

Although sculptural caricature like Dantan's and Daumier's does not seem to have been created widely, it has been practiced. In the eighteenth century Franz Xavier Messerschmidt (1767–83) made caricatural bronze heads in Vienna, and in the twentieth century we have the amusing, vividly colored heads by Dezso Lanyi of Budapest (see A.G., "Lanyi, Caricasculpture," *Coronet*, II (1937), 170–77, most of the article consisting of color photographs of Lanyi's work).

5. Maurice Gobin, *Daumier sculpteur*, p. 143, quotes a passage from *La Mode*, December 1832, which discusses Dantan's *charges* as being possibly directed to political caricature, but such a suggestion, as Gobin notices, could not have influenced Philipon or Daumier, since Daumier's political maquettes had already been started.

6. In the Cabinet des Estampes, Bibliothèque Nationale, *Caricatures politiques*, Vol. V (1830): Princes, Ministers, Tf. 58. (Daumier's "Gargantua" is in this collection.)

7. This theory seems first to have been suggested by Eugène Montrosier, "La Caricature politique: H. Daumier," *L'Art*, II (1878), 27. The entire article, pp. 25–32, is an excellent appreciation of Daumier; it appeared shortly before the artist's death.

8. See Gustave Geoffroy, *op. cit.* Why this article, and hence this notation, passed unnoticed for so long is puzzling, but its neglect explains the long-maintained number of thirty-six caricatural portrait busts only. An article, "Sur les bustes modelés par Daumier," by Madame Philippe Garcin, in *Aesculape* (January 1959), pp. 21–30, mentions, without citation, the gift to Champfleury and that there was in 1878 a total of thirty-nine busts. Madame Garcin's article recognizes the conceiving mind of Philipon, but she fails to place the busts in the general campaign, to tie them closely to the portraits and caricatures for which they were models.

9. I bought the bust at the Sheridan Art Galleries in Chicago on 17 September 1957. It was Item 407, listed as an "Original Sculptured Terra Cotta Bust of a Senator, Circa 1834. Signed H. D. lower right," and it was but one item in a large four-day sale of the household effects of the Berberian Estate and the Arthur Van Sant collection. Who owned the bust before Berberian or Van Sant is as yet unknown. I suspect that it is the bust which Philipon gave to Nadar, because a number of Nadar's effects, especially his enormous collection of photographic plates, have come to America and are now, I believe, in New York. The bust is $5\frac{1}{2}$ inches high and 5 inches at the base. Like all the others, it is tinted in dull browns and blacks, with white for the lawyer's neckpiece. The photographs in this book show the fidelity with which Daumier used this bust—and all the others, too—for models. Dupin the Elder was used in more than thirty subsequent caricatures.

10. Maurice Gobin, *Daumier sculpteur*, p. 26.

11. Charles Baudelaire, *The Mirror of Art*, trans. Jonathan Mayne (London, 1955), p. 164.

12. Louis Blanc, *op. cit.*, I, 402.

13. The bust and lithographs of Guizot are striking exceptions to the rest of the portraits; portrait and bust are only dimly caricatural in effect, if at all, as if Daumier sensed the intelligence and integrity of Guizot even though disliking his conservatism. Guy Pène du Bois, "Corot and Daumier," *The Arts*, XVII (1930), 71–97, wrote: "In this portrait is every bit of the malice (some of it mightily biting), the opposition, which he represented, could want to find, and still beneath it or through it, justice is done. It is one of the most dignified portraits of Guizot in existence" (p. 95).

14. The conclusion came, of course, when the important members of the National Assembly had been portrayed in the two series, bust size and full length. The series was popular. When Philipon published a teaser announcement that the portraits might stop, the public protest compelled, he said, the continuation and completion of the plan. When the series was partially completed, Aubert's shop gathered several of the prints (Harlé père, Viennet, Fulchiron, Sébastiani, Podenas, and Etienne) in a portfolio entitled "The

Non-Prostituted Assembly." Philipon predicted that the pictures "would be a valuable work in several years."

15. Duranty, "Daumier," *Gazette des beaux-arts*, 2nd ser., XVII (1878), 439; but see all of his fine praise.

16. David K. Rubens, "Le Ventre legislatif," *The Bulletin of the Art Association of Indianapolis, Indiana*, XLI (1954), 17.

CHAPTER FIVE

1. File in the Bibliothèque Nationale.

2. From an interview with Philipon in *L'Art* (1876), pp. 265–67.

3. During 1833 *Caricature* published twenty-five of Daumier's prints; in 1834 it printed twenty, and *Charivari* twenty-three; and in 1835, up to the September Laws, it printed thirty-one, and *Charivari* thirty-five. These figures are based upon Delteil. The early volumes of both *Caricature* and *Charivari* should be studied to determine the authorship of the unsigned cartoons; some of the prints should, I feel certain, be ascribed to Daumier. The problem awaits serious study.

4. Charles Baudelaire, *The Mirror of Art*, trans. Jonathan Mayne (London, 1955), p. 164. F. Fosca, in "La Collection Claude Roger-Marx," *L'Amour de l'art*, X (1929), 320, wrote: "Daumier alone has been able to paint the modern worker, without falling into sentimentality and exaggeration."

5. Duranty, "Daumier," *Gazette des beaux-arts*, 2nd ser., XVII (1878), 529, praises Daumier's landscape in this print, pointing out that although Daumier felt uncomfortable in the country, away from Paris, he nevertheless could draw the landscapes near that city with superb effect.

6. Quoted in David Evans, *Social Romanticism in France* (Oxford, 1951), p. 83. Evans quotes other contemporaneous remarks in the same vein.

7. For a detailed account see J. Perdu, *Les Insurrections lyonnaises, 1831–1834* (1933).

8. A. Ledru-Rollin, a Republican leader and a lawyer, investigated the circumstances of the massacre, and his report has been the basis of all subsequent accounts, since he took depositions from eyewitnesses (*Mémoire sur les événements de la rue Transnonain, dans les journées des 13 et 14 avril 1834* [1834]). Reading these depositions, one recaptures some of the shock felt by Parisians, which filtered into Daumier's print. Louis Blanc, in *The History of Ten Years, 1830–1840*, 2 vols. (1845), II, 276–78, has an excellent and vivid account of the massacre, using Ledru-Rollin's pamphlet as his main source. See also F. D. Demay, *La Rue Transnonain ou la royauté et ses défenseurs, par un officier de l'armée* (1834); and also Victor Dupra, *Souvenirs de Paris, le 13 avril 1834, rue Transnonain, no. 12* (1848). A picture of the barricade at the Rue Transnonain is printed in Henri d'Almeras, *La Vie parisienne sous la règne de Louis-Philippe* (n.d.), facing p. 364.

9. For this and the other big early woodcuts by Daumier see Eugène Bouvy, "Autour des bois de Daumier; les planches politiques de 1834," *L'Amateur d'estampes* (December 1932).

10. In *The Telegraph*, trans. Louise Varèse (New York, 1950), p. 163.

CHAPTER SIX

1. An impassioned, detailed, and partisan version of the trial may be found in Louis Blanc, *The History of Ten Years, 1830–1840*, 2 vols. (London, 1845), II, 318–63 (all of Chapter 10), from which I have drawn these details.

2. *Ibid.*, II, 320.

3. *Ibid.,* II, 329–30.

4. See A. Bouverron, *An Historical and Biographical Sketch of Fieschi* (London, 1835), and Jean Lucas-Debreton, *Louis-Philippe et la machine infernale, 1830–1835* (1951). Late in 1955 and early in 1956 a cartoon strip, "L'Attentat de Fieschi," ran in the Paris newspaper *France-Soir.* The drawings were no competition for Daumier.

5. Philipon and his successors on *Charivari* managed to avoid serious trouble with the government during the ensuing years; nevertheless they seized every possible opening to make veiled political commentary, and their indirections and insinuations must have acted as an irritation to the officials of the Juste-Milieu. The 5 December issue, for example, told of a trial against *Charivari* for the printing of an illustration the previous month. The editors demolished the government's case by showing that the illustration in question had previously appeared in a book by Thiers, one of Louis-Philippe's favorite ministers. In the next week's issue, under the title "A Prosecution, please," *Charivari* ironically urged the censor to prosecute Thiers for publishing the illustration and for leading them astray. Or again, the issue of 29 July 1839 memorialized the heroes of the July revolution, in a three-color paper; also included was a politically slanted version of Red Riding Hood, with the Wolf as the "system."

CHAPTER SEVEN

1. Philibert Audibrand, "Charles Philipon et Charlet," *L'Art,* VII (1876), 267.

2. For Paris during the Juste-Milieu see Henri d'Almeras, *La Vie parisienne sous la règne de Louis-Philippe* (n.d.); Robert Burnand, *La Vie quotidienne en France en 1830* (1943); Jules Janin, *The American in Paris during the Winter* (New York, 1844), and its companion volume, *The American in Paris during the Summer* (New York, 1844); Louis Allard, *Esquisses parisiennes en des temps heureux* (Montreal, 1943), with a useful bibliography on the social history of the reign; and Gonzago Truc, *Scènes et tableaux de la règne de Louis-Philippe et de la IIe république* (1935). Also useful for the intellectual activity of the period is David O. Evans, *Le Roman social sous la monarchie de juillet* (1930), and, by the same author, *Social Romanticism in France* (Oxford, 1951); E. M. Grant, *French Poetry and Modern Industry* (Cambridge, Mass., 1927); and H. J. Hunt, *Le Socialisme et le romantisme en France* (Oxford, 1935).

3. The phrase was not as crude in context as when quoted alone. Nevertheless, it was unfortunate for Guizot since the forces of opposition used it against him and as an appropriate motto for the entire Juste-Milieu. See "Deux Mots malheureux ('Enrichissez-vous' et 'Vous sentez-vous des hommes corrompus?')," *Intermédiaire,* 5th ser., XXXIX (1899), 75; and XL (1899), 869–70.

4. The best account of the origins of Robert Macaire and of its subsequent history in the theater is in L. Henri Lecomte, *Frédérick Lemaître,* 2 vols. (1888), especially I, 46–57, 180–84, [223]–236, 244–50; and II, 89–100, [224], [248]–[250]. See also Eugène Silvain, *Frédérick Lemaître* (1930), pp. 22–27, 50–62. Many writers seem to have appropriated Macaire for their fictions, such as Charles Selby, *Robert Macaire* (London, n.d.), (Vol. XXX of Lacy's Acting Edition of Plays); and Henry James Byron, *Robert-Macaire, or the Roadside Inn Turned Inside Out* (London, n.d.); Alphonse Robert, *Robert Macaire en Orient* (Brussels, 1840); Jules Vizentine, *Robert Macaire et Bertrand ou les siècles d'un cauchemar, folie en un acte* (1851); *Robert Macaire* (London, 1888), an anonymous novel "founded on the play L'Auberge des adrets"; and A. Vigneul, *Robert Macaire* (1923). William Henley even rewrote the story of Macaire, and in 1856 (?) Edward Warden burlesqued it as *Robert Make-airs, or the Two Fugitives,* a minstrel act dedicated, appropriately, to George Christy. It finally became a motion picture authored by Robert de Beauplan and directed by Jean Epstein. Jean Angelo played Robert Macaire and Alex Allin was

Bertrand. See *La Petite Illustration cinématographique*, No. 4 (November 1925). Certainly these references by no means exhaust the ramifications of the subject; Robert Macaire awaits a doctoral dissertation. Larousse has a good article on the subject, as has Henri Lyonnet, "Robert Macaire et Mayeux" in John Grand-Carteret, *L'Histoire, la vie, les mœurs et la curiosité par l'image, le pamphlet et le document (1450–1900)*, V (1928), 251–60. *Les Cent Robert Macaire d'Honoré Daumier* in the series *L'Art et la vie* (1926) included a preface by Florent Fels which had previously appeared in *L'Art vivant* (1 August 1926), pp. 583–84. The most recent article on the subject is by Osiakovski, "History of Robert Macaire and Daumier's Place in It," *Burlington Magazine*, C (1958), 388–92.

5. The story of this discovery by Lemaître is told by Théodore de Banville, *Mes souvenirs* (1882), pp. 219–24.

6. Macaire had already become cartoon copy for *Caricature* in August 1834 in a lithograph by Traviès wherein the King addresses Macaire saying, "My father-in-law, you are an old rascal"; Daumier had himself previously drawn Louis-Philippe in the role (D97), and had also used the Macaire image for Thiers (D124).

7. Charles Philipon, "Abdication de Daumier Ier," *Journal amusant* (21 April 1861).

8. In *Le Rappel* (23 April 1878).

9. A vivacious essay reprinted in *The Paris Sketch Book of Mr. M. A. Titmarsh* (London, 1840).

CHAPTER EIGHT

1. See Jean Cherpin, "Reproductions lithographiques de septembre 1839," *Arts et livres de Provence*, No. 8 (1948), pp. [74]–76.

2. The great work on Daumier's woodcuts is Eugène Bouvy, *Daumier, l'œuvre gravé du maître*, 2 vols. (1933). Some of his critical material had already appeared in *L'Amateur d'estampes* in many articles over the years, which the serious student will want to consult. Bouvy's catalogue superseded Arthur Rümann, *Honoré Daumier, sein Holzschnittwerk* (Munich, 1914). For an excellent appreciation of Daumier's woodcuts see William M. Ivins, Jr., "Daumier," *The Colophon*, Pt. V (1931). See also Margaret Daniels, "The Woodcuts of Daumier," *Bulletin of the Metropolitan Museum of Art*, XXI (1926), 16–19; and Clément Janin, "Daumier et ses gravures," *Beaux-arts* (9 March 1934).

3. Since this section on the *Physiologies* was composed, there has appeared an important little monograph, *Les Physiologies* (1957), with three relevant articles: "Les *Physiologies*," by Andrée Lhéritier, pp. 1–58; "Le Succès des *Physiologies*," by Claude Pichois, pp. 59–66; and "Ch. Philipon et la maison Aubert," by Antoinette Huon, pp. 67–76.

4. A point well made by Julien Cain in *Les Gens de justice* (Monte Carlo, 1957), p. 9.

5. Charles Baudelaire, *The Mirror of Art*, trans. Jonathan Mayne (London, 1955), pp. 165–66.

6. Ivins, *op. cit.*, called Daumier the "greatest designer of woodcuts who has appeared since the Renaissance."

7. I have based my account of the Branconnot incident on documents owned by M. Seuillerot, but the episode is told briefly by André Quaintenne, "Peines d'argent," *Arts et livres de Provence*, No. 8 (1948), pp. 94–95.

8. Geoffroy-Dechaume, "Daumier," *Revue de l'art ancien et moderne*, IX (1901), 229–30. Executor of Daumier's will and his closest friend, Adolphe-Victor Geoffroy (the Dechaume was added later) was born in Paris, 29 September 1816. A sculptor, he studied at the Beaux-Arts in 1831, working under David d'Angers. In 1862 he was made a Chevalier of the Legion of

Honor. He died at Valmondois, 25 August 1892. The few papers which Daumier left, especially the letters from such men as Millet and Hugo, are still held by Geoffroy-Dechaume's grandson, himself an artist, who generously permitted me to have copies made.

9. Théodore de Banville, *Mes souvenirs* (1882), pp. 173–74.

10. "Il faut être de son temps." This first appeared beneath the frontispiece medallion of Daumier by Michel Pascal in Arsène Alexandre, *Honoré Daumier, l'homme et l'œuvre* (1888). It is Daumier's only known aphorism, and it is obviously central to his art and to his life. It is no doubt true that, as Malraux has so forcefully written, every artist begins with pastiche, but it is further true that the artist finally discards, or absorbs, or amalgamates what pastiche has taught him in terms of his own direct experience and comprehension of life. (And, after all, pastiche itself is a significant form and presentation of experience.) Daumier's words have been well discussed in George Boas, *Wingless Pegasus, A Handbook for Critics* (Baltimore, 1950), pp. 194–210.

11. The best study of the Realist group gathered around Courbet is in Emile Bouvier, *La Bataille réaliste, 1844–1857* (n.d.). The latest scholarly study of Courbet is by Gerstle Mack, *Gustave Courbet* (New York, 1951). Neither of these books treats of Daumier's influence on the Realist movement, but there can be no question that it was important. See Lia Manoliu, "Aperçu sur Champfleury comme éclaireur et critique d'art," in *Mélange de l'école roumaine en France* (1930), pp. [89]–98.

12. In Banville, *op. cit.*, pp. 163–69. Banville's letter is in the Geoffroy-Dechaume collection.

13. Philippe Jones, "Les Femmes dans l'œuvre lithographique de Daumier," *Médecine de France*, No. 23 (1951).

14. The painting was owned by Dr. Louis Sergent, who showed it to me several years before his death. He told me that he had bought it from Mr. Paul Gachet, son of the doctor who had treated Van Gogh during his last days at Auvers. See Louis Sergent, "Un Portrait de la femme de Daumier," *Arts et livres de Provence*, No. 18 (1950), pp. 28–30. Jean Adhémar, *Honoré Daumier* (1954), reproduced it in color (Plate 152), identifying it as a portrait of Didine from a photograph which he printed facing page 22.

15. The letters are in the Geoffroy-Dechaume collection; the passport is owned by Jean Cherpin. The letters were first printed by Raymond Escholier, *Daumier, peintre et lithographe* (1923), pp. 57–60, but Cherpin has rearranged and redated them, adding the discovery of the passport, to tell the story charmingly in "Lettres à Didine ou les bains de mer de M^me Daumier," *Arts et livres de Provence*, No. 27 (1955), pp. [35]–42.

CHAPTER NINE

1. In *Œuvres posthumes de Champfleury, Salons, 1846–1851* (1894), p. 177. Baudelaire was possibly referring to this remark when he wrote, "The works of Gavarni and Daumier have justly been described as complementary to the *Comédie humaine*. Balzac himself, I am convinced, would not have been disinclined to adopt this idea, which is all the more accurate in that the artist who paints contemporary scenes is a genius of mixed nature—that is to say, a genius with a considerable component of literary ability. . . . Sometimes he is a poet; more often he has a kinship with the novelist or moralist; he is the painter of the occasion, and also of all its suggestions of the eternal" (*The Essence of Laughter*, ed. Peter Quennell [New York, 1956], p. 24). For a recent discussion of the relation between Balzac and Daumier see Julien Cain's introduction to *Les Gens de justice* (Monte Carlo, 1957), pp. 9–17.

2. The relationship of Daumier to Michelangelo and Rembrandt needs to be closely studied by a student of art. There is much valuable material in Hans Sedlmayer, *Grosse und Elend des Menschen: Michelangelo, Rembrandt, Daumier* (Vienna, 1948).

3. *The Complete Letters of Vincent van Gogh* (New York, 1958), I, 518.

4. Cf. Baudelaire, *op. cit.*, p. 36: "When a true artist has arrived at the stage of final execution of a work, a model would be more a hindrance than a help to him. It even happens that men like Daumier and Mr. G. [Constantin Guys], long accustomed to using their memory and to filling it with images, find, when confronted with the model and its multiplicity of detail, that their chief faculty is disturbed and, as it were, paralyzed."

5. A. Hyatt Mayor, "Lithographs," *The Metropolitan Museum of Art Bulletin*, VII (1948), 90.

6. Duranty, "Daumier," *Gazette des beaux-arts*, 2nd ser., XVII (1878), 430.

7. The letters from Bousard and Camelou are in the Geoffroy-Dechaume collection.

8. See Jean Adhémar, "Les Légendes de Daumier," *L'Amateur d'estampes*, XIII (1934), 54–58. The chief source of information about the composition of the legends is Albert Wolff, "La Mort de Daumier," *Figaro*, 13 February 1879.

9. Duranty, *op. cit.*, p. 534.

10. Philippe Diole, "Daumier," *Beaux-arts*, 16 March 1934, in reviewing the Daumier exposition at the Orangerie in Paris, wrote: "It is the *ensemble* . . . where one sees how truly great he was, so hard and fierce, so generous and good, bearing ever within himself, like an inexhaustible treasure, the invented world, the reflection of the great universe, where are blended also laughter and tears."

11. *Daumier*, text by Paul Valéry, Les Trésors de la peinture française, n.p., n.d.

CHAPTER TEN

1. Neo-Hellenism, or neoclassicism, proceeded unchecked; it even accelerated. Rachel's frequent revivals of Racine and Corneille were immensely popular, along with adaptations of classic literature, such as that done by Hippolyte Lucas of Aristophanes' *The Clouds*, or the success of Bocage in Sophocles' *Antigone* at the Odéon, 21 May 1843. Le Bas' 1843 archaeological expedition to Greece stirred national pride. For Hellenism in France during this period see René Canat, *L'Hellénisme en France pendant la période romantique* (1911); Albert Cassagne, *La Théorie de l'art pour l'art en France chez les derniers romantiques et les premiers réalistes* (1906), which is especially useful; Fernand Desonay, *Le Rêve hellénique chez les poètes parnassiens, . . .* (1928); Jean Ducros, *Le Retour de la poésie française à l'antiquité grecque au milieu du XIX^e siècle* (1918); and Henri Peyre, *Bibliographie critique de l'hellénisme en France de 1843 à 1870* (New Haven, 1942). Daumier's fifty prints of *Ancient History* have been reprinted in a little volume, *Gotter und Helden*, with a Preface by Ernst Penzoldt (Munich, n.d.).

2. In *The Mirror of Art*, trans. Jonathan Mayne (London, 1955), pp. 167–68.

3. Quoted by Mahonri Young in Duncan Phillips *et al.*, *Honoré Daumier, Appreciations of His Life and Works* (Washington, 1922), p. 57.

4. For a well-reproduced set of this series, with a good Introduction by Julien Cain, see *Les Gens de justice* (Monte Carlo, 1957). Mary M. Stokes, "Daumier and the Palais de Justice," *Parnassus*, IX (1937), 16–17, stresses the point that Daumier's "attack" on the lawyers has perhaps been exaggerated, that he saw them with the eyes of an artist and was more interested and amused than he was angered. Daumier's handling of form is discussed by Gotthard Jedlicka, *Honoré Daumier, Formprobleme seiner Kunst* (Zurich, 1946), a printed section of a much longer unpublished doctoral dissertation.

5. *That Scoundrel Scapin*, from *Molière, Five Plays*, trans. with an Introduction by John Wood (Harmondsworth, 1953), p. 860.

6. *Variety: Second Series*, trans. William A. Bradley (New York, 1958), p. 51.

7. A watercolor sketch of the same scene is in the Lucas collection of the Maryland Institute, on loan to the Baltimore Museum of Art. The old lawyer is descending alone, with the other figures in the background moving up or across the stairs.

8. Edmond and Jules Goncourt, *Journal, Mémoires de la vie littéraire*, ed. Robert Ricatte, 4 vols. (1956), II, 140.

9. In Jules Troubat, *Un Coin de la littérature sous le second empire. Sainte-Beuve et Champfleury à sa mère à son frère et à divers* (1908), pp. 59–60. Born Jules Fleury, but known by his pseudonym, Champfleury is an important minor figure who needs a complete scholarly study made of his life and achievements. Both Manoliu and Bouvier (see Chapter 8, note 11) have material about him, but see also P. Eudel, *Champfleury, sa vie, son œuvre et ses collections* (1891); Bernard Weinberg, *French Realism: The Critical Reaction, 1830–1870* (Chicago, 1937); Jean P. Hytier, "The Note-books of Champfleury," *Columbia Library Columns*, IV (1955), 29–33; and Adolph Bernard Heller, "Champfleury's Contribution to French Literary Realism," *Dissertation Abstracts*, XXI, 2714.

CHAPTER ELEVEN

1. The literature on the 1848 revolution is enormous; for recent studies up to 1936, consult the bibliographical article by Robert Scherb, "Napoleon II and the Empire," *Journal of Modern History*, VIII (1936), 338–55. See also Jean Dautry, *1848 et la IIᵉ république*, 2nd ed. (1957); and Francis Fetjo, ed., *The Opening of an Era, 1848, An Historical Symposium*, with an Introduction by A. J. P. Taylor (London, 1948).

For Louis-Napoleon see Franklin Charles Palm, *England and Napoleon III. A Study of the Rise of a Utopian Dictator* (Durham, N. C., 1949); J. M. Thompson, *Louis Napoleon and the Second Empire* (London, 1954); Philip Guedalla, *The Second Empire* (London, 1922); and, above all others, the authoritative two volumes by F. A. Simpson, *Louis Napoleon and the Recovery of France, 1848–1856* (London, 1923), and *The Rise of Louis Napoleon, 1808–1848*, 3rd ed. (London, 1950). See also Karl Marx, *The Eighteenth Brumaire of Louis Bonaparte*, trans. Daniel de Leon (Chicago, 1907).

For Napoleonism see Albert Guérard, *Reflections on the Napoleonic Legend* (London, 1924); H. A. L. Fisher, *Bonapartism. Six Lectures Delivered in the University of London* (London, 1928); plus various articles by Jules Dechamp, Jules Garsou, and others, which the interested student will find in the British Museum Catalogue.

For Daumier's activities during the Second Republic the fullest and finest account is by Bernard Lemann, "Daumier and the Republic," *Gazette des beaux-arts*, 6th ser., XXVII (1945), [105]–120.

2. Jules Troubat, *Un Coin de littérature sous le second empire. Sainte-Beuve et Champfleury à sa mère à son frère et à divers* (1908), p. 71.

3. Heinrich Heine showed a similar restraint: "Poor Louis Philippe, to have to take his wanderer's staff once more, and at such an age, and to go to foggy, cold England, where the preserves of exile taste doubly bitter!" *The Poetry and Prose of Heinrich Heine*, ed. Frederic Ewen (New York, 1948), p. 452. There was, of course, an outburst in the French press of cartoons which mocked the exiled monarch, but, as André Blum says, "Few of these prints offer an artistic interest, not even those of Mayeux" (André Blum, "Daumier et la caricature politique

en France sous la seconde république," *L'Amateur d'estampes*, Nos. 2 and 3 [1923], pp. 33–42, the one good study of the subject).

4. The ironic contrast between artistic excellence and intellectual pettiness is shown in another Daumier print, part of the series *Contemporary Profiles*, wherein a man reading in a library says to another that Queen Victoria is lying-in for an eighth child at the moment when kings and emperors are falling, to which the second man answers, "What strength of character." It is completely the small joke, but the print itself is beautifully executed, in a formal arrangement which Daumier used frequently in later years in sketches and paintings.

5. Daumier of course was but one of many who ridiculed the outbursts of feminism, in print, in prints, and on the stage. For the movement as a whole see Alphonse Lucas, *Les Clubs et les clubbistes . . . depuis la révolution de 1848* (1851), especially pp. 135–140 on the Club des Femmes, whose membership included celebrated feminists like Eugénie and Pauline Niboyet, Désirée Gay (Madame Girardin), Jeanne Derain, and Eugénie Foa. See also three works by Léon Abensour: "Le Féminisme en 1848," *La Grand Revue*, LXXIII (1912), [105]–120, [544]–565; *Histoire générale de féminisme* (1921); and *Le Féminisme sous le règne de Louis-Philippe et en 1848* (1913); Comte J. Plessis, "L'Influence des femmes dans l'histoire de la littérature et de l'esprit moderne," *Quinzaine*, LXII (1905), 476–502; Marguerite Thibert, *Le Féminisme dans le socialisme français* (1926); Baron Marc de Villiers, *Histoire des clubs des femmes et des légions d'amazones, 1793–1848–1871* (1910). For the subject in caricature see Gustave Kahn, *La Femme dans la caricature française* (n.d.).

CHAPTER TWELVE

1. Duranty, "Daumier," *Gazette des beaux-arts*, 2nd ser., XVII (1878), 542.

2. Four lithographs in Delteil (254–257), printed in 1835, suggest to me that Daumier was painting and that possibly these lithographs were reproductions of specific canvases which he had done. They are genre paintings in a style then popular with Daumier's friends, Cabat, Huet, and Jeanron.

3. "The association took a ground-floor flat with a garden in the Rue de Amandiers, and arranged a well-lighted studio." Vallery V. O. Gréard, *Meissonier, His Life and His Art* (London, [1897?]), p. 28; but see Alfred Darcel, "Louis Steinheil," *Gazette des beaux-arts*, 2nd ser., XXXII (1885), [61]–73, which discusses the association but omits Daumier's name.

4. Born in 1815, Trimolet knew little other than grinding poverty. See "Louis Trimolet," *Cabinet de l'amateur*, II (1943), 544–49.

5. In the Geoffroy-Dechaume collection is a letter from Decamps to Daumier, 8 October 1848: "After many delays the Committee of the Section on Painting has received the necessary authorization for meeting again. As a result, we announce that the sessions will be held each Thursday at 7 o'clock precisely at the Ecole des Beaux-Arts, amphitheatre No. 1. The first meeting has been scheduled for next Thursday, 5 October. Do not fail to attend."

6. It came into the market in the early 1920's, was shown in London, and was then bought by Mr. Duncan Phillips. Rumor has it that some critics have questioned its authenticity, but after repeated visits to Washington over the past few years to study the painting, I see no question of its being a genuine Daumier. The canvas has Daumier's thrusting power, his subject matter, and, in Baudelaire's term, his certainty.

7. Duncan Phillips, *The Nation's Great Paintings. Honoré Daumier (1808–1879), The Uprising*, The Twin Editions (New York, n.d.). See also the eloquent passage on the picture in Henri Focillon, "Visionnaires—Balzac et Daumier," in *Essays in Honor of Albert Feuillerat*, ed. Henri M. Peyre (New Haven, 1943), pp. [195]–209.

8. See Jean Cherpin, "Deux commandes de l'état," *Arts et livres de Provence*, No. 8 (1948), pp. 76–79.

9. See Jean Adhémar, "Daumier, peintre officiel," *Art français* (7 January 1944).

CHAPTER THIRTEEN

1. For an excellent account of Daumier's lithographic struggle against this second tyranny, see Oliver Larkin, "Daumier and Ratapoil," *Science and Society*, IV (1940), 373–87. For a more comical and less concerned attack on Napoleonism, see the pages of *Punch* (which, incidentally, was founded in 1841 as an English imitation of *Charivari*) for this period; the cartoons are very English and quite un-Daumierish.

2. Naturally, we cannot know all the demands on Daumier at this time, the records being what they are, but the sheer quantity of his lithographic work, plus the fact that he was painting and successfully submitting his oils to the Salon, show him as an immensely busy man. An unpublished note, 3 August 1849, from A. Lorentz (in the Geoffroy-Dechaume collection) asking Daumier to help out with a new periodical which he is starting, *L'Album du peuple*, is phrased in terms of flattery, even adulation, indicating perhaps the high esteem with which journalists regarded the cartoonist.

3. This interesting figure was the target of dozens of Daumier's cartoons and he was the constant scorn of *Charivari*, almost their King Charles's head. Véron's great belly and his baby face were excellent caricatural copy, and the chief satirists of the century all joined in the mockery of this man. Véron had become immensely rich through the invention, manufacture, and sale of a medical salve; later, as owner of the leading conservative newspaper, *Le Constitutionnel*, he increased that wealth and also his power in society. From 1831 to 1835 Véron was Director of the Paris Opera. (See Auguste Erhard, "L'Opéra sous la direction Véron, 1831–1835," a unique pamphlet, apparently, in the Bibliothèque Nationale.) A gourmet and sybarite, Véron was a lavish host; he knew everybody who was anybody in Paris and was an important person in French social history. His *Mémoires d'un bourgeois de Paris*, 6 vols. (1853–55), is a lively and unblushing celebration of himself. In 1852 he successfully sued *Charivari* for libel. It is surprising that a modern biography has not been written about him, but one day it certainly will be.

4. An example of Dantan's *charge* is in the Musée Carnavalet, Paris, but there is a pictorial reproduction of it in *Musée Dantan, galerie des charges et croquis des célébrités de l'époque, avec texte explicatif et biographique* (1830).

5. The original clay figure has disappeared, but Geoffroy-Dechaume made two plaster copies of it in 1890, from one of which twenty bronzes were cast, and, subsequently, twenty more. The original plaster copies are seldom shown, but one of them was recently (late spring 1966) sold in Paris for almost $67,000; the bronzes may be found in galleries throughout the world. See Maurice Gobin, *Daumier sculpteur, 1808–1879* (Geneva, 1952), p. 294.

6. Karl Marx, *The Eighteenth Brumaire of Louis-Bonaparte*, trans. Daniel de Leon (Chicago, 1907), p. 41.

7. The letters from Michelet to Daumier are in the Geoffroy-Dechaume collection.

8. Mentioned in Captain [Frederick] Chamier, R. N., *A Review of the French Revolution of 1848 . . .*, 2 vols. (London, 1849), II, 209.

9. The *Revue de Paris* (November 1852), pp. [131]–133, has an account of a special performance at the Théâtre-Français in honor of Louis-Napoleon Bonaparte, at which Rachel recited "L'Empire, c'est la paix" to a packed, cheering house. The phrase was already a catchword, liked or hated depending on the point of view.

CHAPTER FOURTEEN

1. For the paintings and bas-reliefs of *The Fugitives* see Maurice Gobin, *Daumier sculpteur, 1808–1879* (Geneva, 1952), pp. 308–9; M.·C. Rueppel, "Bas-Relief by Daumier. Fugitives," *Minneapolis Institute of Arts Bulletin*, XLVI (1957), Pt. 1, pp. 9–12; and S.L.C., "Daumier's 'Fugitives': Republican Idealism and Independence of Form," *Minneapolis Institute of Arts Bulletin*, XLIV (1955), 12–15.

2. André Blum, "La Caricature politique en France sous le second empire," *Revue des études Napoléoniennes*, I (March–April 1919), 169–83.

3. Gustave Geoffroy, "Daumier sculpteur," *L'Art et les artistes*, I (1905), 108.

4. There are short letters, or notes, in the Geoffroy-Dechaume collection which fill in part of the story of these years. For example, there is a note of Daumier's, 22 August 1853, to some "Messieurs" relative to special work he will do for them: "Be good enough to send me the caricatural subjects you wish, along with views of places to be represented, if you think it necessary. I am asking the publisher the same price which *Charivari* pays me—fifty francs for each subject. If that is all right, will you tell me to whom I should send the stones?" There is no information on what these prints were, or whether they were ever made.

Another detail worth mentioning was the publication in 1854 of Champfleury's *Les Excentriques*. The author wrote to Daumier on 25 April 1854:

My dear Daumier,

Would you allow me to dedicate a book to you: *Les Excentriques*, which will appear in approximately three months?

I am so afraid of unwittingly annoying people that I take precautions.

Furthermore, I would come to ask you personally, but on two occasions I have not found you in.

Should it please you that we might talk together some morning, answer me if it is possible, a single word, for I want to be sure to meet you.

Having many problems on my hands and little time to lose.

All the best my dear Master,
CHAMPFLEURY

The book appeared with an eighteen-page Preface and a dedication to Daumier in which Champfleury discussed eccentrics in general and the art of seeing them, an art practiced by Champfleury, who was fond of the unusual and exotic, and a gift possessed by Daumier, as Champfleury pointed out. The Preface, signed June 1851, is an eccentric document from an eccentric man.

5. Hitherto unrecorded. Archives of the Hospice de St.-Maurice, Registre de la loi, p. 100, No. 3601.

6. Henry James, *Daumier, Caricaturist* (London, 1954), p. 26. Discussing this same picture and commenting on the grouping of the figures, their expressions, the handling of the masses and of the lighting, W. M. Ivins, Jr., wrote, "The slightness of the scene is forgotten, and one sees only the masterpiece on a par with a work by Rembrandt." (In "Honoré Daumier," *The Print Collector's Quarterly*, VI [1916], 4; the entire article by Mr. Ivins, pp. 1–36, is excellent general criticism.)

7. For a discussion of the relationship between Daumier's lithographs and his paintings see Richard Biedrzynski, *Das brennende Gewissen, Maler im Aufstand gegen ihre Zeit: William Hogarth, Francisco de Goya, Honoré Daumier, Kathe Kollwitz* (Berlin and Hamburg, 1949).

8. The acquaintance of Daumier and Henri Monnier went back at least to 1829 when they

both contributed to *Silhouette*. An artist of talent but not of genius, a gifted writer, and an excellent mimic, the versatile Monnier established his immortality by the creation and exploitation of Monsieur Prudhomme (in modern terms, the complete square). Balzac, who knew Monnier well, called him "very strange and witty. But everything with him is superficial, he represents better than anyone our unbelieving, mocking era, skeptical and unaware of its own significance . . . when he makes fun of Monsieur Prudhomme he does not realize that he is making fun of himself." The Boymans Museum, Rotterdam, has Daumier's drawing of Monnier. Edith Melcher has written an excellent study in *The Life and Times of Henry Monnier, 1799–1877* (Cambridge, Mass., 1950).

9. Isidore Geoffroy Saint-Hilaire, *Lettres sur les substances alimentaires et particulièrement sur la viande de cheval* (1856). Almost 400 pages of enthusiastic cultism, this book is its own unintended satire. Especially amusing is Letter 11, which tells rapturously of the horse-tasting banquets held at Alfort and Toulouse. Also, see Nadar's cartoons on hippophagy in the *Journal amusant* (12 April 1856, *et. seq.*); and Léon Noël's discussion in *Musée français-anglais* (September 1856).

10. *The Complete Letters of Vincent van Gogh* (New York, 1959), I, 516.

11. On 12 January 1856 Charles Philipon's magazine, *Journal amusant*, supplemented *Charivari*'s and Daumier's satire on the Realism-Classicism controversy by printing a cartoon of a duel between Ingres and Delacroix, with Meissonier in the background on horseback.

12. Much has been made, and rightly so, of this interest of Daumier's. See Oliver Larkin, "Daumier, Bourgeois Playgoer," *Theatre Arts*, XXIV (1940), 182–93; A. Hyatt Mayor, "Paris in the 1850's, the Theatre of Daumier," *Theatre Arts*, XXXI (1947), 35–38; and, most important because of its gathering of the salient details, Jean Cherpin, "Daumier et le théâtre," *Revue d'histoire du théâtre*," III (1953), 131–59. M. Cherpin also organized an exhibition of "Daumier and the Theatre" for the Palais de Chaillot, which opened 14 March 1958. See also a review article by Daniel Bernet in *Arts* (28 November–4 December, 1956), which summarizes Daumier's theater interest.

13. Théodore de Banville, *Mes souvenirs* (1882), pp. 170–73.

14. Born in Paris, 26 January 1819, Amédée de Noé, son of a count, used the pseudonym "Cham" to protect the family name. He studied in the studios of Charlet and Delaroche, making his professional debut in *Charivari* in 1848. Indefatigable in energy and inexhaustible in humor, he generally drew the weekly page burlesquing the events of the week in little woodcuts —a treasure, as yet untapped, of illustrational material for historians and writers. His large lithographs became increasingly like Daumier's in manner, but he never attained the skill of his friend, teacher, and colleague, and his prints are only a close, but coarse, approximation of the master's. He died 6 September 1879, one-half year after Daumier. There is no good study of him, the best article to date being Arsène Alexandre, *L'Art du rire et de la caricature* (1893), Chap. 30, "Cham et l'actualité."

15. The relationship between the lithographs and the Fogg painting was first noted by Bernard Lemann, "Two Daumier Drawings," *Bulletin of the Fogg Art Museum*, VI (1936), 13–17: "They referred to a situation that had arisen in the butcher shops, evidently a topic of general discussion of the time. It seems that these tradesmen, in an attempt to gain a tax exemption, had lost the monopoly they had previously enjoyed."

16. Charles Baudelaire, *The Mirror of Art*, trans. Jonathan Mayne (London, 1955), pp. 159–60.

17. In Charles Baudelaire, *Correspondance générale*, ed. Jacques Crepet and Claude Pichois, 6 vols. (1953), VI, 25–26.

18. In the Geoffroy-Dechaume collection.

19. Baudelaire, *Correspondance générale*, III, 64.

20. In the Geoffroy-Dechaume collection, as is also the Carjat note.

21. Daumier drew several cartoons satirizing the fad for photography; this one, the best known and most frequently reproduced, was of his friend Nadar, a pseudonym for Felix Tournachon. An artist at first, contributing woodcuts and lithographs to various periodicals and papers, Nadar later became the most celebrated photographer in France. He was on the committee which arranged the exhibition of Daumier's works the year before Daumier died. An enthusiastic champion of the balloon, he subsequently met his death in a balloon accident. See the important article by Heinrich Schwartz, "Daumier, Gill, and Nadar," *Gazette des beaux-arts*, 6th ser., XLIV (1957), [89]–106; and also Robert Doty, "Daumier and Photography," *Image*, No. 60 (1958), pp. 87–91. For Nadar in general see Georges Geimmer, *Cinq essais nadariens: Nadar, la famille, les débuts* (1956).

CHAPTER FIFTEEN

1. In *The Complete Letters of Vincent van Gogh* (New York, 1959), I, 356.

2. W. M. Ivins, Jr., "Daumier—The Man of His Time," *The Arts*, III (1923), 101.

3. Jean Cherpin, "Le Quatrième Carnet de comptes de Daumier," *Gazette des beaux-arts*, 6th ser., LVI (1956), 11–12.

4. Agnes Mongan, "Six Inédites de Daumier," *Gazette des beaux-arts*, 6th ser., XVII (1936), [251]–253, and its sequel, "Supplement to an Article on Six Unpublished Watercolors by Daumier," 6th ser., XXXVI (1949), [132].

5. Letter in the Geoffroy-Dechaume collection. In the same collection is a letter dated 8 July 1867 from Daumier's editor on *Charivari*, Pierre Véron, reminding the artist that he had promised to sell Véron one of his works: "Do not forget it, my dear friend, if you have the leisure."

6. In the Geoffroy-Dechaume collection.

7. *Le Siècle*, 25 April 1878. Champfleury's remarks appeared in *Le Livre* (1883), p. 105.

8. Charles-Francis Daubigny was born in Paris 19 February 1817 and died there 29 February 1878. He was reared at Valmondois in the home of Mère Barzot and lived in the area, at Auvers, during his last years, just two kilometers from Daumier. Daubigny was a distinguished and popular painter, winning many prizes and much renown. Many of his paintings are in America. He was a loyal friend of Daumier's for most of his adult life. See Etienne Moreau-Nélaton, *Daubigny raconté par lui-même* (1925); Frédéric Henriet, *C. Daubigny et son œuvre* (1875); and *Daubigny, souvenirs et croquis, eaux-fortes par Léonide Bourges*, préface par Roger Miles (1894). For an account of the Daubigny house at Auvers with the paintings by Corot and Daumier, see Charles Yriarte, *Le Monde illustré*, 27 June 1868.

9. Arsène Alexandre, *Honoré Daumier, l'homme et l'œuvre* (1888), pp. 331–32.

10. The contract is printed and discussed in Jean Cherpin, "La Maison et l'atelier de Valmondois," *Arts et livres de Provence*, No. 8 (1948), pp. 81–83.

11. Daumier was probably little affected by the reorganization of *Charivari* beginning 1 March 1866. Its headquarters were by then at 16 Rue du Croissant. It had been capitalized for 150,800 francs in twenty-six parts of 5,800 francs each, and the Philipon family still retained an interest in the paper, Eugène Philipon, son of Charles, having one share. (Archives Nationales, F^{18} 325.)

12. In the Geoffroy-Dechaume collection.

13. In the Geoffroy-Dechaume collection.

14. Described in detail by Anna C. Hoyt, "The Cook and the Charcoal Man," *Boston Museum of Fine Arts Bulletin*, XLIII (1945), 58–65.

15. Champfleury, "Illustrateurs de livres au XIXᵉ siècle," *Le Livre* (1883), p. 105.

16. Pierre Véron, *Charivari*, 20 April 1878.

CHAPTER SIXTEEN

1. John Rothenstein, *Nineteenth-Century Painting: A Study in Conflict* (London, 1932), pp. 123–25.

2. An unpublished letter of 19 December 1891, dictated by Madame Daumier, tells of her ill-health and of how all of her husband's oils and sketches had been carried away by a sharp dealer who had paid her only 1,400 francs. It was undoubtedly from this collection of works in various degrees of completion that the many "half-Daumiers" came, causing complete confusion to cataloguers seeking to distinguish the real and the false Daumier works.

3. K. E. Maison, "Some Unpublished Works by Daumier," *Gazette des beaux-arts*, 6th ser., LI (1958), [341]–352.

4. There are a few important analyses of this painting: S. L. Faison, Jr., *Honoré Daumier, Third Class Railway Carriage in the Metropolitan Museum of Art* (New York and London, n.d.); and Henri Marceau and David Rosen, "Daumier: Draftsman-Painter," *The Journal of the Walters Art Gallery*, III (1940), 9–41, expanded from an earlier study, "Technical Notes on Daumier," in *Daumier, 1808–1879* (Philadelphia: Pennsylvania Museum of Art, 1937).

5. See Thomas Craven, *The Story of Painting from Cave Pictures to Modern Art* (New York, 1943), pp. 188–93: "A plain subject indeed. But the figures are real, among the noblest and most moving in French painting. They stand out in space with sharp lines and the bulk of the human clay; they are alive with the charity, the strength, and the understanding poured into them by the great soul of the artist; and they tell, besides the dreariness of one aspect of French life, the story of forlorn humanity everywhere. Of all French artists, Daumier is the most democratic, and his art bears so directly on the troubles of the present world that we of the democratic nations may say, 'He is one of us.'" (p. 193).

6. Josephine Allen, "Notes on the Cover" (Picture of *The Third Class Carriage*), *Bulletin of the Metropolitan Museum of Art*, n.s., V (1946), verso of cover.

7. Described with photographs, by Henri Marceau and David Rosen, "A Terra Cotta by Daumier," *The Journal of the Walters Art Gallery*, XI (1948), 76–82. For the possible graphic prototype of this statue, see the article in the same issue by Charles Seymour, Jr., "Note on the Relationship between an Illustration by Traviès de Villers and Daumier's 'Le Fardeau,'" pp. 83–84.

A statue of *A Woman and Child* by Giacomo Manzù was exhibited at the Hanover Galleries in London in November 1956 which in technique and spirit recalled strikingly Daumier's statue (see the picture in the [London] *Times*, 14 November 1956).

8. Jean Adhémar, *Honoré Daumier* (1954), pp. 44–45.

9. The relationship between Baudelaire's words and Daumier's painting is explored by Jacques Lassaigne, *Actualité de Daumier*, 2nd ed. (Bayreuth, 1942), p. 33. A pretty little book might be compiled using Baudelaire's verses as legends for much of Daumier's work.

10. Henri Focillon, "Honoré Daumier," *Gazette des beaux-arts*, 6th ser., II (1929), 83.

CHAPTER SEVENTEEN

1. Duranty said that he felt that Deburau was "always before" Daumier's eyes when he portrayed clowns and acrobats.

2. J.K.S., "Study of the Clown's Function," *El Palacio*, LII (April 1945), 79–80.

3. For this and for the Don Quixote drawing mentioned below see *Bulletin of the Metropolitan Museum of New York*, XXII (1927), 291–92.

4. Elie Faure, *History of Art—Modern Art* (New York, 1924), p. 324.

5. This picture (15″ high and 11″ wide) has been lent for exhibit more often than any other Daumier work. For a brief account of it see *Hartford, Wadsworth Athenaeum Bulletin*, VI (1928), 28–29.

6. Claude Roger-Marx, owner of the largest and finest collection of Daumier drawings (acquired by his father from Daumier's widow), has written frequently and appreciatively on Daumier, especially about his linear work. See "Grandeur de Daumier," in *Maîtres de XIXᵉ siècle et du XXᵉ* (1954), pp. 58–68; or "Daumier illustrateur," *Arts et métiers graphiques*, XXVIII (1932), 133–38, where he says, for example, on p. 138: "A single square of a few centimeters imprisons so much movement, so much space, all light, that it stirs the mind—as is also the case with many of the woodcuts—to behold gigantic proportions." Or take his felicitous summation of Daumier in "Musée de l'Orangerie, l'exposition de Daumier," *Musées de France bulletin*, VI (1934), 58: "The genius of Daumier has two sides. One is turned toward the people. It laughs, or rather, it makes one think that it laughs. The other is more concealed, more austere. It is that of a courageous god, all of a piece, of a solitary god who heroically views man and life, without tears and without laughter." That is profoundly true.

7. Henry James, *Daumier, Caricaturist* (London, 1954), p. [36].

8. See Eugène Bouvy, "Autour des bois de Daumier," *L'Amateur d'estampes*, XII (1933), [120]–124.

9. See André Berry, "Les Illustrateurs de Don Quichotte," *Arts et métiers graphiques*, XIV (1929), 823–30; Martin Hardie, "The Illustrators of Don Quixote," *Connoisseur*, XIII (1905), 69–75; Pierre Mornand, "Iconographie de Don Quichotte," *Portique* (1945), pp. 83–105; Jean Seznec, "Don Quixote and His French Illustrators," *Gazette des beaux-arts*, 6th ser., XXXIV (1948), [173]–192; H. S. Ashbee, *An Iconography of Don Quixote, 1605–1895* (London, 1895); *Exposition Don Quichotte, mai-juillet, 1955*, Musée des Beaux-Arts (Pau, 1955); Raymond L. Grismer, *Cervantes, A Bibliography: Books, Essays, Articles, and Other Studies on the Life of Cervantes, His Works, and His Imitators* (New York, 1946); and the article, "Don Quichottisme," in *La Grande Larousse*, VI, 11,1005.

10. For the influence of Fragonard on Daumier see the booklet by Charles Sterling, *Portrait of a Man (The Warrior), Jean Honoré Fragonard* (Williamstown, Mass.: Sterling and Francine Clark Institute, August 1964).

11. For example, *Charivari*, 26 July and 29 July 1849.

12. *The Poetry and Prose of Heinrich Heine*, ed. Frederic Ewen (New York, 1948), pp. 385–86.

13. See Blanche Roosevelt Macchetta, *Life and Reminiscences of Gustave Doré* (London, 1885); Hellmut Lehmann-Haupt, *That Terrible Gustave Doré* (New York, 1943); and Pierre Mornand, *Gustave Doré* [1957?].

14. Lionello Venturi, *Painting and Painters* (New York and London, 1946), pp. 177–78.

15. In Etienne Moreau-Nélaton, *Daubigny raconté par lui-même* (1925), pp. 109-10.

CHAPTER EIGHTEEN

1. Jules Claretie, *Peintres et sculpteurs contemporains*, 1st ser. (1882), pp. 33–35. The second version is in Etienne Moreau-Nélaton, *Histoire de Corot et de ses œuvres* (1905), pp. 327–28; and the third is in Arsène Alexandre, *Honoré Daumier, l'homme et l'œuvre* (1888), p. 334. A fourth version, in Jean Gigoux, *Causeries sur les artistes de mon temps* (1885), pp. 55–56, says that Corot bought the house and then brought the deed of sale to Daumier: "This was a moment of tense emotion for the two brave hearts. Daumier, eyes filled with tears, embraced Corot, saying to him: 'Ah! Corot, you are the only one from whom I could accept such a gift without feeling humiliated.'"

2. Jean Cherpin, "Le Dernier Carnet de comptes de Daumier," *Marseille, revue municipale*, 3rd ser., No. 29 (1956), pp. 35–42. M. Cherpin also owns an unpublished Daumier account

book covering the period of September 1852–December 1861. The importance of these note-books for determining and dating the Daumier canon is obvious.

3. Quoted in K. E. Maison, "Some Unpublished Works by Daumier," *Gazette des beaux-arts*, 6th ser., LI (1958), 352.

4. In *La Chronique illustrée. Journal artistique et littéraire* (28 February 1875), it says that 3,000 persons attended Corot's funeral and mentions the presence of Meissonier, Jeanron, Harpignies, Carjat, and Daubigny, but does not include Daumier. Certainly Daumier must have been there unless ill-health prevented him from attending.

5. In Etienne Moreau-Nélaton, *Daubigny raconté par lui-même* (1875), p. 173.

6. Victor Thauriès, "Honoré Daumier," *L'Artiste*, I (1882), 81–87.

7. In the Geoffroy-Dechaume collection.

8. The committee list, primarily honorary, was long and included such distinguished names as Victor Hugo, Peyrat, Jules Dupré, Théodore de Banville, Steinheil, and Pierre Véron. The main work was done by Geoffroy-Dechaume and E. Maindron. Fortunately, Maindron kept a file of the correspondence and of the newspaper reviews (as he did also in the case of Daumier's funeral), now conveniently deposited in the Bibliothèque Nationale. For a good account of the exhibition see Jean Cherpin, "Autour de la première des peintures de Daumier," *Gazette des beaux-arts,* 6th ser., LI (1958), 329–40.

9. From the committee statement, signed by Geoffroy-Dechaume, 23 December 1878.

10. Jean Cherpin, "La Pension de l'état," *Arts et livres de Provence*, No. 8 (1948), p. 80.

11. The registration of Daumier's death is in the town hall at Valmondois, witnessed by "Raoul Daubigny / Régereau / Charles-Marie-Antoine Bernay."

12. See Henri Garnier, "Les Obsèques de Daumier," *Le Voltaire*, 15 February 1879, which printed all of Carjat's verses; see also the address by Champfleury in *L'Evénement*, 15 February 1879. Several details in my account were taken from Paul Van Ryssel's report in *Le Patriot de Pontoise*, 16 February 1879, and reprinted in Paul Gachet, *Deux amis des impressionistes, le Docteur Gachet et Murer* (1956), pp. 22–23. An important account was written by Albert Wolff, "La Mort de Daumier," *Figaro*, 13 February 1879, in which he introduced a few new facts about Daumier. His tribute said, "He was tolerant; he never showed himself jealous of anyone and far from barring *Charivari* to the young caricaturists, he helped them with his advice."

The disinterment order from the Mayor of Valmondois is given by Lapaize in *Le Bulletin de l'art ancien et moderne*, 22 August 1908. The official report which I quote at length is in the Sûreté Nationale, Archives de la Police Judiciaire: E, A/42, Dossier Honoré-Victorin Daumier, Caricaturiste.

13. Geoffroy-Dechaume was the executor of Daumier's will. During the years immediately following Daumier's death, pictures and sketches were bought from Madame Daumier at ridiculously low prices. A Frenchwoman told me that her grandfather recalled seeing a wagon piled with Daumier's work rolling out of Valmondois, the driver having to stop to pick up some paintings which fell off. When Geoffroy-Dechaume died in 1893 there was a public sale in which enough works of art (Daumier's and those of many others) to fill a small museum were sold off.

Madame Daumier died at L'Isle-Adam, not far from Valmondois, on 14 January 1895. The Valmondois house was willed to a great-aunt of the present (Pierre) Geoffroy-Dechaume, and on her death it passed to *her* niece, who lives in the south of France, at Bédarieux, and rents the house, which is still in much the same condition as when Daumier lived there. The studio at the rear of the lot, built by Gueudé at Daumier's request, has little or nothing in it directly associated with Daumier except for a drawing made directly on the plaster wall (and now pro-tectively covered with glass).

Index

THE TEXT of this book is set in twelve-point Monotype Garamond, two points leaded. One of the most useful and pleasing of the Old Style type faces, it was long thought to have been cut by Claude Garamond, who died in Paris in 1561, after a notable career designing types for many of the finest French printers of his time. Lately, however, it has been proved that the face was in fact cut by a seventeenth-century typefounder, Jean Jannon, who imitated the designs of Garamond. The display types are composed in Plantin, called after the great sixteenth-century printer and publisher Christophe Plantin. Although Plantin's career was mainly associated with the city of Antwerp, he was born in France, and his printing always maintained a distinctively French quality. The present Monotype face is based on designs cut for Plantin by Claude Garamond and is adapted from one of the fonts in Plantin's Index Characterum of 1567.

DESIGNED BY PAUL RANDALL MIZE
COMPOSED BY WILLIAM CLOWES & SONS, LTD., BECCLES, SUFFOLK, ENGLAND
PRINTED BY THE MERIDEN GRAVURE COMPANY, MERIDEN, CONNECTICUT
BOUND BY RUSSELL-RUTTER COMPANY, INC., NEW YORK